NEW MEDIA FUTURES

NEW MEDIA

FUTURES

The Rise of Women in the Digital Arts

EDITED BY

Donna J. Cox, Ellen Sandor, and Janine Fron

FOREWORD BY

Lisa Wainwright, Anne Balsamo, and Judy Malloy

Library of Congress Cataloging-in-Publication Data
Names: Cox, Donna J., editor. | Sandor, Ellen, editor. | Fron, Janine, editor.
Title: New media futures : the rise of women in the digital arts / edited by Donna J.
 Cox, Ellen Sandor, and Janine Fron ; forewords by Lisa Wainwright, Anne
 Balsamo, and Judy Malloy.
Description: Urbana, IL : University of Illinois Press, 2018. | Includes
 bibliographical references and index.
Identifiers: LCCN 2017057074 | ISBN 9780252041549 (hardback)
Subjects: LCSH: Art and technology—Middle West—History—20th century. | New
 media art—Middle West. | Women computer artists—Middle West. | Technology
 and women—Middle West—History—20th century. | BISAC: ART / Digital. |
 HISTORY / United States / State & Local / Midwest (IA, IL, IN, KS, MI, MN, MO,
 ND, NE, OH, SD, WI). | SOCIAL SCIENCE / Women's Studies.
Classification: LCC N72.T4 N49 2018 | DDC 701/.05—dc23
LC record available at https://lccn.loc.gov/2017057074

"Nothing could be worse than the fear that one had given up too soon, and left one unexpended effort that might have saved the world."

JANE ADDAMS

||

This book is dedicated to all of the unknown women heroines who came before us and to future generations who come after us. May all of our efforts continue to shine on, inspire, and endure.

Contents ||||||||||||||||||||||||||||||||||||||

Foreword by Lisa Wainwright xi

Foreword by Anne Balsamo xii

Foreword by Judy Malloy xiv

Preface xvii

Acknowledgments xix

Abbreviations xxiii

Introduction 1

PART 1. RENAISSANCE TEAMS: ART AND SCIENCE COLLABORATIONS 49

From the creation of the Doomsday Clock to exhibitions at Fermilab, women in the arts fostered dynamic, cross-institutional collaborations that contributed to the "Silicon Prairie." These women generated new art forms while inventing, codeveloping, and collaborating on the first PHSColograms, Mosaic Internet browser interface, virtual reality CAVE architecture, artistic visualizations of large datasets, and web-based art. These innovations were produced through a collaborative methodology called Renaissance Teams, a term coined by Donna J. Cox, in which artists became producers and directors of these initiatives.

Ellen Sandor 50

Mixed media installations, wearable art, neon sculpture, analog and digital PHSColograms/ sculptures and installations, web design, iGrams, scientific and medical visualization, 3D printing, projection mapping, and virtual reality

Donna J. Cox 71

Photography, computer and supercomputer art, scientific and data visualization, virtual reality, CAVE, 3D, IMAX, fulldome, and digital film and digital PHSColograms/sculptures

Sally Rosenthal (California) 231
Computer animation, game design,
and independent film

Lucy Petrovic (New Mexico, Arizona, Singapore) 238
Photography, computer animation, and virtual reality

Janine Fron (California, Finland) 242
Digital PHSColograms/sculptures and installations,
web design, digital photography, digital preservation,
mixed media, and game design

Part 3 Color Plates 262

Closing Reflections 275
Appendix: Original List of Guiding Interview Questions 279
Glossary 281
References 283
Index 289

Foreword

As technological advances career through our physical and virtual worlds, it is imperative that artists and designers grapple with these tools and methods capitalized within the military, industrial, and entertainment complexes. Artists and designers who can utilize and invent within the technological landscape are critical to the ongoing humanism with which technology must be fused. It is essential that artists test, deconstruct, play, and repurpose the technologies of our rapidly changing world. *New Media Futures: The Rise of Women in the Digital Arts* is not only a testament to a group of artists, designers, scientists, and thinkers who have taken up the question of New Media's role as a civic enterprise, it is also a tribute to the history of women in the arts, a history all too often woefully underrepresented.

Donna J. Cox, Janine Fron, and Ellen Sandor collect an important array of artistic research and personal narratives that are indebted to those who took risks before them and to those still on the horizon of cutting-edge experimental thinking. Theirs is a book celebrating the "Silicon Prairie," those midwestern outposts of creative thinking and daring production, led by a number of key women pioneers. Brava all. Not only was it challenging to jostle for a place in the patriarchal system of the art world, it was also equally daunting to participate in the arena of scientific technologies as a woman. *New Media Futures* demonstrates a triumph in both camps—indeed, a synergistic explosion of art and science in the hands of a number of women practitioners. And so it continues. This book and the artists and projects recounted here will prove a key text for future generations of intrepid women working across disciplines to ask the hard questions about our place in the universe and how to best "map" the conditions they encounter. Technology is a valuable handmaiden in the advances of culture, but only when wielded with a spirit of empathy, collaboration, and care, skills in which women, in my opinion, excel.

Dr. Lisa Wainwright
Vice President of Academic Affairs and Dean of Faculty
School of the Art Institute of Chicago

Foreword

From where I came from growing up in an industrial suburb west of Chicago, I could send my imagination on fantastic trips across America in every direction: east to Boston, west to Denver, south to New Orleans, north to the Upper Peninsula. Exotic far reaches, filled with interesting people with interesting lives, looked like the LA and New York of Hollywood films. Clearly my young imagination was domestically constrained. Until Nixon went to China, I never thought about visiting or living there. To my younger self, the middle of America, the Midwest of my life, was the perfect center from which radiated exciting lines of thought. There is no better evidence for this than the interviews collected in this book.

Those who came of age, biographically or intellectually, in the places of the Midwest spread their insights, innovations, theories, and artworks in all directions. Not rooted to place, their ideas are free to travel the globe. Let's start with Donna J. Cox, coeditor with Ellen Sandor and Janine Fron of this insightful collection. Donna has always been both an artist *and* a scientist. Her ability to produce significant scientific knowledge that is accessible to a range of audiences is exceptional. While I have had the opportunity to meet some of the amazing women interviewed in this book, others I know only through their art and research. I worked with the New Media artist and game designer Janine Fron at the Institute for Multimedia Literacy, University of Southern California. Learning more about Janine's art practice, I was introduced to the work of Ellen Sandor and the New Media form she invented called PHSColograms. That led me to learn about the artist studio/laboratory (art)n and the work of Dana Plepys and Carolina Cruz-Neira on the development of art-based experiences for virtual reality systems. Nan Goggin was an active member of the Women in Information Technology and Scholarship (WITS) at University of Illinois at Urbana-Champaign, a group I supported when I was doing my doctoral work there in the 1980s. It was at U of I that I first learned about Colleen Bushell's visual design for the interface for the Mosaic browser. In the late 1990s, I had the opportunity to meet Sally Rosenthal who, in addition to having been a pioneer in producing art and technology events for SIGGRAPH, also holds patents for software that enables body-based interactions with virtual objects.

Personally I continue to draw insights from the work of Brenda Laurel, who has been a pioneer exploring the technocultural landscape to understand not only the cultural implications of emergent technologies but also how to design and develop new technologies to serve more liberatory objectives. I was introduced to Brenda by none other than Timothy Leary when we all participated in one of the first academic symposia on virtual reality in 1992. As an academic, a researcher, a designer, and an entrepreneur as well as an activist, Brenda is without peer in her ability to move among domains of intellectual work and to contribute meaningfully to each.

Every figure interviewed in this collection has produced inspiring work in multiple forms, across multiple contexts. Tracing the connections among these artist-technologists reveals the presence of a creative network of collaborators who were deeply engaged in research and development of important "edge" technologies. Each woman featured in this book has been a pioneer in exploring the intersections of art and technology. Individually, and as a group, they have influenced the field of New Media Arts in profound ways by integrating technology into their artistic practice, and by bringing art and cultural considerations to bear on their technological innovations.

In closing, I'd like to give a shout out to Laurie Anderson, another unconventional artist and technologist, who—although being a lifelong New Yorker—was born in the Midwest. Long before I knew she was from my hometown (Glen Ellyn, Illinois), her songs provided the soundtrack of my intellectual coming into being. As is clear about many of the people interviewed in this volume, she too is recognized as a pioneer—in her case, in the creative use of electronic technologies. She is, as is everyone mentioned here, a hybrid figure whose work defies simple categorization. Each offers a unique biography that documents her contributions to the richness of our technological lives, and to the creative possibilities of our collective technocultural futures.

Dr. Anne Balsamo

Inaugural Dean, School of Arts, Technology, and Emerging Communication
University of Texas at Dallas

Foreword

In the Midwest, beginning in the late 1970s, an extraordinary group of women artists explored and expanded the frontiers of the digital arts. In *New Media Futures*, the histories of these women of the midwestern "Silicon Prairie" unfold, as told to their colleagues, the editors of this book: Donna J. Cox, director of the University of Illinois's Advanced Visualization Laboratory at the National Center for Supercomputing Applications (NCSA); Ellen Sandor, founder/director of the collaborative artists' group (art)n; and Janine Fron, longtime collaborator and creative director of (art)n and cofounder of the collective Ludica, which explores the potential of art- and play-centered game design to express women's narratives.

In twenty-two chapters, the work of women digital artists with midwestern roots and/or residence is disclosed—from Donna Cox's creation of the iconic supercomputer Venus, *Venus in Time*, and Ellen Sandor's inventive PHSCologram process; to Jane Veeder's self-portrait game *Warpitout* and Brenda Laurel's Purple Moon software for girls; from Carolina Cruz-Neira's role in the development of the Cave Automatic Virtual Environment (CAVE) to Ping Fu and Colleen Bushell's role in graphical interface design for the Mosaic web browser. Along the way, Abina Manning relates Kate Horsfield and Lyn Blumenthal's cofounding of SAIC's Video Data Bank; Margaret Dolinsky fabricates digital projections for opera and experimental cinema; and there is much more.

Presenting individual histories as situated in the development of the technologies themselves, *New Media Futures* not only provides significant models for women interested in exploring computer-mediated creative media but also documents the challenges of creating digital media from the late seventies to the early nineties. Application software, for instance, was unlikely at the time when many of the artists in this book began working. Explanatory books were scarce; programs were created from scratch, often taking the form of a stack of punch cards. As Lucy Petrovic, whose work focuses on interactivity and virtual reality environments, observes in this book: "We were writing code, step-by-step. Initially that was the only way to create art on the computer."

Yet with the challenges came excitement about the potential of the digital arts. In Donna Cox's words: "I realized that I could digitally control millions of colors using a computer if I learned how to program. I saw the future, and it was computer graphics."

In Joan Truckenbrod's words: "This process is imbued with a complexity—the fact that we can build up layers of ideas, realities, realms that we have envisioned—we can build up a wealth of those and look at them in a very complex way."

Keyed by Cox's concept of Renaissance Teams (collectives formed to collaboratively address complex visualization problems), how collaboration fostered creativity in the midwestern "Silicon Prairie" is an underlying theme of *New Media Futures*. The role of welcoming institutions, such as NCSA and the School of the Art Institute of Chicago (SAIC), where women could access advanced computing environments is also important, as are generous male researchers and laboratory heads, including Dan Sandin, Tom DeFanti, and Larry Smarr. Additionally, the centrality of teaching and the role of the women themselves in creating innovative teaching environments weave in and out of the narratives. Joan Truckenbrod was the first chair of the Department of Art and Technology Studies at SAIC. Ohioan Brenda Laurel designed and chaired the graduate Media Design Program at the Art

Center College of Design in Pasadena and served as professor and founding chair of the Graduate Program in Design at California College of the Arts. Nan Goggin is the director of the School of Art + Design at the University of Illinois at Urbana-Champaign.

Since 2003 when my book *Women, Art, and Technology* was published, the New Media Arts have become more integral in the cultural landscape.[1] Contingently, a decline in women in computer sciences and even at times an undercurrent of hostility persists, despite the fact that "Diversity in the workforce contributes to creativity, productivity, and innovation. Women's experiences—along with men's experiences—should inform and guide the direction of engineering and technical innovation," as a recent report from the American Association of University Women emphasizes.[2]

We are urgently in need of examples of how this innovation can occur. The strength of *New Media Futures*, therefore, is founded on its recognition of the work of the women of the "Silicon Prairie" and on the rich environment of collaboration, teaching, research, scholarship, and the making of art that is core in their histories. As digital culture becomes more central in our lives and scholarship, their histories provide guidance and inspiration on the path to equal inclusion and equal recognition of women in the New Media Arts.

Notes

1. Judy Malloy, "Travels with Contemporary New Media Art," *GIA Reader* 21, no. 2 (Summer 2010). Available at www.giarts.org/article/travels-contemporary-new-media-art.

2. Christianne Corbett and Catherine Hill, *Solving the Equation: The Variables for Women's Success in Engineering and Computing* (Washington, D.C.: American Association of University Women, 2015), 2.

Judy Malloy
Editor, *Women, Art, and Technology*

Preface ||

ince the inception of this seminal oral history project, our goal has been to reveal infrequently told stories of women active in the arts during the digital revolution from the 1970s through the 1990s. Although cultural revolutions are rarely isolated, undeniable midwestern events gave rise to artistic innovations that played a major role in the birth of New Media Arts. Social developments, including the emergence of civic leadership in education and the arts, aligned with the merits of Chicago's women's movement and shaped the milieu from which the intersecting narratives presented in *New Media Futures: The Rise of Women in the Digital Arts* unfold. The University of Illinois and the School of the Art Institute of Chicago provided a foundational framework for the Chicago arts community that supported synergistic cultural environments in which the creativity and careers of the women featured in this book could flourish.

From late 2008 through 2012, we recorded interviews of twenty-two women whose contributions focused on 1985 as a pivotal point for a set of questions (see the appendix). We personally know many of these vibrant, creative women, and in the process of editing the book we discovered many more. This selection represents a breadth of generations and approaches that serve as exemplars from influential years in the twentieth century's digital revolution.

We interweave the twenty-two interviews through an introduction that summarizes historical events that we believe were most relevant to the Midwest's contributions. We establish the relative position of women in society from the late nineteenth century to the Bauhaus and its evolution of a "Chicago style" video arts culture that intersects with a chronology of post–World War II research initiatives that unveiled computer technologies to the world. This evolution set the stage for women's future explorations in the arts. We introduce the twenty-two women interviewed here as they entered the digital playing field in the arts community and academic research institutions. Mixed media and video art began to intermingle with computer software, networking abilities, and digital interfaces that took on new forms of cultural expression. Here we begin to see an evolution of twentieth-century New Media Arts with the innovation of PHSColograms, computer graphics animation, scientific visualization, interactive media, electronic games, the Internet, and virtual reality CAVE (Cave Automatic Virtual Environment), all produced with collaborative teams led by pioneering artists on the prairie. These types of artistic explorations continued to develop and evolve beyond the 1990s to become known as "New Media" or "digital media" (Cook and Diamond 2011).

Following the book's introduction, we organized the interviews into three main parts. We arranged these sections according to major trends and orientations of the women's collaborations along with their communities of influence and migration. The interviews reveal personal as well as career evolutions in New Media Arts through the important advances they made harnessing digital technologies that additionally created inroads for future generations of women to make their own contributions.

In the introduction, we do not attempt to establish a new feminist arts theory, nor do we claim to show a complete timeline of technology history. However, we elucidate many of the constraining attitudes that women faced throughout the twentieth century. We recognize that many doors have opened for women while some remain closed. We also believe that women from those early years adopted a variety of collaborative strategies in order to navigate their career paths. More research

is necessary to fully understand why women establish tenacious stakeholds within male-dominated professional environments. The women interviewed in *New Media Futures* situated themselves within experimental settings that unlocked their imaginations with the garage-art tools of their time. Collaboration was a strategy with a variety of motivations to be part of a larger vision that required women to adopt the new leadership role of being "artists as producers" or "artists as directors" as each project demanded.

The cultivation of this new domain encouraged people to learn new skills and work together across disciplines, cultures, and institutions, which created a different concept of community. It was no longer unusual for teams to be comprised of artists, scientists, technologists, scholars, and educators all working on the same project, pooling together their expertise and experience. Collaboration became an avenue to access technology as well as the specialized knowledge, language, and surroundings of a like-minded community of kindred spirits. Many of the women we interviewed moved forward on their intuition to catalyze the artistic and technological potentials in the spirit of early pioneer women settlers, often with kids in tow who were being raised amidst the changing culture.

Few of these women dialogued around the nature of collaboration; rather, they navigated an overwhelming crest of raw opportunity without time to reflect—until now. It has been an ongoing challenge to preserve and document the work that has been done while being proactive with its scholarship in ways that continue to explore themes that are relevant to our society.[1] Our investigation encouraged interviewed women to reflect orally because many of these stories have left few historical trails. Their anecdotes witness an exciting but nearly forgotten era. All of the interviewed women recalled wearing many hats and did not always have the time or equipment to document important events or transition their artworks to newer technologies. Today, women in New Media Arts have greater opportunities for collective voice through personal blogs, social media dialogs, and the immediacy of documentation through online outposts and journals such as *Femtechnet*, a feminism and technology network and journal. Continued research and dedicated resources for the preservation of New Media Arts remain persistent challenges facing artists and educators today.

One of our goals is to inspire future generations who may continue to grapple with obstacles and reveal little-known synergies and strategies of women artistically using technology to affect cultural change. We additionally hope to provide a message for future generations to understand some of the midwestern foundations and values that helped engender the now so familiar. It is important that we all work together, with men and women on equal footing, to raise human consciousness and make the world a better place. The synthesis of the arts in New Media is a metaphor for a harmonious society. This book is truly about women supporting each other towards this end.

To contribute forewords, we chose three women, each of whom shares a kindred avant-garde and collaborative spirit with the twenty-two women's stories presented here. Dr. Lisa Wainwright is a renowned American art historian, vice president of Academic Affairs and dean of faculty, School of the Art Institute of Chicago. Dr. Anne Balsamo is a cultural theorist, multimedia experience designer, cofounder of *Femtechnet*, and inaugural dean, School of Arts, Technology, and Emerging Communication, University of Texas at Dallas. Lisa and Anne both earned PhDs from the University of Illinois during the backdrop of this rich history. Judy Malloy is the editor of the seminal book *Women, Art, and Technology* (2003) and is a recognized leader in electronic literature and New Media scholarship.

Working on *New Media Futures* has been an incredibly enriching journey for all of us involved in this encapsulating project. We feel blessed and honored to have met, interviewed, and gotten to know these incredible women over the years to whom all of us owe an everlasting debt for their tenacity and guiding inspiration.

Note

1. For an extensive collection analyzing and categorizing collaborative strategies, see *Euphoria and Dystopia* (Cook and Diamond 2011).

Acknowledgments

||

Without the combined talents, efforts, and dedication of all of our collaborators over the many decades of diligent hard work and striving, the works described in this book would not be possible. It is a testament to the spirit of our times that there are more people involved than technologies used in the realization of the complex collaborations that are herein described. Community is a thread that weaves us all together in the circle of life and is unique to midwestern values that have migrated the world over through the seeds planted on the prairie by contemporary women in the arts as well as their forerunners.

We are indebted to the life's work that has been shared with sincere reflection and deep introspection in the oral history interviews provided by our contributors. Their individually unique and yet overlapping stories helped to illuminate a very exciting and pivotal time in history for women to make a difference in the world by charting innovative, collaborative pathways through the arts and sciences.

Special thanks to Lisa Wainwright, Anne Balsamo, and Judy Malloy for writing the three forewords to the book that speak to the historical context of the underrepresentation of women in the arts throughout modern history, and the significance of women equally contributing towards the making of our culture today.

We gratefully acknowledge the dedication, enthusiasm, and unwavering support of our editor, Laurie Matheson, and her staff for bringing this seminal book to fruition. The co-editors express special appreciation to Jennifer Comeau and Julie Laut for their insightful guidance, and to Dustin Hubbart and Jennifer Fisher for their stunning visual design of the book. The peer reviewers selected by the University of Illinois Press provided knowledgeable insights and invaluable suggestions that enriched the historical background of the manuscript and fine-tuning of the transcribed interviews.

Many thanks to additional women who helped shape the initial book proposal, including Kelly Searsmith, Joan Catapano, and Jane Stevens; to Dawn McIlvain Stahl for her beautiful transcriptions and Ann Redelfs for her enthusiastic suggestions; to Ann Beardsley for her keen attention to detail in the final proofreading; to Meridith Murray for her indexing expertise; and to Deanna Spivey for coordinating all of our arrangements to gather and communicate.

With gratitude to Robert Patterson, Jeff Carpenter, Sara Diamond, Lisa Stone, Joann Ferina, Eda Davidman, Samantha Conrad, Nicolle Kate, Margaret Baczkowski, Merle Gross, Florence Shay, Marnie Wirtz, Betsy Birmingham, Julia Bachrach, Brita Bastogi, Marientina Gotsis, Elina Ollila, Jacki Ford Morie, Tracy Fullerton, and Celia Pearce, for sharing their insights, friendship, and support throughout the project.

With fond appreciation to Tiffany Holmes and her staff, including Nia Easley, for organizing the exceptional 150th SAIC milestone event, *Celebrating Women in New Media Arts*, held on March 18, 2016, in the SAIC ballroom in honor of this book. Very special thanks to Jean St. Aubin and the staff of the SAIC Gene Siskel Film Center for the symposium screening and closing reception. Continued appreciation for Walter and Shirley Massey and for SAIC president Elissa Tenny for their enthusiasm and support.

For opening their archives and sharing their resources to make the book visually engaging with a historical resonance: Richard and Ellen Sandor Family Collection; James Prinz Photography; Rachel Bronson, Lisa McCabe, and Kendal Gladish, *Bulletin of the Atomic Scientists*; National Center for Supercomputing Applications Archives; Aimee L. Marshall, Art Institute of Chicago Images; Nathaniel Parks, Ryerson and Burnham Libraries, the Art Institute of Chicago; Jon Cates, Phil Morton Memorial Research Archive, School of the Art Institute of Chicago; Abina Manning and Emily Eddy, Video Data Bank, School of the Art Institute of Chicago; Angeli Arndt, School of the Art Institute of Chicago; Christopher J. Prom, University of Illinois Archives; Kim D. Todd, Jean Jennings Bartik Computing Museum, Northwest Missouri State University; John Mark Ockerbloom and Mary Ockerbloom, *Celebration of Women Writers* site hosted by the University of Pennsylvania Libraries; Rita M. Hassert and Maureen Murphy, Sterling Morton Library, the Morton Arboretum; Robbi Siegel, Art Resource Inc.; Todd Leibowitz, Artists Rights Society; Deborah Cotton, ACM Publications; M. E. Brennan, IEEE; Karen Moltenbrey, *Computer Graphics World*; Elaine Coorens, *Our Urban Times*; Virginia Hohl and Dorren Gertsen-Briand, District 102; Heather Eidson, the *Times of Northwest Indiana*; and James Caulfield.

Special research was conducted at Ryerson and Burnham Libraries, the Art Institute of Chicago; John M. Flaxman Library, School of the Art Institute of Chicago; Special Collections and University Archives, University of Illinois; University Library, University of Illinois at Urbana-Champaign; Columbia College Chicago Library; Charles Deering McCormick Library of Special Collections, Northwestern University; and Avery Library, Columbia University. Additional thanks to Lindsay M. King and Ted Goodman for their help and expertise with providing a plethora of historical references and research materials while at Northwestern University and Columbia University respectively.

We would like to respectfully acknowledge the exceptionally talented and pioneering Renaissance men the editors and book contributors have had the pleasure to work with from the beginning. For their support, enthusiasm, and sharing mutual values to make the world a better place with collaboration as the foundation of artistic and scientific exploration: Dan Sandin, Tom DeFanti, Phil Morton, James Zanzi, Jerry August, Gary Justis, Randy Johnson, Mark Resch, Stephan Meyers, Larry Smarr, Robert Patterson, George Francis, Bill Gropp, Roy Ascott, Roger Malina, Mike Ross, Ryan Wyatt, John Towns, Bill Kramer, Tom Lucas, Mike Bruno, Dan Neafus, Mel Slater, Chunglian Al Huang, Marc Andreessen, Jason Leigh, Drew Browning, Johnie Hugh Horn, Michel Ségard, Miroslaw Rogala, Fernando Orellana, Chris Day, Todd Margolis, Ben Chang, Geoffrey Allen Baum, Keith Miller, Chris Kemp, William Robertson, Marcus Thiébaux, Christopher Landreth, Loren Carpenter, Rob Tow, and Scott Fisher.

We would also like to gratefully acknowledge all of the exceptional men and women from the scientific community whom we have had the sincere privilege to work with. Their unique talents, curiosity, enthusiasm, openness, and shared resources have truly helped us to transcend with the arts to make inroads for future generations of explorers. Without their dedication and perseverance during the changing tides of our times, we would collectively miss seeing the forest beyond the trees.

Donna J. Cox would like to personally acknowledge the Advanced Visualization Lab (AVL) members Robert Patterson, Stuart Levy, Alex Betts, A. J. Christensen, Kalina Borkiewicz, Jeff Carpenter, Matthew Hall, Lorne Leonard, and Deanna Spivey, who through their dedication and hard work have advanced the field of visualization. A special thanks goes to Jeff Carpenter who helped with processing imagery for this book. Other collaborators who have been important in the success of Renaissance Teams include Tom Lucas, George Francis, Ray Idaszak, Michael Norman, Marcus Thiébaux, Toni Myers, Judy Carroll, Frank Summers, Guy Garnett, Chris Landreth, and Mel Slater. Many thanks goes to the National Center for Supercomputing Applications and the University of Illinois leadership who have been supportive of this book effort, including NCSA Director Bill Gropp, Larry Smarr, Ed Seidel, Thom Dunning, Danny Powell, Mike Ross, Dan Reed, and Gabrielle Allen. Donna lovingly expresses deep appreciation for encouragement from her strong and supportive daughter, Elizabeth Cox, and creative life partner, Robert Patterson, who both continue to inspire her through the writing of this book. Much appreciation goes to family, Jimmy and Vicki Troutman; to close friends Jan Kalmar and Monica Trapani; to supportive friends in the Spiritual Inquiry Group and the Women's Song Circle; and to all those who compassionately seek answers to universal questions.

Ellen Sandor would like to warmly thank Chris Kemp, Diana Torres, and Azadeh Gholizadeh of (art)[n] for their dedication and hard work throughout this endeavor and always. Special thanks to Terry Hesser

and Melissa Sage Fadim for creating a documentary film of this lifelong adventure in the arts that parallels the history in this book. It has been a pleasure to work with Georgia Schwendet, Kurt Riesselmann, Anne Mary Teichert, Jennifer Raaf, Sam Zeller, and Thomas Junk at Fermilab in Batavia, Illinois, while completing the book. With love and gratitude to Dr. Richard Sandor, Dr. Julie Sandor, Jack Ludden, Elijah Sandor-Ludden, Justine Sandor-Ludden, Penya Sandor, Eric Taub, Caleb Sandor-Taub, Oscar Sandor-Taub, and Dr. Jeffrey Simon.

Janine Fron lovingly thanks her family, friends, and colleagues for their continued encouragement and enthusiasm, most especially the Fron and Mertz families, Mom, Dad, Leslie, Peter, and Andrew; Aunt Brigitte, Aunt Christine, Aunt Jean, Aunt Nancy, Michael, Jake, Tim, Aunt Myrna, Jackie, and Katie Z. With very special thanks to Celia, Jacki, Tracy, Mary, Elina, Marnie, Florence, Julia, Brita, Lilly, Natasha, Donna, and Nancy. I feel so blessed for having many inspiring people in my life who all share in wanting to make the world a better place for future generations.

The editors are grateful for each other's camaraderie, collegiality, guiding friendship, and inspiration that have enriched our lives and the evolution of our collaborative process with creative joy.

With heartfelt thanks, we are equally indebted to the many more colleagues, collaborators, and friends who have been with us all on this exciting journey from the beginning and beyond, whose inspirations made all things possible.

Abbreviations ||

ABC	Atanasoff-Berry computer
ACM SIGGRAPH	Association for Computing Machinery Special Interest Group in Graphics
AIC	Art Institute of Chicago
ARC	Artists, Residents of Chicago
(art)n	(pronounced Art to the Nth)
A/V	audio/visual
AVL	Advanced Visualization Laboratory
BOM	Battle of Midway
CAVE	Cave Automatic Virtual Environment (recursive acronym)
CC	Columbia College
CGI	Computer Graphics Imaging
eDream	Emerging Digital Research and Education in Arts Media
ENIAC	Electronic Numerical Integrator and Computer
EVE	Electronic Visualization Events
EVL	Electronic Visualization Laboratory at the University of Illinois at Chicago
GRASS	GRAphics Symbiosis System
ICARE	Interactive Computer Assisted RGB Editor
ICP	International Center for Photography
iGrams	immersaGrams
IIT	Illinois Institute of Technology
ILLIAC	Illinois Automatic Computer
KCPA	Krannert Center for the Performing Arts
MCA	Museum of Contemporary Art Chicago
MJH	Museum of Jewish Heritage
NCNP	National Conference of New Politics
NCSA	National Center for Supercomputing Applications
NSF	National Science Foundation
NWU	Northwestern University
ORDVAC	Ordnance Discrete Variable Automatic Computer
PHSCologram	Photography, holography, sculpture, and computer graphics (pronounced skol-o-gram)
PLATO	Programmed Logic for Automatic Teaching Operations
REL	Renaissance Experimental Laboratory
SAIC	School of the Art Institute of Chicago

Sandin IP	Sandin Image Processor
SGI	Silicon Graphics Inc.
SIGGRAPH	Special Interest Group in Graphics
UC	University of Chicago
UIC	University of Illinois at Chicago
UIUC	University of Illinois at Urbana-Champaign
VDB	Video Data Bank
VR	virtual reality
VROOM	virtual reality ROOM
WWW	World Wide Web

NEW MEDIA FUTURES

Introduction

New Media Futures: The Rise of Women in the Digital Arts captures the spirit of women working in digital media arts and education in the Midwest. These pioneers made essential contributions to the international technological revolution, helping to catalyze what we now think of as the age of digital and social media. The story explores seminal events that took place at the University of Illinois and the School of the Art Institute of Chicago in the 1980s and 1990s, in a fertile environment combining social feminist change, artistic energy, and technological innovation. While women artists in Chicago, marginalized in traditional venues, built a network of independent galleries and exhibit spaces to house and highlight their work, interdisciplinary Renaissance Teams at the University of Illinois developed advanced academic computing communities that created a bridge to the humanities and forged new partnerships between the artist and the scientific environment. This historic merging of art and technology in the Midwest, with women at its heart, encompassed digital games, PHSColograms, virtual reality, supercomputing graphics, and Internet browser-based art, as well as graphic tools for medical research and diagnosis and other technical uses. Behind this revolution lay a history of social change, artistic innovation, women's civic leadership, and breakthroughs in science and technology.

EARLY ROOTS: ESTABLISHING A STRONGHOLD FOR MIDWESTERN WOMEN IN THE ARTS

Behind the digital arts revolution in the Midwest lies a long history of women building civic leadership and cultivating dynamic social relationships. By forging a stronghold for change in the arts, education, and design, these pioneering women cross-pollinated creative forces that continue to emerge and evolve from historical contexts to the present day.

Women's civic leadership in Chicago found prominent expression in the Woman's Building of the World's Columbian Exposition in 1893: a pavilion designed, decorated, and managed by women. Philanthropist Bertha Honoré Palmer, who had formed the Chicago Woman's Club in 1876, passionately explained the initiative's merit: "The Exposition will thus benefit women . . . not alone by means of the material objects brought together, but there will be a more lasting and permanent result through the interchange of thought and sympathy among influential and leading women of all countries, now for the first time working together with a common purpose and an established means of communication" (Elliott 1893, 22). Plans for the exposition were directed by the Exposition Commission, composed solely of men, while the leadership of women participants was segregated. The Board of Lady Managers was created by an official act of the US Congress, which commissioned a building to house women's exhibits (Peck and Irish 2001, 228).

The classical Beaux Arts–influenced building was designed by Sophia Hayden, the first woman architect to graduate from MIT.[1] Candace Wheeler, appointed director of interior design, was a pioneer of the field for women. The building's Hall of Honor was anchored by allegorical murals,

1

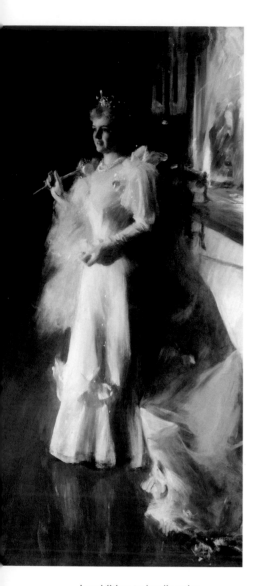

In addition to leading the Woman's Building initiative at the World's Columbian Exposition, Bertha Honoré Palmer (1849–1918) was a major benefactor of the arts in the nineteenth century. She helped establish the Art Institute of Chicago in the Midwest as a renowned, international art museum. *Mrs. Potter Palmer*, 1893, by Anders Leonard Zorn, 101⅝" × 55⅝" oil on canvas. The Art Institute of Chicago.

commissioned from American impressionist painters Mary Cassatt and Mary MacMonnies, and depicted young girls in modern dress pursuing the fruits of science and knowledge. In *Eve's Daughter/Modern Woman: A Mural by Mary Cassatt*, author Sally Webster reminds us, "While Sophia Hayden's design was noteworthy, it was the enterprise itself, the assembling of women's work—handicrafts, inventions, books, paintings, sculpture, and statistics on women's employment—that galvanized women nationally and internationally. The entire project mirrored a passionate desire by women from all walks of life to document the contributions women had made to the world's culture and economy" (Webster 2004, 45–46).

Describing their mission in the official exposition catalog for the Woman's Building, Bertha Honoré Palmer reflected a broad vision of civic responsibility and social concern:

> The desire of the Board of Lady Managers is to present a complete picture of the condition of women in every country of the world at this moment, and more particularly of those women who are bread-winners. We wish to know whether they continue to do the hard, wearing work of the world at prices which will not maintain life, and under unhealthy conditions; whether they have access to the common schools and to the colleges, and after having taken the prescribed course are permitted graduating honors; whether the women, in countries where educational facilities are afforded them, take a higher stand in all the active industries of life as well as in intellectual pursuits; how large the proportion is of those who have shown themselves capable of taking honors in the colleges to which they are admitted, etc. We aim to show, also, the new avenues of employment that are constantly being opened to women, and in which of these they are most successful by reason of their natural adaptability; what education will best fit them for the new opportunities awaiting them. (Elliott 1893, 22)

In addition to leading and contributing to numerous organizations and charities in Chicago, Palmer assembled an influential art collection, including numerous iconic works by the impressionists, that helped establish the Art Institute of Chicago and the metropolis as an international leader in the arts. Prior to Palmer's commissioning of Cassatt to paint *Eve's Daughter/Modern Woman*, the artist suggested to Palmer and her husband some impressionist artists to include in their collection, and she made helpful introductions to her art connections in Paris.[2] Cassatt's own work includes her 1890–91 experiments

with aquatint color printing techniques, resulting in a suite of ten prints, often referred to as "The Ten," that explored a day in the life of a modern woman. The sophisticated printmaking process Cassatt used marks an early example of a woman artist employing technology in her work.

The School of the Art Institute of Chicago (SAIC), formerly the Chicago Academy of Design, was formed in 1882 and housed in the Art Institute's new facility on Michigan Avenue and Van Buren Street. Its basic curriculum emphasized drawing and painting from life, including costumed models and natural landscapes. Lorado Taft, who founded the Sculpture Department, put SAIC on the map for being the only school in the country where students could chisel creations from marble.[3] Most of his students were women, and in 1889, his class staged on the lakefront south of the museum a fountain composed of nude nymphs that was considered controversial—not for nudity, but because it was executed by women. That same year, SAIC initiated a program in architecture and formed an alliance with the Armour Institute of Technology to provide instruction in science and mathematics, thus creating early inroads for art and science to take shape in the city's overall development.

Women's access to education improved during the Columbian Exposition era, with the University of Chicago Law School opening its doors to women in 1889 and Northwestern University establishing a women's college in which Bertha Honoré Palmer was a trustee. Columbia College Chicago, founded in 1890 by Mary A. Blood and Ida Morey Riley as a coeducational school, continues to serve the Chicago community as the nation's largest privately enrolled art school. Hull-House, the famous settlement house established on Chicago's southwest side in 1899 by the Pulitzer Prize–winning writer, reformer, and peace activist Jane Addams, hosted Frank Lloyd Wright's influential 1901 talk, "The Art and Craft of the Machine."[4] Calling the machine "the only future of art and craft" and "the modern Sphinx whose riddle the artist must solve if he would that art live," Wright characterized the machine as "capable of carrying to fruition high ideals in art—higher than the world has yet seen!" (Wright 1901, 77). This American manifesto, later published in *Brush and Pencil*, foreshadowed new schools of thinking that would evolve into the Prairie Style, New Bauhaus, international, and postmodernist styles of architecture for which Chicago became so richly known.[5]

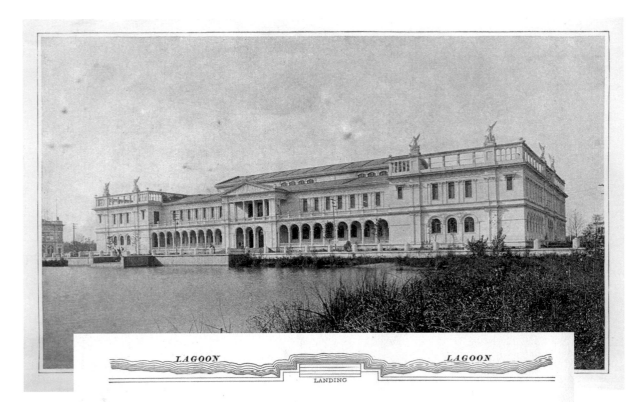

Sophia Hayden (1868–1953), the first woman architect to graduate from MIT, was hired by Palmer to design the Woman's Building for the World's Columbia Exposition. This building and assemblage signified women's accomplishments worldwide and helped to galvanize women nationally and internationally. Frontispiece, Woman's Building, United States. Designed by Sophia G. Hayden.

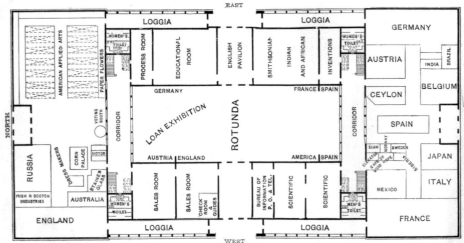

GROUND PLAN WOMAN'S BUILDING.

GALLERY PLAN WOMAN'S BUILDING.

The Ground Plan Woman's Building shows the international impact and the global participants engaged with the midwestern women designers. These countries included England, France, Germany, Italy, Ceylon, and Japan—featuring inventions, artworks, and scientific explorations made by women. Gallery Plan Woman's Building.

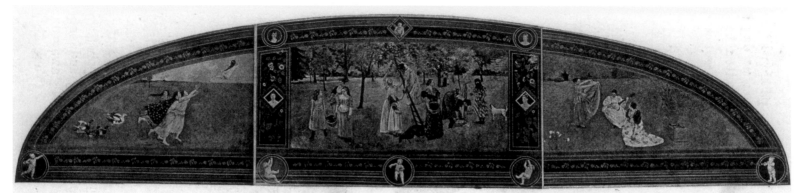

DECORATION OF SOUTH TYMPANUM—"MODERN WOMAN." MARY CASSATT. UNITED STATES.

Mary Cassatt's (1844–1926) design of the Woman's Building South Tympanum celebrated young women pursuing knowledge and science. This is one of the themes emerging in the twentieth-century modern woman. Decoration of South Tympanum, "Modern Woman" by Mary Cassatt. Source: Maude Howe Elliott, *Art and Handicraft in the Woman's Building of the World's Columbian Exposition, Chicago*, 1893, "A Celebration of Women Writers." http://digital.library.upenn.edu/women/.

Wright was influenced by his aunts, Jane and Nell Lloyd Jones, who in 1886 founded Hillside Home School in Wisconsin, the first coeducational boarding school in the United States. Their "learn by doing" pedagogical approach became the hallmark of Taliesin, the rustic studios that Wright established in 1932 with his third wife, Olgivanna. Among other architects, Wright employed Marion Mahony, the second woman to graduate from MIT

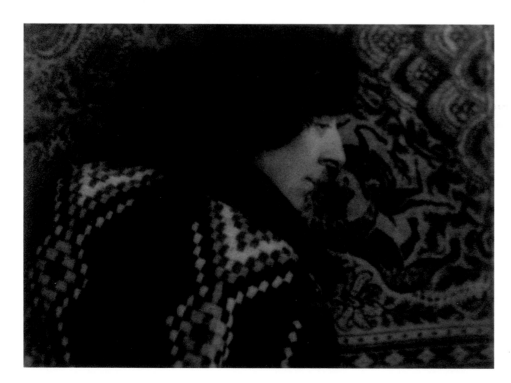

Marion Mahony Griffin (1871–1961) is one of the world's first women licensed architects. She graduated from MIT—the second woman do to so (Sophia Hayden had graduated from MIT four years earlier)—and was both the first architect and first woman to be licensed in the state of Illinois. She delineated the popular Prairie Style architecture that put Chicago on the international map, attracting future architects to Chicago. "Portrait of Marion Mahony Griffin." Magic of America, Art Institute of Chicago portfolio images, Ryerson and Burnham Archives. http://digital-libraries.saic .edu/cdm/singleitem/collection/mqc/id/48263/rec/259.

with a degree in architecture. Mahony became the first licensed woman architect in the world to practice in the field.[6] She initially worked out of a shared office in Steinway Hall, the eleven-story building on Van Buren Street that famously housed Wright and his group of innovative architects.[7]

In 1907, *Ladies Home Journal* published an article that reviewed one of Wright's designs that was delineated by Mahony and quintessentially defined Prairie Style architecture; the article was titled "Fireproof Home for $5000" and described an L-shaped open floor plan that was centered on a fireplace. Wilhelm Tyler Miller further popularized the Prairie Style with his circular *The Prairie Spirit of Landscape Gardening*, which the University of Illinois published in 1915 for the Illinois Agricultural Experiment Station. Mahony's much admired presentation style of immersing architectural renderings in a richly vegetative prairie landscape, which she often delineated on linen and silk, was imitated by the drafters who worked in Wright's office and adopted by fellow architects of the Prairie School (Van Zanten 2011, 51). Mahony's renderings comprised nearly half of Wright's famed *Wasmuth Portfolio* (1910) that was published in Germany and put Chicago on the international map for its organic architecture innovations made during the Prairie School era (McGregor 2009).[8] In 1911, Mahony married a fellow architect from Wright's office, Walter Burley Griffin, a graduate from the University of Illinois, and the two worked in partnership on commissioned residences, educational institutions, and businesses in Australia, India, and the United States. In 1912, the Griffins won the competition to design the Australian capitol city of Canberra. There were 137 applicants, and Eliel Saarinen won second place. An electronic edition

of Marion Mahony Griffin's manuscript, *The Magic of America*, was posthumously published online in 2007 by the Ryerson and Burnham Libraries of the Art Institute of Chicago.[9]

Bridging art and education, art historian Helen Gardner published the first edition of her seminal *Art through the Ages* in 1926, the first single-volume textbook to provide a global survey of art history. A graduate of the University of Chicago, Gardner taught at the School of the Art Institute from 1920 until her retirement. Many editions later, *Art through the Ages* remains a standard text in the field. The third edition, published shortly after her death in 1946, was the first to include women artists (Mary Cassatt, Berthe Morisot, Georgia O'Keeffe).[10] That edition's concluding chapter, entitled "The Arts of the Machine," recalls Wright's earlier Hull-House lecture. Gardner observed that "through scientific advances in transportation and communication, the world has been so interknit that it has become in reality, one world, in which advanced, decadent, and primitive cultures, highly diversified in ideology and art forms, have been brought together, head on."

MODERNISM WITH AN INTERNATIONAL STYLE

The 1930s brought two influential exponents of the German Bauhaus style of architecture, László Moholy-Nagy and Ludwig Mies van der Rohe, to Chicago. Moholy-Nagy arrived in 1938 and founded the New Bauhaus, which became the Chicago School of Design and then the Institute of Design, coming in 1949 under the umbrella of the newly formed Illinois Institute of Technology (IIT). Meanwhile, van der Rohe became the director of the Architecture Department at the Armour Institute of Technology. These training grounds offered new opportunities for women artists, including Marli Ehrman, Else Regensteiner, Lenore Tawney, Claire Zeisler, and Theo Leffmann.

Marli Ehrman studied and taught in arts and crafts schools and universities in Europe and created an experimental weaving workshop at the original Bauhaus. After escaping Germany before the Nazi purges, Ehrman relocated to Chicago where she became the director of the Weaving Workshop at IIT's School of Design under Moholy-Nagy's directorship in 1938. She also taught at Hull-House and in 1956 opened

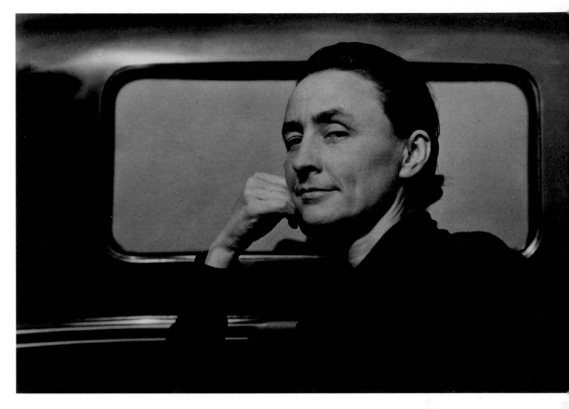

Midwestern-born Georgia O'Keeffe (1887–1986) was an influential twentieth-century artist who helped define modernism with her abstract charcoal drawings, watercolor, and oil paintings, sculptures, and photographs. She briefly attended SAIC and was among the first modern women artists to be recognized in art history texts and included in Helen Gardner's *Art through the Ages*. The Art Institute of Chicago hosted her first retrospective in 1943. "Georgia O'Keeffe, Lake George," 1931, by Alfred Stieglitz, 3" × 3⅝" vintage gelatin silver print from the Richard and Ellen Sandor Family Collection. Digital photo by James Prinz Photography.

the Elm Shop modernist design studio in Oak Park, where she designed textiles for commercial clients. She additionally collaborated with Marianne Willisch and Mies van der Rohe and was awarded first prize in weaving in a national competition conducted by the Museum of Modern Art and another prize in a national competition awarded by Fairchild Publications, Inc. in New York. Equally important to her own achievements was her mentorship of a new generation of influential textile artists that included her students at IIT—Lenore Tawney, Else Regensteiner, Claire Zeisler, and Angelo Testa—all of whom had successful careers as designers and artists.

Else Regensteiner also immigrated to the United States to escape the Nazi regime. She befriended Ehrman in 1936 after settling in Chicago and became her assistant at the Institute of Design. She attended Black Mountain College during her vacations to study with Anni and Josef Albers. In 1942, she graduated from IIT and was hired as a weaving instructor. She later taught at SAIC from 1945 to 1971 and abroad at the American Farm School in Thessaloniki, Greece, from

László Moholy-Nagy (1895–1946) was a Hungarian painter, photographer, and Bauhaus professor who believed in the intersection of art, technology, and industrial design. He helped establish Chicago as a center of international modernism with Mies van der Rohe (1886–1969) while they both taught at IIT. "Self-Portrait (Moholy appears sunken to bottom of the sea in a fish net)," 1928, by László Moholy-Nagy, 8" × 11½" vintage gelatin silver print from the Richard and Ellen Sandor Family Collection. Digital photo by James Prinz Photography.

"Mies van der Rohe," 1952, by Harry Callahan, 4½" × 3¼" modern gelatin silver print from the Richard and Ellen Sandor Family Collection. Digital photo by James Prinz Photography.

1972 to 1978. She collaborated with fellow student Julia McVicker to form Reg/Wick Handwoven Originals, whose regular clientele included the Stiffel Company. She was director of the Handweavers Guild of America, cofounded the Midwest Designer-Craftsmen, and authored three books—*The Art of Handweaving*, *Weaver's Study Course: Ideas and Techniques*, and *Geometric Design in Weaving*—considered hand-weaving classics that brought Bauhaus traditions to a wider audience. Chicago native Theo Leffmann chose another path from her peers and worked with fiber as a mode of personal expression in lieu of practical design applications. She created several bodies of work over a fifty-year period, including figurative sculptures and wall hangings that are represented in the Mary and Leigh Block Museum of Art, Northwestern University.

As a bastion for Bauhaus ideals was building up Chicago, Nordic modernity was flourishing under the influence of the Saarinen family at Cranbrook in Bloomfield Hills, Michigan. The Scandinavian design movement began in Europe during the 1920s to create well-designed objects for everyone. "More beautiful everyday things" was the motto of the movement. Eliel and Loja Saarinen were the first to bring this design philosophy to the United States. Eliel Saarinen was a prominent architect who believed in the fusion of fine arts and crafts, akin to the Bauhaus. Like Wright, he also worked holistically and was interested in designing everything from the buildings and their interiors and furnishings to their communities. When Cranbrook opened in 1932, it provided students unique opportunities to work alongside European men and women who came to Michigan to create works of architecture, sculpture, furnishings, and textiles for the Cranbrook campus (Waagen 1990, 50).

Loja Saarinen, who trained as a sculptor and photographer in Finland before immigrating to Michigan in 1923 with her husband, architect Eliel Saarinen, made pivotal contributions in the Midwest at Cranbrook Academy of Art, where she taught and designed textiles until retiring in 1942. While Loja built most of Eliel's architectural models, she also designed rugs and textiles for the buildings he designed for Cranbrook. This helped her establish her own firm, Studio Loja Saarinen, before October 1928. Frank Lloyd Wright and Charles Eames were among her many clients. The following year, the Weaving Department opened at Cranbrook, of which Lola was named director (Clark 1983, 173–96). Her successor, Marianne Strengell, was both an influential teacher at Cranbrook through the 1960s and a successful designer whose clients included Knoll Associates, General Motors, Ford Motor Company, and the architectural firm Skidmore, Owings and Merrill in Chicago.

In parallel, Frank Lloyd Wright designed thirty-six structures on the West Coast that began with the Stewart House in Santa Barbara (1909) and

ended with the Marin County Civic Center in San Rafael (1959), migrating midwestern innovations in organic architecture and modernism.[11] In a July 1957 address to the people of Marin County, Wright said, "Beauty is the moving cause of nearly every issue worth the civilization we have, and civilization without a culture is like a man without a soul. Culture consists of the expression by the human spirit of the love of beauty." Wright believed the Civic Center offered "a crucial opportunity to open the eyes of not Marin County alone, but of the entire country to what officials gathering together might themselves do to broaden and beautify human lives." Other historical works in California by Wright include the Barnsdall (Hollyhock) House (1917–1921), the Charles Ennis House (1923), the Storer House (1923–1924), and the Freeman House (1923–1925), all built in Los Angeles.[12] Wright's work on the West Coast influenced California-based architects Richard Neutra, Rudolph M. Schindler, and Frank Gehry, which helped spread midwestern-born ideals throughout the twentieth century for using creativity and innovation to make the world a better place for future generations (Wilson 2014). In addition to Marion Mahony Griffin, Wright employed many talented women in a variety of capacities throughout his career, including Lois Davidson Gottlieb, Isabel Roberts, Jane Duncombe, Eleanore Pettersen, and Read Weber, among a hundred others (Willis 2009).

ALTERNATIVE ART SPACES EMERGE: CHICAGO'S COUNTERCULTURE BEGINS

In the post–World War II period, a multitude of alternative art venues, spaces, and contexts sprang up in Chicago. One launching pad was the venerable Art Institute itself, whose "Chicago and Vicinity Show" came under criticism in 1947 for favoring works by the institute's students and faculty over those of community members. When the museum responded by banning all student participation in the exhibition, more than 800 protesting students from both SAIC and the Institute of Design at IIT signed a petition they presented to Daniel Catton Rich, the Art Institute's director. When the museum refused to rescind its ban, the students mounted their own show, *Momentum*

Exhibitions, from July 15 to August 28, 1948, at Roosevelt College, that was open "to all artists of the local area, to all media, to all art languages . . . to provide that universality of opportunity necessary to insure the vital movement of art" (Warren 1984, 11). Josef Albers, Robert von Neuman, and Robert Jay Wolff came to Chicago at their own expense and juried the show.

One outcome of these exhibitions, which continued through 1964, was the growing number of alternative spaces to Chicago's art establishment that began to emerge, along with the formation of artists' groups to support them. To meet the demands of SAIC students, the school expanded and remodeled again, and in 1959 the museum received a generous endowment from Mrs. Sterling Morton to add a south wing to the building. However, a structure housing several of the SAIC studios stood on part of the ground the new museum wing was going to cover, and so it was decided that a long-term plan to consolidate SAIC could finally be implemented, with nineteen new classrooms and its own Columbus Drive entrance. In this respect, the students managed to unite the school with the museum through *Momentum Exhibitions*, while forming a united sense of community among Chicago artists. In Lynne Warren's critical essay "Chicago Alternatives" (1984), she explained, "The moral imperative of artists of the 1950s and 1960s was that work should be shown without regard to, as Leon Golub put it, 'the status of its creator or the circumstances implicit in its creation'" (Warren 1984, 15).[13]

Warren's essay implied that many Chicago artists who were doing interesting work had been left out of exhibitions at the Hyde Park Art Center and other establishments because Chicago's art world was becoming stagnate with acceptable "counterculture" works by the Chicago Imagists, for example, thereby narrowing the community's range of participation.[14] Activist and art critic Lucy Lippard wrote a thoughtful feminist essay, "The Women Artists' Movement—What Next" (1976), where she highlighted the importance of alternative art and cautioned women artists not to be "content with a 'piece' of the pie, so long dominated by men, satisfied with the new found luxury of greater representation in museums and galleries (though not yet in teaching jobs and art history books) rather than continuing to explore the alternatives." For Lippard, alternative spaces and ways of making art could change "the superficial aspect of the way art is seen, bought, sold and used in our culture" (Parker and Pollock 2013, 135).

Detail from *Lucy Lippard 1974: An Interview*, conducted by Lyn Blumenthal and Kate Horsfeld. Lippard earned degrees from Smith College and New York University; she became an art critic in 1962, contributing to *Art International* and *Artforum*. Image copyright of the artist, courtesy of the Video Data Bank, SAIC.

most of whom had studied at the School of the Art Institute—a constant factor in Chicago's history of alternative spaces—were nationally and internationally oriented, working more and more in experimental modes—performance, installation, and conceptual art, which dealers found difficult to sell even when produced by such luminaries as Vito Acconci, Walter de Maria, and Dennis Oppenheim, to name a few," noted Warren (Warren 1984, 16).

In parallel, women artists in the city were encouraged by the women's movement at large. Alternative spaces became a strategy used by women to organize both artistic aspirations and feminist change as a means to influence the art system while addressing the multigenerational discrimination against women in the arts and the workforce in general. Warren explained, "The alternative spaces of the 1970s thus arose out of very different needs—the necessity to promote a new aesthetic in art, one that seemed natural and right to those educated in the late 1960s and early 1970s when painting had been declared dead (reminiscent, interestingly, of the battle of the first generation of alternative space artists against the summary rejection of 'modern art'); and the need by women artists to feel a part of the system which, heretofore, as in many other fields, had discriminated against women, particularly those with families" (Warren 1984, 16).[15]

Simultaneously fueled by alternative ideas of making and showing art sparked by *Momentum Exhibitions*, a group of twenty-five artists, collectors, architects, art dealers, and critics met on January 9, 1964, to formulate plans for the Museum of Contemporary Art Chicago (MCA), the second contemporary art museum that was established in the United States, "with a desire to educate audiences by encouraging visual literacy and familiarity with contemporary art" (Olson 1996, 6).

In 1967, the museum opened its doors on East Ontario Street in Chicago with Jan van der Marck as its inaugural director, and received its first work in 1968, *Six Women*, by a Venezuelan sculptor simply known as Marisol. The initial goals set by the museum's founder and board president Joseph Shapiro were to "present the newest art and a growing permanent collection." The MCA was a welcoming venue to women artists and innovative projects. In 1969, Christo and Jeanne-Claude wrapped the MCA with eight thousand square feet of tarpaulin that became the first building wrapped by the couple in the United States. MCA board president Lewis Manilow

Feminist writers Rozsika Parker and Griselda Pollock examined if Lippard's challenge to women should be directed at accessing the male-dominated art establishment or whether they should be creating alternative networks of galleries, exhibitions, and programming. "Tactically women's collective efforts to provide their own supportive networks are immensely important and they have effectively opened up new spaces and extended the possibilities of work for many women" (Parker and Pollock 2013, 134–35). The danger of this strategy, they claimed, was that women artists might have remained working in isolation at the periphery of cultural expression with an artistic practice that diverges too far away from a larger dialog of transformative change. In Chicago, women artists trod along both of these pathways and broke new ground that reinvented the future for the next generation of women artists.

During the 1960s, the new wave of third-generation alternative space artists did not adhere to discourse or care to foster community like its predecessor—the momentum generation. "Because of the changing times, these artists,

described the project as "avant-garde in the best possible sense. That is to say, it expanded the vision of art. We had a grand vision. I remember dancing and cloth being everywhere, and looking at this new building, the whole idea, the scale of the imagination" (Olson 1996, 8).

By 1972, the MCA presented the first retrospective in the United States for American sculptor Lee Bontecou, who was one of the first women artists to achieve broad recognition for her work during the 1960s. This retrospective was paired with the first museum exhibition to examine Chicago Imagist art. In 1973, the museum presented a memorial exhibition for Eva Hesse before she received recognition from other institutions. The MCA continued its tradition of showing avant-garde women artists for many decades to come, including the compelling Frida Kahlo, Laurie Anderson, and Louise Bourgeois.[16]

Important women artists working and exhibiting in Chicago included Barbara Rossi, Christina Ramberg, and Sarah Canright—Chicago Imagists whose works were popularized by the pivotal MCA exhibition *Don Baum Sez "Chicago Needs Famous Artists"* (1969). Gladys Nilsson and Suellen Rocca were part of the Hairy Who, while Nancy Spero and Jean Leaf were part of the Monster Roster, a group of artists who were mentored by Vera Berdich, post–World War II. Berdich was an SAIC alum who worked for the Works Progress Administration (WPA) at Hull-House and taught at SAIC 1947–1979. She was inspiring and influential to the Chicago Imagists. Barbara Crane, Ruth Duckworth, Jeanne Dunning, Lee Godie, Ellen Lanyon, Kay Rosen, Holis Sigler, Diane Simpson, Margaret Wharton, and Margaret Whitehead are among women artists featured in the MCA's *Art in Chicago: 1945–1995*, whose works influenced Chicago's evolving arts community. Also during this era, Vivian Maier was an unknown American street photographer who supported herself as a nanny in Chicago's North Shore suburbs for forty years before her work was internationally exhibited.

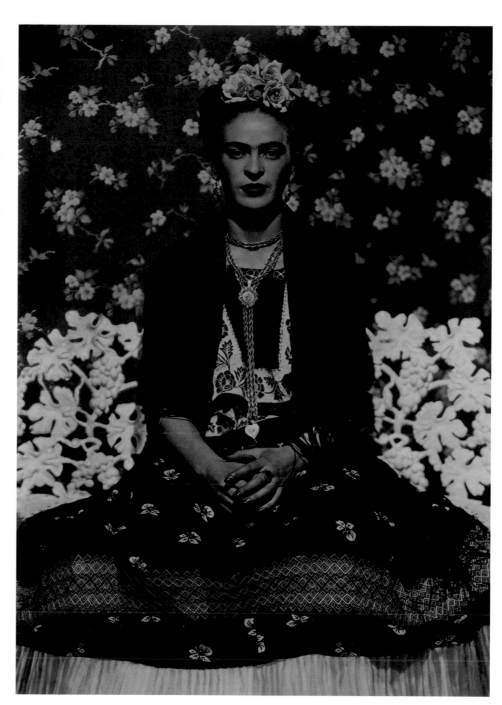

In 1978, the MCA hosted Frida Kahlo's (1907–1954) first solo show in the United States, which was visited by many women artists and curators who were part of Chicago's alternative movement to exhibit art. "Frida Kahlo on White Bench, New York," 1939, by Nickolas Muray, 11½" × 14½" modern color carbon print. From the Richard and Ellen Sandor Family Collection. Digital photo by James Prinz Photography.

WOMEN ARTISTS AND ALTERNATIVE SPACES

During the 1970s, several new alternative art spaces emerged with the goal to show women's artistic visions. These alternative spaces were organized by women artists. ARC (an acronym for Artists, Residents of Chicago) was formed in September 1973 and was located at 226 East Ontario Street, situated across the street from the newly established MCA. ARC was catalyzed by Ellen Lanyon, a key organizer of the *Momentum Exhibitions* and Superior Street Gallery as part of a women's network called W.E.B. ("West Coast–East Coast Bag"). As women artists were

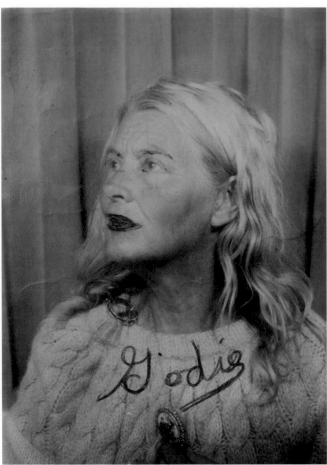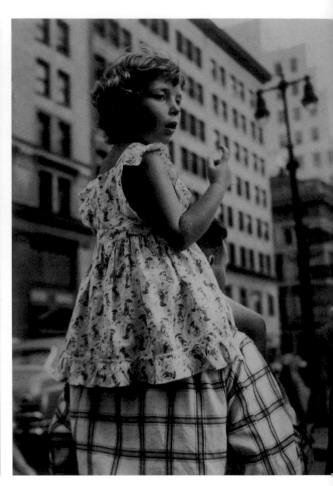

Women artists who lived and worked in Chicago included Jeanne Dunning (1960–), Lee Godie (1908–1994), and Vivian Maier (1926–2009). Dunning and Godie were featured in the MCA's *Art in Chicago 1945–1995* retrospective, while Maier recently enjoyed her own retrospectives at the Chicago Cultural Center and Chicago History Museum. "Head 6," 1989, Jeanne Dunning, 30" × 19" vintage Cibachrome on Plexiglas; "Lee and Cameo on a Chair . . .," early–mid 1970s, Lee Godie, 4¾" × 3¾" vintage silver print; "New York (Girl on Shoulders)," 1951–1955, Vivian Maier, 4½" × 3½" modern gelatin silver print. From the Richard and Ellen Sandor Family Collection. Digital photos by James Prinz Photography.

gathering to discuss topical issues, they began to realize there was a need for an outlet to exhibit the growing number of women artists in Chicago who were having difficulty entering the Chicago art world. Seventeen of these women, some of whom who were part of the W.E.B. dialogs, were invited to join ARC.

ARC was organized by this pioneering collective of women artists with goals of "enhancing members' status in the art world and, by extension, enhancing the status of all women artists, and of providing a model for younger women artists" (Warren 1984, 17). As a nonprofit still operating today, ARC Gallery and Educational Foundation aims to empower women by providing professional services and mentorship in the visual arts through exhibitions, workshops, discussion groups, and public programs for underserved populations.

A second women's cooperative, Artemisia, was opened in the same building and named in

honor of Baroque painter Artemisia Gentileschi. Artemisia had similar goals to that of ARC and included women from divergent artistic backgrounds. In addition, Artemisia included SAIC students and alumni. Their first exhibition opened in 1973 with a group show of gallery members and continued through 2003 when their doors closed. Artemisia was pivotal in supporting the careers of more than 150 women artists. In May–June 2013, Artemisia uniquely celebrated the fortieth anniversary of its opening with a special exhibition, *Artemisia after 40: Current Works by Past Members*, at the Bridgeport Art center in Chicago. Their inclusion in the SAIC community combined with a more "hardline feminist philosophy supported a greater cohesion and stronger institutional identity" (Warren 1984, 17).

ARC and Artemisia were the first women artists' cooperatives in Chicago as well as in the Midwest. Both organizations invited notable artists to discuss their work, including Judy

Chicago, Ruth Isken, Cindy Nemser, Arlene Raven, and Miriam Shapiro. They also created landmark feminist exhibitions in 1979: ARC's *A Day in the Life, 24 Hours in the Life of a Creative Woman* and Artemisia's *Both Sides Now: An International Exhibition Integrating Feminism and Leftist Politics*, which was curated by Lucy Lippard.

Along with ARC and Artemisia, a third alternative space was also formed, primarily by SAIC graduate students, who were all men with one exception. This was the N.A.M.E. Gallery, which catered to emerging artists working with performance, filmmaking, conceptual, and installation art. Although N.A.M.E. was organized as a co-op, its doors were opened to other artists with its exhibitions selected by a majority vote of its members. Other venues, including the Phyllis Kind Gallery, Rhona Hoffman Gallery, and Feature [gallery], were also important in establishing Chicago as a center for imagist art and postmodernism. Art Chicago, first held in 1980 at Navy Pier and modeled on the prestigious Art Basel in Switzerland, became the premier contemporary art exposition in the United States, providing prominent international exposure to Chicago artists and galleries.

During the 1970s, women artists were boldly innovating on their own terms, bolstered by the feminist movement and other currents of social change, in which Chicago played a crucial role harkening back to the efforts of Jane Addams, and decades later, Betty Friedan and Jo Freeman. The 1950s postwar era had precipitated widespread discontent in many workforce-displaced women, and some identified the foundation of unhappiness and inequality. Betty Friedan, from Peoria, Illinois, was the author of *The Feminine Mystique* (1963) and a leading figure of the women's movement in the United States. The book unearthed the extensive disillusionment in women of her era and fueled the dissent of young women in the workforce. In 1967, when the National Conference of New Politics (NCNP) omitted the participation of women activists to voice their position as a plenary session, Freeman circulated a newsletter from her Westside apartment she called *Voices of the Women's Liberation Movement*. Her efforts catalyzed the formation of feminist liberation groups across the country and, by the following year, a national conference was held in the Chicago suburbs (Lake Villa, Illinois).

Artists resonated with this tide of change, and the growing nationwide women's movement surged with artistic voices that reflected

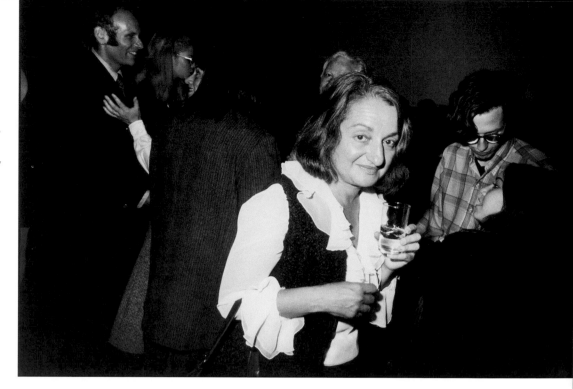

Betty Friedan (1921–2006), American writer, activist, and feminist, born in Peoria, Illinois. Friedan was a leading figure of the women's movement in the United States and the author of *The Feminine Mystique* (1963) in which she declared, "The only way for a woman, as for a man, to find herself, to know herself as a person, is by creative work of her own." "Betty Friedan opening at the Whitney Museum," 1969, by Garry Winogrand, 12⅜" × 18½" modern gelatin silver print. From the "15 Big Shots Portfolio," Richard and Ellen Sandor Family Collection. Digital photo by James Prinz Photography.

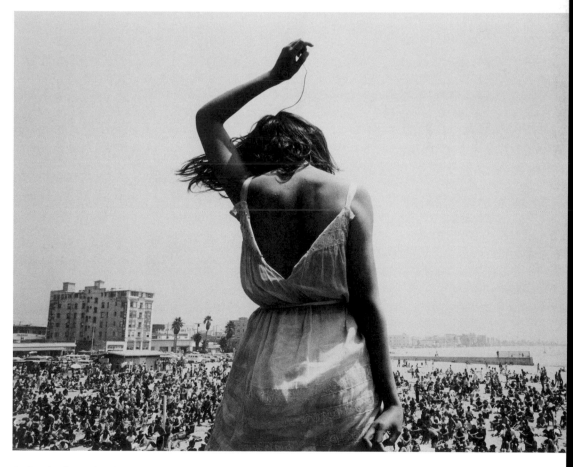

An iconic photo showing women's empowerment during the late 1960s. "Venice, California," 1968, by Dennis Stock, 13" × 19¼" vintage gelatin silver print. From the Richard and Ellen Sandor Family Collection. Digital photo by James Prinz Photography.

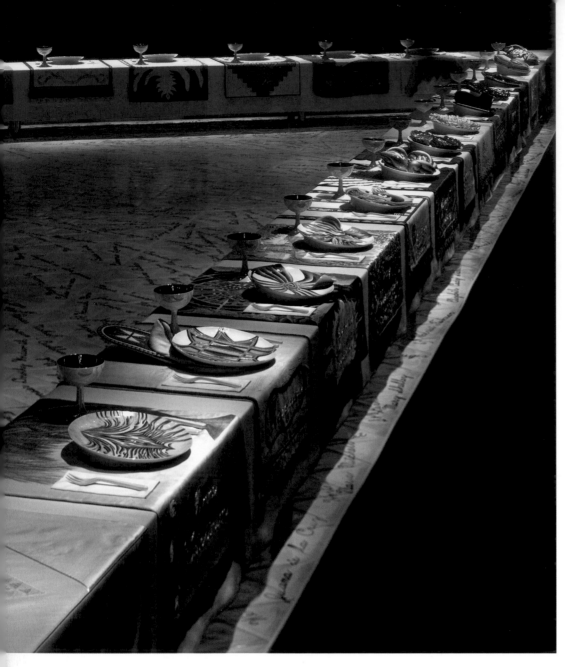

Installation view of *The Dinner Party: Wing 3* by Judy Chicago © 1974–1979. Judy Chicago/Artists Rights Society (ARS), New York. Photo courtesy of Judy Chicago/Art Resource, New York. Used with permission.

table set for thirty-nine mythical and historical women. The table sits on a "Chicago floor" on which the names of 999 women are inscribed in gold. As Sally Webster explained, "In the 1970s our first task was to exhume the lost histories of women artists. . . . The late 1970s were also a time when women critics, as well as art historians gave voice to the ideas and struggles of contemporary women artists" (Webster 2004, 1).

In 1971, Linda Nochlin's historic, illustrated essay was published by *ARTnews* in January. The Vassar College art history professor cited women artists dating back to circa 1225, including painters, sculptors, and textile designers, and concluded her argument by urging women to use "their situation as underdogs in the realm of grandeur, and outsiders in that of ideology, women can reveal institutional and intellectual weaknesses in general, and at the same time that they destroy false consciousness, take part in the creation of institutions in which clear thought—and true greatness—are challenges open to anyone, man or woman, courageous enough to take the necessary risk, the leap into the unknown" (Nochlin 1971, 70).

NEW OPPORTUNITIES IN TIME-BASED ARTS WITH VIDEO TECHNOLOGY

Beyond traditional plastic media, the 1970s accelerated creative opportunities and visibility for a whole new generation of women artists with the advent of video technology, which enabled their works to be easily distributed over free-access cable television networks. The Chicago Editing Center (renamed the Center for New Television in 1980 and the Center for Communications Resources in 1995) was an influential media center under Joyce Bolinger's directorship. Now known as the CNTV, the center was built on a concept of access to training workshops, equipment, screening programs, and publication through *SCAN* magazine. Video artists could realize, show, and publicize their work in a well-equipped production environment coupled with a supportive community. This resource was invaluable, given that it was financially impossible for video artists to purchase their own editing suite, and few places

women's demand for equality and freedom. Brazen Judy Chicago, who legally changed her surname from Cohen (to the name of the city in which she had been born) in 1970 "to liberate herself from male-dominated stereotypes" (Richards 2010, 89), said that the women's movement gave her "a possibility of building support among women, who seemed hungry for images that affirmed them. As I was then trying to create female-centered iconography, for the first time in my life, my ideas and the audience meshed" (Chicago 2007, 13).[17] Chicago's massive installation from 1974, *The Dinner Party*, memorializes the contributions of women in the arts throughout history. For *Dinner Party*, Chicago directed and assembled a large team of women artists to create a harmoniously shaped triangular dinner

outside of universities, including SAIC and the University of Illinois at Chicago (UIC), offered facilities for students and faculty.

Even in the absence of sophisticated editing equipment, video offered a platform for documenting and depicting subjects previously overlooked. Anda Korst, who worked in print journalism, started a video collective, and co-organized the first festival of women's video in Chicago with Judy Hoffman and Lilly Ollinger, remarked:

> We know that women have been consistently excluded from any but subsidiary work in television, both on a production and technical level. The "Porta-pak" makes it possible for women to learn the technical skills of television so that they can begin to make programs, which directly represent their point of view toward their own problems and accomplishments. These programs might be addressed only to women, or they might be aimed at everyone. The point is that we no longer need to rely on the occasional "specials" on rape or divorce or other currently hot media subjects to examine issues of concern to us. And we no longer need to sit passively while television presents the same male-interpreted face of women to the millions sitting before the television set each night. (Chapman 2005)

Most early video reels were composed of raw, unedited material that made up a series of long takes. Artists exploited this limitation of the medium that aesthetically became associated with Chicago-style video and subsequently formed a foundation for New Media Arts in the late twentieth century.

Galvanized by technological advances as well as by the spirit of the women's movement, the Chicago Women's Video Festival was held in 1973 at UIC, offering workshops and screenings of works produced by women. In the same year, Susan Sontag published a series of essays, including "On Photography" in the *New York Book Review*. British scholar Laura Mulvey conceptualized the idea of "the male gaze" in an essay she wrote in 1973 that *Screen* published in 1975, titled "Visual Pleasure and Narrative Cinema." The historic event at UIC was considered critical in bringing together women's video collectives and providing a connective link between the coasts for feminist dialogue.

By the mid-1980s, Warren noted, "As the cycle of ossification of established cultural institutions and the emergence of an alternative voice to counter this ossification continues, so will the history of alternative spaces in Chicago" (Warren 1984, 22). The visionary ideals behind these alternative spaces and the works they presented throughout the 1970s into the early 1980s ushered in new attitudes about art, innovation, and exhibition spaces for artists in the Chicago and Midwest.

Until many breakthroughs were made during the 1970s and 1980s via alternative channels, women artists faced recurring resistance to their participation and for serious recognition in the art world. Since the late nineteenth century, women had slowly gained access to higher education and inclusion in organized art exhibitions. This historical change in attitudes around women in the arts was also reflected in a similar struggle to change attitudes around women's contributions to science and technology during the twentieth century.

From 1914 to 1945, the United States fought in two world wars, both precipitating an industrial need for women to enter the workforce and engage with technology in new ways. At the same time, Illinois social activist Jane Addams wrote, lectured, and helped lead the US women's suffrage movement, following a movement started in the UK by Emmeline Pankhurst and her daughters, who helped UK women win the full right to vote by 1928.[18] Addams's philosophies had an international impact on repositioning the invaluable roles women contributed to society. In 1920, in between the wars, the United States legislated the right of women to vote. The Women's Suffrage Movement in the United States was an important political hallmark Addams helped foster.

The film *Suffragette* (2015) recounted the sacrifices made by Pankhurst, Emily Wilding Davison, and numerous underground women feminists. In a cast interview for the film, Sarah Gavron, director, and Faye Ward, producer, explained, "We did a huge amount of research, and read the unpublished accounts, diaries and police archives. There was a police surveillance unit that they were subjected to. Surveillance really was created to find and to fight and crack the suffragettes" (*Suffragette* 2016).

Brendan Gleeson, "Inspector Arthur Steed," noted, "They had these cameras and some of them were very tiny that they looked modern almost. But the one that had a zoom lens, the one that could capture from far off, was quite boxy, was quite big. The new advance was that they didn't have to be on a tripod. It meant they were mobile and that you could go quite far away and get a reasonably good image. The suffragette movement was the first to be put under that kind of photographic surveillance." Meryl Streep,

Jane Addams (1860–1935), born in Cedarville, Illinois, was a pioneering American settlement activist and reformer, social worker, philosopher, sociologist, author, and leader in women's suffrage. She was awarded a Nobel Peace Prize in 1931. Her philosophies around women's roles in society had international influence. Portrait photograph of Jane Addams seated at desk, holding pen, circa 1914, published by Bain News Service, from Wikimedia Commons.

As shown in the film *Suffragette* (2015), surveillance began with handheld cameras to track the suffragette movement in the United Kingdom, which also left a historic trail of photos from the movement for further research today. From left to right: Annie Kenney and Christabel Pankhurst, Emmeline Pankhurst's daughters, circa 1908; Suffrage Parade, New York City, May 6, 1912. Vintage 1920s poster, "Read our paper. Votes for women." Source: Wikimedia Commons.

who portrayed Pankhurst in a cameo, said, "The movement was seen as a threat because it was classless" and united women from all walks of life, from socialites to laborers and everything in between to gather and rise up against a patriarchal political system. "Women are globally joining together on behalf of each other," Streep said (*Suffragette* 2016).

When the United States entered World War II, women began to join the war industry as both a critical part of the workforce and as political agents of social change. As women gained more access and some recognition in the modern arts, they began to foray beyond the nineteenth century's gender disparity in science and technology. World War II and its aftermath inspired alternative ways of thinking in which the Midwest played a major role in the resulting post–World War II computer revolution and its artistic renaissance.

WARTIME CHALLENGES CREATE NEW OPPORTUNITIES FOR WOMEN

During World War II, science and technology teemed in the Midwest and proliferated academic research in binary computer systems and telecommunications that changed the way people thought about the world, how they interacted and shared digital space with each other. Universities undertook major research efforts and, at the same time, enriched academic environments with fledgling technologies that inaugurated a new digital era of possibilities. Up-and-coming research institutes in the Midwest attracted experimental artists and musicians who sought New Media in its infancy. Waves of feminist movements throughout the twentieth century provided women with experiences of newborn social freedoms and revolutionary attitudes as their culturally shaped roles shifted and continue to infuse society into the present day. Within forty years after the first electronic digital computer was developed, a dynamic cultural transformation was in full force. Multiple generations of women sowed New Media seeds and in the process fostered social change through the arts.

Tracing back to 1937–1942, inventors at Iowa State University were among the first to develop the electronic digital computer, the Atanasoff-Berry computer (ABC). The ABC influenced the University of Pennsylvania builders of the ENIAC (Electronic Numerical Integrator and Computer), lauded as the first general purpose programmable computer. From 1943 to 1946, the US military commissioned the ENIAC. During the

critical period 1940–1945, nearly 50 percent of the workforce was composed of women, while men served overseas in the war.

The US Department of Defense hired young female students with strong mathematical abilities to work in classified makeshift labs as code breakers, calculators, and machine programmers. These women became part of a working class of young people who often lived far away from home and earned a substantial wage that gave them new freedoms. In the recent documentary *Top Secret Rosies: The Female Computers of World War II* (2010), Dr. Jennifer S. Light of the Massachusetts Institute of Technology explained:

> Programming did not exist before the 1940s because there were no computers except for human computers. The army decided to create a machine to automate the same computing work that was done by humans. Because this labor was done by females, once the actual machine was designed largely by male engineers working for the army and at the University of Pennsylvania—someone's work was needed to set up problems on the machine. This was the work of the first programmers. Because women had been primarily engaged in the human computing work, they were invited to program the first machine. (Erickson 2010)

During the war, physicist J. Robert Oppenheimer, director of Los Alamos National Laboratory, led the development and detonation of the atomic bomb in New Mexico. At the onset of the Cold War, the first computer program was installed on the ENIAC for Oppenheimer's team to compute complex calculations for their nuclear weapons research, which created an arms race with other nations, including the former USSR. This collaborative scientific effort brought two classified projects together in advanced mathematical computing and atomic bomb research. Six brilliant young women—Kay McNulty, Betty Jennings, Betty Snyder, Marlyn Wescoff, Fran Bilas, and Ruth Lictherman—secretly programmed the ENIAC. These selected self-taught women initially studied elaborate block diagrams and collaborated on developing the first successful ENIAC program that would change the world. Their collaborative achievements paved the way for computer software and were at the forefront of technological innovation. Superiors informed these female workers that their efforts would be a great contribution to the country. Betty Jennings and Betty Snyder developed the demonstration trajectory program that was unveiled to the press on February 1, 1946. Invited journalists,

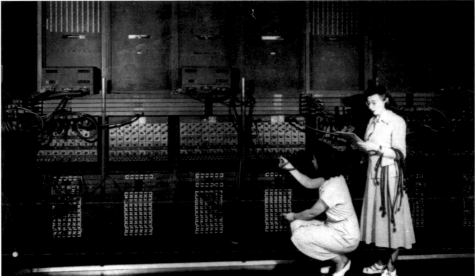

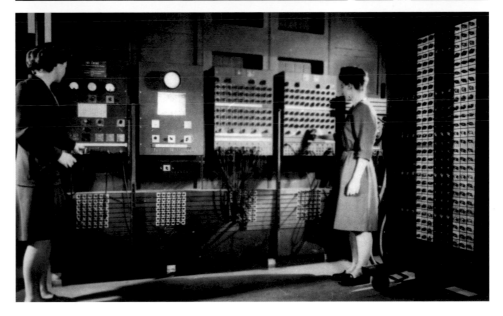

The Rosies. Top: Only known picture of all of the ENIAC female programmers, except for Betty Snyder [Holberton] (Betty took the picture), circa 1946. Left to right: Herman Goldstein, Frances "Fran" Bilas Spence, Homer Spence, Jim Cummings, Marlyn Wescoff, John Mauchly, Ruth Lichterman, Betty "Jean" Jennings [Bartik], Kathleen McNulty [Mauchly]. Center: Marlyn Wescoff Meltzer (left, crouching) and Ruth Lichterman Teitelbaum (right, standing) wiring the right side of the ENIAC with a new program, 1946. Bottom: Jean Jennings Bartik (left) and Frances "Fran" Bilas Spence (right) operating the ENIAC's main control at the Moore School of Electrical Engineering, 1946. Copyright ©2002 Jean Jennings Bartik Computing Museum, Northwest Missouri State University. Used with permission.

Ada Lovelace (1815–1852), daughter of the English poet Lord Byron. Lovelace was a mathematician and writer who created the first algorithm based on Jacquard looming for Charles Babbage's difference engine. Often considered the first computer programmer, Lovelace has become the modern-day poster child of unduly overlooked or intentionally ignored women programmers and mathematicians in history. Watercolor portrait of Ada King, Countess of Lovelace (Ada Lovelace), 1840, by Alfred Edward Chalon, from Wikimedia Commons.

whose experience of what they saw was tightly controlled by the government, excluded the women's contributions to this significant achievement from press release announcements and celebrations. Light explained, "Photographers and journalists were invited on several occasions to come in and see what exactly was the ENIAC, what could it do, who was involved, and archival records show that women were photographed but these photographs never appeared in articles written by the journalists or never were published in newspapers and magazines. So many of the men—engineers—received publicity while the female computers and programmers did not" (Erickson 2010).

Only recently has this lack of recognition been rectified and women's vital contributions to the war recognized.[19] Some women working in the Midwest had to wait decades to receive international recognition for important contributions to the war.[20] In 1997, many of these women were inducted into the Women in Technology International Hall of Fame, harkening back to earlier achievements made by the famous Ada Lovelace, who is now recognized as the world's first programmer for creating the first programming language based on Jacquard looming for Charles Babbage's difference engine in 1833.[21] Such innovations made by both women and men ushered in a modern era of software-driven, large-frame computer hardware, though often women were relegated to the sidelines.[22]

Women working outside of the home had a tremendous impact on US industrial manufacturing and the outcome of the war. In *Women and the Machine*, Julie Wosk pointed to one government report that revealed an example in which "the number of women in aircraft engine plants went from 600 in December 1941 to 4,000 in June 1942, and by the end of June 1943, women made up 40% of the nation's aircraft workers." Wosk highlighted *Life* magazine's published report dated August 9, 1943, that "of the 65 million American women who were employed overall, one-quarter were working in war industries" (Wosk 2001, 196).

To show readers changes in the workplace, *Life* assigned staff photographer Margaret Bourke-White to a historic 1943 photo essay, "Women of Steel," by capturing a day in the life of midwestern "Rosies" who were working at a plant that manufactured components for ballistic tests, among other war machine parts, in Gary, Indiana. Bourke-White's published photographs

portrayed "women . . . handling an amazing variety of jobs" in steel factories—"some completely unskilled, some semiskilled and some requiring great technical knowledge, precision and facility" (Cosgrove 2014, 1).[23]

After the war ended, returning GIs displaced most of the blue-collar Rosies. Their lives returned to their prewar jobs and roles, like many women who had joined the workforce while men were away. The situation was similar in many countries, as men returned to native lands from military service and needed employment at the same time that postwar manufacturing and production jobs were declining. As Wosk explained, "Women's roles after the war reverted back to prewar employment patterns, with the bulk of men and women remaining in prewar sex-typed job categories, women largely in clerical and domestic occupations and men in skilled jobs. The drop in the number of women in war industries buttressed the American government's own intentions. As many have argued, the government had not intended to make a permanent change in women's roles but viewed women's employment as temporary" (Wosk 2001, 228).

The reality of the postwar 1950s boom was not often like the world romanticized in the *American Graffiti* movie; instead, many women discovered they needed employment as single-parent widows. The prewar mind-set that women should return home and men should comprise the major workforce was inconsistent with the real issues that many women faced, such as becoming widows due to loss of their husbands. Many women, like the ENIAC Rosies, had developed a newfound confidence in their expertise and skills to lead projects outside the home. Dissatisfaction with this postwar workplace displacement and other women's inequality issues later gave rise to the national women's liberation movement.[24]

DAWN OF THE ATOMIC AGE AND THE DOOMSDAY CLOCK

During the war, the top-secret Manhattan Project induced thousands of scientists, including Oppenheimer, to participate. The project gave birth to the atom bomb, the first nuclear weapon. At the same time, mathematicians pushed the boundaries of computing. Research initiatives in computing, communications, and nuclear

"We Can Do It!" iconic 1942 poster for Westinghouse by J. Howard Miller, an artist employed by Westinghouse for the poster used by the War Production Co-ordinating Committee. Closely associated with Rosie the Riveter, although not a depiction of the cultural icon itself. Pictured Geraldine Doyle (1924–2010), at age seventeen. From a scan of copy belonging to the National Museum of American History, Smithsonian Institution, retrieved from the website of the Virginia Historical Society.

Margaret Bourke-White (1904–1971) was an American photographer and photojournalist who influenced many generations with her images of strong women playing a major role in the industrial workforce during World War II. "Self-Portrait," 1943, Margaret Bourke-White, 19⅛" × 15¼" vintage gelatin silver print. From the Richard and Ellen Sandor Family Collection. Digital photo by James Prinz Photography.

development comingled. Toward the end of the war, many scientists grew concerned about the risks and ethics of the nuclear bomb. In early 1945, a group of University of Chicago scientists from the Manhattan Project coalesced. Alexander Langsdorf Jr., formerly professor at Washington University in St. Louis, and University of Illinois biophysics professor Eugene Rabinowich joined other scientists, including Albert Einstein, to appeal to President Harry S. Truman to avoid unleashing the bomb. However, presidential political strategies circumvented these warnings. After the tragic civilian outcome from the Hiroshima and Nagasaki bombings in Japan, a coalition of University of Chicago scientists launched a national publication, the *Bulletin of the Atomic Scientists*. This publication continues its original mission to raise public awareness about consequences of nuclear escalation, war, and environmental disasters.

After World War II, many of the Manhattan Project scientists settled in Illinois at universities and national labs.[25] The *Bulletin of the Atomic Scientists* continued to attract more scientists and attention but needed a compelling graphic to capture the imagination of the public. Chicago artist Martyl, who was also the wife of the *Bulletin*'s cofounder Langsdorf, created and published the first version of the Doomsday Clock for the cover of the *Bulletin* in 1947. This early example of information design, which predates computer-generated visualization, captured the world's political proximity to looming global nuclear disaster and devastation. The iconic cover ushered a new epoch of global awareness and socially conscious art that continues to attract international public attention. The clock also points to feminist values for showing how the improper use of technology can destroy humanity and the earth. It is essential to our survival that we all learn how to work together to use technology in mindful ways that are in balance with nature.

The dawn of the atomic age, coupled with the advent of digital computing, created intellectual debates on the social implications of

Famous group photo of the scientific community from the October 1927 Fifth Solvay International Conference on Electrons and Photons, which includes Marie Curie as the only recognized woman scientist in the community, Albert Einstein, Niels Bohr, and others. They debated the newly formulated quantum theory, which contributed to the underground formation of the Manhattan Project and development of the atomic bomb that eventually led Martyl and the *Bulletin of the Atomic Scientists* to create the Doomsday Clock. Pictured in the front row, Marie Curie was one of seventeen out of twenty-nine attendees to become Nobel Prize winners, in two separate scientific disciplines. Photo by Benjamin Couprie, Institut International de Physique de Solvay. Front: Irving Langmuir, Max Planck, Marie Curie, Hendrik Lorentz, Albert Einstein, Paul Langevin, Charles-Eugène Guye, C. T. R. Wilson, Owen Richardson. Middle: Peter Debye, Martin Knudsen, William Lawrence Bragg, Hendrik Anthony Kramers, Paul Dirac, Arthur Compton, Louis de Broglie, Max Born, Niels Bohr. Back: Auguste Piccard, Émile Henriot, Paul Ehrenfest, Édouard Herzen, Théophile de Donder, Erwin Schrödinger, J. E. Verschaffelt, Wolfgang Pauli, Werner Heisenberg, Ralph Fowler, Léon Brillouin.

computational mathematics, biology, and ecology. From 1946 to 1953, a series of conferences funded by the Macy Foundation attracted key intellectuals who helped establish the conceptual foundations of cybernetics, a cross-disciplinary study of complex systems relating to computing, biology, social science, and philosophy. Massachusetts Institute of Technology mathematician Norbert Wiener popularized the term. Anthropologist Margaret Mead was among a core group of cybernetics pioneers and was attributed to have said, "Never doubt that a small group of thoughtful, committed citizens can change the world. Indeed, it is the only thing that ever has" (Lutkehaus 2008, 261).

University of Illinois professor and biologist Heinz von Foerster was a key cybernetics architect who continued to engender interdisciplinary discourse for many years as director of the Urbana campus's Biological Computer Laboratory. Cybernetics philosophical discussions around computer, biological, and social systems would later influence twentieth-century computer and conceptual artists around the globe. Von Foerster was known for his intellectual envisioning of the future of humanity and computing.

Many public institutions continued to advance digital computing in the 1950s. Commissioned by the military, UIUC researchers built the ORDVAC (Ordnance Discrete Variable

Automatic Computer). At the same time, Illinois replicated its construction to build the ILLIAC I (Illinois Automatic Computer). This major academic computing effort infused energy around digital possibilities. From 1952 to 1976, the university developed the ILLIAC series of computers and set a long-term direction in advanced computing. Faculty and students campus-wide explored novel uses, setting a precedent for academic access to advanced computing resources.

As early as 1955, art faculty innovated and composed music with the ILLIAC I while earning international fame. Music professors Lejaren Hiller and Leonard Isaacson created one of the first pieces of music ever to be written with the aid of a digital computer.[26] At the same time, cybernetician Heinz von Foerster established the Biological Computer Laboratory, where he was director and collaborated with innovators of computer music. University colleagues not only explored ILLIAC composition, they also invented several new areas in music: Herbert Brün's gestural computer synthesis; Salvatore Martirano's Sal-Mar construction, and James Beauchamp's harmonic tone generator. Von Foerster and Beauchamp coedited *Music by Computers* that captured much of this early research.

At the University of Illinois, women were unintentionally missing at this groundbreaking stage of computer music composition.[27] Beauchamp explained, "We used to ask, 'Where are the women?' because it would have been more fun to have them participate. Perhaps they chose to stay home and have children" (Cox 2014). Such casual assumptions about women reflect a common mind-set from the 1950s. Today it is recognized that many women had limited choices and were often discouraged from careers. As attitudes changed, younger colleagues came into leadership roles and more opportunities opened for women.

ARTISTIC EXPERIMENTATION AND THE EXPANSION OF DIGITAL MEDIA

During this time of rapid computer technological development, concepts in art and its boundaries were expanding beyond historical precedents. Many US artists took their expression to real-life impromptu experiences called "happenings." Inspired by Alan Kaprow—an artist who conceived

Early history of computer at Illinois. A woman points to the screen of a PLATO terminal as part of her studies. Courtesy of the University of Illinois Archives, Photographic Subject File, COL-13-13, Image #0001141.

art as integral to everyday, spontaneous events—many artists envisioned a new kind of freedom in art expression. With cultural movements in civil rights, feminism, and nontraditional art, many women transcended gender paradigms while building their dreams at midwestern universities. As computer technology proliferated, women could conceivably enter the computer age through art and music beyond the computer science inroads made during the war era. Women composers and artists began to imbue communities at the University of Illinois when they slowly appeared on the computer music scene at the Urbana campus.[28] Illinois electronic and digital music innovations continued through the 1960s as artists in general were expanding concepts in art and life. The university simmered with avant-garde events, where John Cage joined Hiller and other faculty to create artistic "happenings" at the Illinois Stock Pavilion.

Elsewhere at the Urbana campus during the 1960s, the ILLIAC I enabled a revolution in computerized education. Rapidly returning World War II veterans created a demand for increased

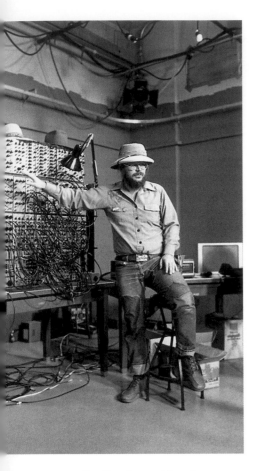

Dan Sandin speaking at the multiple-day Electronic Visualization Workshop organized by Phil Morton and Jane Veeder in 1978 at the Sacramento State University Art Department, California. The Sandin Image Processor shown is a subset of Phil Morton's large Sandin IP, which was the very second one constructed as Phil Morton wrote the IP documentation for Sandin, who made the machine what we call today "open source" and copyable by anyone. Courtesy of Jane Veeder.

educational facilities in the postwar period. Electrical engineering professor Donald Bitzer led a team to implement the first version of PLATO (Programmed Logic for Automatic Teaching Operations), a computer-based education system that provided individualized instruction. The system became the basis for the first online community with online forums and message boards, online testing, email, and remote screen sharing. The system signaled the beginnings of modern online email and social computing.

While the University of Illinois innovated computer architectures, computerized music, and education, other US research advanced computer graphics, displays, and animation. Bell Labs became an important research lab for inventing frame buffer technologies and generating artistically inspired computer visuals and animations. In 1962, Bell Labs researcher Michael Noll is credited with creating the first digital computer artwork. The lab attracted experimental visual artists and musicians, including midwestern native Lillian Schwartz, who collaborated with Bell Labs scientists and invented early two-dimensional digital visual forms. At that time, she was one of the few women exploring these technologies through her collaboration with Bell Labs. In parallel, the Chicago art scene was flourishing with alternative spaces for artists to exhibit their work outside of mainstream venues, which was particularly crucial for women artists to assemble and give voice to their visions around the same time as other women activists in the late 1960s. As described in Lynn Warren's essay "Alternative Spaces," MCA opened in 1967 and, along with other alternative art spaces, it became a welcoming environment for women artists and experimental work.

Meanwhile in Europe in 1968, British art critic and writer Jasia Reichardt curated the first large international and most influential computer art exhibit, *Cybernetic Serendipity: The Computer and the Arts*, at the London Institute of Contemporary Arts. She organized a comprehensive overview of artistic works that either emulated or employed digital computers; she contextualized early computer art within a cybernetics framework of possibilities. Cybernetics cofounder Norbert Weiner wrote the opening article for the exhibition catalog. The Midwest had a strong presence at this major exhibit through the groundbreaking work of Urbana faculty Hiller, Isaacson, Brun, and Beauchamp.[29] London op artist Bridget Riley and Lillian Schwartz were among other women on the international participant list.

Ohio State University professor Charles Csuri also exhibited in *Cybernetic Serendipity*, showing work he created after joining the Department of Art in 1963 as one of the first digital computer artists using a mainframe computer. Csuri received one of the first National Science Foundation grants to support research in scientific visualization and the visual arts. He established an important art department around computer imaging and later formed Ohio State University's Computer Graphics Research Group. This academic program supported many influential graduates, including Tom DeFanti, who joined the faculty at UIC after earning his PhD. As an Ohio State graduate student, DeFanti developed the GRASS (GRAphics Symbiosis System) programming language. Ohio State University staked a claim in early computers graphics research and human-computer interfaces.[30]

Elsewhere in the Midwest at the University of Wisconsin–Madison, video artist and graduate student Dan Sandin was exploring kinetics, light shows, and photography. In 1969, Sandin accepted a position at UIC, where he initially taught interactive art and kinetic sculpture. Largely self-informed, he experimented with electronic processes and image processing. An Illinois Arts Council grant for $3,000 helped fund his research and development of the Sandin Image Processer (IP). The invention could generate a variety of abstract colorful video images and became an important tool for many artists in Chicago.

VIDEO ARTISTS TRAILBLAZE EXPERIMENTAL COMPUTER GRAPHICS

Nearby at SAIC, artist and professor Phil Morton embraced the importance of video as an emerging art form along with Sandin's IP undertakings. Morton convinced SAIC dean Roger Gilmore to offer video courses that eventually became organized into the country's first video department circa 1972. Morton also established the country's first cultural repository for video art. This historic documentation effort helped establish video art as a field of practice and sanctioned it as a form of expression worthy of preservation. Later, this

repository would become an important foundation for the Video Data Bank (VDB).

Along with student-produced video reels, Morton's early vision included generating tapes from the Visiting Thinker–Visiting Artist Program featuring a series of futuristic writers, including Ram Dass, R. Buckminster Fuller, Gene Young-blood, Alvin Toffler, and Anaïs Nin.[31] At the same time, with funding from the National Endowment for the Arts and the Illinois Arts Council, SAIC also launched the Midwest Regional Film Center that provided a staff-supported theater and office space to serve the general public, students, and faculty, offering film programs four evenings a week over a forty-eight-week calendar, complete with study collection access to three hundred films, housed in SAIC's library.[32] Most experimental performances involved analog video and electronic technologies, but the movement toward digital was in the making in the 1970s.

In 1973, Tom DeFanti joined UIC as faculty and began a multidecade collaboration with Sandin. They founded the Circle Graphics Habitat and synergized around technologies and art. They blended capabilities of the Sandin IP with ZGrass, a new raster implementation from DeFanti's PhD research at Ohio State. This combination empowered artists to explore and generate a unique variety of colorful graphics images, abstractions of moving light, video, and animation. It

Dan Sandin and Phil Morton jamming together, often collaborated to synthesize image processing and art video. Dan Sandin (left) and Phil Morton (right), 1975–1976. Courtesy of the Phil Morton Memorial Archive, care of Jon Cates.

also provided an important foundation for real-time video-game software. The Circle Graphics Habitat held public events called the Electronic Visualization Events (EVE). EVE I (1975) and EVE II (1976) featured homemade video equipment assembled into a dynamic, playable electronic studio environment.

Eventually, the Circle Graphics Habitat was renamed the Electronic Visualization Laboratory (EVL). The EVE events were important opportunities for expanding collaborations among the UIC,

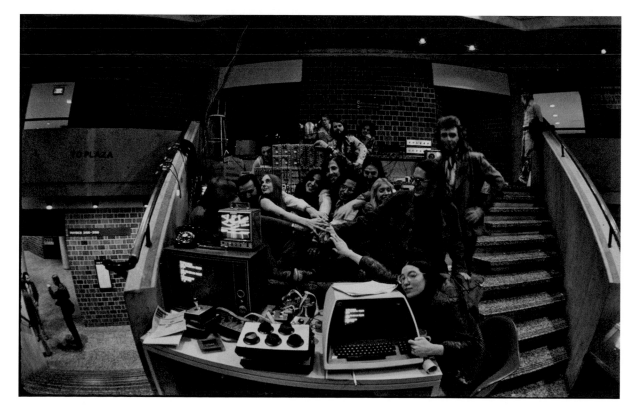

Faculty, students, staff, collaborators, and friends of the Circle Graphics Habitat at UIC, now known as the UIC Electronic Visualization Laboratory (EVL), circa 1977. Courtesy of the EVL Archives, UIC.

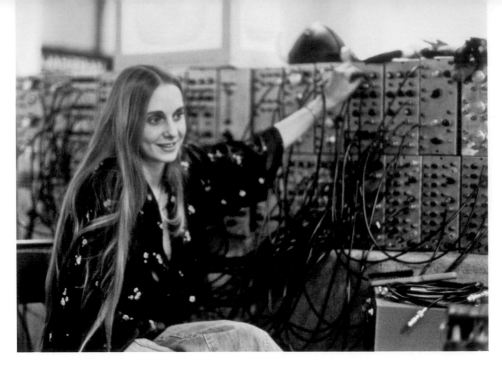

Barbara Sykes jamming and performing on the image processor during "Environmental Symmetry," 1977, a day-long multimonitor, interactive performance environment that included audience participation, dancers, and musicians. Courtesy of Barbara Sykes.

Vintage SIGGRAPH '83 Art Exhibition dinner picture in Tokyo with Sally Rosenthal, Copper Giloth, and Cynthia Neal. Courtesy of Copper Giloth.

SAIC, and Chicago art scenes. SAIC professor Bob Snyder, founder of Sound Area, provided music accompaniment for EVE I and II. Artist Barbara Sykes, as a very young EVL student, creatively participated in the EVE performances. She had been a prodigy of Sandin's from his teaching days at Antioch University and used the IP for numerous 1970s performances with audience participation, music, and dance.

Through faculty, students, and the local video community, EVL, UIC, and SAIC enriched their interactions and coalesced into a dynamic

midwestern base for research in the developing fields of electronic video, image processing, and computer graphics. For example, Sykes first studied at EVL and eventually crossed over to SAIC for her master's of fine arts (MFA). Likewise, Jane Veeder began as an SAIC graduate student during the intensification of the video scene at SAIC. She started a long collaboration with Phil Morton and EVL on a variety of projects. Morton and Veeder's collaborative works are widely referenced in academic media programs as early examples of video art.[33]

UIC graduate Copper Giloth joined EVL as a graduate student where she met Veeder, Morton, Sykes, Rosenthal, and others. Annette Barbier joined UIC as an undergraduate and earned an MFA at SAIC studying video with the Video Data Bank (VDB) community that included Sykes, Veeder, Morton, and others. She eventually joined EVL as a graduate student. In the 1970s, EVL provided access for Morton's VDB. SAIC student Dana Plepys was attracted to the creative VDB artists, wanting to explore image processing, small computers, and real-time graphics prior to the commercial games industry emergence. Both EVL and SAIC students also benefited from the VDB as a source of inspiration.

At SAIC, many artists were independently exploring nontraditional media as artistic expression. Among these was artist and SAIC MFA student Ellen Sandor, who saw the great potential of sculptural mixed media that could incorporate neon, video, and photography. SAIC professor and artist Sonia Sheridan popularized the Xerox machine for artistic work using 3M's Color-in-Color machine and several other industrial-use copiers. She developed an experimental "generative systems" course while mentoring Joan Truckenbrod when the latter was an MFA student. Truckenbrod began exploring computers and plotter printouts to make art about mid-1970. Elsewhere in the Midwest, students were discovering computer graphics. For example, Brenda Laurel was discovering computer graphics at a local research institute while getting her PhD (1975) in theater at Ohio State University.

Also at SAIC, video artists Lyn Blumenthal and Kate Horsfield organized Phil Morton's repository and cofounded the Video Data Bank in 1976. A few years earlier, the duo had started recording their first artist documentary, an in-depth interview with art historian and curator Marcia Tucker. Blumenthal and Horsfield also interviewed other important women from the art world, including

Details from *Marcia Tucker 1974: An Interview*, *Agnes Martin 1974: An Interview*, and *Joan Mitchell 1974: An Interview*, conducted by Lyn Blumenthal and Kate Horsfield. Tucker (1940–2006) was an influential curator, writer, and art historian known for founding the New Museum of Contemporary Art in New York City. Canadian born Martin (1912–2004) moved to the United States in 1931 and lived in Taos, New Mexico, from 1954 to 1957, where she established herself as an important minimalist painter and a friend and contemporary of Georgia O'Keeffe. Mitchell (1925–1992), a native Chicagoan who migrated to New York City, was a second-generation abstract painter, printmaker, and essential member of the abstract expressionist movement. Images copyright of the artists, courtesy of the Video Data Bank, SAIC.

Joan Mitchell, Lucy Lippard, Agnes Martin, and Ree Morton. Their work established the VDB as an important archival center that gave marginalized women who were working in the arts their voice and put Chicago on the map for its dedication to serious scholarship and preservation initiatives in media arts.

Along with video, the computer was coming of age as an artistic medium and amplified by the "conceptual art" of the 1970s. Art, in general, was moving away from an object-centered tradition to include art that was incorporated in everyday life. Conceptual art incorporated political, conceptual, performance, and nontraditional media. At the same time, "feminist art" — a term coined by midwesterner Judy Chicago—was being born. Jo Freeman and other women activists in Chicago catalyzed the national women's liberation movement in the late 1960s at the first National Women's Liberation Conference held in Chicago.

Clearly, artists were embracing nontraditional media. However, many envisioned the potentials of the computer as more transformative than formerly imagined. The latent possibilities for the art world became a central dialog in the 1970s. Ruth Leavitt published an influential book, *Artist and Computer* (1976), a collection of essays by early computer artists, including midwesterners Ben Laposky (Iowa), Charles and Colette Bangert (Kansas), Charles Csuri (Ohio), Joanne Kolomyjec (Michigan), and Karen Huff (Kansas). They presented new implications of the computer and presaged a digital cultural transformation: "Computer art challenges our traditional beliefs

about art: how art is made, who makes it, and what is the role of the artist in society. The uninitiated artist asks: what can this machine do for me? Really, the question should be: what can I do with this machine? The artist has only to choose what role he/she wishes the computer to play. The computer helps the artist to perceive in a new way. Its features blend with those of its user to form a new type of art" (Leavitt 1976, vii).

This new type of digitally mediated art included the ability of the artist to write software and invent the tool. In 1977, Leavitt met SAIC artist Joan Truckenbrod at a humanities conference at the University of Waterloo where Truckenbrod was presenting one of the first papers to explore computer-assisted instruction for basic design curriculum. Like the artists in Leavitt's book, Truckenbrod recognized the power of the computer for art, ideas, and education. She would eventually teach at both SAIC and Northwestern University a few years later.

ACM SIGGRAPH: BUILDING INTERNATIONAL COMMUNITIES OF INNOVATION

Computer graphics technology surged during the birth of the Association for Computing Machinery's Special Interest Group on Computer Graphics (ACM SIGGRAPH) and the formation of

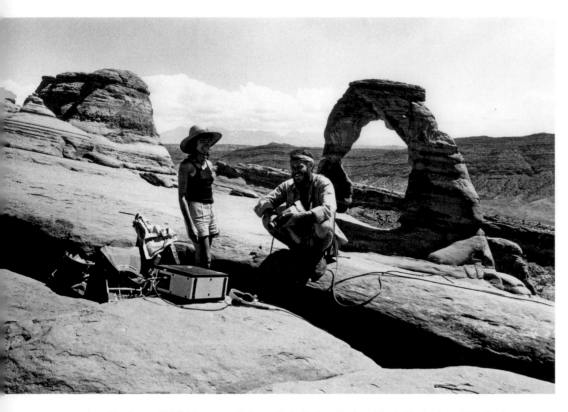

Jane Veeder and Phil Morton at Delicate Arch, Arches National Park, Utah, circa 1979. Each summer from 1976 to 1982, Jane and Phil used BW ¾" video to record input material to process through the Sandin IP and edit during the winters in Chicago. Southwestern Utah and Arches, in particular, were favored territory. Courtesy of Jane Veeder.

build the conference and have international influence. Copper Giloth graduated with an MFA in 1981 as the first EVL student while conceiving and designing the first juried SIGGRAPH Art Show. Also in 1981, Sally Rosenthal joined EVL as a graduate student and attended her first SIGGRAPH, where she met Veeder as A/V chair. EVL students Lucy Petrovic and Dana Plepys participated in the 1980s. Young leaders of the computer graphics research and production industry, such as Pixar, helped to forge the quality of the conference. Pat Hanrahan, a graduate student at the University of Wisconsin–Madison, eventually joined Pixar and then Stanford University. While at Wisconsin, Hanrahan mentored Donna Cox, an MFA student and artist, in computer graphics and introduced her to the SIGGRAPH conference. She began attending SIGGRAPH and collaborating with EVL.

Other notable figures in the SIGGRAPH community include Judy Brown and Patric Prince. Brown consulted, taught, and led computer graphics initiatives at the University of Iowa, coauthored a popular textbook, and won an Outstanding Service Award for her twenty-plus years of SIGGRAPH contributions.[35] Art historian and private collector of computer art Patric Prince organized the first SIGGRAPH traveling art exhibition that helped establish digital arts and New Media internationally.[36] Cox, Rosenthal, Plepys, and other women eventually contributed to and led major venues at the annual conference.

During the early years of computer art, SIGGRAPH became an important haven for emerging digital artists. This unique community attracted many women in the field who migrated from the Midwest to both coasts and abroad but could reconnect, stay in touch, and share their work through the annual conference events. Rebecca Allen is an Illinois native who migrated to the West Coast and stayed connected to her peers through the SIGGRAPH community. Allen made inroads for women in the male-oriented computer graphics field through her experimental interactive experiences while teaching future generations of students at UCLA. Over the past thirty years, she has explored a variety of digital technologies from animation to games to large-scale interactive works, and some of these are in the permanent collection of the Whitney Museum of American Art in New York City and the Centre Pompidou in Paris. Likewise, influential musician Laurie Anderson migrated from Chicago to New York City, where she became an electronic music

the SIGGRAPH conference in mid-1970. Artists, technologists, and scientists coalesced at the conference. SIGGRAPH changed the lives of many professionals, including computer scientist Maxine Brown, who gave her first paper at the conference in 1976. Brown became an active organizer and helped build the organization along with others from the University of Illinois.[34] The 1977 conference was the most successful and signaled the expansion of the industry that would reach around the world. Jane Veeder first attended SIGGRAPH that year. By 1979, Veeder and Phil Morton were well-established art videographers and agreed to enhance the quality of the SIGGRAPH audio/visual (A/V) venue. SIGGRAPH became an important academic and industrial melting pot for artists, scientists, and computer professionals focused on computer graphics technologies and interactive techniques, and the video game industry in the later 1970s. The advancement of computer graphics displays heralded a new era of flexibility and programmable visuals. Newly formed publications reflected tremendous strides in this research.

SIGGRAPH provided an eventually international forum for a diverse community for midwestern faculty and students who helped to

COMPUTER GRAPHICS BECOME AN ARTISTIC MEDIUM

Dr. Pat Hanrahan, a professor at Stanford, has been a leader of computer graphics research and industry. Shown here as a graduate student at University of Wisconsin, he met and introduced Donna J. Cox to graphics computing, 1983. Courtesy of Donna Cox.

artist and inventor.[37] Anderson created electronic music along with Pauline Oliveros and other women explorers of new technologies. She has been an inspiration to many artists in the SIG-GRAPH community.

The 1980s publications clearly delineated a movement recognized as computer art (Herbert Franke published *Computer Graphics—Computer Art*) and marked a new attitude toward the creative use of computers. Sociologist Sherry Turkle heralded this change in her famous article "Computer as Rorschach," where the "act of programming can be an expressive activity" (Turkle 1980). Like many artists from Leavitt's book and at Chicago's EVL, the primary way to make graphics images was to develop the software because there were no tools like Photoshop. UIC alum Giloth and SAIC alum Veeder's well-known article "The Paint Problem" questioned the standard approaches for building artists' software tools and forecast new modes of use. Artists like University of Wisconsin alum Donna J. Cox were developing software to make art. She published a SIGGRAPH article to articulate the debate around best educational practices for artists: to develop software versus learning to be users of tools that others developed. In general, academic and commercial dialogs reflected a rethinking about how computers and technology could be incorporated into the artistic process. A plethora of arts publications in international journals such as *Leonardo* reflected this new era of artistic exploration.

In 1981, Joan Truckenbrod joined the SAIC faculty and became the first chair of the newly created art and technology program, thus marking a major change of a formerly nondigital school for artists in the Midwest. Computer graphics had come of age as an artistic medium at SAIC. Truckenbrod became a proactive figure in Chicago's video art community, including Chicago's public access television station.[38] In parallel, Barbara Sykes graduated with an MFA from SAIC and curated the landmark *Video: Chicago Style* exhibition that showed avant-garde work that was happening in the community with video and image processing.

This growing renaissance within the Chicago art scene was significantly catalyzed through artist and SAIC alum Ellen Sandor. As early as 1982, Sandor created a unique, large-scale, three-dimensional backlit photographic mural.[39] A private collector commissioned this precursory virtual-reality-like artwork that had been created with a room-sized film camera in a garage-art studio. The immersive work combined photography and sculpture with the visual illusion of holography without lasers. From the success of this project, Sandor formed an artists' collaboratory in 1983 with SAIC peers and faculty.[40] She envisioned a new art form that blended aspects of photography, sculpture, and holography with computer graphics and coined the term PHSCologram (pronounced skol-o-gram). She named the collaboratory (art)n. This complexity of media required collaboration across disciplines with artists, technologists, and thinkers who shared her enthusiasm.

The first exhibition of *PHSCologram '83* on Wacker Drive in Chicago featured tributes to famous women and men artists, including Georgia O'Keeffe, Man Ray, Marcel Duchamp, Louise Nevelson, and the Outsider, Intuitive, and Naïve artists. This public installation was an early example of a virtual reality environment assembled within an artistic context. It opened a dialog with others working to combine emerging technologies with traditional art forms. The provocative installation caught the attention of the arts community and was reviewed on the front page of the *New Art Examiner* as a historic

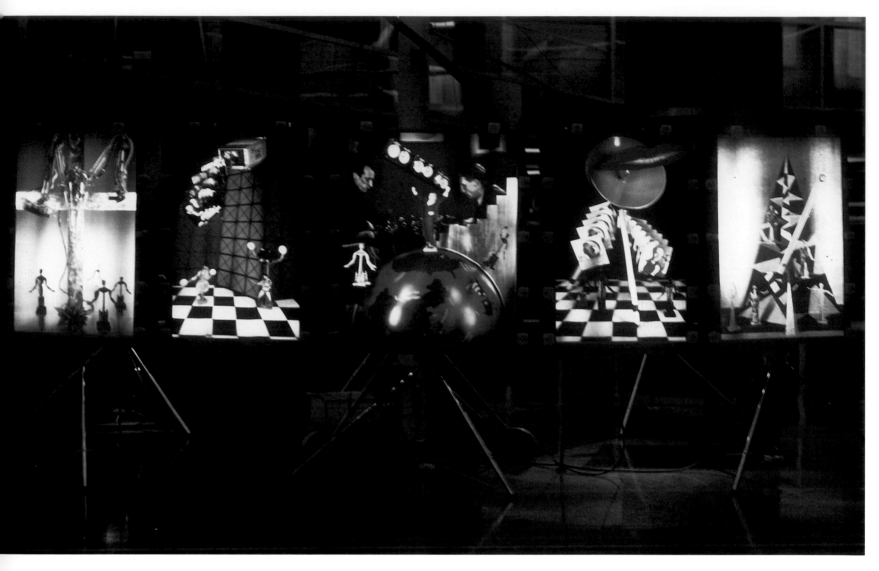

PHSCologram '83 by Ellen Sandor, Jim Zanzi, Mark Resch, Randy Johnson, and Gina Uhlmann, (art)ⁿ and Gary Justis, Jerry August, Tom Cvetkovich and Steven Smith. Five 32" × 48" PHSCologram panels, Cibachrome, Kodalith, Plexiglas featuring tributes to Georgia O'Keeffe, the Outsider Artist, Marcel Duchamp, Man Ray, and Louise Nevelson. Exhibited at SAIC, Fermilab, and other venues, and featured in the *New Art Examiner* cover story, January 1984. Courtesy of Ellen Sandor, (art)ⁿ.

breakthrough for its original form, process, and approach. SAIC's Morton and UIC's Sandin and DeFanti were intrigued by Sandor's efforts and developed a collaboration that would later inspire EVL's research to create the virtual reality CAVE.[41]

While computer graphics was burgeoning at SIGGRAPH and digital media was infusing fine art traditions, a new advanced computing (supercomputing) was being born at the University of Illinois at Urbana-Champaign (UIUC). After the postwar boom, US researchers did not have access to academic supercomputers for nonmilitary science. The use of high-performance computing to solve basic scientific problems required academic researchers to travel abroad.

ESTABLISHING THE NATIONAL CENTER FOR SUPERCOMPUTING APPLICATIONS

In 1982, University of Illinois astronomy professor Larry Smarr published a now widely circulated article, "The Supercomputer Famine in American Universities," which helped garner support to rectify this national deficit. The Urbana campus helped address this supercomputing famine in US universities. Smarr and scientific colleagues prepared an unsolicited proposal for developing a supercomputing center at the University of

Illinois. The National Science Foundation (NSF) recognized the need for expanding academic supercomputing and initiated a national solicitation in 1984. The Urbana campus was among the original five NSF supercomputing sites, and this honor fostered a continuation of its historic groundbreaking success in computing from the ILLIAC days. The National Center for Supercomputing Applications (NCSA), University of Illinois at the Urbana campus, received its charter grant in February 1985. It attracted early computational researchers from around the world who would help lead the supercomputing revolution.

That same year, University of Wisconsin alum Donna J. Cox joined the faculty at the School of Art and Design at the Urbana campus and immediately arranged a meeting with Smarr, the founding NCSA director. She developed a white paper on the history of artists using technology and introduced the concept of Renaissance Teams, a collective group of diverse experts who could effectively solve complex visualization problems. She proposed that artists could help visualize scientific data at the new supercomputing center. Smarr appointed her adjunct faculty.

NCSA celebrated its grand opening at the Krannert Center for the Performing Arts; Arthur C. Clarke participated via satellite from Sri Lanka as part of the opening ceremonies. In his popular novel *2001: Space Odyssey*, Clarke designated Urbana, Illinois, as the birthplace of the HAL 9000, the artificially intelligent computer. NCSA attracted national publicity as the hotbed of supercomputer innovation. In 1985–1986, Cox introduced EVL cofounders DeFanti and Sandin to NCSA director Smarr. University of Illinois EVL and NCSA began collaborations that continued for many years to come. They effectively expanded national technological access and increased interdisciplinary efforts across the arts and sciences in the United States and abroad.

The 1986 SIGGRAPH conference was an important event that fostered cross-institutional collaboration between both campuses at the University of Illinois and became a model widely used for university research at other institutions. Smarr and members of his NCSA staff attended their first SIGGRAPH conference, where Cox introduced them to Maxine Brown and key leaders of the SIGGRAPH community. In collaboration with Patric Prince, Cox participated in a satellite art exhibition in conjunction with SIGGRAPH '86 art show, while UIC alum Sally

Left to right: NCSA founding director Larry Smarr, deputy director Jim Bottum, with computational scientist Karl-Heinz Winkler, and Michael Norman. NCSA, University of Illinois, circa 1986. Courtesy of Donna J. Cox.

Early collaborations between NCSA, EVL/UIC, and other partners. Standing left to right: Tom DeFanti, Maxine Brown, unknown, Lauren Herr, Larry Smarr. Seated: Ray Idaszak, collaborator on *Venus* series, with George Francis and Donna J. Cox. University of Illinois and NCSA collaborators, circa 1988. Courtesy of Donna J. Cox.

Rosenthal became A/V chair. Cox's students went to SIGGRAPH for the first time.

After the conference, there was an influx from the commercial and Hollywood computer graphics industry to the Urbana and UIC campuses. Excitement was in the air and everyone wanted to be a part of the new wave emanating from the

VISUALIZATION IN SCIENTIFIC COMPUTING

Computer Graphics • Volume 21 • Number 6 • November 1987
Edited by Bruce H. McCormick, Thomas A. DeFanti, Maxine D. Brown
Published by ACM SIGGRAPH

Cover of the influential 1987 National Science Foundation special report that delineated the major visualization challenges in the twentieth century. Coauthored by Bruce McCormick, Tom DeFanti, and Maxine Brown. Cover art visualization by Donna J. Cox and Michael Norman. Courtesy of Donna J. Cox.

of well-designed data visualizations as a collaborative process. This environment would later engender the first visual web browser that would help bring the World Wide Web (WWW) to create the global village, the electronically connected international community.

Later in 1986, DeFanti, Brown, and Bruce McCormick published a pivotal NSF report, *Visualization in Scientific Computing*, with the cover image of an astrophysical jet by Dr. Michael Norman and Cox. This seminal report recognized the importance of visualization, outlined technical challenges of high-performance computing, and called for a new level of government support for scientific visualization. Such synergistic efforts established the University of Illinois as a leader in the emergent field of data visualization. The report called for an international response from the scientific community and created a watershed in visualization research.[42]

Also in 1986, Sandor and her research took root at the Illinois Institute of Technology (IIT), a historic Bauhaus site. She emerged as one of IIT's most experimental artists working with advanced technologies during those years where she housed her room-size camera to make PHSColograms and collaborate on a growing number of projects with researchers at the University of Illinois and NCSA.

VENUS ON THE PRAIRIE

During Sandor's collaboration with Sandin and DeFanti in 1986, she traveled to the Urbana-Champaign campus and met Cox, math professor George Francis, and computer science student Ray Idaszak. Cox, Francis, and Idaszak were collaborating together to visualize complex mathematical data as computer graphics imagery. Using innovative interactive software, the team artistically rendered a variety of geometric surfaces into a digital, sculptural form. Cox named this artwork after the iconic mythological Venus because the visualizations resembled historical paintings and sculptures of the classical goddess from antiquity. Through this collaborative effort, Cox brought a feminine spirit of the arts into the team's experimental research by referencing the Venus archetype, a long-recognized cultural symbol of beauty and empowerment. Sandor collaborated with the group to produce the first PHSCologram of the four-dimensional,

Midwest. Maxine Brown accepted a position with UIC to work with EVL researchers and students on the *Interactive Image* exhibit for the Museum of Science and Industry in Chicago, and NCSA participated. Two leaders from Los Angeles commercial graphics companies—executive producer Nancy St. John and graphics scientist Craig Upson—migrated to help establish an NCSA visualization production group. Scientific visualization proliferated at the Urbana campus. After studying with Cox, MFA design student Colleen Bushell graduated and joined the newly formed visualization group to collaboratively design science visualizations. The combined synergies of visualization and supercomputing at the Urbana campus set the stage for the importance

mathematical model of the *Etruscan Venus*. The collaborators created the *Venus* series with the first digital process for making PHSColograms. The series also generated other characters, including *Apollo*, a sculpture made from the mathematical rib of *Venus*. Early in 1987, Feature [gallery] exhibited the PHSCologram *Venus* series in Chicago at the *Nature* and *New Photography* exhibits.

In parallel, archeologist Marija Gimbutas was editing her important manuscript that would first be published in 1989, *The Language of the Goddess,* which explored an untold history of feminist symbolism through the ages and included the prehistoric Paleolithic and Etruscan origins that initially captured Cox's imagination for the *Venus* series. "The Goddess in all her manifestations was a symbol of the unity of all life in Nature" (Gimbutas 1991, 321).[43] Joseph Campbell's insightful foreword acknowledged that "at just this turn of the century there is an evident relevance to the universally recognized need in our time for a general transformation of consciousness" (Gimbutas 1991, xiv). Looking back, part of this consciousness may have included developing new technologies for creativity, collaboration, and artistic transformation for social good, with women at the frontlines, equally creating new opportunities together. Technologies of the past were often developed in isolation, sometimes causing destruction and devastation, with the majority of women on the sidelines or a select few involved behind the scenes. By the turn of the last century, it was time for something new.

Sandor and Cox connected on a shared appreciation for photography combined with original concepts of collaboration that harnessed the advancing supercomputer technologies and engendered new forms of artistic expression. It was a cultural renaissance in the making that has fundamentally changed the way people live and learn, while empowering women to achieve in the workplace *and* to create businesses of their own. NCSA director Smarr was exceptionally supportive of this interdisciplinary group's goals and was part of the influential team at SIGGRAPH. The *Venus* collaborators exhibited the PHSCologram series at the SIGGRAPH '87 Art Show. SIGGRAPH attendance exceeded twenty-seven thousand people and showcased the *Venus* PHSColograms to a record number of attendees.

This PHSCologram collaboration is historically significant in two ways. The *Venus* series served as a practical data visualization that improved

Commemorative photo of the first digital PHSCologram, *Etruscan Venus*, NCSA. Left to right: Tom DeFanti, Donna J. Cox, Ellen Sandor, and Larry Smarr, circa 1986. Courtesy of Ellen Sandor, (art)[n].

SIGGRAPH '87 Art Show juried and exhibited the *Venus* series shown in the background. These were the first digital PHSColograms from multidimensional *Venus* surfaces. Left to right, back to front: Larry Smarr, Dan Sandin, Ray Idaszak, Tom DeFanti, Donna J. Cox, and Ellen Sandor. Courtesy of Donna J. Cox.

research in mathematics, supercomputer graphics, and stereo 3D; at the same time, *Venus* represented an emergent supercomputer sculptural art form that embodied feminine qualities with reference to historical art and Renaissance precedents. These PHSColograms reflected new

COMPUTER GRAPHICS

Volume 21 • Number 1 • January 1987
A publication of ACM SIGGRAPH

PALEOLITHIC POSTMODERN

The cover image was published in 1987. It was exhibited in the SIGGRAPH Art Show 1998 retrospective as part of the twenty-five years of pioneering computer art. Joan Truckenbrod was art show chair. The cover shows a visual comparison between the Paleolithic Venus on the left and the postmodern supercomputer graphics *Venus* on the right. Both represent human artifacts created using the best technology of their time in order to help predict and sustain a worldview. Unlike the original hand carved, soft stone Venus figurine, a team of specialists created the digital *Venus*. Courtesy of ACM Computer Graphics.

digital methods and were distinctive from other computer art because the artwork was a result of collaborating inventors who were leaders of the emergent communities of scientific visualization, supercomputing, virtual displays, and the high-art scene of Chicago's video, film, and photography arts. This collaborative Renaissance Team leveraged and anticipated some of the most advanced display technologies of any institutional artwork at the time, including precursors of virtual art, and represented several emerging fields of art and science. The process to develop the work characterized an emerging model of international artist-scientist collaborations of the twenty-first century where women defined a new style of leadership that encompassed "artists as producers" in both the design and organization of teams, also acting as innovators of scientific and nascent technologies.

This evolution of historical tools into the post-modern Venus was featured as the cover image for the 1987 SIGGRAPH *Computer Graphics*. It compared the supercomputer Venus to the Paleolithic Venus de Willendorf as both the art and science of the past and the future. By the autumn of 1987, the *Venus* PHSColograms were exhibited at the Fermilab Gallery exhibition near Chicago, Illinois, in the historic institution for particle physics. During the same month, Ellen Sandor helped to bring *Simulations/Dissimulations* to SAIC. This influential, international symposium focused on "the interchange between artistic and technological modes of thinking and methods of production" (from the promotional materials). Well-known philosophers and practitioners in contemporary arts, technology, and culture presented. This symposium marked a cross-pollination of academic, high-art practice, and science.[44]

During the same watershed year, (art)[n] and the University of Illinois collaborative works were shown, discussed, and accepted into the quickly evolving technology-art scene in Chicago. The Chicago video and computer art community started garnering recognition for its experimental and collaborative nature, through collaborations between institutions that attracted artists with an eye toward the future. The recordings of the 1970s EVE live events, "Re-Scanning of EVE-I" and "EVE-II," attracted museums and television broadcasters to screen the tapes. Barbara Sykes internationally evangelized Chicago's growing video and computer art community. In 1987, she curated *Video and Computer Art: Chicago Style*, an international traveling exhibit she assembled during her sabbatical from Columbia College Chicago, where she taught experimental video and advanced production courses. The landmark survey of video and computer artworks combined with Sykes's artist lectures introduced video art, computer art, and concepts of collaboration as an artistic process to audiences in Japan, China, Australia, and Spain. This pivotal traveling exhibition internationally marked the unique Chicago aesthetic of blending video, graphics, and image processing with traditional media to innovate new forms of creative expression and artistic practice. As Sykes recalled in her interview, people were impressed with "the variety of the work being made in Chicago, the quality that was being produced and the significance of community to achieve it." The exhibition essentially migrated Chicago culture and popularized electronic media throughout the world.

Simulations/Dissimulations Symposium Poster. A major Chicago conference held at SAIC, November 5–7, 1987, where presenters and attendees discussed the primary contemporary issues around emerging computer art and New Media. Invited speakers included Jean Baudrillard, Muriel Cooper, Alan Rath, Stephen Wilson, and Myron Krueger. Courtesy of Donna J. Cox.

The Cray-1 supercomputer was a very photographic environment for many people who visited Illinois. Photographer Kurt Fishback captured Donna J. Cox as part of his series documenting female artists in their studios. Donna J. Cox sitting on the Cray-1. Courtesy of Kurt Fishback, 1988.

TEAMS EMERGE AT NCSA

By 1988, Cox published an influential article in *Leonardo*, an international peer-reviewed journal for art, science, and technology. "Using the Supercomputer to Visualize Higher Dimensions: An Artist's Contribution to Scientific Visualization" (Cox 1988a) detailed interdisciplinary collaborations with researchers at the University of Illinois and described Renaissance Teams, a term she neologized to describe a collaborative methodology. In "Renaissance Teams and Scientific Visualization: A Convergence of Art and Science" (Cox 1988b), Cox documented simple guidelines for successful collaborations, which she has presented internationally. The article provided a variety of examples where visual artists

could participate in meaningful cocreations and influence science and technology through the collaborative process. The Renaissance Teams collaborative process helped codify emerging collaborative roles such as artist as programmer, software designer, social engineer, iconographer, and artist as producer—a role that typically is assigned. The concept captured the imagination, and the methodology inspired collaborative possibilities among artists, technologists, and scientists working together on visualizing computational data from the Cray-1 supercomputer.

A year later, Cox published in the *Leonardo* SIGGRAPH Art Show supplemental issue that a "shift in criticism" was needed to recognize the potential for "art production within all aspects of culture, including economics, mass media, science and the whole interrelatedness of our whole heterogeneous cultural life" (Cox 1989, 7–12). Bringing together the two cultures of art and science could help create a new international economy by which women could contribute to and earn a living in the arts and sciences. Mary Rasmussen, an EVL student who was inspired by Cox to work in scientific visualization, graduated in 1989. Her MFA thesis show, which Sandor helped produce, was held at Maxine Kroll's upscale salon where guests would have their portrait morphed into the face of an animal. Rasmussen's graduate work led to software development that aided law enforcers in the location of missing children. She subsequently led collaborative teams of surgeons, medical specialists, computer scientists, and artists to develop networked virtual reality applications for educational and clinical use.

At the same time, the building of the interdisciplinary Beckman Institute was completed and NCSA became one of the early tenants. The establishment of the Beckman Institute at the Urbana campus was one of the most important events in decades, according to then-president Stanley Ikenberry. The Beckman dedication concert by the Champaign-Urbana Symphony Orchestra, held in the Foellinger Great Hall of the Krannert Center for the Performing Arts (KCPA), featured a commissioned multimedia production by music professor Scott Wyatt and Cox. The NCSA Renaissance Experimental Lab (REL) was the first Beckman Institute graphics laboratory. It was established with a donation from Silicon Graphics, Inc. (SGI). SGI founder and REL donor Jim Clark visited NCSA for the formal dedication on April 20, 1989. The REL provided a fertile environment

for teaching interdisciplinary coursework and resulted in award-winning work and a home for new digital-media class participants. Among them was Chris Landreth, who was nominated for an Academy Award in 1996 for Best Animation Short for *The End*, and later won the award in 2005 for *Ryan*. Ellen Sandor and (art)n created several PHSColograms from Landreth's animations, including *The Story of Franz K.* and *Bingo*.

INVISIBLE TECHNOLOGIES REVOLUTIONIZE SOCIAL CHANGE

In the summer of 1989, NCSA led a national Boston SIGGRAPH conference experiment at the Boston Science Museum auditorium. The "Science by Satellite: Televisualization" show was extraordinary. At that time, the Internet did not exist as a teleconferencing communication provider; visualizing data and streaming images was not yet possible as we know it today. NCSA convinced AT&T to donate a satellite communications link to help introduce the look and feel of the future of conducting science remotely on the then-emerging Internet. The SIGGRAPH audience witnessed a real-time streaming event of scientists and visual images over the satellite link with scientists interacting remotely across the United States to the Urbana campus to control a supercomputer and to see visual images being generated. Never before had the combination of the commercial telecommunications, computer graphics industry, emerging academic network, government-funded research scientists, and supercomputer artists come together for such a spectacular demonstrative evening. Ironically, the Urbana scientists were standing only a few feet from where the first visual browser was being invented. This was the future in the making.

At this very same time, the Chicago campus was embarking upon building virtual reality (VR) technology. In 1989, Carolina Cruz-Neira joined EVL as a graduate student in computer science. She began developing software, hardware, and physical architecture with an EVL Defense Advanced Research Projects Agency grant by Professors DeFanti and Sandin. Cruz-Neira worked to help conceive and build the virtual immersive environment that would later evolve into the CAVE (Cave Automatic Virtual Environment), a room-size rear-screen projected hemi-cube with

REL during an animation class. Left to right: Cesarr Augusto, Ingred Kallick, Fred Daab, Chris Landreth, and Donna J. Cox. Courtesy of NCSA, University of Illinois, 1990.

In the REL, members of the team who created the award-winning *Venus & Milo* animation 1990. Left to right, front to back: Donna J. Cox, Bob Patterson, Chris Landreth, Marc Olano, Gisela Kraus, Robin Bargar, Fred Daab. Courtesy of Donna J. Cox, 1990.

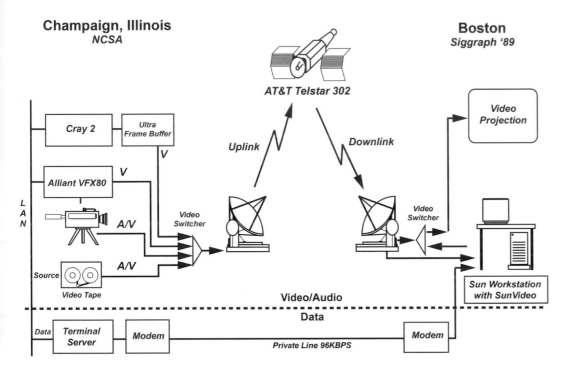

Champaign, Illinois
NCSA

Boston
Siggraph '89

AT&T Telstar 302

"Science by Satellite: Televisualization" 1989 event on stage in Boston Computer Museum auditorium. Three screen projections in the background showing images being broadcast in real time over satellite from Illinois. This was the first demo showing the "look and feel" of the future of Internet teleconferencing so common today. This vision of doing science and data visualization interactively and remotely was ahead of its time. The diagram above shows the complex technology requirements of the event. Courtesy of NCSA, University of Illinois, 1989.

interact with data. *Virtual Director* was an early CAVE application developed by UIC computer science student Marcus Thiébaux, NCSA Donna J. Cox, and Robert Patterson. *Virtual Director* software was among many CAVE applications that helped cross-pollinate the EVL and NCSA research.

During the late twentieth century, the Internet and browser technologies were among the most socially transformative technologies, and the University of Illinois was at the epicenter of development. As an NSF-funded center, NCSA had become one of the leaders in developing network technologies for the NSFNet, a general-purpose backbone network built upon protocols specified by the Department of Defense. NSFNet's primary mission was to provide network access to the broad academic community for research and education. Like scientific visualization, networking software became another important development spawned from original NSF academic supercomputing centers.

NCSA was a national hub that supported advanced networking, supercomputing, and scientific visualization. Women artists were gravitating to NCSA due to the unparalleled opportunities it afforded and its unique, state-of-the art collaborative environment. Internationally known Christa Sommerer (Austria) and Robin Tracey (Australia) were among several visiting artists in residence at NCSA.

REIMAGINING MEDIA AND ARTISTIC PRACTICES

By the 1990s, the NCSA Telnet network protocol was gaining global fame. Among those attracted to NCSA was Ping Fu. A native of China, Fu was working at Bell Labs in Naperville, Illinois, when she accepted a technical position at NCSA. As Fu described in her autobiography *Bend, Not Break: A Life in Two Worlds* (2012), "I was instantly attracted to the Renaissance Experimental Lab, which contained cutting-edge computer graphics machines. Displayed on the wall were visualizations of five thousand years of global climate change, and a poster of *Tin Toy*, the first computer-animated short film to win an Oscar. I was interested in converging art and science through the use of technology, and that was clearly being done here." After arriving in Urbana, Fu "took a

head tracking and stereo 3D glasses. Cruz-Neira made significant contributions to the CAVE and virtual reality. She also helped support some of the earliest CAVE applications developed by women artists as well as scientists. The CAVE immersive virtual reality room/environment was extremely popular because it enabled groups of people to share in the virtual reality experience. NCSA, among other institutions, cloned the CAVE and built scientific visualization applications exploiting the interactive ability to immerse and

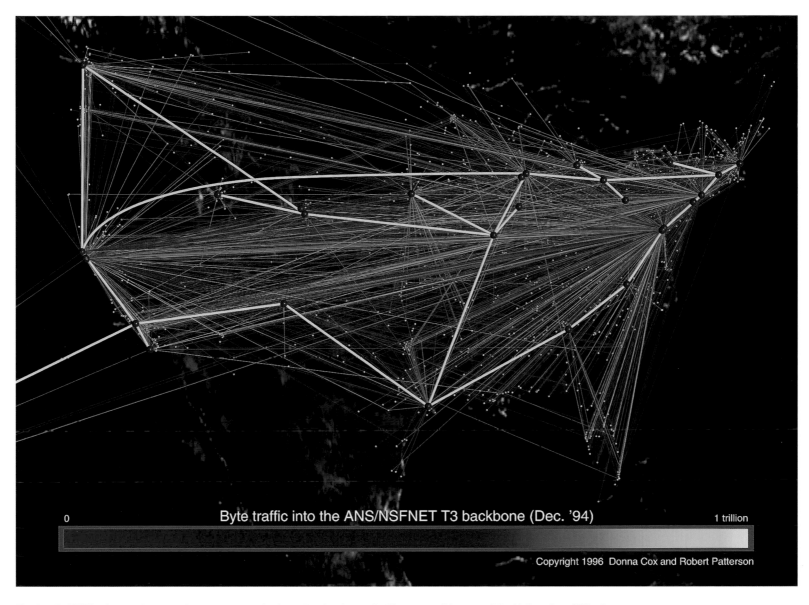

0 Byte traffic into the ANS/NSFNET T3 backbone (Dec. '94) 1 trillion

The iconic NSFNet image that was the precursor to the Internet of today and still requested for use of the University of Illinois. The network data was first visualized by Donna J. Cox and Robert Patterson in 1991 and again in 1993. This version is from 1993. Courtesy of Donna J. Cox and Bob Patterson, NCSA, University of Illinois.

class from Donna J. Cox, a professor in the School of Art and Design at UIUC, on computer animation. She said, 'Offering a different perspective and challenging the dominant worldview—this is a role artists always have played in culture.' Her words made me excited about the prospect of engaging people with technology in such a way that it changed their lives." Fu has contributed to the changing world through technology and sees herself as both an artist and scientist. "As a child, I had always sought out beauty; it had been a critical part of my survival strategy. Now, creating beautiful objects from computer programs was an integral part of my everyday life."

Through her insight and technical expertise at the NCSA Software Development Group, Fu led

efforts in CAVE development, scientific visualization, and most importantly, the popular Mosaic Internet browser. Fu explained,

> In 1992, I received a grant from the National Science Foundation (NSF) and was able to hire a few students to work with me at NCSA. One of them was Marc Andreessen, a witty, upbeat, and extremely bright undergraduate who had done some user interface programming in Austin, Texas, as a summer intern at IBM. We talked about building a browser, which is a graphical user interface, to manage our public domain Web site at NCSA. We were bored with telling people to type cumbersome network addresses in order to access free software and research papers. We thought people ought to be able to click on a link to pull up words and images.

Ping Fu returned to NCSA to participate in a discussion panel, "Entrepreneurship and Transformative Thinking," held on September 19, 2016, and she spoke about creativity. Panelist Austin Lin is seen in the background. Courtesy of NCSA, University of Illinois.

The year before Fu arrived, Colleen Bushell had moved to the same software group to design visualizations and to work on interface design. Invited by Fu, Bushell collaborated on several projects, including the Mosaic web browser. Through Fu's insight, she was impressed by Andreessen's capabilities and managed the integration of simple technologies to build the browser. Fu invited Bushell to collaborate on its graphical interface design that helped shape an early look and feel of the WWW that is commonly used when a URL is accessed, as one example. The visual location of the website URL address that visually appears at the top of a browser screen was part of Bushell's innovative visual layout standards that were adopted by technology companies across the globe to the present day.

Fu recalled, "Every day I had fun, was challenged, and felt happy. Here in the middle of the endless cornfields, some of the computer industry's greatest and most creative minds had converged. We had few budget constraints and no limits set on our imaginations. We wrote history in scraps of software and tossed much of it into the public domain. We took the work of theoretical scientists and gave it dimension, color, and transparency." By 1993, Fu "was impressed when Andreessen and another colleague, Eric Bina, put it all together in just six weeks. They introduced Mosaic early in 1993, and NCSA offered free downloads of the software to the public. While the program was originally developed for Unix, our group released versions of Mosaic for PCs and Macs soon after the initial success became apparent."

This first, well-designed visual browser met the world with instant success. Mosaic drew upon existing browser technologies but expanded features aimed at ease of use. The team effort that included a visual design with the icons, buttons, layout, and search history appealed to many early adopters. The Mosaic browser technology created a new generation of thinking, working, and playing, making it one of the most socially transformative technologies to be developed at NCSA under Larry Smarr's leadership. REL donor and cofounder of SGI Jim Clark persuaded key developers of Mosaic to form Netscape. Unfortunately, a legal struggle evolved between the University of Illinois and the Netscape startup. Eventually, the University of Illinois licensed Mosaic to Microsoft to create Internet Explorer. Fu added, "Mosaic was a desktop application and fell outside the supercomputing mandate

for which the federal government funded NCSA, so the university asked us to license it, to make a 'technology transfer.' But no one seemed interested—not Apple, Hewlett-Packard, Silicon Graphics (SGI), or IBM. Only Marc, now a senior in college, seemed to grasp the potential of the world's first multimedia browser."

A few years later, First Lady of the United States Hillary Rodham Clinton visited Fu's native China and delivered a watershed speech at the fourth UN World Conference on Women in Beijing on September 5, 1995, in which she declared, "Human rights are women's rights—and women's rights are human rights."[45] The glass ceiling was cracked, if not shattered, in 2016 when Clinton, who is an Illinois native, won the Democratic Party nomination for US president, becoming the first female major party nominee in US history, who also won the national popular vote. The unimagined success Fu's team achieved that changed the world and opened many doors for women parallels Clinton's journey, and she remarked, "I have always believed that women are not victims, we are agents of change, we are drivers of progress, we are makers of peace—all we need is a fighting chance."[46]

In the same year that Ping Fu joined NCSA, Nan Goggin was attracted to the University of Illinois because of new technological opportunities at the Urbana campus. Goggin joined the graphic design faculty and connected to other women working with art and technology across campus. Colleen Bushell, one of Goggin's former graduate students, demonstrated to her an early version of Mosaic. Amazed by the potential for art, Goggin took advantage of the Internet and produced early Internet art experiences. She cofounded one of the first curated art spaces on the Internet that was dedicated to Internet art.

During UIC's CAVE development and NCSA's visualization and networking developments, collaborations between the Illinois campuses escalated when EVL's Maxine Brown was invited to chair the 1992 SIGGRAPH conference in Chicago. It was another record year for attendance with the featured immersive virtual reality CAVE applications and surrounding PHSCologram artworks by (art)[n].

PHSCologram research had been one of the inspirations and precursors to the CAVE. At the Chicago SIGGRAPH conference, a grouping of forty PHSCologms were displayed on the exterior walls of the CAVE to show visitors a glimpse of what they would experience inside while they

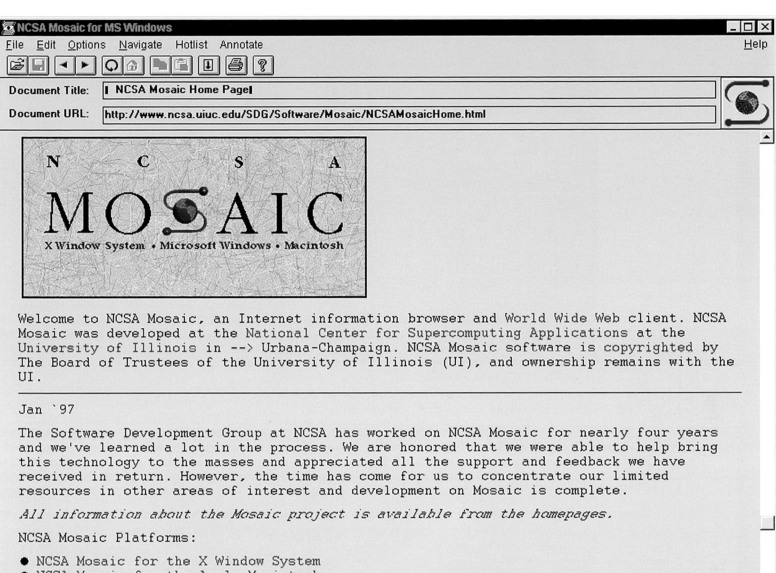

Mosaic was developed at NCSA and was the first graphical web browser; it became a global phenomenon leading with an easy-to-use interface. Colleen Bushell worked with the Mosaic team to design the interface for the first Mosaic. She designed the Mosaic wordmark with the world globe in center of the "S" that became the NCSA logo. The animated globe was created by Robert Patterson and was the first Internet icon that served as an indicator to users that processing or downloading was taking place while browsing. Courtesy of NCSA, University of Illinois.

were waiting for their turn. This work was featured in the *Science in Depth* traveling exhibition that was sponsored by ACM. Other early CAVE applications shown at SIGGRAPH included the first MFA show of EVL artists' works by Michelle Miller and Kathy Koehler, who had both been mentored by Cruz-Neira. The *Virtual Director* also made its debut. Such CAVE research led the way for large-scale networked immersive collaborations and teleimmersion. The University of Illinois connected researchers around the world over high-speed networks and virtual reality

Maxed Out, 1992, Computer Graphics for print. Maxine Brown, director of EVL/UIC, was the conference chair for a major international computer graphics conference, ACM SIGGRAPH '92, held in Chicago. This image of Maxine's face morphed into a mandrill was generated for use on SIGGRAPH T-shirts and posters using software developed for Mary Rasmussen's MFA thesis show. Courtesy of Mary L. Rasmussen.

software prototypes through an international collaborative alliance. Virtual reality and flying avatars became a daily event at NCSA and UIC.

During this expanded CAVE research, Brenda Laurel, another Renaissance figure from the Midwest, was also doing important VR research at the Banff Centre in Alberta, Canada, with Rachel Strickland that investigated differing ways that women naturally explore space. This research led Laurel to originate the "women in games" movement, combined with her past work at Atari as the company's first woman employee—who put a bow on Pac-Man to create Ms. Pac-Man. She created her own company, Purple Moon, during the technology boom under the Interval Research umbrella. Her new company focused on computer games for girls that emphasized imagination, exploration, and a rehearsal for trying on different points of view. Purple Moon fans were also social

on the web before social media was invented. The popular website was an early example of a successful online games community produced for girls. Laurel's PhD thesis was published as the classic text *Computers as Theatre* (1991).

In 1993, Ellen Sandor and Janine Fron saw Brenda Laurel speak about her research at Banff during *Images du Futur* in Rochester, New York. Janine Fron had joined (art)n the year before amid the excitement of the *Science in Depth* traveling exhibition. The birth of the WWW, the CAVE, and technical improvements for PHSColograms gave way to artistic innovation and medical visualization applications. Fron coauthored and published papers with Sandor. They collaborated on commissioned installations for MCA, Museum of Jewish Heritage, Smithsonian Institution, "Battle of Midway Memorial," and many others. While living in Finland and California, Fron additionally

began to explore collaboration as a creative process for developing games. She coformed the Ludica collective with Celia Pearce, Jacquelyn Ford Morie, and Tracy Fullerton in Los Angeles to cultivate a feminine spirit of cooperative play within the international game studies community.

The University of Illinois celebrated its contributions to the evolutions of and revolutions in computing through a historic convergence of film, technology, and history in Urbana, Illinois: Cyberfest, March 10–15, 1997. Roger Ebert, film critic and native son, hosted the weeklong birthday party for HAL 9000, the artificially intelligent computer in Stanley Kubrick's film *2001: A Space Odyssey*. In the novel of the same name by Arthur C. Clarke, HAL was born in Urbana in 1997. Cyberfest events included Smarr's presentation on why HAL was born in Urbana and demonstrations of NCSA's technologies and high-tech art. Ebert acquired a pristine copy of Kubrick's original film that was screened at the Virginia Theatre. The climax of the week's festivities was the CyberGala at the Krannert Center for the Performing Arts (KCPA), Urbana, which featured a one-of-a-kind virtual space-time performance by NCSA research artists and programmers. The "Machine Child" performance integrated images, sounds, and music from Kubrick's film in a digital experiment where musicians played and interacted with virtual computer graphics projected on an 18' × 24' screen. During part of the performance, Insook Choi, composer and virtual artist, leaned on, walked through, and controlled a digital model of the film's space lab *Discovery*'s centrifuge while the virtual scene was projected on KCPA's large stage screen.[47] Arthur C. Clarke made an appearance from Sri Lanka at the CyberGala through a tenuous Internet videoconferencing setup, while a circle of onstage guests posed questions to Clarke. Cyberfest's great success fueled Ebert and the community to establish the annual Ebertfest international film festival held annually in Urbana since 1999. Ebert hosted academic panels at the University Illini Union during the early years of Ebertfest.

Through the SIGGRAPH conference and other venues, the University of Illinois and the Chicago art scene catalyzed changes across the country in academic departments, international art exhibits, funding agency opportunities, and commercialization of technologies. Individuals and their ideas migrated to other parts of the country and abroad. SIGGRAPH has maintained its stature as the largest international computer graphics technical organization premiering the who's who and state

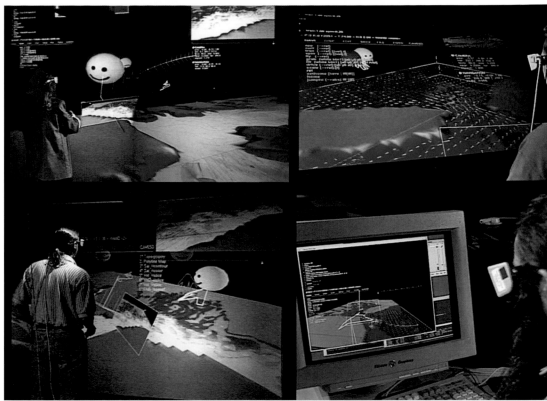

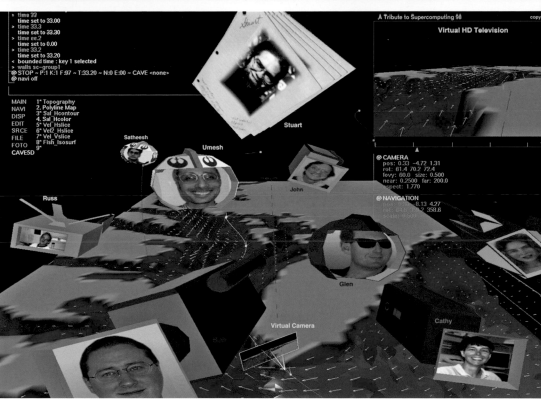

At top, four people simultaneously and remotely collaborating over the internet using the *Virtual Director* environment in four different environments, including the VR CAVE and the ImmersaDesk. Donna J. Cox, in upper left using Virtual Power wall; Professor Glen Wheless in upper right at ImmersaDesk; Stuart Levy, lower right on desktop; and Bob Patterson on lower left in the CAVE. Figure on bottom, screen of the *Virtual Director* environment with remote individuals converging as avatars in three-dimensional virtual space. The *Virtual Director* preceded Second Life software. It is still used today for collaborating on IMAX film and digital dome productions, images circa 1997–2000. Left to right, foreground avatars: Robert Patterson, Umesh Thakkar, Stuart Levy, John Shalf, Dr. Glen Wheless, Dr. Cathy Lascara (Old Dominion University), and Donna J. Cox. Courtesy of Donna J. Cox.

The Purple Moon team, led by founder Brenda Laurel, innovated a form of "emotional navigation" for the interface to the Rockett games based on research from play-testing with girls and boys conducted with Cheskin Research. Screenshot from 1998. Courtesy of Brenda Laurel.

of the art in the field, although its heyday was in the 1970s–1990s for the EVL and NCSA communities.

Carolina Cruz-Neira graduated from EVL, UIC, with a PhD, joined the faculty at Iowa State University, and built one of the largest virtual reality academic environments in the United States (in 1995), and is the present director of the George W. Donaghey Emerging Analytics Center, University of Arkansas–Little Rock. Cruz-Neira's CAVE research captured the attention of artists like Margaret Dolinsky, a trained painter and EVL alum who was inspired by Brenda Laurel. Dolinsky created a series of personal, narrative VR experiences and iGram snapshots in the CAVE for her MFA show in 1998 that was shown at Ars Electronica and later made the cover of *Computer Graphics World* magazine.[48]

WOMEN IN NEW MEDIA ARTS: THE NEXT GENERATION

After its initial peak in research, computer graphics became mainstream. With the release of animated feature films like *Toy Story* and *A Bug's Life*, the early work that appeared within the SIGGRAPH community became a part of popular culture, and the art world was taking notice. In the late 1990s, Claudia Hart, a former art critic for *Artforum International*, continued to develop her vision that a new aesthetic culture would emerge from the technical advances that were taking place. She experimented with Maya software and entered academia to change the culture of typical computer graphics content that was made for a mass audience. She attracted young women students to her classes at the Pratt Institute. After seeing Cox's work at the Hayden Planetarium, she eventually came to Chicago where she is now a tenured professor at SAIC. Her New Media installations have been shown internationally in museums, festivals, and at bitforms and TRANSFER galleries in New York.

When Hart came to Chicago, she met Sandor and fellow New Media artist Tiffany Holmes. Joan Truckenbrod had mentored Tiffany Holmes, who eventually became the SAIC dean of undergraduate studies. Like Hart, Holmes knew the art world was changing. She began to chart her own waters and created socially conscious New Media installations that speak to contemporary concerns about the environment and surveillance.

After leaving the University of Michigan in 2000 to teach at SAIC, Holmes was introduced to Cox and commissioned to create experimental environmental animations for the opening of the new NCSA building at UIUC. Her work was also exhibited at the J. Paul Getty Museum in Los Angeles, MCA, and Lake Forest College.

At SAIC, the Video Data Bank continues to provide archival documentation of the historic birth of Chicago-style video and women's influence upon the medium. Abina Manning stepped into the position as executive director in 1999 and worked with the influx of formats as the revolutionary work continued to unreel itself from tradition.

This younger generation of women included Hart, Holmes, and Manning. Early innovators Copper Giloth, Jane Veeder, Sally Rosenthal, and Lucy Petrovic migrated from the Midwest yet they continue to raise feminist awareness through the making of digital art, continued research, and teaching. Some women stayed in the Chicago area, including the late Annette Barbier, who taught at Columbia College Chicago, and Dana Plepys, who is the associate director of EVL. Sandor continues to innovate and collaborate with scientists through (art)n, producing commissioned works featured in art exhibitions and museum collections, while she

has served on the advisory board of SAIC's Gene Siskel Film Center since 2000, and as chair since 2013. Fron continues to collaborate with Sandor while investigating the origins of play culture and alternative education. Her collaborative work with the Ludica collective continues to inspire new generations of women interested in feminist games research and cooperative play. Colleen Bushell joined faculty in the School of Art and Design, participated in startup commercial ventures, and is continuing to collaborate at the University of Illinois. Years after Sandin and DeFanti retired from EVL, Maxine Brown became the director and helped lead an international network consortium. In 2000, Smarr left Illinois and carried ideas of inventing new digital media at the University of California–San Diego. In 2003, Cox contributed to Judy Malloy's seminal *Women, Art & Technology*, published by MIT Press (Leonardo Series). Malloy's book continues to resonate with many professionals and included Artists' Papers by Brenda Laurel, Dara Birnbaum, Lynn Hershman, Pauline Oliveros, and others. In the preface, Malloy wrote, "Many paths emerge from the matrix where art, technology, and gender intertwine." For over three decades, Cox has continued to lead the art of scientific visualization at NCSA and the University of Illinois, producing numerous large-format digital

"Interior of a Barracks at Auschwitz-Birkenau," "Unprocessed, Color Processed," and "Black and White Processed," 1995. Stephanie Barish and the Survivors of the Shoah Visual History Foundation; Ellen Sandor, Stephan Meyers, and Janine Fron, (art)n. 40" × 30" vintage PHSColograms—Cibachrome, Kodalith, Plexiglas. Courtesy of Ellen Sandor, (art)n. It was essential to the Shoah Foundation and the Museum of Jewish Heritage that artifacts donated by survivors were artistically conceived with digital media to create a lasting message of tolerance that would resonate with future generations in the visual language of contemporary society.

Roger Ebert moderating an Ebertfest panel discussion that included Donna J. Cox at the University Illini Union during the early days of Ebertfest. Urbana, circa 1999. Courtesy of Donna J. Cox.

Dr. Carolina Cruz-Neira, director, George W. Donaghey Emerging Analytics Center, University of Arkansas–Little Rock. Inside the Anatomical Eyes CAVE application, 2015. Courtesy of Carolina Cruz-Neira.

Margaret Dolinsky, Indiana University, showcases *Blue Window Pane II* in the CAVE at the iGrid 2000 workshop held at the INET 2000 Internet Global Summit, Yokohama, Japan, July 2000. Interactive virtual reality piece by Dolinsky, Edward Dambik, Markus Greunz, Carlos Orrego, Joe Reitzer, with special thanks to Dave Pape. Courtesy of the EVL Archives, UIC.

films that have been translated into multiple languages and enjoyed by international audiences. Dr. Antoinette Burton, director of the Illinois Program for Research in the Humanities, has recently called Donna J. Cox a campus "legend" for ongoing efforts to bring together art and science. Cox continues to work for women through various initiatives at the university.

Throughout the 1960s–2000s, the Midwest played an important feminist, artistic, and technological role that rippled internally from a nearly forgotten center. The Guerrilla Girls, whose feminist media arts work inspired many women in the book throughout this era, received an honorary doctorate from SAIC in 2010, in which Guerrilla Girl "Kathryn Born" gave the commencement address.[49] Equality and diversity in the realm of science and technology also became topical from the early seeds planted in the Midwest. The following year, First Lady Michelle Obama, a native Chicagoan, spoke about the importance of supporting women and girls through STEM initiatives at an NSF event held at the White House on September 26, 2011.[50] "If we're going to out-innovate and out-educate the rest of the world, we've got to open doors for everyone," Obama encouraged. "We need all hands on deck, and that means clearing hurdles for women and girls as they navigate careers in science, technology, engineering, and math (STEM)." National Science Foundation director Subra Suresh introduced the NSF's Career-Life Balance Initiative, a ten-year plan to provide greater work-related flexibility to women and men pursuing research careers, aimed at retaining talented scientists and engineers in the United States (Suehle 2011).

New Media Arts also became the familiar in academic circles and was commemorated during SAIC's 150th anniversary with a one-day symposium, *Celebrating Women in New Media Arts*, held on March 18, 2016, in the SAIC ballroom in honor of Women's Month. During the celebratory year, Elissa Tenny became SAIC's first appointed female president after serving as provost and senior vice president of Academic Affairs since 2010. In the compendium *Euphoria and Dystopia: The Banff New Media Institute Dialogues*, Sarah Cook and Sara Diamond captured the vibrant period that evolved into New Media Arts from the 1990s: "The period of the early '90s through to 2005 saw intensive technological change: the massive adoption of 'new media' and its normalization as 'digital media,' and the rise, fall, and re-emergence of an information-, technology-,

and communication-boom economy. . . . Virtual reality, simulations, and data visualization moved from the margins and became mainstream industrial and research practices. Technologies became relatively fail-safe and user-friendly" (Cook and Diamond 2011, 21).

As an important marker of time, Martyl passed away in 2013 at the amazing age of ninety-six. She created one of the definitive examples of socially conscious artworks about technology with her design of the Doomsday Clock. Her revealing oral history and life trajectory through the two cultures of fine arts and modern science reflects the social landscape that many midwestern women artists treaded from early to late twentieth century. Born in St. Louis in 1917, she prodigiously exhibited art at age seventeen. She came of age when important art history texts overlooked women. Out of a period when women artists were marginalized, Martyl's personal story evolves into a new era of midwestern women artists thriving within the socially situated contexts of technology and scientific knowledge. Her precursory collaboration with scientists to create the Doomsday Clock predates many projects that span the modern art-science cultural divide at the onset of the atomic age. In 2015, the *Bulletin of the Atomic Scientists* marked its seventieth anniversary and welcomed Rachel Bronson as the new executive director and publisher. The *Bulletin* enjoyed record-high readership and media attention for its commitment to informing

Claudia with The Dolls House installation at Transfer Gallery, Brooklyn, New York, 2016. Photo by Stephen Spera. Courtesy of Claudia Hart.

Ellen Sandor and Jennifer Doudna with *CRISPR-Cas9: A Ray of Light*, 2017 at the Innovative Genomics Institute, University of California, Berkeley. Richard Sandor, Jean St. Aubin, Jamie Foxx, Ellen Sandor, Robert Downey Jr., and Walter Massey at the 2011 GSFC Renaissance Award ceremony in honor of Foxx's career. Photo by Dan Rest. Courtesy of the Gene Siskel Film Center, SAIC.

On Saturday, May 22, 2010, thousands gathered at the Millennium Park Pritzker Pavilion for SAIC's commencement ceremony to hear the Guerrilla Girls' "Käthe Kollowitz" speak. Photo credit: Yoni Goldstein. Courtesy of SAIC.

Maxine Brown, Brenda Laurel, Tiffany Holmes, Carolina Cruz-Neira, and her son Alexander gather during the opening reception for *Celebrating Women in New Media Arts* during SAIC's 150th Anniversary. Courtesy of Ellen Sandor, (art)[n].

public discussion about nuclear weapons, climate change, and emerging threats to global security.[51]

The following interviews illuminate the early years of the digital revolution, capturing ways these women met various challenges from their inception that circle back to their current life's work.

Several themes emerge from these stories, including New Media artworks inspired by the backdrop of the prairie landscape and scenic Chicago lakefront. Core midwestern values of hard work and perseverance run through these stories. Each contributor uniquely values collaboration but few analyze their collaborative nature. Until the last half of the twentieth century, many artists, especially women, did not have computer equipment access except through endowed institutions. Collaboration was sometimes a necessary strategy to access not only technology but also the community of knowledge around that technology. These pioneering women share a passion and a set of mutual foresights on the positive potential of intermingling art and technology with education.

Each woman interviewed reveals untold benefits from preceding generations of women who cultivated dynamic social opportunities and forged the changes that enabled the 1980s second wave of New Media women artists to take root in the Midwest. The twenty-two women recorded here recognize that they benefit from former generations of women like Martyl, who pioneered their own artistic practice during an era of widespread social change. Their legacy includes a commitment to inspire future generations of women in New Media Arts. While these women attribute their success—at least in part—to the Midwest, their influence resounds internationally. Sometimes exciting, sometimes evoking disappointment, their stories reflect an extraordinary era of transformation from a firsthand perspective.

SAIC 2012 Commencement photo featuring Elissa Tenny, SAIC president (2016); Golden Lion Award Recipient James Zanzi, SAIC professor emeritus, sculpture; Walter Massey, SAIC chancellor (2016) and past SAIC president; and Lisa Wainwright, SAIC dean of faculty, vice president of Academic Affairs, and professor, Department of Art History, Theory and Criticism. Courtesy of SAIC.

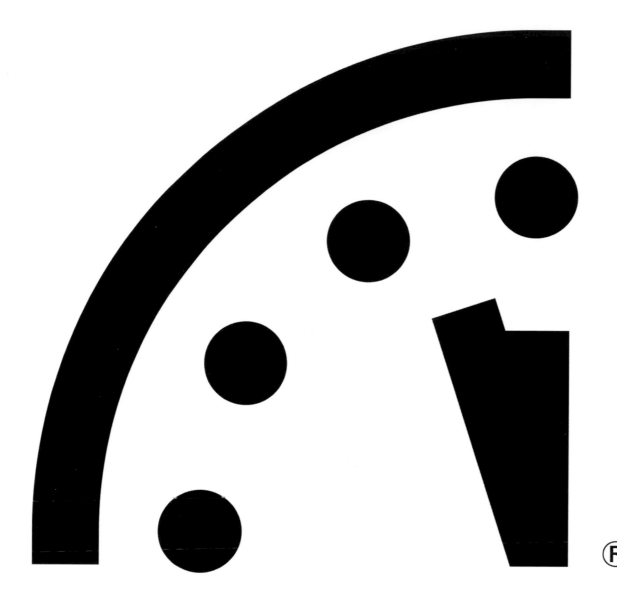

Notes

1. As described by author Glenda Korporaal, Hayden "designed a three-story white Italian Renaissance-style building with arches and columned terraces. She only received $1,000 for her design, one-tenth of what the male architects had received for their winning designs for buildings for the Exposition, but she had eagerly accepted the prize" (Korporaal 2015).

2. In his foreword to the *Edlis|Neeson Collection*, Douglas Druick, past president, and Eloise W. Martin director, the Art Institute of Chicago, acknowledged, "In 1922, the museum acquired much of the collection amassed by Bertha Honoré and Potter Palmer, which included paintings by artists such as Edgar Dégas, Claude Monet, and Pierre-Auguste Renoir. Many of these canvases are now among the highlights of our holdings; when Bertha Palmer began collecting Impressionist art in the 1890s, however, it was considered radical, even controversial. It is due to her forward thinking and influence that Chicago is home to one of the greatest collections of Impressionist art in the world" (Rondeau 2015).

3. Lorado Taft was born on April 29, 1860. He attended UIUC, where he received a bachelor's degree and master's degree. His father was on the faculty at the university in the Geology Department.

4. According to Glenda Korporaal, Frank Lloyd Wright, Marion Mahony Griffin, Dwight Perkins, Lucy Fitch Perkins, and others from Steinway Hall met at Hull-House to form the Chicago Arts and Crafts Society. The arts and crafts movement emerged in England as William Morris's response to the industrial age, underscored by his appreciation for nature. This inspired an organic style of architecture that Prairie School architects innovated in Chicago. Marion Mahony's studio conversations with Wright influenced his famous Hull-House speech, which planted seeds for New Media Arts by suggesting that aesthetics must be part of new technologies (Korporaal 2015).

5. In Mickey Muenning's first architectural monograph, he remarked, "The Midwest has a legacy of ignoring the boundaries of politics and art. The progressives of the early twentieth century defied East Coast banks and political establishments to proclaim—and establish—a new populist man. The Midwest also gave birth to the Prairie style and organic architecture, for once a completely new idea of architecture, space, and ornament that launched the Modern century" (Muenning 2014).

6. In January 1898, Marion Mahony "fronted, and passed, the state licensing examination for architects.

A recently enacted initiative, the Illinois law was in fact the first of its kind in the profession's history. Of the dozen candidates, Marion gained the third-highest pass in the challenging three-day examination and duly became the first woman anywhere in the world to be licensed to practice architecture" (McGregor 2009).

7. Dwight Perkins, a cousin of Marion Mahony, was the architect of the Steinway building. Perkins leased a large office loft on the top floor and invited a friend from MIT, Robert Spencer, to share the space, along with Wright, who joined them. Soon they were joined by the Pond brothers, Myron Hunt, Walter Burley Griffin, and Mahony. As Alasdair McGregor explained in *Grand Obsessions*, "The Steinway loft quickly became more than a work space; it was a fertile ground for the exchange of new and progressive ideas in architecture, design and the large questions of life" (McGregor 2009).

8. McGregor elaborated, "a young Le Courbusier acquired a copy, and the atelier of Peter Behrens in Berlin is said to have downed tools for an entire day when their copy arrived. (Walter Gropius and Ludwig Mies van der Rohe were both apprenticed to Behrens at the time.) Wright's work had previously been known outside the United States only from magazine articles such as the *1908 Architectural Record*. The portfolio would now form a focus of study for the architects of the Bauhaus in Germany and the De Stijl movement in Holland. The young Austrian architects Richard Neutra and Rudolf Schindler were lured to the United States in part because of the portfolio's impact" (McGregor 2009).

9. In her manuscript, Griffin pondered, "Men and women must work together in practically all fields. But it is true that there are certain things women can do that men cannot. The essential man's function is to conquer nature. Woman stands timid and frightened before that requirement, whereas man registers joy and enthusiasm at the very thought of it and at every opportunity that offers. Woman's function is to see to it that man does not destroy what he has conquered. Today man is conquering and destroying the world and woman is failing to perform her function" (Griffin 2007, 294).

10. In 1917, *School and Home Education* reported in a clipping, "Inventions of an American Artist," that Mary Cassatt had "invented surgical appliances for patients suffering from fractures, which have contributed to the comfort and recovery of the wounded in France."

11. The Marin County Civic Center has been a source of inspiration for futuristic films like George Lucas's *THX 1138* (1971) and Andrew Niccol's *Gattaca* (1997) (Wilson 2014).

12. The Ennis House was the setting for a variety of Hollywood films, TV episodes, and music videos, including *House on Haunted Hill* (1959), *The Day of the Locust* (1975), *Blade Runner* (1982), *Twin Peaks* (1990–1991), and many others (Wilson 2014).

13. This imperative had almost vanished by the late 1960s and is conspicuously absent from the thinking and manifestos of the third and best-known generation of alternative spaces—those, including ARC, Artemisia, and N.A.M.E., founded in the early 1970s (Warren 1984).

14. In 1939, the Hyde Park Art Center was formed in Chicago as one of the oldest alternative spaces for exhibiting art in the city. The Chicago Imagists were an informal group of artists working during the mid-1960s and early 1970s who defined a unique Chicago style of painting that had surrealist elements mixed with pop art and fantasy; the group included Ed Paschke, Roger Brown, Ray Yoshida, Don Baum, Christina Ramberg, Barbara Rossi, Ed Flood, Sarah Canright, and Phil Hanson.

15. Warren's essay was very influential to midwestern women artists, including Barbara Sykes and Copper Giloth, because it gave a voice for this new art from a new generation of women.

16. In 1978, the MCA hosted Frida Kahlo's first solo museum show in the United States. The Kahlo show was part of the museum's expanding curatorial mission to commission artists from outside of Chicago to create site-specific works. In 1982, Laurie Anderson performed at the museum during *New Music America*, an alternative festival of experimental music sponsored by the City of Chicago with assistance from MCA staff. At age seventy, French-American sculptor Louise Bourgeois enjoyed her first retrospective organized by the Museum of Modern Art in 1982 that traveled to the MCA in 1983, along with the Contemporary Arts Museum in Houston and the Akron Art Museum, Ohio.

17. In addition to Judy Chicago, accomplished women artists who were born in the Midwest include Gertrude Käsebier, Berenice Abbott, Ruth Pratt Bobbs, Isobel Steele MacKinnnon, Overbeck Sisters, Esther Bubley, Nancy Burson, Georgia O'Keeffe, Jenny Holzer, and Laurie Anderson. Berenice Abbott, who was a photographer and inventor, wrote an article in *Art in America* in 1959, "The Image of Science." Additional notable Chicago women artists include Lyn Blumenthal, Kay Rosen, Hollis Sigler, June Leaf, Ellen Lanyon, Ruth Duckworth, Nancy Spero, Phyllis Bramson, Frances Whitehead, and Claire Zeisler.

18. Jane Addams was also early to exhibit international artwork at Hull-House in June 1891 by Mr. and Mrs. Barnett of London before the Art Institute was formally established.

19. For example, it is believed that one of the first women to receive a PhD in the computer sciences was from the Midwest. Sister Mary Kenneth Keller, from Cleveland, Ohio, was one of the first women, and possibly the first known woman, to receive a PhD degree in computer science in the United States. She studied at DePaul University, where she received a BS in mathematics and an MS both in mathematics and physics. Her dissertation constructed algorithms that performed analytic differentiation on algebraic expression, written in CDC FORTRAN 63. As a graduate student, Keller additionally studied at Dartmouth, Purdue, and the University of Michigan. At Dartmouth, the university broke its "men only" rule, enabling her to work in the computer center where she participated in the development of BASIC. The combined efforts of women of science dating back to the 1950s became important precursory work to the unborn fields, including computer science and scientific visualization. Collaboration played an important role to their discovery process, perhaps by necessity.

20. Maria Goeppert-Mayer, for example, made significant contributions to the Manhattan Project; later, she taught physics at the University of Chicago and

was a senior physicist at nearby Argonne National Laboratory. She eventually won a Nobel Prize in physics for developing a mathematical model of the structure of nuclear shells, shared with J. Hans D. Jensen and Eugene Wigner; however, this contribution was not widely recognized during her day. Like her contemporary Rosalind Franklin, who worked with James Watson and Francis Crick on the discovery of the DNA double-helix (1953), Goeppert-Mayer's entry into the scientific world depended upon her ability to collaborate with men. She became the second woman Nobel Laureate in physics, after Marie Curie in 1903, whose award is shared with her husband, Pierre, and Henri Becquerel. Also UIUC alum (1949) Jean E. Sammet, an active ACM member, managed the first scientific programming group for Sperry Gyroscope Co. from 1955 to 1958. Afterwards, she worked for Sylvania Electric Products, where she served as a key member of the committee that created COBOL. Her book, *Programming Languages: History and Fundamentals*, became a classic text after being published in 1969.

21. Augusta Ada Byron, became Ada, Countess of Lovelace, after marriage to Baron William King, who later became an earl. Her father was the romantic English poet Lord Byron. Michael Faraday and Charles Dickens were among her correspondents. In 1979, the ADA programming language was named in her honor.

22. Another example of a critical technology contributor around the World War II era was Agnes Meyer Driscoll, a cryptologist and former graduate of Ohio State University, where she studied mathematics, physics, foreign languages, and music. During her thirty-year military career, Driscoll trained many code breakers. Driscoll broke Japanese navy manual codes, and the US Navy exploited this information after the attack on Pearl Harbor and for the duration of the Pacific war. Early in 1935, Driscoll led the attack on the Japanese M-1 cipher machine used to encrypt Japanese naval messages around the world. These examples provide a few contributions that women made around the World War II era.

23. Margaret Bourke-White, whose career began with architectural and industrial photography assignments, briefly attended the University of Michigan and spent time in Ohio before she became the first official woman photographer for the US Army Corps in 1942.

24. The national women's liberation movement was catalyzed by Jo Freeman with other women activists in Chicago in the late 1960s. The movement was spawned by society issues of inequality in the workforce.

25. In 1946, Nobel Laureate and physicist Enrico Fermi joined the University of Chicago and became the founding director of the first national laboratory, Argonne National Laboratory, established near Chicago. Other scientists included Maria Goeppert-Mayer, who taught at the University of Chicago and was a consultant at Argonne National Laboratory. She later won a Nobel Prize in physics in the 1960s.

26. Three years later, Hiller established the first experimental music studio in the Western world and eventually received NSF funding for his computer music investigations and computer sound synthesis.

27. The apparent absence of women in computer music also parallels a lack of documented early explorations of electronic visual art. Ben Laposky in Iowa and

Herbert Franke in Germany developed some of the first electronic art images using the oscilloscopes. Notable American filmmaker John Whitney Sr. explored analog computer animation and eventually used digital computers. It was not until the 1960s that we see many women contributing to computer visual art.

28. Experimental composer Pauline Oliveros frequently performed at Illinois and developed a strong association with the faculty. Another accomplished musician who participated in concerts, Maryanne Amacher, was a postgraduate in acoustics and computer science.

29. British cybernetics artist Roy Ascott analyzed and integrated cybernetic theory into the process of making art and was Donna J. Cox's PhD advisor many years later.

30. Later in the 1980s at Ohio State, Brenda Laurel became one of the first in her field to receive a PhD in theater. Her thesis was widely published as *Computers as Theatre* (1991) and focused on the human-computer interaction. She is also an innovator in virtual reality and girl games.

31. Ram Dass was formerly Richard Alpert, Harvard University professor; Gene Youngblood is the author of *Expanded Cinema*, a treatise on the transformation of cinema due to technology.

32. This landmark epicenter has since evolved into SAIC's internationally renowned Gene Siskel Film Center, where Ellen Sandor has been the chair for more than a decade.

33. Morton's "General Motors" video and "Program #9" coproduced with Jane Veeder.

34. She would participate in SIGGRAPH for twenty-five years, helping to build the organization and employ computer graphics to support artists. SIGGRAPH recognized Brown and DeFanti for their service contributions.

35. Judith R. Brown and Rae Earnshaw, *Visualization: Using Computer Graphics to Explore Data and Present Information* (New York: John Wiley and Sons, 1995). She received an Outstanding Service Award in 2004 for building SIGGRAPH's Education Committee and developing collaborative relations with international computer graphics societies.

36. The Patric Prince Archive at the Victoria and Albert Museum in London is composed of two hundred original artworks, correspondences, papers, and artifacts, including a PHSCologram by Ellen Sandor and (art)[n].

37. Laurie Anderson invented instruments like a "tape-bow violin" that used recorded magnetic tape instead of horsehair on her violin bow. In the late 1990s, she invented a "talking stick"—a six-foot baton-shaped MIDI (musical instrument digital interface) controller that could access or replicate sounds for her and even exaggerate her vocal expressions, which she used to convey her political views by figuratively questioning authority figures in an amplified voice set to a lower vocal range. These instruments became icons for her performances as she influenced a wave of artists through her adept analysis of the digital turn through her electronically mediated voice, "Nobody wants to be a zero."

38. Truckenbrod later wrote *The Paradoxical Object* (2012, Black Dog Publishing) that explores a conceptual

evolution of video, film, and sculpture that she was a major part of through her own artistry.

39. Sandor was also a founding member of the first Berkeley chapter of the National Organization of Women (NOW).

40. These SAIC peers included Jim Zanzi, Randy Johnson, Gina Uhlmann, Gary Justis, and Mark Resch.

41. In 2014, Sandor received an honorary PhD from SAIC for pioneering the future of photography and the invention of PHSColograms, which was acknowledged in a commencement tribute given by Claudia Hart: "Throughout my career, she has been my mentor and my role model, and while I'd like to claim her entirely as my own, she has also supported many other women artists and creative professionals who use technology. Things are far easier for my peers and me because Ellen got there first, and I consider myself very lucky that she did."

42. It wasn't until 2005 that NSF and the National Institutes of Health embarked upon an update to this seminal 1986 report.

43. Also in 1989, Dr. Clarissa Pinkola Estés released the critically acclaimed *Women Who Run with the Wolves: Myths and Stories of the Wild Woman Archetype* as an audio bestseller ahead of the print edition. Estés encouraged, "Ours is not the task of fixing the entire world all at once, but of stretching out to mend the part of the world that is within our reach."

44. Attendees and/or presenters included Jean Baudrillard (French philosopher), Muriel Cooper (Media Lab pioneer), Pamela McCorduck (cultural theorist), Myron Krueger (technology inventor), Stephen Wilson (computer artist and historian), Maxine Brown, Muriel Cooper (MIT Media Lab), Donna J. Cox, Peter D'Agostino, Scott Kim, Ellen Sandor, Dan Sandin, Alan Rath, Salvatore Martirano (computer music), James Seawright (Yale), Michel Ségard (art critic), Joel Slayton (early computer artist), Larry Smarr, and Joan Truckenbrod.

45. Clinton was born and raised in Park Ridge, Illinois. She graduated from Wellesley College in 1969 and earned a JD from Yale Law School in 1973. She served as the sixty-seventh US secretary of state from 2009 to 2014; junior US senator representing New York from 2001 to 2009; first lady of the United States during the presidency of husband Bill Clinton from 1993 to 2001; and first lady of Arkansas during his governorship from 1979 to 1981 and 1983 to 1992. A full transcript of Clinton's historic speech can be found online: http://www.emersonkent.com/speeches/womens_rights_human_rights.htm.

46. Clinton's remarks were made during a speech at the "Women in the World" summit held at New York's Lincoln Center to continue her support for women's global rights in April 2013.

47. Insook Choi and Robin Bargar are composers and producers for the virtual performance "Machine Child," which premiered at Cyberfest 97. Software programmers included Alex Betts, Camille Goudeseune, John Wu, Carlos Ricci, Kelly Fitz, and Bryan Holloway. Stephen Unterfrantz and Aaron Parmelee created the 3D models for the performance. CAVE tracking sensors were employed on computers, including four Silicon Graphics workstations and a deskside Onyx that was used to run the interactive graphics. During part of the performance, Choi controlled a model of the projected digital model of the movie's centrifuge. The team developed a custom foot controller from shoes with sensors glued into the soles.

48. iGrams were invented at (art)n using proprietary software to create real-time PHSColograms output from the CAVE on an inkjet printer. A joint paper coauthored by (art)n and EVL was published by IEEE and presented at IV '99 in the UK.

49. The Guerrilla Girls is an anonymous collective of artists and feminists from New York who have been championing equality and diversity in the arts since their inception in 1985. In 2016, the Guerrilla Girls were in Germany for the fortieth anniversary of Cologne's Museum Ludwig for the group show "We Call It Ludwig. The Museum is turning 40!" As part of their participation in the exhibition, the collective reevaluated the museum's collection from a feminist viewpoint. In their online video (https://www.youtube.com/watch?v=WMx8DouJvTA) with German subtitles, they assessed that in one of Germany's most diverse cities, the works in the museum's collection are 89 percent male and 97 percent white, and that the museum has made little effort to become more inclusive of the community it now serves, where over 17 percent of its residents are non-German: "Unless the art in the museums is as diverse as the culture it's supposed to represent it isn't telling the history of art. It's telling the history of money and power," said one of the masked activists in the video (Neuendorf 2016).

50. The STEM acronym, for science, technology, engineering, and math, was developed under the leadership of NSF director Dr. Rita R. Colwell in 1998. Colwell, who served as the first woman and eleventh NSF director, from 1998 to 2004, promoted K–12 science and math education, and increased opportunities for women and minorities in science and engineering. On January 20, 2009, Michelle Obama became the first African American first lady when her husband, Barack Obama, became the forty-fourth president of the United States, serving two terms. Like Hillary Rodham Clinton, Obama was an Illinois native, born and raised in Chicago. She studied sociology and African American studies at Princeton University and graduated from Harvard University Law School in 1988. In 1996, she became associate dean of Student Services at the University of Chicago, and subsequently, vice president of Community and External Affairs for the University of Chicago Medical Center. As first lady (2009–2017), she created innovative programs like *Let's Move!* and *Let Girls Learn* to inspire America's youth.

51. In a January 28, 2016, interview with *Chicago Tonight*, Bronson explained, "There is a tendency, especially with nuclear security, to think that all these issues can be put to bed as Cold War problems that aren't relevant anymore, but what we're seeing is these issues are back in the headlines, they're front page news. This morning the news reported Japan was anticipating another test from North Korea. For us, it's important to highlight that some of the actors are changing but that the danger is still there. [Bill] Perry [former US Secretary of Defense] said yesterday that our politics aren't keeping up with the dangers we're facing" (Garcia 2016).

PART 1

RENAISSANCE TEAMS: ART AND SCIENCE COLLABORATIONS

Though interdisciplinary coalitions are central to the first selection of interviews, women's motivations differ and complement each other. The title "Renaissance Teams" captures the spirit of these collaborative endeavors among artists, technologists, and scientists working together toward a common goal.[1] Part 1 opens with Ellen Sandor and Donna J. Cox, who have made collaborative means primary to their "artist as producer" modus operandi. Drawing from the roles of filmmaking producers, they not only contribute aesthetic guidance within a team setting, they also help to organize, direct, and operate within highly shifting and dynamic environments. Both women actively assemble teams, sometimes with international contributors, while realizing final artworks or visual products within collaboratory settings. Colleen Bushell's orientation is more focused and directed as a visual designer who helps to advance innovation. With Marc Andreessen, she helped invent a visual design for the first visual browser, Mosaic, a transformative technology that had global impact. In contrast, Nan Goggin, who pioneered ad319 and early web art experiments, describes how collaborations naturally formed out of mutual academic goals and needs. Maxine Brown and Dana Plepys operate within a highly interdisciplinary academic environment and connect large communities of practice. On the other hand, Mary Rasmussen preferred the social benefits of working with small collaborative teams. Carolina Cruz-Neira was motivated by the necessity to solve complex virtual reality problems. She forged new entrepreneurial partnerships in commercial as well as academic endeavors. Finally, the late Martyl closes the chapter with her last oral history interview and provides a personal glimpse of the end of World War II, emerging feminist art, and attitudes that marginalized women in the history of art. She collaborated out of a sense of duty to bring together early artists and scientists in a critical time to create the Doomsday Clock, which ushered in the modern era of social responsibility during the nuclear age.

Note

1. Donna J. Cox, "Using the Supercomputer to Visualize Higher Dimensions: An Artist's Contribution to Scientific Visualization," *Leonardo: International Journal of Art, Sciences and Technology* 21 (1988): 233–42.

Ellen Sandor

Ellen Sandor is a New Media artist and founder/director of the collaborative artists' group (art)n. She believes in the transformative role of artist as producer and director. In 1975, Sandor received an MFA in sculpture from the School of the Art Institute of Chicago (SAIC). Her time at SAIC led her to be inspired by photography, sculpture, and video, and intrigued by the spiritual nature of Outsider art. In the early 1980s, Sandor had the vision to integrate these things with other art forms, including computer graphics, which resulted in a new medium she called PHSColograms—the photography of virtual reality (VR) and computer graphics that can be viewed reflectively or backlit as multidimensional photographs and sculptural installations.

Because PHSColograms are a collaborative endeavor, Sandor has had the good fortune to work with an incredible group of gifted artists, scientists, technologists, and thinkers. These collaborators hail from distinguished institutions and universities, including the Scripps Research Institute; NASA Ames, Langley, and Lewis Research Centers; Jet Propulsion Laboratory; Electronic Visualization Laboratory (EVL) and the National Center for Supercomputing Applications (NCSA) at the University of Illinois; and SAIC. Some acclaimed artists that Ellen and (art)n have worked with include Ed Paschke, Karl Wirsum, Roger Brown, Mr. Imagination, Robert Losutter, Christopher Landreth, Martyl, Claudia Hart, and Carla Gannis. All these collaborators have shared her enthusiasm for utilizing technology to push conceptual and technical boundaries within the arts.

Her works of (art)n are in the permanent collection of the Art Institute of Chicago, Santa Barbara Museum of Art, International Center of Photography, the University of Oklahoma, the Smithsonian Institution, and others. Commissions include those from the City of Chicago Public Art Program, the State of Illinois Art-in-Architecture Program, and SmithBucklin Corporation.

Sandor coauthored US and international patents awarded to her for the PHSCologram process. She also coauthored papers that have been published in *Computers and Graphics*, *IEEE*, and *SPIE*. She is an affiliate of eDream and a visiting scholar of culture and society, NCSA, University of Illinois at Urbana-Champaign. She is chair of the advisory board of SAIC's Gene Siskel Film Center. She is on the board of governors for SAIC, life trustee of the Art Institute of Chicago, and secretary of the board of directors, Eyebeam, New York. In 2012, she received the Thomas R. Leavens Award for Distinguished Service to the Arts through Lawyers for the Creative Arts. In 2013, she received the Gene Siskel Film Center Outstanding Leadership Award, and in 2014, SAIC awarded her an honorary doctorate of fine arts. In 2016, she was honored as Fermilab's artist in residence. In 2017, the *Bulletin of the Atomic Scientists* honored her for her longstanding commitment to integrating art and science. She is cofounder of the Richard and Ellen Sandor Family Collection.

ollaborating was always easy for me. I find being both a team member and a team leader to be very natural. I absolutely love it. I have always been a collaborator. I've never been the type of person to sit alone in a room and paint. I love working with exciting, creative people and getting to play in worlds that are completely new and different to me. I've worked with traditional artists, video artists, filmmakers, animators, mathematicians, scientists, and historians. I learn something amazing from each new group I work with. It's hard work but rewarding.

As a collaborator you can't let your team down—even if it's a first-time experiment. I believe in delivering. I believe in finishing. You just don't fail and walk away. If a piece doesn't work, you keep going until it works. I've often had to work at a fast pace, which I thoroughly enjoy. I also had to learn to keep remaking my teams. I'm relentless. I won't let it go. It's been an interesting odyssey and I feel blessed.

In 1966 my husband, Richard, and I moved to Berkeley, California, which was a happening place. I got to meet some intriguing, exciting women, and together we founded the Berkeley chapter of the National Organization for Women.

Hanging out with these pioneers helped me build my confidence for future endeavors. It was a lot of fun but we didn't realize the full extent of what was going to happen. Most of us knew that our daughters and our granddaughters would benefit from our efforts and that sons and grandsons would benefit too because there could be more equal partnerships. I just didn't realize what a revolution it would cause. The same could be said of the digital/scientific revolution.

In 1972 we moved to Chicago, which is one of the greatest cities in the world. The Midwest has a heart and soul and this was where I wanted to raise my children. It's where new beginnings are looked upon with joy. Artists can show their work on either coast but in Chicago they can truly innovate. It's a fantastic place to both make art and see it everywhere. It can be found in museums, labs, galleries, studios, film centers, theaters— even in many transcendent restaurants where the art is edible.

That year, my dream of being able to go back to graduate school came true. It was the beginning of a journey where I learned that working solo was *not* part of *my* dream. Next to my working space at SAIC was the first Video Data

California, 1966–1972, 80" × 28" × 18" mixed media sculpture by Ellen Sandor comprised of wood, hardware cloth, Portland cement and coloring, broken china and glass, polyester resin, found objects, photographs, cloth, and paper Day-Glo; Sandor pictured with her wearable artwork submissions for her SAIC graduate studies in sculpture. Courtesy of Ellen Sandor.

Bank where I found inspiration. I intuitively realized it was part of the beginning of New Media and this *was* part of my dream. I graduated with an MFA in sculpture in 1975 and started doing neon installations. I collaborated with Ace Neon and Sons to complete commissions I received from private collectors. It was the beginning of my early New Media work producing neon pieces based on Picasso's erotic drawings, later blending photographic personal statements with neon. The controversial content of the work did not stop me, and fearlessness had officially begun.

In 1981 I received a commission from a private New York collector to do a large 3D postcard about the financial markets. Of course, I had no idea how I was going to do this. I hired artists Greg Gundlach and Grayson Marshall to work on this commission with me. We used barrier screens, Cibachrome film, and dioramas using metaphors about capitalism in the United States. The same scene was photographed nine times with forty-five minutes for each exposure, moving it slightly along a horizontal track—it was all analog, a real garage-art process.

A Tribute to Modigliani, 1978 neon sculpture installation with detail. Commissions included *The Money House*, 1976, for Citizens Savings and Loan Association, San Francisco, California; and the Fiorucci boutique in Water Tower Place, Chicago, Illinois. Courtesy of Ellen Sandor.

Then in 1982 I was compelled to rebuild the garage-art camera with the help of Jerry August. I put together a small team of artists ("it takes a village") that I called (art)n Laboratory, (pronounced Art to the Nth). From conversations with Michael and Peggy Spencer, we came up with the name PHSCologram for **p**hotography, **h**olography, **s**culpture, and **c**omputer graphics. I worked with really wonderful artists I knew from SAIC, like the late, fabulous sculptor Randy Johnson, the amazing video artist Mark Resch, the exquisite fashion photographer Gina Uhlmann, and my mentor and extraordinary artist, Professor Jim Zanzi. We collaborated with the exceptional Gary Justis, who is a fantastic sculptor. We also worked with the holographers Steve Smith and Tom Sketkovich. The challenge of this installation was not only technical but also artistic. Even though it was analog, I needed people with specific skills who could thrive on my leadership style, "getting it done." I sincerely loved my creative and high-energy team, and with them *PHSCologram '83* was created [see p. 26].

For (art)n's first installation, we built huge sculptures around large PHSCologram panels.[1] They were tributes to Outsider artists Georgia O'Keeffe [see p. 5], Louise Nevelson, Man Ray, and Marcel Duchamp. When Tom DeFanti and Dan Sandin, codirectors of EVL, Phil Morton, chair of video at SAIC, and others from the digital world saw it, they recognized that this was an immersive environment (a precursor to VR). At the time, I thought I was just making exciting sculpture, but they realized this was something that could one

Ellen Sandor with the garage-art camera and stage set for real-time objects that were used as three-dimensional imagery for PHSColograms. Courtesy of Ellen Sandor, (art)n.

day become a digital, immersive environment. In November 1983, we showed *PHSCologram '83* on Wacker Drive, and Michel Ségard, one of the art critics from the *New Art Examiner*, said, "This is one of the ways the future is going to go." He wrote an extensive article called "Artists Team Up for the Future" for the *New Art Examiner*.[2] The PHSCologram years had officially begun.

In 1985, I had a gut instinct that the world was going digital, so I wanted to collaborate with some of the gurus of that world. I worked with the great pioneering artist Dan Sandin [see p. 20] and engineer extraordinaire Tom DeFanti at the Electronic Visualization Laboratory (EVL) [see p. 21], along with fashion photographer Gina Uhlmann at (art)n. We started to develop the computer-camera technique to feature

Mark Resch, Ellen Sandor, and Randy Johnson. Courtesy of Ellen Sandor, (art)n. Randy Johnson and Gina Uhlmann at the opening of *PHSCologram '83*, 311 S. Wacker Drive, Chicago, November 1983. Courtesy of Gina Uhlmann. Portrait of James Zanzi with André Kertész's fun-house mirror included in the *The Other Window: Distortion '06* PHSCologram. Courtesy of Ellen Sandor, (art)n.

Man Ray '83 detail from *PHSCologram '83* by Ellen Sandor and (art)[n]. Courtesy of Ellen Sandor, (art)[n]. The PHSCologram included a reference to Man Ray's *A l'Heure de l'Observatoire—Les Amoureux*, 1967, Man Ray, 18½" × 47" vintage hand-colored print from the Richard and Ellen Sandor Family Collection. Digital photograph by James Prinz Photography.

computer-generated imagery.[3] Dan was shooting digitally constructed models off the computer screen, so the PHSCologram content was computer generated and the process was still analog. The first successful piece created was *Ellen Test 2*. It had animation and was the first animated 3D PHSCologram created with video input.

In 1986 we were given the privilege to work with University of Illinois art professor Donna J. Cox and her team at NCSA. She had put together her first Renaissance Team of artists, scientists, and mathematicians, and had coined the term. When I first met Donna, it was really pivotal because I had never seen a woman who was so vibrant, beautiful, and intelligent. She was collaborating with everyone and doing cutting-edge work in scientific visualization. It was one of the most inspirational things I'd ever seen. The way she and her team were using computers to artistically render four-dimensional mathematical models into sculptural forms like the *Etruscan Venus* was thrilling. Gina Uhlmann worked on fashion PHSCologram at the same time that had an ethereal quality like Julia Margaret Cameron's gorgeous, haunting albumen prints I studied with Jim Zanzi in the Art Institute's archives.

Mrs. Herbert Duckworth (Julia Jackson), c. 1867 by Julia Margaret Cameron, 10⅜" × 8½" vintage albumen print from the Richard and Ellen Sandor Family Collection. Digital photograph by James Prinz Photography. Cameron was a preeminent feminist artist from the Victorian era who began creating photographic artworks in England when she was given a camera for her forty-eighth birthday. Pictured here is the mother of Virginia Woolf and her sister, Vanessa Bell. Inspired by Cameron, Sandor and Gina Uhlmann created a series of Fashion Video Portrait PHSCologram in 1986 that were shown at Feature in Chicago. Courtesy of Ellen Sandor, (art)[n].

Since then, I have met and continued to work with many amazing women. One of the most memorable women was the great scientist Dr. Muriel Ross. We worked on her scientific data for a PHSCologram, *Inner Ear-Macula*. Lucy Petrovic is an artist and curator of some of the most amazing shows I've ever seen and was a constant inspiration. I would often look at video artist and professor Barbara Sykes's early work for inspiration. She is an exquisite pioneering artist doing exceptional work even to this day. EVL's executive director Maxine Brown's work ethic and leadership abilities to galvanize, understand, and transcend scientific visualization constantly amazes me. Former EVL graduate student Mary Rasmussen was another woman whose pioneering work straddled many arenas, and her work was important yet visually stunning. Dana Plepys is a pioneer video artist and one of the most generous women with her time, who never lets you down. Her leadership and devotion to the SIGGRAPH Video Review is an important historic gem. SAIC dean and artist Tiffany Holmes continues to transcend with her ability to propel New Media Arts into established educational environments. The great artist and SAIC professor Claudia Hart and her endless energy and creativity never cease to amaze me. Carolina Cruz-Neira, cocreator of the CAVE and director of the Emerging Analytics Center, University of Arkansas at Little Rock, was another woman who blew me away. She was accomplished beyond belief, talented, brilliant, and a leader with deep artistic sensibilities yet an analytic scientific mind. I had the privilege of collaborating with her on some exhilarating projects later on in the 1990s and beyond. However, the early collaboration with Donna J. Cox was among the most influential collaborations for me at the beginning.[4]

Mathematic/scientific visualization was never on my radar screen. I thought of numbers as numbers. Never had I imagined four-dimensional mathematical equations as exquisite visualizations that transcended into exciting art pieces until Dan Sandin, Tom DeFanti, and Donna Cox started working with (art)n. I went down to the National Center for Supercomputing Applications [NCSA] in Champaign-Urbana, Illinois, to meet with Donna and her boss, Larry Smarr, the director of NCSA. Donna had the vision to add team members George Francis and Ray Idaszak, who were both NCSA scientists and mathematicians. Together we created the first *Etruscan Venus* PHSCologram [see pp. 28, 29, 30]. It became one of Donna's icons. We were visualizing the

invisible and Renaissance Teams became very chichi. I would always say, "Scientists are the rock stars of the future."

Working with the early pioneers who invented and understood the early tech is different from working with the young artists today because the tech is ubiquitous. In decades past, we all had to learn to speak each other's languages, even though we all spoke English. It was exciting at times but very challenging all around. In parallel, we were working at EVL at the University of Illinois. A young man by the name of Stephan Meyers, a genius EVL student who was still a teenager, joined the team because I saw that he worked very quickly with the computer in addition to having a deep understanding of the arts. With Dan Sandin's tutelage and my producing this next step, Stephan began writing the first PHSCologram code where everything could be computer generated. Previously all the interleaving for our 3D was done in an analog manner in the darkroom, whether I was actually moving the camera, moving the lens, moving the actual sculpture, or moving the computer screen. Eventually, the process was streamlined and we were able to do the first completely all computer-generated PHSColograms. It was published in *SPIE* and we were awarded a patent for the entire process. The cumbersome analog process was history. We were defining the new realm of digital virtual photography.

SOCIAL POLITICAL WORK IN THE 1980S

During this time, many of our friends and artists were dying of AIDS. We felt compelled to visualize our confusion and sorrow, and it seemed logical to visualize the AIDS virus and combine the sculpture with metaphorical symbols to express our feelings.[5] The data Stephan and the team were working with to build the computer-generated model was 80 percent scientifically correct, based on available drawings published in *Scientific American*. Sculptor Randy Johnson and Professor Jim Zanzi worked on PHSCologram metaphors called *Hope, Chance, and Death*. All of the pieces were assembled into a large-scale sculptural cross. Thanks to SAIC adjunct associate professor Lisa Stone, each PHSCologram of "Messiah" included the real patient's CT scan

NOVEMBER 1988

IEEE
Computer Graphics
and applications
FOR COMPUTER GRAPHICS PROFESSIONALS

GRAPHICS INTERFACE '88
Interactive Animation
Deformable Models
Input Device
Fractals

PLUS
Voxel Processing

IEEE COMPUTER SOCIETY

THE INSTITUTE OF ELECTRICAL AND
ELECTRONICS ENGINEERS, INC.

The PHSCologram imagery for *AIDS Virus, Second Edition* made the cover of *IEEE Computer Graphics and Applications* in November 1988. Used with permission.

in the background. The sculpture debuted along with the *Rhomboy Homotopy* PHSColograms (4D mathematical models), video PHSCologram portraits of my children and fashion models. All these works were included in an (art)[n] seminal show in 1987 at Fermilab. The ICI—Independent Curators Inc. based in New York—also included the sculpture in the traveling group show *From Media to Metaphor: Art about AIDS*.[6]

After the Fermilab show debut, the *Hope, Chance, and Death* sculpture traveled all over the United States and abroad with the ICI exhibition. Later on in the 1990s, the US Art in Embassy Program requested to borrow the *AIDS Virus* PHSCologram. Anne Marie Macdonald, the US ambassador to Zimbabwe, showed the *AIDS*

Virus piece in her home and at a museum festival in Zimbabwe. She wrote us, "The 'AIDS Virus' is clearly the most talked-about piece in our collection. While this country has the fourth-highest concentration of HIV infection in the world, Zimbabweans are still generally reluctant to talk about the disease. The PHSCologram offered us a chance to discuss AIDS in an informal, less-threatening way, but nonetheless, an important way. They were drawn to the technology that the piece evoked. Americans are stunned by the artistic feel, the vivid color, and the amazing shape of the disease." We learned our piece opened up discussions about ways to help people save lives. This was indeed a milestone.

In the mid- to late 1980s, one of the things I brought to the table was the ability to get mathematical and scientific visualization shown as art in major Chicago and New York galleries. For instance, Feature Gallery, directed by the late Hudson, first showed the pieces in Chicago and then in Soho, New York.[7] He was a true champion of the work. Never before had a gallery shown things like the AIDS virus or four-dimensional mathematical models. Even today, New Media Arts continue to chart new waters in the art world.[8]

The emotional, scientific, and artistic success of our work with visualizing AIDS inspired us to continue working with scientists. Some of the exceptional scientists were T. J. O'Donnell, as well as Arthur Olson and David Goodsell from the Scripps Research Institute. Like many Americans, I fantasized about exploring space and was thrilled to be able to work with Christine Gong, Lewis Schiff, Fergus Merritt, and others at NASA Ames Research Center, while the Jet Propulsion Laboratory [JPL] was another stimulating collaboration that fulfilled my space fantasy involving PHSColograms.

As more scientists were requesting their data to be made into PHSColograms, Tom DeFanti and Maxine Brown helped create a proposal for ACM SIGGRAPH to provide matching funds for over twenty new PHSColograms and a two-year traveling show called *Science in Depth*. It opened at the Museum of Science and Industry in Chicago. Then it went to the NASA Ames Visitor Center, the Computer Museum in Boston, and finally at SIGGRAPH as an installation around the VR CAVE when it premiered in Chicago in 1992. We made new pieces for each show as it traveled.

I realized that fearlessness was one of the variables that motivated my artwork during those times, so with (art)[n] I created a sculpture called

The Politics of Pleasure: A Tribute to Robert Mapplethorpe/The Nineties, which contained classical nudes models. Several members of the team, including myself, scanned our body parts using the first black-and-white CyberWare Scanner and we juxtaposed the nudes with sexually transmitted viruses. It was quite controversial and shocking. We showed it at SIGGRAPH in 1990 and Montxo Algora showed it at Art Futura '91 in Barcelona, Spain, at the suggestion of filmmaker and producer Sally Rosenthal, an extraordinary artist and pioneer, and the late, great tech guru Johnie Hugh Horn.

In the tradition of producing controversial work, in 1991, we created *The Equation of Terror* in response to the Gulf War, which included animated mathematical equations in between PHSCologrames about chemical, biological, and economic warfare juxtaposed with art historical images by Lee Miller, Edward Curtis, and others. Italian media guru Maria Grazia Mattei showed it in Lugano, Switzerland, and it was later included in the catalog for *Art in Chicago, 1945–1995* by the Museum of Contemporary Art Chicago.

During this time, video games were also infiltrating popular culture, so it was exciting to turn early video games, such as Donkey Kong and Nintendo, into PHSCologrames. Oskar Friedl went against the artistic norm of the time and turned his gallery into an arcade installation that was reviewed in the *New Art Examiner* in 1995. We were early to show games and art with social meaning.

In 1992 Janine Fron officially joined the team. She was a young woman whom I saw blossom and develop into this brilliant collaborator. Our content was already pushing the envelope, and I felt it was time to advance technically. With the help of Stephan Meyers, a new rotated computer interleaving technique was created. This improvement allowed for a smoother three-dimensional view of an art object or limited animation by including more frames, rotated at different angles so one can make a matching line screen and have more creative control of the process. We were jointly awarded a patent for it.

Words cannot describe the excitement we felt in the early 1990s when Ping Fu's team—Marc Andreessen, Eric Bina, and Colleen Bushell of NCSA—were developing the Mosaic web browser [see pp. 36, 37]. Even though we were excited, we still didn't fully understand the extent to which this revolution would change the world. At that time there was very little visual imagery on the web, but with Mosaic we now had a whole new way to conceptualize and convey our artwork to a growing international arts community. My team and I took advantage of this earth-shattering event. What a thrill to begin our online portfolio with curated exhibitions and gallery spaces, innovatively designed by Janine Fron, Stephan Meyers, and myself. We made our own (art)n galleries with original exhibitions we curated together, which could only be seen online. Nothing like it was happening at that time. There were PHSCologram images juxtaposed with art historical images, presented in themes or as artistic statements. We created one of the very first examples of virtual galleries and exhibitions on the Internet, which have now become ubiquitous. Our website also helped promote our work and led us to getting commissions as well as invitations to participate in museum exhibitions. We won awards every year until the rest of the world came online in 1995. Our website was launched early on under NCSA's Mosaic web browser and it won Cool Site of the Day. This was 1993 when hardly anyone was on the web.[9]

I was beyond inspired and moved by a documentary I saw about Steven Spielberg's Shoah Visual History Foundation. We contacted the Shoah Foundation and heard back from their creative

The Equation of Terror, 1991 by Ellen Sandor, Stephan Meyers, and James Zanzi, (art)n. Three 20" × 24" PHSCologrames and two 11" × 14" animation images: Cibrachrome, Kodalith, and Plexiglas. Photograph by James Prinz Photography. Courtesy of Ellen Sandor, (art)n.

director, Stephanie Barish, who had a drawing of the barracks from one of the survivors. We built a virtual barracks in black and white. We also made versions in color and color image-processed [see p. 41]. These pieces led to a commission from A Living Memorial to the Holocaust—Museum of Jewish Heritage (MJH) in New York City. The MJH commission was for a series of sixteen PHSColograms for the Third Floor Rotunda Gallery at the museum in Battery Park across from the Statue of Liberty on Ellis Island. We worked closely with the museum director, David Altshuler, and his team of historians to make sure the models we were sculpting were accurate with the museum's artifacts from survivors. In 1997 we completed the commission and were invited to a wonderful opening. It was a Renaissance Team with the ultimate rock star, Carolina Cruz-Neira. We also worked with Stephanie Barish of the Shoah Foundation in California, and artists Cynthia Beth Rubin in Rhode Island and Miroslaw Rogala in Chicago. I directed the team along with Stephan Meyers and Janine Fron, (art)ⁿ. Carolina led and worked brilliantly with a team of six students from Iowa State University, who collaborated daily with us, via the Internet, on the modeling and rendering for many of the pieces, while Cynthia worked on some of the collage elements. Stephanie and her team at Shoah worked with us in the beginning on some of the storyboards [see p. 244]. The original barracks image continued to resonate with me, and I

was inspired to do a deconstructed barracks piece with current (art)ⁿ members SAIC graduate Diana Torres and renaissance artist Chris Kemp, which we showed at Art Basel Miami 2011. It is now in a private collection.

The Holocaust theme continued to haunt me. Current visual effects supervisor at Weta Digital and BAFTA [British Academy in Film and Television Arts] nominee Keith Miller was an EVL graduate student working with (art)ⁿ at the time. Keith was about to graduate and wanted to do something special for his MFA thesis. I asked Keith to write to the museum at Auschwitz-Birkenau and try to get the plans of the concentration camp, never expecting them to comply. Sure enough, we obtained the plans to do an actual virtual reality piece about the camp. This was not just a PHSCologram but also a real-time, interactive virtual reality experience. Keith, along with EVL graduate students Jeffrey Baum and Todd Margolis, and later SAIC professor Ben Chang, developed *Special Treatment*. We showed it first at (art)ⁿ's studio for Keith and Jeffrey's MFA project. We recreated the whole thing to show it again at Art Basel Miami in 2011 and ICIDS [International Conference on Interactive Digital Storytelling] 2014 at the ArtScience Museum in Singapore.

I've always felt incredibly grateful to the heroes both living and passed of World War II. My team and I were commissioned by the City of Chicago, Public Art Program, and Department of

Early screenshots from the second edition of (art)ⁿ's award-winning website under the Netscape browser while at Northwestern University's BIRL Research Park in Evanston, Illinois, circa early 1995. The first edition of the (art)ⁿ website was released in 1993 under NCSA's Mosaic web browser. Courtesy of Ellen Sandor, (art)ⁿ.

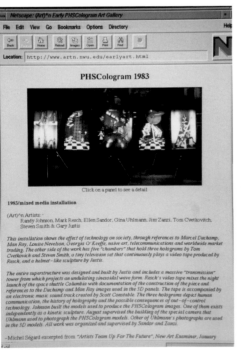

Aviation to create a memorial for the new Midway Airport. In 2001, we completed and installed the *Battle of Midway Memorial*. We worked with the veterans from the Battle of Midway [BOM] roundtable hosted by veteran Bill Price. Janine Fron did all of the historical research, including finding photographs from archives we could use in the piece, and connected with BOM veterans. The extraordinarily talented artist Fernando Orellana worked with T. J. McLeish, along with artists Pete Latrofa, Mike Kosmatka, and Nichole Maury, on the PHSCologram photomurals. It is the first sculptural monument honoring the Battle of Midway participants and includes aluminum etchings, photographs, and quotes. The unveiling of the *Battle of Midway Memorial* was hosted by Mayor Richard M. Daley and the City of Chicago. The US Navy came and the veterans were honored. I invited all of the Midway veterans to my house afterwards. I really fêted them and we had a wonderful time. The memorial still stands today. The Battle of Midway was a real turning point in World War II that secured our freedom for the United States and the world. The encryption intelligence and code-breaking efforts that were led by Agnes Driscoll and Lieutenant Joseph J. Rochefort were critical to winning the historic battle that occurred on June 4, 1942.[10]

The *Battle of Midway Memorial* has personal meaning for me. During the summer of 2012, in honor of the battle's seventieth anniversary that coincided with my seventieth birthday, something

unexpected happened that brought me to tears. Understand that if I had been born in Europe in 1942, my life would have indeed been different. The fact that I was born and live in America with the people who fought so hard to make Americans free has been something I feel deeply about. One of the BOM veterans, Ed Fox, is one of the few surviving veterans of that major turning point of World War II. His picture is included in one of the photo banners and one of the PHSColograms in our memorial at Midway Airport. He called the US Navy and stated he'd like to give me something special in appreciation for making the *Battle of Midway Memorial*. The navy then flew Ed out to Midway Island (which is now a nature sanctuary) and had him raise the flag in my honor before bringing it to me. He said, "The real heroes are the ones that never came back." The event was a reminder to me that art inspires and art can have a real impact.

An artist who had a real impact on me was the late Martyl. She was a dear friend of mine who was ageless. In 2002, I wanted to do a PHSColo-gram with her about the famous Doomsday Clock that she designed for the *Bulletin of the Atomic Scientists*. We juxtaposed one of her painted landscapes with the clock and called it *Have a Nice Day*. Many people know about the cultural and social significance of the Doomsday Clock, which was recently moved "three minutes to midnight" because of the state of the world and the environment [see p. 124].

VISUALIZING THE INVISIBLE: MEDICAL IMAGING

Even though I was very passionate about using PHSColograms to express social and political issues, I loved working with scientists and medical researchers. We moved to our new space in the early 1990s at the research park headquarters at Northwestern University [BIRL]. There we made our first medical PHSColograms with Ken Freeman and his team at Picker International in 1994.[11] They were CT scans of the human brain of a patient with an aneurysm. We showed them at SIGGRAPH in Orlando. I loved working with Ken and his team at Picker International. We did many research pieces together and later an installation for the National Institutes of Health, "Heart, Lung and Blood"—all real-patient data made into PHSColograms. This led to our joint development of epiView in 1996 for creating PHSColograms in hospitals as a surgical tool for physicians. It was way ahead of its time and showed how art can literally save lives. At the same time, we received a commission from JPL to create an installation for their Cal-Tech headquarters. We included an EVL student on our team, Joseph Alexander, who helped create animated graphics for the PHSCologram diptych.

The first experimental medical imaging PHSColograms produced in collaboration with Ken Freeman, Picker International, who began to work closely with Sandor and her team in 1994 to develop the epiView licensed application for use in hospitals. Here is a series of successful test images from CT and MRI images of the skull and brain.

In keeping with the theme of scientific visualization, (art)[n] also finished a commission for the Smithsonian Institution. The installation for the Smithsonian was a twenty-panel mosaic of PHSColograms that we reconstructed into a dramatic view of the salt crystal, NaCl. We had never done this before and had to innovate. Terry Healy from Douglas Gallagher worked with us on the MJH series. He helped us get the Smithsonian commission for the new wing. The piece is still there today, a scientific, digital, immersive environment near the Hope diamond in the Janet Annenberg Hooker Hall of Geology, Gems, and Minerals.

Upon discovering (art)[n]'s online portfolio of scientific visualization PHSColograms, a private collector and a scientist were doing research together. We were then commissioned to work with Dr. Sam Gambhir and his team at UCLA on PET [positron emission tomography] study data to be made into an original PHSCologram. We worked with Robert Grzeszczuk and his team at the University of Chicago to render the PET files in 3D for our software. We were literally reinventing the wheel by reconstructing the real patient's PET data into a three-dimensional, virtual sculpture that was scientifically correct and artistic. The pose of the patient reminded us all of Rodin's *Thinker*, and so we *called it PET Study: Reconstructing Rodin*. This was commissioned by Camera Works for the Santa Barbara Museum of Art's *Out of Science Imaging, Imaging Science* curated by the late Karen Sinsheimer in 1998.[12] In an interview with the Center for Photographic Art, she explained she "was looking at scientific photographs and work by artists who understood science" (Kasson 2007). That was the first contemporary art exhibition of art and science since the museum's historic collaboration in 1967 with John Szarkowski at the Museum of Modern Art. The piece made the cover of Hank Whittemore's book *Your Future Self*, which had some of Arthur Olsen and David Goodsell's important viral research in it.

As (art)[n] continued to create, there were more exhibitions. In 2003, International Center for Photography [ICP] curator Carol Squires curated *How Human: Life in the Post-Genome Era* at the International Center of Photography and featured two new PET study PHSColograms. At the same time, Karen Sinsheimer included our *Cryptobiology: Reconstructing Identity* in *PhotoGENEsis: Opus 2: Artists' Response to the Genetic Information Age* "that looked at the age of genetics and

(art)ⁿ's *PET Study: Reconstructing Rodin, 1998*, made the cover of Hank Whittemore's scientific book, *Your Future Self*. Courtesy of Ellen Sandor, (art)ⁿ. *Rodin, le Penseur*, 1902, Edward Steichen, 10⅝" × 13¼" vintage gelatin silver print from the Richard and Ellen Sandor Family Collection. Digital photograph by James Prinz Photography.

PET Study II/Man Ray/Picabia Imitating Balzac, 2003, made the cover of *Issues in Science and Technology* with a short article about the PHSCologram that is now part of the permanent collection of the National Academy of Sciences in Washington, D.C. The original *Francis Picabia Imitating Rodin's Statue of Balzac*, 1923 by Man Ray, 9½" × 7¹/₁₆" vintage gelatin silver print from the Richard and Ellen Sandor Family Collection. Digital photograph by James Prinz Photography.

how artists were looking at and thinking about the issues raised by this new work" (Kasson 2007). Karen also included the first *PET Study* in a *Decade of Collecting* at the Santa Barbara Museum of Art. Carol Squires also curated *The Art of Science* in 2004 and included our work.[13] That's when science and art were beginning to get accepted within the established art world.

A scientific sculptural installation we worked on that had interactive music was called *Telomeres Project on Imminent Immortality* and debuted at SIGGRAPH 2001 in Los Angeles. In 2009, Elizabeth Blackburn, Carol Greider, and Jack Szostak actually shared a Nobel Prize for their discovery of telomerase enzyme. When we showed the sculpture in 2001, very few people had ever heard about it. We worked with experimental scientists in our area, including Barry Flanary, who believed in this research. The *Telomeres* sculpture was also included in *Genomic Issues(s): Art and Science* at the Graduate Center Art Gallery at NYU during the fiftieth anniversary of the discovery of DNA.

Another scientific visualization PHSColo-gram that took on personal meaning was "Brain + Love," which showed Raun Kaufman's fully recovered brain from autism. Currently Raun is a CEO for the Son-Rise program at the Autism Treatment Center of America. We worked with Kaufman along with the director of the Neuro-linguistic Research Laboratory at Northwestern University, Dr. Cynthia Thompson, and her colleagues to create two PHSColograms. We were able to work with Kaufman's brain scans, derived from functional MRI data conducted in Thompson's research laboratory.

More recent scientific visualization images were transformed into sculptures called *Magnificent Micelle*, done at the (art)n lab on Washington Blvd. in Chicago, with scientist Matthew Tirrell from the University of Chicago, as well as the award-winning *Rough Waters* with Seth Darling from Argonne along with Steven Sibener and Carl Eisendrath at the University of Chicago. The incredible renaissance artist Chris Kemp joined the (art)n team in 2006. Among his many talents, he is a painter and a photographer. Talented computer-graphics artist, 3D animator, and SAIC alum Diana Torres also works with us; it is exhilarating to have a young woman on the team who can do 3D modeling on such a high level. She is amazing.

CHICAGO IMAGISTS AND DECONSTRUCTING ARCHITECTURE

Along with scientific visualization, I had been dying to work with the Chicago Imagists because I knew it would be lots of fun to make something exciting with them. The late Ed Paschke, a Northwestern University professor and Chicago Imagist art star, came into our little BIRL space.[14] Stephan found a wireframe sculpture of a man's head from View-Point and we all said in unison, "Oh it's Duchampian!" and Ed was all excited and started painting a tattoo for the head on a digital tablet. I said, "Look, Ed, we own the 'Fumar' painting. Let's do something that is topical. We don't want to smoke and die. We want to live forever." He laughed and said, "Okay, wonderful." So we did *No Fumare por Favore* with *Fumar* in his memory. That piece became a PHSCologram icon. After finishing *No Fumare por Favore*, the US Art in Embassies Program requested a loan for the US ambassador in Bonn, Germany. The High Museum of Art included it in *Chorus of Light*, since it was also in Elton John's collection. The second piece we collaborated on together was called *Primondo, 1997*, and is in the permanent collection of the Union League Club of Chicago.

(art)n collaborated on many pieces with Paschke, which were shown throughout the United States and Europe, including in Paris at the Darthea Speyer Gallery and in Germany at the DAM. Gallerists Maya Polsky and Eva Belavsky from the Maya Polsky Gallery in Chicago represented our work with Ed until their closing in 2016. They immediately understood the importance of our collaboration. They worked very hard for the pieces to be included in exhibitions, museums, and private art collections. Along with Paschke, we also had the privilege of working with other great Chicago Imagists such as Karl Wirsum, Robert Lostutter, the late Mr. Imagination, and the late great Roger Brown. Christopher Landreth, who was a student of Donna Cox, collaborated with (art)n on many PHSColograms that have become icons. His talent and expertise go unchallenged even today [see pp. 126–29]. I also enjoyed working with Terry Dixon, an SAIC alum who created an early hip-hop video about (art)n at IIT [Illinois Institute of Technology]. Dixon has lectured about his mixed

Fumar, 1979, by Ed Paschke, 60" × 46" oil on canvas, from the Richard and Ellen Sandor Family Collection. Digital photograph by James Prinz Photography. *No Fumare por Favore*, 1997, by Ed Paschke; Ellen Sandor, Stephan Meyers, and Janine Fron, (art)ⁿ.; 20" × 24" PHSCologram: Duratrans, Kodalith, and Plexiglas. Ed Paschke and Ellen Sandor at Galerie Darthea Speyer, Paris, September 1998. *Primondo*, 1997, by Ed Paschke; Ellen Sandor, Stephan Meyers, and Janine Fron, (art)ⁿ.; 20" × 24" PHSCologram: Duratrans, Kodalith, and Plexiglas. Courtesy of Ellen Sandor, (art)ⁿ.

Mies-en-scène: The Farnsworth House, 2009, Ellen Sandor, Chris Kemp, Chris Day, and Ben Carney, (art)n; 40" × 24" PHSCologram: Duratrans, Kodalith, and Plexiglas. *Perfect Prisms: Crystal Chapel*, 2009, was commissioned by the Fred Jones Jr. Museum of Art, University of Oklahoma, and was featured on the 2010 exhibition catalog for *Bruce Goff: A Creative Mind*. Installation detail from *Arts for a Better World* featured at Art Basel, Miami Beach, 2011. Courtesy of Ellen Sandor, (art)n.

Opening reception for *Deconstruction in the Virtual World: Building Peace by Piece* at the National Arts Club in New York, November 2015. Photos by Sandrine Kukurudz. Courtesy of Ellen Sandor, (art)n.

media artworks at the US consulate in Guangzhou, representing contemporary African American artists abroad in China.

One of my passions has always been architecture. I was inspired by Louis Sullivan to create the *Chaos* sculpture with Jim Zanzi and the late photographer Ron Nielson. We juxtaposed Sullivan images that we had photographed in real 3D with mathematical/fractal visualizations. The piece was shown at the Bronx Museum [see p. 126]. My husband is the architect of many financial futures and environmental markets, so it made sense to start my architectural series of PHSColograms with the interior of the first French commodity exchange, the MATIF, in '94. In 2000, a PHSCologram of the MATIF Stock Exchange was included in *Paris in 3D from Stereography to Virtual Reality, 1850 to 2000* at the Museum of Carnavalet in Paris. It was an impressive historical show with a huge, exciting catalog. We were also able to have our own show in Berlin called *Pixels in Perspective* in 2004 at the Digital Art Museum [DAM].

In a September 2, 2015, press release, Georgia Schwender, curator, Fermilab Art Gallery, explained, "Your work and vision for what you could do as an artist in residence at Fermilab resonated with all of us." Diana Torres, Ellen Sandor, and Chris Kemp at Fermilab, Batavia, Illinois. Photo by Georgia Schwender. Diana Torres, Chris Kemp, Jennifer Raaf, Bonnie Flemming, Ellen Sandor, Sam Zeller, and Thomas Junk at Fermilab, Batavia, Illinois. *Neutrinos and NOvA: A Vasarely Variation, 2016*, installation details from Fermilab exhibition. Courtesy of Ellen Sandor, (art)ⁿ.

Featured in the *New York Times*: Portrait of Ellen Sandor (looking like the Gerhard Richter oil painting *Woman Descending the Staircase*, 1965, in the background) at the opening of the Modern Wing, Art Institute of Chicago, 2009, Michelle Litvin, 17" × 22" digital C-Print from the Richard and Ellen Sandor Family Collection. In May 2014, Sandor received an honorary PhD from SAIC for pioneering the future of photography and the invention of PHSColograms. Photograph by Erika Lowe. Reese Witherspoon, Sandor, and Walter Massey at the 2016 Gene Siskel Film Center Renaissance Award ceremony in honor of Witherspoon's career. Photo by Robert F. Carl. Courtesy of the Gene Siskel Film Center, SAIC.

Wolf Lieser showed our work early at the Berlin gallery, which he opened in 2003. Wolf included (art)ⁿ's European PHSCologram collaborations with Phillipe Paul Froesch, Gero Gries, Gerhard Mantz, and Miroslaw Rogala—featuring virtual portraits, virtual architecture/objets d'art, and the black-and-white image-processed barracks we produced with Stephanie Barish and the Shoah Foundation [see p. 41]. In the exhibition catalog, Oskar Friedl wrote:

> Public perception of digital media arts has made an incredible leap in an unbelievably short period of time, and so did I. It was (art)ⁿ that opened that window for me, giving me my first glimpse of the digital future. It was almost ten years ago that a European traveling exhibition entitled "Photography after Photography" shook the very foundation of this young art form, proving rather conclusively that traditional photography is a transitional medium giving way to a new era—the digital age. No one else has read the signs that announced that change earlier and influenced its development more than (art)ⁿ.

To continue with my passion for architecture, I had the privilege of collaborating with extremely talented T. J. McLeish on *Townhouse Revisited*.[15] To this day, I am still inspired to reconstruct and deconstruct architectural icons by Mies van der Rohe, Frank Lloyd Wright, Bruce Goff, and Antonio Gaudí, among others.

I was so inspired by the VR Singapore show that I turned many of our architecture pieces into Oculus VR experiences and hope to work with other themes. During November 2015, a transitional installation of only PHSCologram sculptures [not framed, wall-mounted pieces] and Oculus Rift 2 stations were included in an exhibition, *Deconstruction in the Virtual World: Building Peace by Piece* at the National Arts Club in New York. This work shows a trajectory of PHSCologramms inspiring VR and was reviewed by Paula DiPerna in the *Huffington Post*, US edition.[16] During February 2016, the *Starchitects Revisited* VR experience and related PHSCologramms were included in *Women's Empowerment* at the KateShin Gallery and Waterfall Mansion in New York City.

My Fermilab 2016 residency included PHSCologram sculptures, VR, projection mapping, and 3D printing that visualize the invisible. The Fermi scientists' research included their NOvA, MINOS, and MINERvA neutrino detectors plus their new MicroBooNE argon chamber detector. We have been working with Fermilab scientists from various departments, translating their data and research on neutrinos into beautiful works of art

William J. Perry, former Secretary of Defense, delivered opening remarks for the Bulletin of the Atomic Scientists' 2017 Annual Dinner and Meeting at the University Club of Chicago, honoring Ellen Sandor. Photo by Melissa Sage Fadim. Used with permission.

and science.[17] Neutrinos are strange elementary particles produced by the decay of radioactive elements that travel near the speed of light and rarely interact with matter and other particles. Such properties make these particles mysterious and exciting subject matter for researchers and artists. It is (art)ⁿ's role to take such intricacies and put them into visual art that speaks to scientists and artists, while connecting with the society in which we all live. The final works were first shown at the Fermilab Art Gallery in Batavia for *Neutrinos in a New Light*, December 2016–March 2017 [see p. 129].

After my Fermilab residency, I was inspired by my grandson to research and artistically explore the CRISPR-Cas9 genome. (art)ⁿ and I collaborated with Jennifer Doudna, The Doudna Lab: RNA Biology, and Megan Hochstrasser, Innovative Genomics Institute at UC Berkeley, on a PHSCologram sculpture we called *CRISPR-Cas9: A Ray of Light*. The dramatic three-panel sculpture supported by a twisting double-helix base reveals different stages of the CRISPR-Cas9 genome, which may help prevent and treat complex diseases including autism, heart disease, cystic fibrosis, cancer, and HIV. The PHSCologram sculpture is installed at the Innovative Genomics Institute, Energy Biosciences Building, University of California–Berkeley [see pp. 43 and 126].

While working on CRISPR, I was very touched that after seeing *Neutrinos in a New Light* show, the Bulletin of the Atomic Scientists wanted to honor me at their annual dinner along with William J. Perry, former Secretary of State. For the event, I wanted to create an homage to Martyl with a PHSCologram sculpture featuring panels from a VR tour that encapsulated the movement of the Doomsday Clock from its inception to the present day [see pp. 122 and 142–43]. Viewers can explore the clock's timeline, which was narrated by Rachel Bronson. Both the VR and PHSCologram sculpture were called *Have a Nice Day II*, in memory of Martyl, and feature many of her painted landscapes that we scanned from catalogs she gave us for the book. Also represented are historic works from the public domain and the Sandor Family Collection that help illuminate the history of the Doomsday Clock from the 1940s to 2017. The event was covered by the *New Art Examiner*.

In the end, my family was part of the gestalt that made my art possible. My husband, Richard, encouraged me to go back to school and get my MFA from SAIC. He also supported my artistic endeavors. One of the most enduring, important, and possibly inspiring aspects of our partnership was the origin and continuing development of our art collection. It is a mutual obsession that continues to enlighten. Another aspect of this partnership is sharing the collection with others. My fabulous daughters, Dr. Julie Sandor and Penya Sandor, and their wonderful husbands, Jack Ludden and Eric Taub, plus my brilliant, empathetic brother, Dr. Jeff Simon, have always been an inspiration and support system for my work. No wonder their four children—my grandchildren, Caleb and Oscar Sandor Taub, Eli and Justine Sandor Ludden—do the same. I've been blessed

to experience it all. So as the late great Gene Siskel used to ask his interviewees, "What do I know for sure?" What I know for sure is: Art saves. Tough art really saves. Cooperation and collaboration rock even more than competition. Partnerships within relationships are mutually inspiring. Family makes it all worthwhile.

Special thanks to (art)ⁿ members since 1983:

Craig Ahmer, Ben Carney, Michael Cone, Chris Day, Miguel Delgado, Janine Fron, Nick Gaul, Azadeh Gholizadeh, Randy Johnson, Gary Justis, Christopher Kemp, Pete Latrofa, Jack Ludden, Todd Margolis, Nichole Maury, T. J. McLeish, Thomas Meeker, Stephan Meyers, Keith Miller, Fernando Orellana, Sabrina Raaf, Mark Resch, Dan Sandin, Mike Siegel, Diana Torres, Dien Truong, Gina Uhlmann, and James Zanzi.

Special thanks to all of our major collaborators:

Stephanie Barish, Bill Cunnally, BINO and COOL, Roger Brown, Steve Boyer, Donna J. Cox, Carolina Cruz-Neira, Charles Csuri, Tom DeFanti, Margaret Dolinsky, Michael Dunbar, Andre Ferella, Barry Flanary, George Francis, Phillipe Paul Froesch, Carla Gannis, David Goodsell, Gero Gries, Claudia Hart, Martyl, Mr. Imagination, Raun Kaufman, Chris Landreth, Robert Lostutter, Gerhard Mantz, Feng Mengbo, Ron Nielsen, T. J. O'Donnell, Arthur Olson, Ed Paschke, Robert Patterson, Dana Plepys, Maggie Rawlings, Miroslaw Rogala, Cynthia Beth Rubin, Dan Sandin, Paul Sickenger, Larry Smarr, Lisa Stone, Cynthia Thompson, Margaret Watson, Karl Wirsum, and Zhou Brothers.

Very special thanks to all of our multitalented technical collaborators and postproduction support:

William T. Cunnally, Kenny Elliott, Arthur Kerbs, Ron Neilsen, Bill Sickenger, Paul Sickenger, Debbie Nakawatasse, Robert Mitz, Brian Mustanski, Leavett Wofford, and James Adler.

|||

Notes

1. Inspired by the process-oriented works of Man Ray, Marcel Duchamp, and László Moholy-Nagy, the early process for creating PHSColograms combined sculpture with photography, resulting in a three-dimensional photograph, viewed with rear lighting. The (art)ⁿ group Sandor formed with her peers from the School of the Art Institute of Chicago (SAIC) in 1983 created large-scale sculptures and collaged backgrounds that were photographed nine times at slightly different positions in a horizontal movement with a room-sized camera. These images took thirty minutes for each exposure, which were combined with a special

darkroom technique to one piece of transparent, color film. A second piece of black-and-white film displaying clear vertical lines was mounted to a piece of Plexiglas with the blurred, combined image mounted to the reverse. The linescreen functioned as a viewing screen to interpret the transparent photograph as a three-dimensional sculpture.

2. In his *New Art Examiner* article, Ségard said of *PHSCologram '83*, "The message is not in the subject, but in the structure. In this work the message is that technology will not only influence the materials or medium of a work of art, but it will also affect the

works' role in society." The *New Art Examiner* debuted in 1973 and was founded by former *Chicago Tribune* art critics Derek Guthrie and Jane Addams Allen, the great-grandniece of Jane Addams.

3. Instead of building physical models that were photographed incrementally along a horizontal path with a room-sized camera, computer-generated images were captured in a horizontal sequence on a computer monitor with a video camera and were then combined in the darkroom, exposed to transparent film, including Eastman Kodak's fast film, developed and laminated to ¼" Plexiglas with a matching linescreen on the reverse. The linescreen or barrier screen enables viewers to interpret the combined image multidimensionally without glasses, and sometimes with limited animation.

4. Sandor has produced numerous PHSCologram artworks that promote the awareness of women's health issues, including breast, ovarian, and cervical cancers. As part of the first *Rhomboy Homotopy* PHSCologram, she collaborated with Donna J. Cox on *Sadie Elmo* (1988) that featured mammography scans. In Judy Malloy's *Women, Art, and Technology*, Cox explained, "At (art)n, artistic collaboration is the primary mode of working and provides collective synergism for invention. Ellen Sandor acts as creative producer and director and organizes, coordinates, and participates with her creative team. (art)n collaborations are some of the most important in the contemporary art world. Such interdisciplinary collaboration potentiates important educational directions."

5. Sandor and (art)n reconstructed the AIDS virus based on available scientific data in 1987 that was featured on the cover of *IEEE Computer Graphics and Applications* in November 1988 and *Computer Graphics World* in February 1991.

6. The *From Media to Metaphor: Art about AIDS* traveling exhibition was organized and circulated by Independent Curators Incorporated, New York, New York, made possible, in part, by a grant from the National Endowment for the Arts and contributions from the ICI Exhibition Patrons Circle: Grey Art Gallery and Study Center, New York University, New York, January 19–March 5, 1994; Santa Barbara Contemporary Arts Forum, Santa Barbara, California, November 6–December 23, 1993; Fine Art Gallery, Indiana University, Bloomington, September 3–October 23, 1993; McKissick Museum, University of South Carolina, Columbia, May 15–July 15, 1993; Bass Museum of Art, Miami Beach, Florida, February 12–April 4, 1993; Musée d'Art Contemporian de Montréal, Montréal, Québec, Canada, November 5, 1992–January 3, 1993; Sharadin Art Gallery, Kutztown University, Kutztown, Pennsylvania, September 8–October 6, 1992; Center on Contemporary Art, Seattle, Washington, June 19–August 1, 1992; Emerson Gallery, Hamilton College, Clinton, New York, January 20–March 15, 1992.

7. In a 2014 memoriam published in *Art in America*, Sarah Schmerler described Hudson as "the one-named art dealer whose New York gallery Feature Inc. redefined the role of the dealer and set new standards of innovation and experimentation in the display of contemporary art." "It is the responsibility of the galleries to challenge and broaden the market, not to acquiesce to it," Hudson said in an interview with the artist Dike Blair in 2004 (Schmerler 2014).

8. By 1990, PHSCologram became a digital photographic process by simulating the early darkroom technique with other features common to the computer graphics industry. PHSCologram imagery is constructed from sculpting objects with a computer graphics software application. These objects are painted and placed in a scene with lighting and other special effects. Once the digital scene is complete, a series of as many as sixty-five images are photographed in (art)n's proprietary art program, and the photographs are rotated on the output device to use its resolution in both directions simultaneously for smoother animation or an increased multidimensional visual effect. These snapshots are captured at slightly different positions across a horizontal plane and combined on the computer for final output to transparent film. (art)n's program also generates a matching linescreen to interpret the final mounted photograph as a three-dimensional sculpture. This process of photographing computer-combined images on the computer that are visible with special viewing apparatus is a patented process, invented and owned by Ellen Sandor and her colleagues. PHSCologram is a trademark of (art)n, US Patent Numbers: 5,113,213, RE: 35, 029, and 5, 519, 794. (art)n has worked with archival materials produced by Ilford and Kodak, and has experimented with various darkroom techniques, prepress, and high-resolution devices, including the Crosfield, LVT, Iris, Epson, Lamda, Hewlett-Packard, Lightjet, and others. (art)n has worked with the highest quality photo labs in Chicago, the Midwest, and California. (art)n has used various professional computer graphics software packages, including Maya, Alias, and SoftImage, in addition to Photoshop, Fractal Design Painter, and others. (art)n first used the CyberWare scanner in 1990. Prior to 1992, early digital content was programmed in C and other languages.

9. By special request circa the mid-1990s, Jenny Holzer's "Truism" web-based artwork that was hosted by Ada Web and the Walker Art Center was linked on (art)n's popular website. In a 1992 interview with Janine Cirincione for the exhibition catalog *Through the Looking Glass: Artists' First Encounters with Virtual Reality*, Holzer said, "Like any other new medium, printing, photography, video or whatever, VR is potentially important and it becomes everyone's responsibility to imagine what it can do, and then make it something miraculous."

10. In our research efforts with the help of the Battle of Midway roundtable, we learned that Agnes Driscoll was considered the "Mother of Cryptology" and in World War II, she led the code-breaking efforts that cracked JN-25, the Japanese operations code cipher that helped the United States to win the pivotal battle. According to Lieutenant Susan M. Lujan, USNR, "Mrs. Agnes May (Meyer) Driscoll served 41 years of devoted government service from 1918 to 1959 in the field of cryptology. She was often the first in a group of skilled analysts to break new systems and codes considered milestones in the history of the field, including solutions to the Hebern cipher machine, the Japanese Orange Grand Naval Maneuvers cipher, the Japanese 'Red Book' and 'Blue Book' super enciphments, and more. Due to the sensitive nature of her work, Mrs. Driscoll led a private lifestyle characterized by anonymity" (Lujan 1987). In 2017, (art)n's *Battle of Midway*

crafting at a very young age. By the 1970s, I was showing drawings in an art gallery at the Public Market in Seattle, but I didn't start a formal art education until my latter twenties, after I was married and had my daughter, Elizabeth. She often became the subject matter of drawings, art photography, and eventually digital imagery [see p. 130]. She loved to pose for photos and participate in the making of art. We lived in Denver and Seattle, and eventually returned to midwestern Madison, where I finished undergraduate and graduate degrees at the University of Wisconsin in 1985. We engaged with cooperatives across the country as we followed academic goals.[1] A mature point of view informed this "returning woman" education.

While studying art and science at Madison, Pat Hanrahan, a graduate student, introduced me to emerging raster computer graphics. Until that time, I had been studying color perception in painting. He provided access to the only color computer display on campus. The experience was transformative. Suddenly, I realized that I could digitally control millions of colors using a computer if I learned how to program software. I envisioned the future and it was digital graphics. Pat encouraged me to go to the SIGGRAPH conference. Before Pat left the university to research computer graphics at New York Institute of Technology, he gave me his software code. I studied it, took computer classes, and learned how to create computer graphics for the first raster computer art and digital vector animations at the University of Wisconsin.

The computer was my primary tool for graduate school; it was a lonely affair, although the act of programming was an expressive activity.[2] I created algorithmic art and synthesized digital images by using Xerox photographic printing on paper and cloth. Before the advent of digital scanners and printers, I captured computer images by setting up an analog camera on a tripod in front of the computer screen. My algorithm partitioned a single computer image into sections and then each was enlarged into a single screen for capturing on film. Then I printed each section in the darkroom and reconstructed the entire

computer screen into a large computer collage called "compulage."

During my final year, I met Professor Dan Sandin when he presented a visiting lecture. He visited the computer lab where I was developing the Interactive Computer Assisted RGB Editor [ICARE], a software program to generate color in digital images and to collaborate with remote sensing scientists.[3] It provided color mapping in tandem with other image-making software that I was developing. This was a time before the invention of Photoshop so most artists had to program the computer. ICARE mapped colors into arrays of numbers that filled the pixels of the computer images. This was part of my MFA research. Dan was impressed and said that ICARE was a digital version of his analog color synthesizer, the Sandin Image Processor [IP]. Later that year, Dan introduced me to Tom DeFanti and the folks at the

Electronic Visualization Lab [EVL]. They seemed like a happy tribe, and I was a ready to join the computer art fun. I met interesting women at EVL, including Sally Rosenthal and Dana Plepys. Chicago was an attractor and I longed for more social interaction around image making. A few years later I reprogrammed ICARE to be an interactive computer art installation called *Pseudo Color Maker*. It was part of the Chicago Museum of Science and Industry's 1986 *The Interactive Image* show, curated and led by EVL colleagues.

During graduate school, a vision emerged that art and science would converge through computer graphics technology and interdisciplinary teams. Inspired by Renaissance artists who worked with scientists to create the foundations of botany and anatomy, I coined the term "Renaissance Teams" during the summer before moving to the University of Illinois as an assistant professor.[4]

Donna J. Cox art installation exhibiting some of the first digital art and animations developed at University of Wisconsin, May 1985.

Left: *Metamorphosis*, Cox, 24" × 18" Cibachrome original, 1983. Right: Cox presenting the *Metamorphosis Compulage* at the Milwaukee Art Museum, 1984. Cox digitally separated the original computer image *Metamorphosis* into sections, photographically printed each section, and reassembled the pieces into a collaged construction 6' × 5' called a compulage.

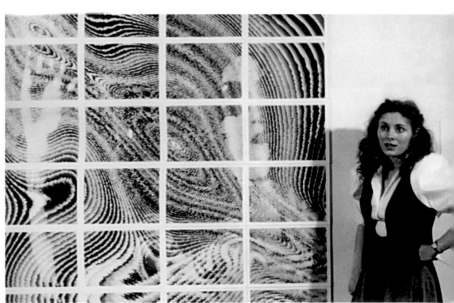

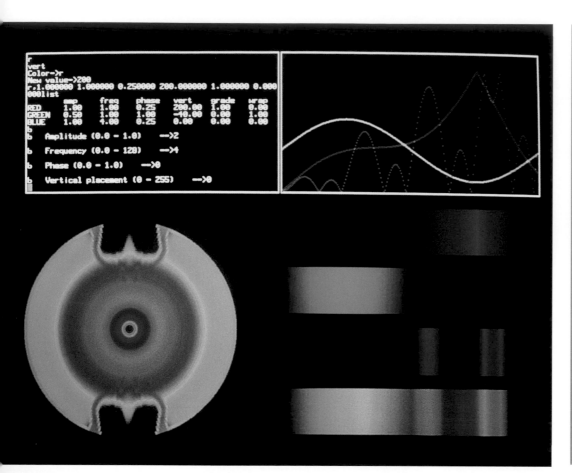

Top left: The 1982 screen of *Interactive Computer Assisted RGB Editor* (ICARE) written by Donna J. Cox to map color into digital imagery. This software functioned for both artistic and scientific color-transfer functions. Top right: Cover of "Programming the User Interface" with ICARE cover image to demonstrate novel interface design. Judith Brown, coauthor, was an important leader in computer graphics education at SIGGRAPH. Courtesy of Donna J. Cox. Bottom left: ICARE served as the basis for the *Pseudo Color Maker*, an artistic learning game installation in the 1987 Chicago Museum of Science and Industry *The Interactive Image*. The player interactively created and controlled red, green, and blue image color maps using a joystick. Bottom right: Second game level showing options to play game and learn more about the color editing.

I officially joined the School of Art and Design at the University of Illinois at Urbana-Champaign (UIUC) in August 1985. Before I left Wisconsin, my MFA advisor, Professor Cavalliere Ketchum, highlighted a new supercomputing center in Urbana and recommended that I look up the director by the name of "Larry Star" who was leading the effort. Ketchum's misnomer fit the persona of Larry Smarr, the founding director of the National Center for Supercomputing Applications (NCSA) in 1985. Smarr invited me to show some of my compulages at one of the opening events, where I met many scientists—including astrophysicist Michael Norman, with whom I have collaborated for over thirty years [see p. 27].

Motivated by the opportunity in a follow-up meeting, I presented collaborative ideas on a dot-matrix-printed paper. The concept paper included the history of art and technology while arguing for the value of visually literate artists at the center. The paper included the concept of Renaissance Teams, interdisciplinary groups of experts, and was the foundation for an award-winning *Leonardo* journal article. I longed to make the invisible natural processes visible and insightful. Lynn Margulis, a nonconformist evolutionist, further influenced my thoughts on collaboration in "Microcosmos": the whole birth of cellular life evolved from cooperation, not competition. Cooperation is a philosophy that has informed my participation in food, housing, and babysitting cooperatives since my youth. I was ready to form Renaissance Teams to do research, and fortunately Larry Smarr was receptive. Our initial meeting had a long-term influence on Smarr and helped shape the NCSA as an interdisciplinary center.

My former graduate advisor warned me to be prepared to continuously justify the use of the computer to make art. In its infancy, any medium is suspect by traditionalists. For example, photography artists were scoffed at in the genre's infancy. So working with a computer was also suspect for any artist in the 1980s. The medium seemed to be the message at most exhibits. To strain traditions further, my personal enthusiasm was to collaborate on teams with scientists. At that time, computer artists met with resistance. Creative teamwork needed even greater justification as an emergent methodology for artists. I persisted with these goals to connect visual literacy and science in important and meaningful ways.

The first NCSA Renaissance Team was composed of three academics: George Francis, a professor of mathematics; Ray Idaszak, a student in computer science; and me, an assistant professor in art and design. George and Ray developed computer graphics software to study multidimensional geometric surfaces in topological mathematics. I used the software as a virtual sculpture machine to create shape forms. A feminine hourglass shape emerged and we named her *Venus* after the goddess. We invented a series of mathematical nudes that included *Apollo*, who evolved from the ribs of *Venus*. I learned a lot about math and topology as well as the tenure process. George was an important mentor on my road to tenure.

Through a campus MillerCom speaker series, I invited Dan Sandin to Urbana to give a lecture and meet Larry Smarr. Dan was hesitant to meet a supercomputing center director. His philosophy was captured in his statement, "No computer is a good computer if it is too big to pick up and throw." A Cray-1 supercomputer seemed off scale, but I convinced Dan and Tom DeFanti to make the trip to NCSA and introduced them to Larry Smarr.[5] The introduction proved to be a great beginning of a long-term collaboration that has continued for many decades.

My first SIGGRAPH conference was in 1984 where I first saw Maxine Brown in a gold lamé outfit on stage at SIGGRAPH 1984 Electronic Theater. I have attended SIGGRAPH every year consecutively since that time, often wearing fashion statements like Maxine.[6]

In 1986, I met Maxine and Jane Veeder at the Pacific Northwest Computer Graphics conference in Eugene, Oregon. I introduced Smarr to Maxine at the following SIGGRAPH conference. He asked me to show him around and introduce him to people since I had many connections as a contributor/co-organizer with the SIGGRAPH satellite art show. I introduced him to many SIGGRAPH forerunners.

The 1986 SIGGRAPH conference was a pivotal point that converged Hollywood-style computer graphics with "Silicon Prairie" computational science. Soon after the conference, producer Nancy St. John and scientist Craig Upson joined NCSA to build a scientific visualization group. Nancy had been an executive producer at the famous Robert Abel Associates, working with groundbreaking computer special effects in commercials and movies. Craig had been a scientist at Digital Productions. These Hollywood filmmakers came to NCSA to apply computer graphics techniques to hard-core science. They helped formalize the visualization collaboration process into

Venus on a Glass Pedestal, 1988, Donna J. Cox, George Francis, Ray Idaszak. This single image showing Venus and two Apollos required twelve hours of ray-traced rendering on an Alliance supercomputer. The image was featured in a National Geographic magazine article on computer graphics in 1989. Courtesy of Donna J. Cox.

create the first digital PHSColograms from the mathematical *Venus* surfaces [see pp. 29–30]. We worked through the night to solve problems so that the computer graphics could be generated from multiple viewpoints to enable the PHSCologram process. It was great fun and we were elated with discovery. That first evening, Ellen and I had a long talk in the ladies' room. Her political strategies for collaboration influenced me. Around that time, Ellen and I were interviewed on a local Chicago television talk show and were asked questions about "Supercomputers and God," an implausible combination. Ellen never hesitated with words. She intelligently connected computer bits to the sacred numbers from the kabbalah. I thought to myself, "This woman can really think on her feet." The *Venus* PHSColograms were featured at the Feature [gallery] in Chicago 1987 and SIGGRAPH '87 Art Gallery. Her perseverance brought international attention to the *Venus* PHSColograms.

The *Venus* image had become iconic and represented much more than a digital art sculpture. The *Venus* and derivative characters covered magazines and newspapers. The idea of the supercomputer *Venus* expanded to become an analog to the Paleolithic *Venus de Willendorf*. Both the prehistoric *Venus* and the supercomputer *Venus* were created by artists motivated to formulate worldviews and solve mysteries of the universe. The new postmodern *Venus* represented a new kind of collaborative art/science making and functioned in culture in similar ways

Cover images incorporating digital Venus artwork. Left to right: *Red Venus*, *Science News*, 1987; *Ménage à Trois*, *Academic Computing*, 1990; *Apollo in Transition*, *Computer*, 1989. Courtesy of Donna J. Cox.

a production model and creatively worked with scientists. Colleen Bannon Bushell had been one of my best design students, so I introduced her to Nancy St. John. Nancy hired Colleen to work as a designer within the NCSA Visualization Group.

In 1986, I met Ellen Sandor and was impressed by her energetic personality and knowledge about the Chicago art scene. She visited Champaign-Urbana with Dan Sandin to collaborate with George Francis, Ray Idaszak, and me to

to bring insight and predictability. The *Venus* evolved into an icon that represented women in various situations. I collaborated with Ellen Sandor to create a PHSCologram of *A Tribute to Sadie Elmo*, a digital layered image that was a tribute to my grandmother and her bout with breast cancer [see p. 133]. The *Venus* icon overlays digitized x-rays of breast cancer. It is a tribute to women and their struggle against the disease. The *Venus* project came to reflect evolving female issues, a goddess culture, and the cocreative, collaborative spirit that especially spirited my work.

At NCSA, we formed and participated in other small Renaissance Teams. Dr. Michael Norman and I collaborated to create color transfer functions in his simulation of a cosmic jet using ICARE to feature detail in the data. This collaboration received a great deal of notoriety, and our time-evolving animation was juried into the SIGGRAPH 1987 Electronic Theater, the first astronomical jet to be shown as part of the competitive conference venue. The Norman/Cox astrophysical jet was also the cover image of the influential NSF report, "Visualization in Scientific Computing," by Bruce McCormick, Tom DeFanti, and Maxine Brown. Kodak became NCSA's first industrial partner, and the visiting engineers also collaborated in Renaissance Teams to create some of the first three-dimensional glyphs in computer graphics. From these early collaborative experiences, I began to formulate guidelines for successful Renaissance Teams. These helped make complex projects successful and enabled innovation around the technologies where people bring a variety of motivations, talents, and perspectives to collaboration. One important characteristic of a successful collaboration is that members are motivated by a common goal. They need mutual respect for each other. Each member needs to benefit, get appropriate credit, and be rewarded within his/her peer system. Feminism was about women becoming equal partners with men. Women seem to have a very intuitive understanding of the collaborative process of partnership. Renaissance Teams guidelines captured many important ideas from collaborations with a variety of domain scientists and engineers.

NCSA was one of the first residents to occupy several floors in the new interdisciplinary Beckman Institute building at Urbana where I started the first computer graphics lab in 1988. A year before the building was finished, I met Jim Clark, cofounder of Silicon Graphics Inc.

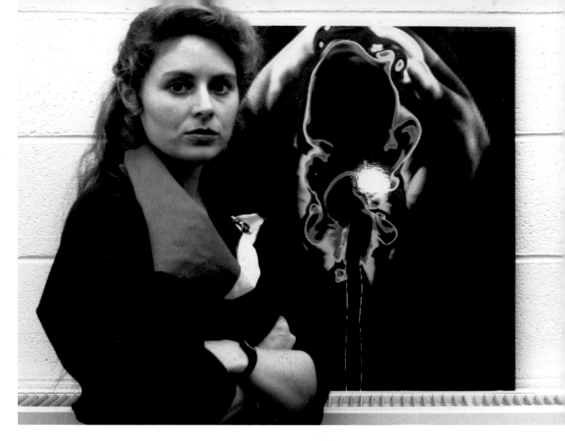

Donna J. Cox posing with a still from the astrophysical jet in the basement of the Computing Applications building after SIGGRAPH 1986 where the astrophysical jet animation was juried and featured in the coveted SIGGRAPH Electronic Theater. Courtesy of NCSA, University of Illinois.

[SGI], when I gave a public lecture at Princeton. He asked for a proposal for a new education lab, so I worked with diverse Illinois faculty, including Professor Francis, to develop a set of interdisciplinary classes. Clark donated twenty new SGI machines for the Renaissance Experimental Laboratory [REL], where I organized and taught interdisciplinary courses around the philosophy of collaboration.[7] When Clark visited Urbana for the REL dedication, we had coffee and he described his technological vision. He told me that his life goal was to become a billionaire. He eventually achieved that goal, in part through his connection to NCSA Mosaic and Netscape. His SGI donation to the REL was important because it supported unique-to-campus classes. Students produced digital animations that won awards at SIGGRAPH.[8] Years later Chris Landreth won an Academy Award and Ping Fu became an influential entrepreneur.

SIGGRAPH 1989 in Boston was historic for NCSA. We led a public experiment to provide people with a preview of scientists working remotely with supercomputers and visualizations. This demonstration was prior to the Internet and it was a very cutting-edge vision to remotely control a supercomputer and visualizations. AT&T donated a satellite link to visually connect people in the midst of cornfields at NCSA to the Boston Science Center stage. From the Boston stage,

SIMULATION

VOLUME 51 : NUMBER 5 NOVEMBER 1988

Special Issue
on
Numerical Modeling

[SCS] THE SOCIETY FOR COMPUTER SIMULATION INTERNATIONAL
INTERNATIONAL

"Simulation" journal cover of Kodak glyphs created by Kodak scientist Richard Ellson and Donna J. Cox, published in 1988. The first digital three-dimensional representations of plastic injection molding. Courtesy of Donna J. Cox.

Larry Smarr, scientist Michael Norman, scientist professor Bob Haber, and I interacted with scientist Bob Wilhelmson in Illinois, where Bob demonstrated how scientists could remotely control a supercomputer and visualize data. In preparation, all of us had been working all night testing the complex array of technologies and practicing our script. Nothing worked and we were all getting grumpy. The first flawless connection was, in fact, the first public SIGGRAPH show after hundreds of people had filled the theater to see the event. By the time the show started, all technologies and people synchronized like a well-choreographed play. Enthusiastic SIGGRAPH audiences glimpsed the future. The *Televisualization: Science by Satellite* was an extraordinary event and one of the

most expensive single demonstrations at SIGGRAPH ever. AT&T donated the equivalent of a $250,000 satellite link. This cost was in addition to extensive technology and human resources from NCSA and industry contributing to the event [see pp. 33–34].[9]

In 1990, EDUCOM invited me to give one of five keynote speeches.[10] I was told that I was the first female to deliver a keynote at the conference. Among the other keynote speakers that included former president Jimmy Carter, Steve Jobs (Apple), and Robert Allen (AT&T), I spoke right after Jimmy Carter and met him in person during the event. The short chat was one of the highlights of my career.[11] Later, I published highlights of my keynote in *EDUCOM Review*, where I described the "Renaissance Team" approach in interdisciplinary classroom education.

During the '80s and early '90s, we witnessed and visualized the birth of the Internet revolution. NCSA was one of the leading supercomputer centers in the development of the NSFNet, the foundation of the Internet that we know today.[12] Bob Patterson, a visualization artist at NCSA, and I visualized the first version of the NSFNet in 1991 and updated the visualization with new data in 1994 [see p. 35]. We worked with networking people and rendered a data-driven visual of the emerging Internet. We hand-edited files because the data was crudely recorded into text files. Bob and I wanted people to see how networking connected cities and locations through a backbone across the world. These images remain as icons of the early emergent Internet. This was the first data visualization collaboration between Bob and me. It heralded a long-term collaboration and life partnership.

Around that time, an NCSA team of software developers led by Ping Fu began developing an online browser. Colleen Bushell collaborated with student Marc Andreessen and the group. The first time I saw Marc demonstrate Mosaic, I heard a scientist ask, "Why would anyone want to send an image in email?" This casual comment signaled the novelty of a visual browser [see p. 37]. At that time, Jim Clark asked me if NCSA had anyone who could write an "authoring system" for networks. I provided the telephone number to NCSA's team where he connected to Marc Andreessen, one of the authors of Mosaic. During the Netscape browser launch, I lost contact with Clark. Later, it was rumored that he surreptitiously traveled to Urbana, Illinois, to hire the entire Mosaic team to form Netscape. I may have

inadvertently helped start that upheaval through a simple referral. After Netscape had formed, I visited Clark and Andreessen at Netscape in California. They encouraged me to join the startup. Jim warned me about academia and touted the burgeoning company, but I preferred to stay in the Midwest.

By the early '90s, I had traveled the world to give speeches on supercomputer visualizations and Renaissance Teams. I presented in some very exotic international places, but one of the most interesting events was back in the Midwest at the 1992 Virtual and Interactive Arts symposium in Normal, Illinois. Other speakers included Brenda Laurel, Anne Balsamo, and Timothy Leary.[13]

A major turn in the direction of my visualization research was during the making of the IMAX film *Cosmic Voyage*. In 1993 during the film's fund-raising phase, Director Bailey Silleck contacted me to potentially contribute images to the science education film partially funded by NSF and the Smithsonian's National Air and Space Museum [NASM]. Bailey was seeking a major sponsor. I had been consulting with Motorola through NCSA's industrial partner program and working with Mel Slater on visualization; he was one of the leading corporate executives. Motorola valued NCSA's groundbreaking visualizations while I was greatly motivated to bring scientific data to the general public through such a high-profile project. We played a significant role in securing the Motorola Foundation to provide funding of $5 million for *Cosmic Voyage*.[14]

While I could see how the scientific imagery could be compelling on the big screen, the producers had to be convinced. At that time, computational science was still a very young field, and we had never created high-resolution movie production-quality visualizations. The director of the NASM thought that computational simulations were too speculative, so we had to convince him that the data was valid science and that scientific visualizations could be used in the IMAX film. When I look back, it seems unreal that I, as an artist, defended computational science in front of a room full of Smithsonian scientists. My voice was quivering but I had passion. I showed a hand-drawn storyboard, data printed in dots on a computer printout. To convince people and help fund the film, we developed a short data visualization of colliding galaxies [see p. 130].

At the beginning of the *Cosmic Voyage* preproduction, then-Pixar creative director John Lasseter, president Ed Catmull, and other Pixar leaders

Honoring dedication in the REL, Beckman Institute, with twenty Silicon Graphics Personal Irises, Donna J. Cox, 1988.

took me to lunch and invited me to join Pixar to work on the first *Toy Story*. I had known Lasseter and Catmull for years. Lasseter and I became acquainted as speakers at AUSGRAPH '90 conference. I knew Ed Catmull well at that time through SIGGRAPH. This would have been a great opportunity to join Pixar, but I decided to stay in Illinois to ensure that computational science would be a part of the *Cosmic Voyage* film and became NCSA scientific visualization producer/art director on the film. I subcontracted Pixar to work with their chief scientist, Loren Carpenter, to render the *Cosmic Voyage* big bang scene. Loren loved to work on astronomical projects. His wife, Rachel, and I were friends. As part of the big bang scene, we filmed scientist Rocky Kolb at Fermilab in Chicago.

Though I didn't leave Illinois, I continued to work with friends and former students at Pixar for many years. By 1996, we completed two major scenes for *Cosmic Voyage* using scientific data. One scene was the visualization of a numerical model of a collision of two colliding galaxies [see p. 130]. This set a precedent in the IMAX community because up until that time, special effects had been used instead of scientific data for science educational IMAX films. Motorola was quite pleased.[15]

We completed our production of the *Cosmic Voyage* IMAX movie the same year that I walked the red carpet as a guest of Chris Landreth and Robin Bargar, who were nominated for an Academy Award for *The End*.[16] In 1997, I fortuitously attended the Academy Awards again for the contributions to *Cosmic Voyage*, nominated in

Left: Academy Awards, 1996, nomination of *The End* for best animated short. *Right to left:* Director Chris Landreth, Professor Donna J. Cox, Audio/Music Robin Bargar and Insook Choi. *Right:* Academy Awards, 1997, *Cosmic Voyage* IMAX movie team at the Beverly Hills Hilton. Left to right: Bob Patterson, Donna J. Cox, friend of Mrs. Silleck, Mr. and Mrs. Bayley Silleck (director), and Mrs. and Mr. Jeff Martin (producer). Courtesy of Donna J. Cox.

Left: Donna J. Cox, 1993, with the virtual reality Fakespace boom used for initial design of *Virtual Director* with Robert Patterson. Right: Donna demonstrating *Virtual Director* in the ImmersaDesk at Alliance conference in the University of Illinois Assembly Hall, 1997. Courtesy of NCSA, University of Illinois.

the documentary short subject category.[17] *Cosmic Voyage* did not win the Academy Award but it was an honor and fun to be nominated. The work was also given a "thumbs up" by Roger Ebert as he followed the University of Illinois productions over the years until his passing. The movie set a precedent in IMAX science educational filmmaking and demonstrated that scientific data could be visualized into production quality. *Cosmic Voyage* set our small NCSA visualization team on a new trajectory: the cinematic presentation of science.

Bob Patterson and I had envisioned the use of a virtual camera and mocked up an early version using the Fakespace boom display. To create

Bob Patterson and Donna J. Cox standing within the *Virtual Director* environment in the CAVE, used to create and collaborate on the IMAX film *Cosmic Voyage* and digital dome productions, circa 1997–2000. *Virtual Director* created by Donna J. Cox, Bob Patterson, and Marcus Thiébaux. Courtesy of NCSA, University of Illinois.

Donna J. Cox standing inside the *Virtual Director* CAVE environment, with camera path in yellow, while inside a dataset, circa 1997. Courtesy of NCSA, University of Illinois.

Donna J. Cox **81**

Notes

1. Many philosophy books shaped my world-view before and during college. *The Phenomenon of Man* by Teilhard de Chardin provided a grand scientific and poetic view of the universe, evolution, and interconnectedness.

2. I worked alone and late at night in order to care for my daughter when she was home during the afternoons after school. Photographs of my daughter were an important part of this image-making process and sometimes I'd fall asleep at the computer after programming all night.

3. I presented ICARE at the Small Computers in the Arts Network [SCAN], http://www.scanarts.org, where I saw Timothy Leary give a presentation.

4. I adapted and used the term "Renaissance Teams" in 1984, presented at SIGGRAPH in 1986, and published in *Leonardo* (Cox 1988a, 1988b).

5. The Cray is a supercomputer designed by Cray Research; the Cray-1 was first installed at Los Alamos National Laboratory in 1976 and was considered the most successful supercomputer, created by Seymour Cray and Lester Davis in Seattle, Washington.

6. Another significant influence was a Madison performance by midwesterner Laurie Anderson; her use of and commentary on technology were enlightening.

7. We had more workstations than any SGI training facility at that time. We originally called it the Renaissance Educational Lab. Because of a policy against classes in the research institute, we renamed it the Renaissance Experimental Laboratory and began our educational experiments.

8. In one animation, we brought the *Venus* mathematical character to life within a virtual art museum as she interacted with a digital character by the name of Milo, the janitor. *Venus & Milo* was filled with postmodern referential metaphors. The REL was a very synergistic place where collaboration was a key practice as part of education. Chris Landreth, an engineer research assistant, and Robin Bargar, a graduate student in music, collaborated with the REL teams to make *Venus & Milo*. Chris and Robin continued to collaborate after leaving the REL and eventually were nominated for an Academy Award for one of their computer animations.

9. I heard this dollar amount during some of the preparatory meetings. Other participating vendors donated technical expertise and lots of equipment.

10. EDUCOM was a national nonprofit association established in the 1960s to advance higher education by promoting the intelligent use of information technology. It is now named EDUCAUSE, and more information can be found at www.educause.edu/about/mission-and-organization/history/educom-history.

11. During my meeting with former president Jimmy Carter, the Secret Service moved a few of us into a room behind stage, and we stood in a circle while Jimmy Carter went around the circle, shaking our hands and asking us what we do. I gave a nervous spiel about artists and scientists collaborating on scientific visualizations. After he made the circle, he returned to me to explain his son was an engineer and his daughter an artist. I was nearly tearful during Carter's keynote on the topic of education.

12. NSFNet was a National Science Foundation government-funded academic network that provided the foundation for the Internet we know today, www.nsf.gov/about/history/nsf0050/internet/launch.htm.

13. We had dinner with Leary and listened to his tales around the dinner table. The next day, immediately after Brenda, Anne, and I had given our presentations, Leary went to the podium to speak and said something like "These women have blown my f***ing mind in a place called Normal, Illinois. It's really not so normal here." My students were impressed that I had blown Timothy Leary's mind.

14. The primary justification to the foundation was that the movie would have—as a first—NCSA visualizations of scientific data featured in the movie. We convinced all of the stakeholders that we could render numerical data into beautiful scientific images for the big IMAX screen even though it had never been done before.

15. At one point, I flew on a jet and sat by the Motorola CEO to preview the colliding galaxies at the Smithsonian big IMAX screen. He gasped when he first saw the scene in the NASM's expansive theater. I watched the little kids watching the finished film, and they were awed. I was so moved by the final film because it showed such a grand view of the processes of the universe, very much like *The Phenomenon of Man*.

16. *The End* was nominated for Best Animated Short Film category. They asked me to accompany them to the Academy Awards. I was so frugal that I borrowed a friend's daughter's high school prom dress to wear. I thought, "Why spend a lot of money on a dress you only wear once?" *The End* did not win in 1996, but Chris would win an Academy Award for *Ryan* in later years, http://chrislandreth.com/films.html. In 1996, it was fun to go as a guest, walk down the red carpet, and star-gaze at celebrities in the flesh.

17. This time I purchased a dress instead of borrowing one. It was amazing that the press were more interested in what I was wearing than the visualizations we contributed to the film. We went to Hollywood with Bailey Silleck, Jeff Marvin, Mel Slater, and other key contributors. Bob Patterson and I did not arrange the big-ticket postaward dinner. Instead, the limo drove us to a restaurant nearby the Shrine Auditorium for buffalo burgers and we dined in the limo. The limo-jam after the event was extraordinary and tiresome. All of the stars were waiting for their limo pickup; some of them became irate, but there was nothing to do but wait due to the congestion.

18. A couple years later, I gave a presentation in the Hayden fulldome. Claudia Hart and others saw the presentation.

19. Women continue to explore new avenues with digital arts media. Tiffany Holmes recently installed creative works at NCSA and our campus. A few years ago, Ellen's lab and our team cocreated a large seven-foot free-standing sculpture called *Universal Atmospheres*, computed from a tornado and galactic structures.

Carolina Cruz-Neira

||

Carolina Cruz-Neira is known as the co-inventor of the CAVE and the original developer of the CAVELibs. She spearheaded the open-source virtual reality (VR) application program interface (API) movement with the development of VR Juggler and has been an advocate of best practices on how to build and run VR facilities and applications. She is also known for conceiving, developing, and operating large-scale virtual reality research centers, such as the Virtual Reality Applications Center (VRAC) at Iowa State University and the Emerging Analytics Center at the University of Arkansas–Little Rock, as well as for implementing innovative graduate degree programs aligned with the centers' activities. She has chaired several international conferences, given over one hundred keynote addresses, served on a number of review boards for national and international funding agencies, and participated in technology advisory task forces in countries around the world, defining the research directions of her field. Many of her former students are now doing leading work in VR at places such as Unity Labs, Intel, Microsoft Research, Google, DreamWorks, EA, Deere & Company, Boeing, Sony Pictures Imageworks, and Argonne National Laboratory.

Beyond her academic career, Dr. Cruz is a business entrepreneur. She cofounded Glass House Studio and Infiscape Corporation. She serves on several industry advisory boards and has performed corporate consulting for companies around the world due to her expertise and visionary take on virtual reality. She has also designed and produced stage performances and public exhibits in New York, Chicago, Los Angeles, Orlando, Madrid, Barcelona, Florence, Paris, and other places, combining technology, dance, theater, and art.

Among her many achievements, *Business Week* magazine named Dr. Cruz a "rising research star" in the new generation of computer science pioneers. She received the Boeing A. D. Welliver Award in 2001, the Virtual Reality Technical Achievement Award from the IEEE Society in 2007, the Career Achievement Award from the International Digital Media and the Arts Association in 2009, and the Arkansas Research Alliance Scholar Award in 2014. She was inducted as Eminent Engineer by the Tau Beta Pi Engineering Honors Society in 2002 and inducted as a Computer Graphics Pioneer by the ACM SIGGRAPH society in 2003.

Dr. Cruz has a PhD in electrical engineering and computer science (EECS) from the University of Illinois at Chicago (UIC) (1995) and a master's degree in EECS at UIC (1991). She graduated cum laude in systems engineering at the Universidad Metropolitana at Caracas, Venezuela, in 1987.

It started when I graduated from engineering. I won the Rotary International ambassador scholarship to the United States that brought me to the University of Illinois at Chicago to begin my studies in August 1988. At the time I didn't know much about computer graphics or what electronic art was. I was a hard-core software engineer and my specialization was designing very complex systems, such as airline management systems that coordinate passengers, planes, airports, gates, kitchen supplies, and the mechanics. When I came to the United States, my interest was in artificial intelligence because with a lot of those large systems, you had to figure out a computational way to manage them.

The professor at the University of Illinois who had agreed to be my adviser decided to leave the university, so I ended up a lost puppy with no professor who could take me. In one of the classes I took for fun—the computer graphics class—I met Gordon Lescinsky, one of the early EVLers. He's the one who said, "Oh, I work in the Electronic Visualization Laboratory [EVL]. You should talk to the two professors there, Tom DeFanti and Dan Sandin." And I thought, "Well, computer graphics doesn't sound very serious or it sounds like art." He said, "No, no. There's engineers, computer science people, and artists involved so you should go." That's how I got started. It was not a planned agenda on my part. It just happened. So I went to EVL and they did have some assistantships and put me on probation for one semester where Tom DeFanti said, "Well, if I think you work out okay, then next year I will put you on the assistantship."

That semester, I was able to get a tuition scholarship, but like everyone else, I had to pay the rent for my own apartment, so I needed an additional scholarship. I applied for a supercomputing scholarship and I also won it that semester. Tom DeFanti supervised both scholarships. During my first semester at EVL I spent time on IBM and with a company that doesn't exist anymore, Thinking Machines, working on the Connection Machine, so I got introduced to supercomputing and high-performance computing. That was early 1989. That's how I got involved, totally by chance. Survival guided my career in computer graphics.

Because of the scholarship, I spent a week down at the Beckman Institute at the University of Illinois at Urbana-Champaign, using one of the Cray XMP machines. The National Center for Supercomputing Applications (NCSA) had a Connection Machine and a bunch of other supercomputers that I also used. On the supercomputing side of the house, we spent time with the technical people, not the system administrators but the networking and software development guys. When it all wrapped up, Tom was happy with what I did with the supercomputing training. The following semester, which started in January 1990, I got the assistantship and I officially became part of EVL.

It just blew me away at the beginning. I thought, "Wow, this is so neat." The artists were doing incredible things. It was the time when John Hart was creating fractals and Gordon Lescinsky was creating art with fractals—his beautiful images with waves. It was fun to watch the art students working with different computer styles, where many technical issues needed to be resolved to finish their work. EVL was a very rich environment and it's a pity that there are not more places like it because it was certainly stimulating.

Part of the mind-blowing experience was that I had two parts of my life—where dance and technology were disconnected. By being in the EVL program, I saw a possible way to bring them together. I love the arts and I was missing my dance. I traveled all over the world and I would go to all the art museums. I grew up surrounded by creative, colorful, unique, and very avant-garde things, but on the other hand, I was doing this very dry style of engineering. When I went to EVL I thought, "Oh, I can put the two together. This is really cool." So I did a little more art on the side when I was there and I was engaged with the art students. I kept getting more and more engaged with understanding the complexity and technical challenges that we faced.

Then I started meeting a lot of people and interacting with people like Janine Fron from (art)n and all of the other fun people at EVL. I met Ellen Sandor, director of (art)n. She was my hero! When I walked in at the old EVL, which was a very tiny space before they moved to the newer building, when you open the door to this tiny space the first thing you saw was a PHSCologram on the wall. I was like, "Oh, wow!" So when I first met Janine Fron and Stephan Meyers from (art)n, I thought the world of them, because I thought, "How could they do something like this?" I couldn't even understand how these things were drawn and then when I met Ellen Sandor she was

so excited about everything and so open about what she was doing. It was just heaven! On the virtual reality side, I was so blown away by the PHSColograms that I was talking with Ellen about possibly doing something with (art)n. Then we went to SIGGRAPH and saw the *Tomorrow's Reality* VR exhibit and that got me really excited.

When I finished my master's at EVL, I went to work for IBM on Wall Street in New York. I didn't have a clear path to a PhD but when I saw the VR exhibit at SIGGRAPH, it opened up a completely new world of expressing, displaying, and creating for me where I can get inside of a computer and do anything I like, because there are no limitations. That became really appealing to me.

Tom DeFanti called me [at summer's end of 1991, just after the excitement of being at SIG-GRAPH] and said, "Hey, Carolina, I have this grant and I can fund you for three years if you want to do your PhD. You will be doing virtual reality for the next three years." That's about as much as he could tell me at the time because the plan of the CAVE was not thought of yet. He wanted to investigate alternative methods to do virtual reality, when at the time everything was helmet based. I asked him, "Well, what are we going to do?" He said, "Well, I don't really know, that's why I need you, so we can figure out what we're going to do." The National Science Foundation (NSF) funds EVL received in 1991 to do VR research were also tied to what later became the *Showcase* activity at SIGGRAPH, and he couldn't get any students excited to work on this project. I had just returned from SIGGRAPH and was like, "Whoa! This is what I want to do and now Tom is calling me to return to Chicago!" I quit my job at IBM, packed up, and drove back to Chicago.

I sat down with Tom DeFanti and Dan Sandin and we all said, "We've got to come up with something. Well, what are we going to do?" Apparently, Tom and Dan had the idea of putting four monitors on a pedestal where you could squat down and get in the middle of those four monitors and that was supposed to create some kind of in-your-face VR environment. I thought, "Well I don't know. I'm not very excited about having my head in the middle of four monitors." To me, it was almost like wearing a head-mounted display on crutches.

One night I was walking around the building with Lewis Siegel, another EVL student, and we saw a Sony projector kind of up in a corner, semi-abandoned. I thought, "Hmm, I wonder if I can hook up this thing to a computer and get 3D

projected because, hmmm, this might be better than the monitors." So in the middle of the night, we dragged the projector back into EVL, hooked it up, and projected just on the wall, and hey, voila! The 3D worked when we projected it! The next day I showed it all excited to Dan Sandin. I said, "Hey, Dan, look. We can do this. It's really cool and it works. I really don't know very much about projection, but could we maybe do something that instead of the monitors, we can somehow project, so it's bigger so we could get inside this thing, entirely inside or something?" So that's how it came out. This happened around late September or early October of 1991. It's not that the CAVE was defined ahead of time—it was an evolution.

By January or February of 1992, we had the first structure of the CAVE made. It was kind of tiny and it had very big corners because we had not figured out how to do the corner seam. The CAVE as it is known today was finished around May 1992. Michelle Miller and Kathy Koehler were the first EVL students to have their MFA show in the CAVE before it was officially shown at SIGGRAPH '92 at McCormick Place.[1] The CAVE

The Virtual Hindu Temple, 2003. Religious studies students visit a fifteenth-century Hindu temple and experience the religious rituals that took place at that time. Courtesy of Carolina Cruz-Neira.

was driven by art, and it was driven by women, so that was pretty neat. We ran it for a few hours one evening, like all the MFA shows. Then I got ready for SIGGRAPH, which was at the end of July, where I was working in the McCormick Place. I worked on all of the applications because even though every application that was shown had a primary graduate student assigned to it, they all had to use my very rough version of the CAVE libraries. I had to get fairly involved in making sure that all of the applications ran well and I had to write code for a lot of them to help the students with my first version of the software.

In the very early days, I was interested in music. I created a piece that evoked the feeling of being part of a musical band or an orchestra. If you stood in the middle of the CAVE with a wand, you could actually play musical notes assigned to different plotting 3D objects. If you went around the CAVE with a wand hitting all of those objects, you could actually play music. Visuals

would appear whenever you hit something that would explode into particle systems. That particular application survived for a very long time on the EVL demo set.

The evolution was threefold. On one part, we kept evolving the technology. The first CAVE was driven by five PCs, because at the time, those were the graphics machines. But those machines were not designed to work together. Today, we talk about clusters and you can get a bunch of PCs to make a cluster, but in those days, the whole concept of a cluster didn't exist. So when I was using multiple computers to drive the CAVE, this was one of the most difficult things I had to solve technically—how to make five machines work transparently as if they were a single machine. I had to come up with external video hardware that could synchronize all the video images so whenever you were in the CAVE, all the walls moved in sync at the same time and also changed at the same time.

Ashes to Ashes: A 9/11 Memorial, 2001. A group reflects on the remains of the World Trade Center from the aftermath of the 9/11 tragedy. Courtesy of Carolina Cruz-Neira.

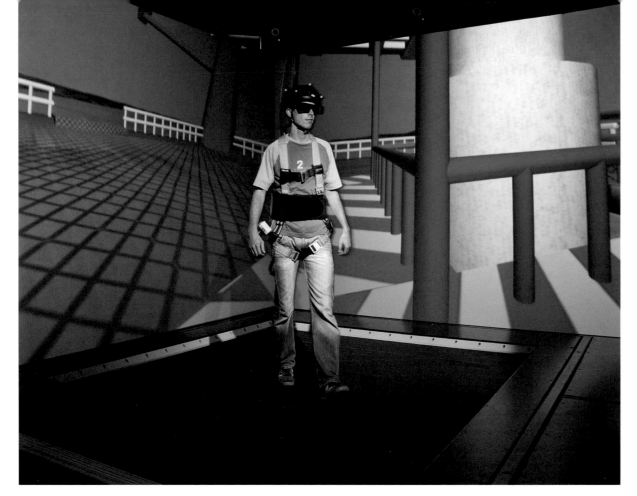

The Omnidirectional Treadmill: Physical Walking in Virtual Spaces, 2010. A visitor walks in a rig to explore its evacuation routes. Courtesy of Carolina Cruz-Neira.

Silicon Graphics Inc. actually incorporated this feature into their graphics boards [during the mid 1990s] when they came out with the reality engine, which became a built-in feature. This was a huge improvement, because logistically it was very complicated to have these external bunches of cables and microprocessors just to handle video, so at that level, we made a lot of improvements. The other evolution was that as the student leading the CAVE development, I worked with more and more people, in particular the artists. I learned a lot about what was easy for them to do and what was very hard for them to do. In 1993, I invested most of that year on hiding very deep down in the software all of the difficulty of running programs in the CAVE to give the artist the simplest content of the software. I hid as much as I could of the CAVE software complexity mostly for the artists. As we learned more and more of what this technology could do, the applications became savvier. If you look at what we did in 1992 and what we showed at VROOM in 1994 and Supercomputing in 1995, it is just leaps of advancement.

I had three and half years of fun [completing my PhD in 1995] and it was a great life but now was time for me to get really serious. I went to Iowa State University [ISU] because there was a group of people there who already had good relationships with the industry. I wanted to see if what I had done actually had real meaning. I wanted to change the world with my work. I was highly focused, especially in the first few years, really, really hard on generating groups of publications that would have a very noticeable benefit of using something like the CAVE. A lot of scientific studies and technical papers prove numerically that if you do things in this way, you can be more efficient and maybe make fewer mistakes. You can go faster by looking up more design alternatives. More recently, I was talking with an NSF project director who told me he thinks I'm the only researcher who has been able to make funding successful with the CAVE and impact the world outside research because nobody else has been able to do it.

I invested the first two or three years to really understanding what it means to do something in a CAVE. I did a lot of psychological experiments because when I meet people whom I would like to work with, I know I can tell them what can be done or cannot be done. Or we might be able to do this, but I cannot give you a time frame and I cannot guarantee that we can even do it. I think that has helped me tremendously. I understand what can be done, how we can do it, and how long it might take us. Collaboration, of course, is very important because you cannot be an expert on

everything. You cannot be a physicist today and a biologist tomorrow and a civil engineer the day after. You need your collaborators who can be, in a sense, the expert or they can be your computer scientist and they know about all the areas of the field that you are not very familiar with and then you have a much richer idea discussion group. It's not a one-person show by any means, but you need to have somebody who can put it together. I've been fairly good at putting groups of people together, keeping everybody excited about really feeling the collaboration and having the group being proud of what we're all doing together.

The dean of engineering at ISU was very generous and gave me a lot of freedom to work with the architects on the design of a new building to house my research—anywhere from the hallways to the color of the carpeting, the fixtures on the walls to the waiting areas before you get into the CAVE—the whole thing, so I was tremendously fortunate. I was able to pull a little bit of my former background in fashion design when I was working with my parents. We came out with a pretty facility overall because it did not look like your typical dry, old gray hallways of an engineering building. It was warm and welcoming but at the same time, the moment you closed the door, you knew you were in a very high-tech location. That was a one-of-a-kind opportunity and I enjoyed it for almost ten years. It was a beautiful place. We were inspired by tornadoes because that's one of the biggest things in Iowa, so we built this Plexiglas reflective metal tornado shape to enclose the six-sided cave. I was very lucky the team was so supportive.

Then Ellen Sandor approached me and said, "Hey, we have this important project." It was very special. The Museum of Jewish Heritage came to us from New York. They had a group of artifacts that were recovered from concentration camp survivors that they wanted to re-present to the visitors in the museum in a unique way with PHSColograms. The job was very important to me because until then my adventures in the arts were more of a supporting role. By working with Ellen Sandor, it was really exciting because I actually did something that was very artsy with a lot of help from her, Janine Fron, and Stephan Meyers at (art)[n] and Stephanie Barish from the Shoah Foundation, and I had a lot to do with the overall result [see p. 244]. Then I launched myself into doing some other projects in the arts.

When I first went to Iowa, my experience was very different about the Midwest. There's Chicago, and then the rest of the Midwest as far as I'm concerned. When I went to Ames, I experienced a huge culture shock because Ames is not that far away from Chicago and it's not that far away from Minneapolis. I would find a tremendous percentage of people who would call Ames a big city, and this is a town with only twenty thousand people. In the summer of 2001, I had a grant from Iowa Academy of the Arts. I proposed creating a virtual reality CAVE experience of explaining [that area] to the rest of the world—in my sense, the Iowan. My initial idea was to have people from Iowa tell me a little bit about their life and stories, you know, "How's your life?" and almost 100 percent of them had the same life. They were born on a farm, grew up on a farm, their closest neighbor would be thirty miles away, and when they went to Ames, that was a big city with twenty thousand people on top of each other.

I wanted to produce an art piece in the CAVE where you could have a ten- to fifteen-minute experience of living their life, where you go out with them in their world. We never made it, as

This initial concept planted seeds for a future project Cruz-Neira completed in 2015, *Immersive Google Earth in a CAVE*, in which a group virtually flies over the New York City skyline, admiring works of architecture. Courtesy of Carolina Cruz-Neira.

Anatomical Eyes, 2015. Physicians virtually dissect a cadaver to increase their anatomical knowledge. Courtesy of Carolina Cruz-Neira.

the tragic events of 9/11 caused me to change the focus of the project, but we were going to experiment with using the CAVE for visual narrative in a sense and virtual theater. We hooked up with a music composer. Her name is Anne Deane. I contacted Anne because I wanted somebody who was a real expert in music and sound so we could have the visual and the audio experience as well. I also invited Valerie Williams to collaborate on the project who was an experienced choreographer who could help me choreograph the virtual characters as we illustrated the story. Then 9/11 happened.

At the beginning of October, we completely changed the intention of the project. Instead of documenting and experiencing the life of someone in Iowa, we decided to document an experience of a survivor of 9/11. The base concept was still the same. We wanted to use the CAVE as a space for exploring visual narrative and so we ended up going to New York. We worked through the annex office with all the first psychology responders. We put up a website for all the survivors who wanted to participate in the project could join us.

We then interviewed the survivors of 9/11 at the office on Fifth Avenue, so I have about three or four hundred hours of never-heard testimonies of these witnesses of 9/11, which we reduced to fourteen and a half minutes with Larry Tuch, a scriptwriter from Paramount Pictures. He actually spent about three months listening to all those recordings and picking a selection of about thirty-second segments, trying to get the essence of the tragic event. We very fortunately worked with undergrad students, especially Jeff Rusell and Andres Renoit, graduate students like Laura Arns, art geniuses like Ellen Sandor, and many others to visually illuminate the 9/11 survivors' stories as vignettes inside of the CAVE [see pp. 134–35].

The sound that people experienced was according to what was happening inside the World Trade Center at the time of the attack. Anne did a fantastic job. The piece was almost like a theatrical play with four acts. Act One was a beautiful day, because everybody told us what a beautiful day it was. Act Two we called "What They Heard" because everybody who told us their story started with noises—they heard explosions. Very few people saw anything. Most of them heard it. The Third Act, we called "Ashes" because after they heard the noises they only saw ashes and ashes and more ashes. The last act was about the residents, where a lot of them gave us their own views on how their life is now different. The whole experience from the beginning to the end is about fourteen or fifteen minutes because in every act, as a viewer, you have the choice of how many stories you hear. You navigate through the space and have four stops. In every stop you can hear the backdrop and, for example, hear the story of somebody who was in the towers, or you can hear the story

of someone who was in the subway, or the story of someone who was in the park, or somebody who was across the river. You can branch out and hear all the stories in original voices with sound effects and experience unique visuals.

We took a pretty high risk, but the sophomores working on the project got really, really motivated. At the beginning, I think, it was just a job for them—"We're going to get paid if we do this thing"—but after some progress, they started to understand what the project really meant and saw people like Ellen Sandor taking the time and putting in effort all the way from Chicago. Ellen would participate in our weekly conference calls and a few times she flew in to meet with us in person. They started to really understand what they were doing and I also gave them significant freedom on how they built the visuals, and they did a fantastic job. With patience and getting them to listen to what the survivors were saying, to listen to the tone of their voice, and to listen to the emotion of their heart speaking. They really got into the project and did a really, really good job of capturing the essence.

Many of the stories were surprising because you don't really know when you enter a particular scene what's going on. There's one scene where you branch out and enter that space completely surrounded by floating eyes. The CAVE is really dramatic because you have this infinite sea of floating eyes around you, above you, underneath you, and you don't know why those eyes are there. Then you hear the narration where the person said, "We were in the seventies-something floor. We were okay and we were going down the stairs as fast as we could to get out of the towers because they were telling us another plane was coming. But once in a while, we had to stop because the rescue people were bringing down on stretchers the people who were burned and we couldn't tell if they were white people, black people, Asian people, all we could see was a black mask and two eyes." And that's when finally the eyes kick in you're like, "Oh, my. That's what it is." It's really emotional. That piece has been shown at Supercomputing but it was in an art museum in Madrid, Spain. It's been to France and Germany. We took it to Poland. It went to Japan. We had it for six months in a museum in Des Moines. Though it's been in different places around the world, it never made it to New York.

[A few years later, Cruz married Dirk Reiners and started a family after relocating to Louisiana for a new position to expand her research possibilities with the University of Louisiana at Lafayette, which included building a CAVE with an omnidirectional treadmill in the floor.] Something that I've wanted to do for years is walking, really walking in the CAVE, because a CAVE without walking is not a good sensation. It's neat that you can actually walk indefinitely in the CAVE. It changes your experience completely.

I think the future is wide open [for younger women hoping to join the field]. One of the lessons I learned over many years is that things become tough when you move up and have a little more power. People can get nervous around you. But when you are beginning your career and you have a lot of excitement and creativity—I think right now, for younger women, being a woman should not be a major issue. I also think people like us are demystifying whether or not this is the right thing for a woman to do. We all have been very successful. We are all very visible and you can be successful in the arts, or you can be successful on the technical end. I really think there's a lot more opportunities than before. I cannot wait to see the next ten years.

||

Note

1. The SIGGRAPH premiere of the CAVE also included an exhibition of forty PHSColograms produced by (art)n, EVL, and many collaborators, highlighting scientific visualization research juxtaposed with art historical imagery. The forty pieces were installed surrounding the outside of the CAVE and were then featured in *Science-in-Depth*, a traveling exhibition sponsored by ACM SIGGRAPH that was curated by Tom DeFanti and Ellen Sandor to complement the first public experiences of the CAVE.

Colleen Bushell

Colleen Bushell is the interface designer of the first visual browser, Mosaic, a technology that led to the popularization of Internet browsing in the early '90s. She pioneered digital visualization techniques as one of the first designers at the National Center for Supercomputing Applications (NCSA) Visualization Group. As a Chicago native daughter, the Midwest influenced her visual approach to the design of information. Bushell began her undergraduate studies at the University of Illinois in graphic design and additionally included fine arts courses. She was cofounder and director of product development at RiverGlass Inc., a spin-off company from the University of Illinois at Urbana-Champaign (UIUC) and now holds a senior research scientist position at UIUC's Applied Research Institute developing visual analytics for biomedical research and health care. She leads the visualization research effort for the National Institutes of Health's Center of Excellence in Big Data at UIUC's Institute of Genomic Biology. She collaborates with doctors and researchers at the Mayo Clinic, Northwestern University, and UIUC, discovering biomarkers and integrating genomic and microbiome data into clinical practice. She was a tenured professor at UIUC in graphic design and continues her interest in teaching by working with students through NCSA's student innovation program. She and her husband, Peter, and their two sons and daughter live in Mahomet, Illinois.

|||

When I look back on my whole career, creating visualizations was probably the most interesting and exciting. It was similar to watching *NOVA* programs and always learning something interesting. We mastered a new topic for each visualization project. We combined visually rich material with skillful communication. We learned as much as possible to address the challenges of communicating scientific concepts in a way that people could understand. As I mastered the concepts, I began to communicate to the audience at that level. It was exciting to tackle new projects.

My education focused on the historic Bauhaus work in Illinois and incorporated other midwestern influences such as Prairie Style architecture as part of my formal training [see p. 4]. This early training influences how I approach and organize information. I have always been interested in organizing information, but I did not realize that it would lead to my career path.

The School of Art and Design established a computer lab [in 1985]. I decided to stay an extra year as a graduate student and studied with Donna J. Cox during her first semester teaching in that lab. I enrolled in the design program knowing that I wanted to explore the area of computers. Donna taught me many different technologies working in that lab. I explored the computer and applied graphic design techniques to that medium. I explored the spatial relationships of animated text more than other kinds of imagery. I was able to explore the computer and design using Dr. Halo and Tom DeFanti's Real-Time (RT) scripting language. Donna had established connections to

NCSA. They were starting to hire people to build the National Center for Supercomputing Applications (NCSA) Visualization Group with Donna, Nancy St. John, and Craig Upson in 1986.

Donna set up a meeting with Bob Wilhelmson and me, a time before Nancy and Craig had officially arrived at NCSA. Bob was one of the associate directors and scientists in atmospheric science at the university. After viewing my portfolio, he said, "I don't know where you would fit in but I know that I need someone who can do the kinds of things that you are doing." And with that vague entry, he took the chance and hired me. I joined the NCSA Visualization Group, a good group with people from diverse backgrounds. Nancy St. John was a producer who left a large Los Angeles production to join NCSA and direct the Visualization Group. Donna shared with me that Nancy was very glad I joined the team and that I became a contributing designer of the group. It was a rewarding experience.

Stefen Fangmeier was a very dynamic leader of the NCSA Visualization Group who later went to Industrial Light and Magic and was nominated for an Academy Award for visual effects as supervisor of *Twister*. One of his last NCSA projects was the "Visualization of the Thunderstorm" [see p. 136]. That project had two lives for me. First we worked with Bob Wilhelmson and devoted a lot of time to the visualization. While learning about the science of the thunderstorm in Bob's office, I used pipe cleaners to build a model of the wind flow. For years, Bob saved one of those models and used it to describe the process: starting with drawings taped on the wall to show a sequence of how the storm changes over time, then using the three-dimensional pipe-cleaner model to describe the twisting nature of the wind flow, and finally creating animations to combine both. Bob's colleagues chased storms, and they would give me videos of their storm chases to use as part of the study. I reviewed hours of tornado footage. I had nightmares of being caught in tornados. They would call while in route to a tornado and inquire, "Do you want to come and see?" answered by my emphatic "No!"

[NCSA gained notoriety] for the thunderstorm visualization because it enabled people to understand the science. It is a poetic metaphor and a Midwest icon. In a second round of research with the study, I explored specific information design concepts in collaboration with Professor Edward Tufte at Yale University and Polly Baker and Matthew Arrott at NCSA. We collaborated to redesign the thunderstorm visualization, and Tufte incorporated some of those redesigns in one of his books on information design [see p. 136].

The year before Mosaic came out [1990], I moved to the NCSA's Software Development Group directed by Joseph Hardin. The group developed software applications for scientists to use to understand data and collaborate. The NCSA Visualization Group worked with a variety of scientists and industrial partners to help visualize their data, including chemistry, astronomy, and atmospheric data.

Ping Fu was a very influential software developer in that group. She did not have an art or design background but she had a very interesting background that included professional creative writing and software engineering [see p. 36]. One of her student interns was Marc Andreessen, who worked with her on software called Alpha-Shapes. Ping was aware of the type of work in the Visualization Group. Ping asked if I could work on that project, apply my visualization experience, and explore new interface techniques to address a problem of representing the complicated mathematics of a huge data set and provide the user with a method to select the data range.

Working on Ping's project was a breakthrough for me. I didn't have any training in interface design; rather, I approached the problem from the point of view of both a graphic designer and visualization designer, and not by applying traditional interface standards. My visual approach leveraged data-visualization techniques to represent and choose the range of data. This transition from visual animation toward interactive interface design involved a mutual goal: communication. In visualization, the goal is how to communicate and use the medium to convey the data and the concepts. In interface design, the goal is to clearly communicate to the user what the software can do in an easy-to-use interaction. It is the same design objective applied to a different problem. Today this visual approach is considered straightforward, but at that time, it was very different from the standard "widgets" used in software applications.

Marc Andreessen then invited me to work with him on several projects, including Mosaic. Marc developed the Mosaic software and was interested in my visual approach to interface design. He worked with Eric Bina, another NCSA employee and Unix programmer. They sent me an email asking if I could help them design the

The first production Scientific Visualization Group at NCSA, located in the basement of the Computing Applications building. Left to right: Michael Johnson (now at Pixar), Matt Arrott, Nancy St. John (international movie producer), Stefen Fangmeier (now a movie director), Michelle Mercer, Colleen Bushell, Ronnie Johnston, Jeff Yost (now at Industrial Light and Magic), circa 1987. Courtesy of NCSA, University of Illinois.

Mosaic interface. They had developed a good starting point and I helped with new ideas for the interface and organized the features and the layout more effectively. Their software was able to embed images in the content display, and this feature was a dramatic characteristic of Mosaic. Mosaic enabled people to easily acquire diverse content from the Internet from one screen view and that was very unique at the time. That is why we named it Mosaic—because it brought together many separate pieces into one frame. Previously, people had to use discrete software tools for each type of Internet site, such as FTP, HTTP, and WAIS.

The basic browser design [evolved from the graphical user interface] with simple characteristics like the position of the line where the user searches for URLs. There were many details that went through much iteration. For example, one of the first plans that we explored used buttons at both the top and bottom of the screen, placing the primary content in the middle. But this arrangement created too much visual weight and would be clumsy for the user. My focus was to make the interface secondary to the primary content and to always maintain this visual hierarchy. This basic concept minimized interface clicks and visually focused on the content. The objective was a minimal design with carefully positioned text. I wanted it clear and not visually noisy.

We debated how to represent the browser and these discussions revealed interesting philosophical and conceptual ideas about how people might think about this new technology. These ideas seem so simple now, but at the time, designing the interface around a conceptual angle had ramifications for how one would describe the software features. For example, is it software that "brings things to you," such as "go fetch me this page," or does the user ask to go someplace: "Let me go to this website." Do we design "Go to this place" or "Get me this thing"? It could have gone both ways, and it has in recent browsers. However, in the beginning stages, it

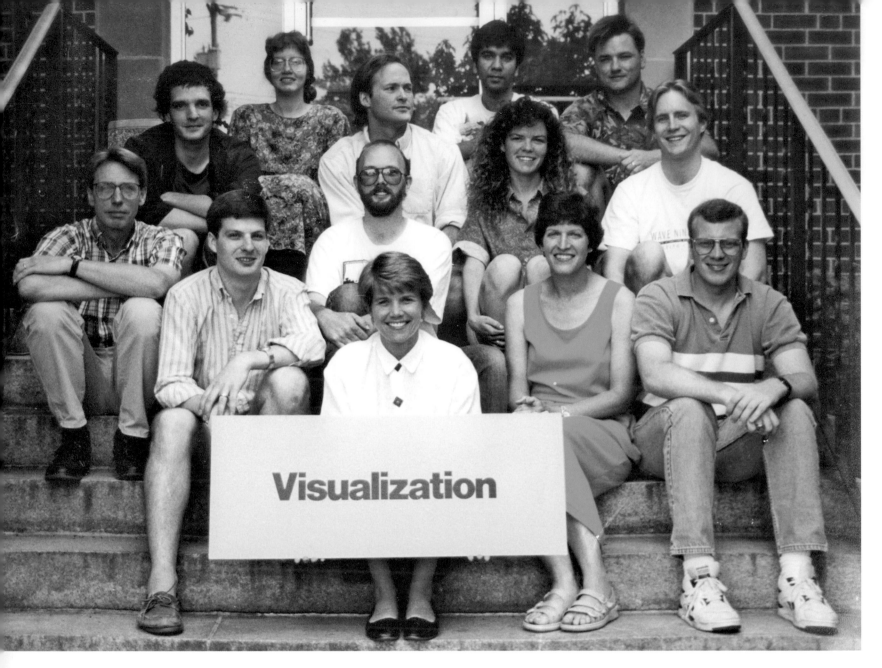

Visualization

The NCSA Visualization Group photo on the stairs in front of the Computing Applications building, the original home of NCSA. Front to back, right to left: Deanna Spivey, Bill Sherman, Polly Baker, Mike Krogh, Dan Brady, Alan Craig, Colleen Bushell, Jeff Thingvold, Mark Bajuk, Matt Arrott, Ingrid Kallick, Guatam Mehrotra, Mike McNeill, 1992. Courtesy of NCSA, University of Illinois.

was an open-ended design question. When Marc made this version of Mosaic public on the web, it instantly generated a massive response. The initial feedback was striking. Marc was often up late online reviewing the hundreds of messages he received per day from people saying they liked it and offering their suggestions. People instantly gravitated toward Mosaic.

I lived in a small town called Philo, Illinois. It is a small farming community near Urbana boasting only eight hundred people. Once, Marc, Eric, and I met at our house to work on plans for Mosaic. We were sitting out on my old rinky-dink porch of a hundred-year-old house in the middle of this tiny midwestern town. You could see the edge of the town each way you looked from the intersection in front of my house and you could see the Philo water tower that stated "Center of the Universe." We were discussing Mosaic's

popularity and how to reduce the speed of transferring the images. The thought emerged that one day software developers might intentionally make the download slower so they could display advertising. We were laughing, "Do you think it will ever get to that point?" This event sticks in my mind because it was when I really understood that "Wow! This is definitely something that people want." Several years later it seemed that advertising on browsers was creating transfer delays. Marc and I kept in contact, and years later he pointed Eric and me to an article about download times and advertising. Marc reminded us of our Philo prophetic experience.

NCSA [wanted to] promote Mosaic and brand the NCSA logo on the application interface itself. I was concerned about this requirement because it went against my desire to keep the interface visually subtle. We compromised by modifying

the logo so it at least presented information that is meaningful to the user. We animated the logo to indicate when content was being acquired and loading into the Mosaic window. The NCSA Mosaic logo was the first animated browser logo, and its primary function indicated data transfers [see p. 37]. After that, animated logos began to appear on other browsers. The University of Illinois had a major impact on early browser design. University of Illinois graphic design graduates designed all three of the popular browsers, Mosaic, Netscape, and Internet Explorer. Mark Enomoto worked on Microsoft's Internet Explorer and Darrel Sano worked on Netscape. I had several students go to work for these companies doing user interface design. It was an exciting time.

I participated in many different conversations about how the Internet was going to be used everywhere by a lot of people. But there was a lot of skepticism by many people saying, "Oh, it is just a fad." Many people were convinced that Internet websites were a whim. One day, I took eggs out of a carton. An egg had a .com company name printed on the eggshell. I remember thinking, "OK, if it's gotten to this point, It can't be a whim!"

While teaching graphic design as a professor at the University of Illinois, I continued to have a research position at NCSA and included some of my students on several projects. We worked with Vice President Al Gore's legislative office on a prototype of the National Workplace. Initially, I didn't realize that NCSA director Larry Smarr was referring to *the* "vice president" when we discussed the potential project. I assumed Larry was referring to a VP of one of our industrial partners. Then I saw that an email he forwarded to me was from "Albert Gore." NCSA had the opportunity to work on these kinds of projects because it has a national mission and interesting connections. Vice President Gore's office was involved in early conversations to explore the use of this new Internet technology to facilitate collaboration with policymakers working at different places in the country. Remote collaboration over the Internet using a browser was a novel idea at that time.

The design of the National Workplace involved philosophical and conceptual discussions. I worked with two of my students, Lisa Gatzke and Kristen Coomer (who later went to work for Microsoft to develop their PDA interface), and another group at NCSA. We designed a web-based virtual space using the metaphor of a building. This virtual building was like a library where different content was stored at different locations. People could add floors to the office space to support collaboration among different groups of people. The building had "conference rooms" for threaded discussions and "water coolers" where one could informally interact with others who happened to be in that place at the same time—it was an early use of what was later termed "chat rooms." Our objective was to provide a collaborative space where people physically located across the country could access the same resources and could discuss policy and collaborate on coauthoring documents effectively. The National Workplace was a proof-of-concept to explore how to think about the future of the Internet and its usability for serious collaboration. The "spaces" concept was futuristic and, to our knowledge, we were the only group designing with those ideas at that time. Virtual reality technologies and the CAVE were also on the rise at the University of Illinois.

We [referring to an NCSA spin-off company, RiverGlass, that Bushell cofounded in 2004] develop linguistic techniques that focus on the meaning of text for searching content and for extracting relevant information. I look at the needs of the people who might use our product, and I problem-solve the necessary features to accomplish those tasks. Recently, I have been moving to combine this experience with my knowledge of scientific data representation and apply these skills in the field of bio-informatics. I am working on a project with Mayo Clinic and exploring ways to effectively communicate a cancer patient's genetic information to the oncologist. In this next phase of my career, I hope to expand on this and work with teams to develop biomedical software that helps to advance medical research in auto-immune diseases, especially type 1 diabetes. Both of my sons have this disease and I want to find a way to use my knowledge and somehow affect the research of this disease. I am open to opportunities, and it will be interesting to see where the path leads.

All of my projects have relied on interdisciplinary collaboration where people contribute specialized skills. We needed the combination of everyone's talents together to accomplish the research or goals. All of these collaborations included people who valued visual work as part of the effort. As I mentioned with Bob Wilhelmson, he wanted my skills but wasn't sure how it would fit in the NCSA organization. Sometimes people evaluate the situation and the designer as part of the team. Other times it could be the

Welcome to @art, an electronic art gallery affiliated with the School of Art and Design, the University of Illinois at Urbana-Champaign.

This gallery is curated and maintained by the faculty members Nan Goggin and Joseph Squier; who function collectively as ad319. Our intention is to encourage artists' involvement in the global electronic community, and to provide an electronic viewing space for talented artists of outstanding merit.

Website entrance page for @art gallery, 1995, designed by Mick Brin, run by Joseph Squier and Nan Goggin. Courtesy of Nan Goggin.

twin sister majored in art at the University of Missouri, where my brother took journalism. After changing my major to art and printmaking, I had to pick up lots of classes, resulting in a five-year undergraduate degree. I wanted to draw and sketch, so I went to grad school and got a fellowship at Western Michigan for one year, where Curtis Rhodes was a Tamarind printer. I met some excellent graphic designers, including Barbara Markstein, and wanted to learn more about photography and photo etching. I finished my MFA at the University of Florida and studied with Jerry Uelsmann and Kenneth Kerslake. Uelsmann created photos with Photoshop characteristics before the software was invented. Kerslake was known for photo etching.

I worked for a graphic design company [after finishing her MFA], drawing designs and separating prints. When in Florida, as a student apprentice, I worked on the Christo project and was lucky to assist printing for people like Philip Pearlstein and Rauschenberg.[1] I was even lucky enough to print at the Cranbrook Institute, where I met Katherine McCoy. I kept learning more and more about graphic design. Although my art used a lot of text, I was more interested in how art communicates viscerally, emotionally, and empathically. This interest continues through later work.

I had a teaching job [at Florida State University] circa 1985, about the time I met my husband-to-be. I became chair of the Graphic Design program and was smart enough to hire Andrew Blauvelt, who is now a director at Cranbrook. I also hired Ann Bush from Yale. April Greiman's digital work at Cal Arts inspired me. She was using a Mac computer to explore bitmap dots for text and image. Her work *Does It Make Sense?* is well known. I got a Mac SC and started working with video and editing, text and image. At the same time, the *Emigre* and *Ray Gun* magazines were showing punkish and cool designs using text and image. The line between design and fine art was blurring and a lot of women like Zuzana Licko from *Emigre* were designing fonts with the bitmap look.

In 1988–89, I became aware of the supercomputer and advanced computing here and [wanted to explore new areas of graphic design and technology]. Art and Design's traditional graphic design program [at the University of Illinois, in 1990] hired me because I could cross boundaries, but after I joined they said, "Wow, you're really different." After a while, they understood why I wasn't teaching the usual.

For some traditional designers, the Macintosh computer was threatening. The design tradition separated jobs such as image, typography, and other separate tasks. A traditional designer would specify the job and send parts to different contractors and be responsible for the final product. I viewed the Macintosh computer as an opportunity to integrate these different design processes. I taught my classes with the computer, and this approach dismayed some of the traditional faculty. The Mac finally got a laser writer and printer. PageMaker publication software changed everything for future designers, and the older traditional designers were not happy. I was the only female in design and the only designer with a computer.

I connected with the Women in Information Technology and Scholarship [WITS], a support group in the department. Cheris Kramaarae and Jeanie Taylor started WITS, and they were a part of the Center for Advanced Study. Another important faculty member in the School of Art and Design was Bea Nettles. When I first came to the Midwest, Bea Nettles was one of the first artists I met who was exploring photography, computers, sewing, and everyday objects. A lot of men resisted this type of mixed media art. Nettles took me under her wing. We were

among the few women in the department. That same year, Colleen Bushell was one of my grad students. She worked on the early Mosaic and showed Joseph Squier and me one of the first versions. The first time Colleen took us to the National Center for Supercomputing Applications (NCSA) at the Beckman Institute to show Mosaic (what became Netscape), our mouths dropped open [see p. 37]. She said, "Yeah, I'm working on this."

When I was working with the computer, I would go upstairs in the Art and Design building because there was a printer in room 319. First some techy guys and I began to work together. Then Rob Springfield, graphic design faculty, came to use the room and finally Joseph Squier, another faculty. So this group of faculty started collaborating in that room. We named this group after the room we used to make computer art and the only room that had an Internet connection. The idea behind ad319 was an artist collective using technologies in a shared space, room 319. Artists would come and go, except for Joseph and me. Joseph and I have been colleagues and collaborators for over eighteen years. We were the primaries. Rob, Joseph, Kathleen Chmelewski, and I partnered about 1995–98 and made what we felt was empathic art using the computer and the Internet in a time where much of it was non-narrative and abstract. Joseph is an only child and often worked alone before our collaborations through ad319. As I said, I'm a twin and like to collaborate on everything. I believe that ideas from different collaborators can create something unique and that's what's exciting to me. Joseph got used to that style of working. Collaboration is how many of the ad319 pieces were created.

Joseph and I did the website for an English punk rock band, Elastica. Geffen Records liked the piece so much they asked us if we would design their whole website. One day I called Geffen and talked to a really young guy on the phone. Finally I said, "How old are you?" He said, "I'm twenty-seven." "Do you realize you hired two forty-year-old people in the middle of the cornfields to design your website?" I replied. The significance here is that the web changed everything for Midwest artists like us.

For about six or seven years, Joseph and I curated art and facilitated pieces for artists to show on the website.[2] The first two shows were digital photography. After that we decided to only show "web art," artwork created for the web that only exists as a web piece. Back then they didn't call it "web art." Joseph created one of the first web artworks, which was featured in the *New York Times* in 1995. At that time, the university administration didn't understand our web work as research art so it was separated from my design work for the tenure process.

[Eventually, the Walker Art Center] absorbed "the place" [ad319]. We began curating another show for the Krannert Art Museum, *Art as Signal: Inside the Loop*, an international exhibition of electronic art. Kathleen Chmelewski helped us around 1995. We had no idea what we were getting into. It ended up being a very smart thing because we met many other artists around the world. There was no Lynda.com. The only way to learn Unix and HTML was by downloading and playing with source code. To this day I can still write HTML faster than using Dreamweaver.

Art as Signal was significant because it went beyond showing digital images on a wall. We curated pieces that had some empathic kind of feeling to the artwork. One of my favorite pieces at that time was by Jean Louis Bossier. It was beautiful and evocative. Joseph and I were collaborating in New Media, creating works that were like narrative games. You could travel through a story

In[side]out, 2000. An interactive multimedia artwork, created in collaboration with Professors Joseph Squier and Robb Springfield, exploring the conceptualization of private and public space. Courtesy of Nan Goggin.

Nan Goggin's workspace at the University of Illinois. Courtesy of Nan Goggin.

with us. As you touched things, text and verbiage would emerge. You could follow a path and find your location at the end; it was a narrative game piece. It relates to input/output and the Greek myth about Zeus's affair with Io. Jealous Athena banished Io to Earth as a heifer cow. When Io was scratching in the dirt with her hoof, her father recognized that she was Io because she could write something. The idea is that you are human if you can write. We made a computer piece that could write to you and could write poetry. As you put more information into it, such as images and text, it would create for you [see p. 137].

About 1998, we created a CAVE work. Rose and Rick Marschak developed the CAVE code for that narrative entitled *360* [see p. 137]. I was turning forty-five and thinking about making irreversible life choices, much like a computer or design loop. Life is like a series of "if/then" statements and this piece is about making a choice when other choices aren't allowed anymore. In the CAVE, you could hear the same story in the context of a young couple, an older couple, and a really old couple. We were interested in things like that then, but now computer work is not as touchy-feely and a lot more intellectualized.

[Many UIUC graduate students] wanted to work with Joseph and me, but there was no program. These students didn't belong in traditional graphic design, so we started the New Media program. At first we hand-selected graduate students from computer science, graphic design, fine art, English, and other disciplines. Every student was radically different. People like Rose Marschak didn't have traditional art background, so we had to place people to get a foundation while learning web art. Others had a lot of photography and video but didn't have digital training. It was very interesting and fun. I was the only designer in the group of teachers. I was always trying to cross

fine art with design because I didn't see a big line between the two.

Red Grooms was one of my favorite multi-media artists from the 1960s and one of the first people to create "happenings." He used humor and crossed the boundaries of technology and media. I was always interested in how people juxtaposed text and image for communication. I look back on my life and it makes sense that video and digital media were primary interests. Computers made it easier to blend these ideas.

Sometimes women have to deal with stereo-types. For example, when Joseph and I presented our collaborative work, people would invariably talk to Joseph even though I was responsible for a lot of the coding. I was just sort of present. They probably didn't realize the level of my contribu-tion. Many professional colleagues wanted me to be a part of the crowd so they could say a "woman works here." I was lucky that the people with whom I collaborated had that attitude. Joseph would never have taken credit for my work. We collaborated on lots of projects. In the early days he would say to people, "We're doing this work together but I have my own work." Perhaps guys seem to need to establish that kind of inde-pendence. But I didn't care. Eventually Joseph described our collaborative art as "our work."

From a female point of view, I think women care more about all kinds of communication because we want to discuss things. Digital com-munication tools will be changing the future on a lot of different levels, not just the social. Digital communication can be ubiquitously recovered or accessed. Unfortunately we will develop more ways to hide our communications rather than making more public. Early social media like Facebook was motivated to share and get everyone on the same page, to let everyone "see my world." In the future, the motivation will be to find secure, safe, and private communication places.

Students and faculty here in Illinois have great opportunities. It has been relatively easy to get equipment grants at the University of Illi-nois, although it is difficult to maintain the hard-ware. Academia has been a bit of struggle for me because I am dyslexic. I perform better if I have an image and can talk about it. What makes me a good designer and now administrator is that I can see and imagine five things at the same time. I see relationships and assemble things together. Computers and the Internet have enabled me to integrate interests and pioneer new avenues. I am glad to have been in the Midwest during these exciting times.

||

Notes

1. Christo and his partner, Jeanne-Claude, were a married couple who were famous conceptual artists best known for their wrappings of large environmen-tal landscapes. In 1969, they wrapped the MCA for its opening, which became the first building wrapped by the duo in the United States. The couple shared a birthday, June 13, 1935, and until 1994, only Christo was credited for their work.

2. @art gallery was developed in 1995–98 and was one of the early examples of art-curated websites that featured sequential one-person exhibitions.

Mary Rasmussen

Mary Rasmussen, professor emeritus at the University of Illinois, is a New Media artist and bio-visualization specialist. As a graduate student, she was part of a team that developed software to aid in the location of missing children. In 1989, Rasmussen graduated with an MFA from the Electronic Visualization Laboratory (EVL) at the University of Illinois at Chicago (UIC) and joined the faculty of the Biomedical Visualization Department at UIC. She developed and taught the department's first computer classes for medical illustrators and sculptors. In 1997 she founded the Virtual Reality in Medicine Laboratory (VRMedLab) at UIC. She led collaborative teams of surgeons, medical specialists, computer scientists, and artists to create networked virtual reality applications for educational and clinical use, and she developed the grants that provided the VRMedLab's public and private funding. She led teams that received the Dr. Frank Netter Award for Special Contributions to Medical Education in 1998 and 2007.

In the art community, there was this notion that artists are lone creatures. I never wanted to be the solitary artist. Anything I would've done by myself would not have been as interesting. Donna J. Cox pioneered scientific visualization Renaissance Teams and created an awareness of the power of collaborative teams of artists and scientists. That really helped me in my career.

The first time I programmed a few moving images on the screen [as an undergraduate at the University of Illinois at Chicago], I was totally addicted. It was an amazing experience. I realized I needed more mathematics to be able to program my visualizations. Back when I was an undergraduate in the late 1970s, the Art Department offered a comprehensive major that was a result of the Bauhaus influence on the department [see pp. 5–6]. That allowed me to design my own curriculum. So I actually took a lot of mathematics and computer programming courses along with my art training. My advisor was very gracious and said he wasn't sure what I was doing but I seemed to know and so he let me do

it. Although I was the only art student in most of those engineering and math classes, I found the students and faculty to be very open and supportive. This combination of fields may have been unusual at the time, but it provided me with golden opportunities to do useful and interesting work.

Job openings were listed in the newspaper under either "Help Wanted, Male" or "Help Wanted, Female." The interesting and good-paying jobs were definitely not in the "Help Wanted, Female" section. Feminism helped me to raise my dreams and expectations for a career, a fair wage, and a full life. Feminists had to work for decades to get the antidiscrimination provisions of the Civil Rights Act enforced for women and I can't imagine what my life would have been without their extraordinary effort.

We worked with a variety of law enforcement agencies through 1994 to locate missing children and used the system to assist surgeons in planning reconstructive surgeries of children who had facial deformities because of accidents or

disease.[1] I was the principal programmer and interface designer for this project. In 1989 it was awarded the Computerworld/Smithsonian Award for Heroic Use of Information. This was a real example of the power of a collaborative team.

We were working so hard, I had ignored my studies a little. It was time to graduate. My boss said, "Hurry up and graduate and I will offer you a job." I thought I could take what I had learned about the human face and apply it to my MFA thesis show. I took anatomical landmarks on the human face and mapped them to homologous points on a variety of animal faces—dogs, cats, tigers, chimps, mice, and even bats. The computer then automatically aligned the homologous, or structurally equivalent points of the player and the selected animal, and morphed the human face to fit accordingly. Mouths on cats became small and delicate; noses on horses became long and flat. The software was also smart enough to retain facial information so that different players could be morphed into the same animal and still look different.

Ellen Sandor, a pioneering 3D graphics artist, was a mentor on this project who helped me figure out where I could install this show.[2] She suggested Maxine Kroll's fabulously upscale salon on Michigan Avenue. Ellen taught me the power of presentation and mentored this project to its glamorous conclusion. A hair salon seemed a good choice as not only would we be guaranteed a reliable electrical system but there was something fun about taking a sleek salon where people usually came to improve their appearance, and for one evening map their faces into the faces of animals instead. Again, a collaborative team was essential to the success of this project. Fellow graduate students in white lab coats acted as facial stylists. PhD student Robert Grzeszczuk developed the morphing engine. Lewis Sadler provided his full support, and Nancy Burson's early morphing work provided inspiration. Maxine Brown's portrait of herself morphed into a mandrill was used as the visual icon for SIGGRAPH '92 in Chicago for which she was the conference chair [see p. 138].

This department [the Biomedical Visualization Department in 1989] had a long tradition of artists who were medical illustrators and medical sculptors. They worked with surgeons, medical professionals, and scientists. Medical illustrators did visual communications for the medical and biological sciences. Medical sculptors created physical 3D models for teaching as well as

prosthetics for patients. There were a lot of interesting people there and they decided it was time to computerize.[3]

Marc Andreessen and Eric Bina, students at our sister campus at the University of Illinois at Urbana, sent us a copy of their new graphical web browser called Mosaic [see p. 37]. It was amazing. I will never forget it. We installed it on one of our Silicon Graphics Inc. (SGI) machines because it could only run on Unix. I remember thinking this was something that was so elegant and clearly transformative. There was so little to look at on the web back then that the National Center for Supercomputing Applications (NCSA)

An early example of the Bauhaus: "Photogram," 1925, László Moholy-Nagy, 9⅜" × 7" vintage sepia-toned photogram from the Richard and Ellen Sandor Family Collection. Digital photograph by James Prinz Photography.

Evolution II, 1984, Nancy Burson, 7" × 7" vintage gelatin silver print from the Richard and Ellen Sandor Family Collection. Digital photograph by James Prinz Photography.

show museums how they could get their collections online to let researchers around the world measure and use those collections remotely. Paul's work was the first 3D interactive application on the web.

Working with the Urbana students was just amazing and it was a great time for us to have access to our cutting-edge equipment and software. The Field Museum website won a couple of awards. I won a Women in Technology Award and the site won a MUSE Award.

We had a few SGIs, and EVL's new virtual reality (VR) display called the ImmersaDesk [at the Virtual Reality in Medicine Laboratory (VRMed-Lab) at the University of Illinois]. The first application the VRMedLab developed was called the "Virtual Temporal Bone." Dr. Theodore Mason, a surgical resident in the Department of Otolaryngology–Head and Neck Surgery, had a human temporal bone that had been sliced and mounted on big glass slides. Encased in this bone are the organs of hearing and balance. He wondered if we could use these slices to build a 3D computer model that would better communicate this complex anatomy. Dr. Mason explained that when performing surgery in this region he must rely on a precise knowledge of the complex interrelationships of the structures hidden within the temporal bone so that the few anatomic landmarks would provide clues as to where drilling would be safe and where it would lead to disaster. Drilling one millimeter in the wrong direction could mean permanent deafness, facial paralysis, bleeding, or weeks of dizziness and possibly permanent loss of balance. This sounded like a perfect use of our networked VR ImmersaDesk. Not only could we build 3D digital models that could be viewed and interacted with in stereo, but we could leverage the networks to allow experts to teach this anatomy to students around the world.

At the time [of the debut of their work in 1998 at the Internet2 Conference in Washington, D.C.], President Clinton's science advisor was there, and Senator Bill Frist, who was the only physician in the Senate, was there. Senator Frist tried it and said, "If I had this, I could've learned this anatomy in hours instead of days," which was great. We then applied for National Institutes of Health (NIH) funding and they gave us one million dollars to further develop it. NIH does not like to see "MFA" as the degree of the principal investigator. I asked a collaborating physician to be the PI for our proposal and I was the co-PI. These applications produced really compelling

was able to keep a "What's New" list of what was new to browse every day. Eventually we came across a website that could generate a personalized tarot reading for you and that's when we realized that we could program a CGI script to output dynamic results. That was stunning.

[This discovery led Rasmussen to make a formal proposal to the Field Museum of Natural History in Chicago] to get some of their collections online with this new technology. They agreed. It was a great project because I could bring in a lot of enthusiastic students to work on it. We put the first round of the online Field Museum on the web and let NCSA know that it was live. They put it on their What's New list and it immediately brought down our best SGI computer server because there was so much traffic. We actually had to beef up our system at the lab to run it.

Electronic Visualization Laboratory (EVL) PhD student Paul Neumann worked on this with me and he developed an SGI Inventor application that displayed a 3D model of a T-rex tooth. Not only could you zoom in and look at the tooth from different angles, but also you could take measurements of the tooth. This was used to

imagery, and when they were touring people through our college, they always brought them to our department.

The kinds of things we did you could only do as a team. It took so much specialized expertise that you had to pull together a team. Early on, it became clear that if everybody had ownership of the project, that people were more motivated, happier, and worked together. The people who were the major players understood this was a project where the credit was split between all of us. Most of the time that worked really well. Occasionally there were people who did not like that setup, but that was rare.

This work led to further funding for new VR applications. We worked with colorectal surgeon Dr. Russell Pearl to develop the "Virtual Pelvic Floor," a complex region of human anatomy that is underrepresented in medical school curriculums. We also worked with Professor Richard Fiscella to develop the "Virtual Eye." Rita Addison and EVL student Marcus Thiébaux had earlier used VR to simulate Rita's diminished vision after a car accident. We'd always used VR to see things better but now we realized we could use VR to make things look worse. It's very hard to understand verbal descriptions of visual phenomena and it's even harder if you've never experienced something similar. We built a 3D model of a house that users could "walk" through and try to perform everyday tasks. Views for the left and right eyes were computed separately and that gave a pretty realistic experience of glaucoma, macular degeneration, and diabetic retinopathy. We wanted to provide healthy people with the opportunity to understand what friends and loved ones with eye diseases faced every day. We found that using this system had a powerful effect on the viewers.

I had worked with Professor Ray Evenhouse, a famous medical sculptor, on many projects over many years. One of the most amazing projects was "A Tele-Immersive System for Surgical Consultation and Implant Modeling." Ray had pioneered new techniques for using patient CT data to design implants that fit precisely into missing parts of the skull. These implants were used in nine surgeries and cut operating room and hospital stays dramatically, and people recovered faster and performed better. Our networked VR allowed Ray to collaborate on the design of implants with neurosurgeons in other locations. For sculpting, the sense of touch is very important and we added a haptic interface

The Virtual Temporal Bone Team, 1998, networked ImmersaDesk virtual reality system. Clockwise from left: Dr. Edward Applebaum, Dr. Ted Mason, Prof. Ray Evenhouse, Prof. and VRMedLab director Mary Rasmussen, research assistant Alan Millman. Not pictured, Prof. Walter Panko, director of the School of Biomedical and Health Information Sciences, UIC. Photo: Roberta Dupuis-Devlin. Courtesy of Mary L. Rasmussen.

"The Virtual Pelvic Floor." Colorectal surgeon Dr. Russell Pearl used networked virtual reality to give an anatomy lesson of the complex pelvic floor region to students both local and in networked remote locations. 1999, Mary L. Rasmussen, director, VRMedLab, UIC. Courtesy of Mary L. Rasmussen.

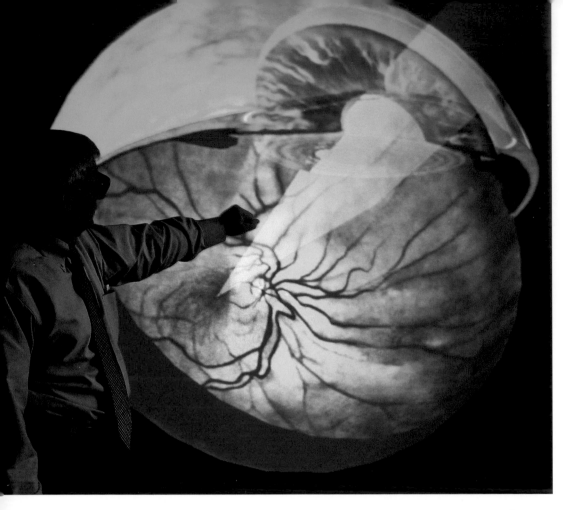

"The Virtual Eye," 2006, C-Wall virtual reality display description. Using 3D computer modeling and VR technology, we created an affordable, portable VR application that provides an interactive exploration of the anatomy of the eye showing normal anatomy and ocular disease states, as well as a simulation of impaired vision. Outer structures can be peeled away to allow viewing inside the eye, and changes due to ocular diseases including glaucoma, macular degeneration and diabetic retinopathy are demonstrated. Courtesy of Mary L. Rasmussen.

superimposed over the patient's CT skull images. The computer program designed by Professor Zhuming Ai created a rough implant by filling in the missing part of the skull, and Ray used the system to refine the implant while collaborating with a neurosurgeon remotely. The finished implant could then be sent out for 3D printing.

I have always lived in the Midwest. During the time I was working, there was a real open collaborative feeling. In general, when people invented something or had developed a new algorithm or discovery, they were very sharing, which was incredibly helpful. We were always looking for ways to apply new tech to medical problems and were really fortunate to find good collaborators who were open to applying VR and computer technology to their medical specialties. We had to work hard to keep funding coming, and my least favorite job was writing grant proposals. On the other hand, I was always amazed that I got paid to do this work that was so interesting. I have no complaints. We're all smarter because of the web, and the graphical browser that came out of Urbana showed the way. Since I retired, I spend many hours a day online. In my life, the web is better than anything I could have imagined or wished for. It is the most transformative technology that I have experienced, and I am glad to be alive when it's here.

Notes

1. While a graduate student in the Electronic Visualization Laboratory's MFA program, Rasmussen worked as a research assistant in the Biomedical Visualization Department (BVis), part of the UIC medical campus. Professor Lewis Sadler, head of BVis, and Scott Barrows, a prominent medical illustrator, pioneered the visualization of facial growth in children to assist law enforcement in the recovery of children who had been missing for years. Sadler secured funding to computerize the process and led a team of physicians, medical illustrators, computer scientists, and computer graphics experts to design a system that predicted and visualized facial growth in children.

2. Rasmussen also created PHSColograms of mathematical forms for her MFA project.

3. Rasmussen was hired to bring the power of computer graphics to those activities and to develop the department's first computer classes. Her classes included operating systems, use of networks and web authoring, and 3D modeling and animation. As the department's research evolved, she developed paths for students to participate. One early research project involved the use of the new World Wide Web.

Dana Plepys

III

Dana Plepys is an artist-videographer who participated in the burgeoning Chicago video art scene in the 1970s–90s. She is an associate director of the Electronic Visualization Laboratory (EVL) at the University of Illinois at Chicago and serves as the editor/administrator for the ACM SIGGRAPH Video Review (SVR), one of the largest video publications of computer graphics in the world. Dana is also the director of the CineGrid Exchange, a distributed digital media archive, supporting research, development, and preservation of super-high-resolution content. Dana lives in Chicago with her husband and three children.

II

I was also very interested in film and film history [at the School of the Art Institute of Chicago (SAIC), from which she received her bachelor's degree in 1981 with a specialty in photomechanical printmaking]. Early abstraction in film influenced my visual aesthetics for photomechanical serigraphs. I was very fortunate at the time to experience media art with Sonia Sheridan's Generative Systems before it was folded into what became the Film and Video Program at SAIC.

I discovered the Video Data Bank [at SAIC]. It was an amazing resource—an unusual mixture of an art library, consisting of video recordings, experimental films, and the like. Creative work was being generated and preserved at the same time. Artists participating in the Chicago Video Data Bank inspired and influenced my later work: people like Barbara Sykes, Drew Browning, Jane Veeder, Phil Morton, Annette Barbier, and others. After having received my BFA, I became keenly aware of these communities of artists experimenting with video and computer graphics both at SAIC and at the Electronic Visualization Laboratory [EVL] at the University of Illinois at Chicago [UIC]. Fortunately, this tight-knit community embraced me along with some of my other colleagues like Sally Rosenthal and Kathy Tanaka. It wasn't competitive; rather it was inclusive, and people encouraged others to get involved. At that time, the Video Data Bank was a very unusual place: a whole social network of people, working together to learn, get inspired, and make artworks. People helped others to produce artworks as well. The social constructs were very strong and in many ways similar to Facebook social networking.

I continued to look for opportunities [after graduation] to hone my craft and make art, so the Center for New Television [CNT] was an important resource. It was a culturally diverse community-based underground cooperative that supported people who were making documentaries. It had galleries, equipment, and editing facilities and access to an educational institution. *The Kitchen* in New York provided a similar environment, but CNT was radical for Chicago. I continued to be involved with CNT over the years and served on the board of directors from 1993 to 1994.

In 1982, I decided to apply to graduate school at UIC/EVL. The sense of community appealed to me. Artists were contributing their artwork to "happenings" and "experiences." At the time, I started working with the Sandin Image Processor (analog). The images I could create were very similar to my photomechanical silkscreens, yet

the IP could produce hundreds of images with similar color schemes and techniques while moving through time. The IP provided a much faster turnaround in the completion of artwork. ZGrass was very tangible and enabled me to learn a high-level programming language, applying my strength in mathematics to create electronic art. After I discovered the IP and computer, I could produce videos and create paper still frames from the videos. It was just amazing! I had sixty frames per second to explore what would have taken months to produce with traditional methods. Prior to using electronic technology, I produced images on paper with a large-format process camera. Suddenly, I could experiment with these types of images with almost immediate results while dialing various effects on the IP. The electronic technology gave me the ability to advance my craft and develop a more refined aesthetic. Coupling processed video with computer graphics being routed through the IP resulted in richly multilayered imagery. This was indicative of my earlier 2D print works, where I drew by hand on top of the printed silkscreens to layer imagery [see p. 140].

Among my strongest recollections of work during this period [in 1984, after Plepys graduated from EVL and began working as a freelance videographer, video editor, and audio engineer] was videography for the *MTV Basement Tapes* show. The show's videos were shot all over the world and broadcast out of New York. Martha Quinn was the host of the show; a young female host was novel. They shot a series of programs in Chicago. MTV was emerging, and they shot very creative, underground guerrilla-style video that changed the face of cable television. Early music videos were produced as part of the *MTV Basement Tapes* show. The MTV logos changed continually. These visual innovations were very exciting and incorporated a lot of experimental video techniques. Today many contemporary music videos reflect some of those early innovations. I was fortunate to have the opportunity to work there, see the productions, and be involved in pioneering a unique aesthetic applied to cable television.

After my MTV experience, I was very fortunate to work with a company called Telaction from 1986 to '89. Telaction was a subsidiary of the JCPenney Company. They were the first teleshopping cable television channel that predates the Internet. It was interactive home shopping on a cable channel. People used a push button telephone with no special equipment to interact with

catalogs from a broad variety of stores. Consumers could fill their shopping bag with groceries directly from the wholesaler, and products would be delivered to their home. The concepts were groundbreaking. A Canadian firm, Cableshare, Inc., developed the technology for which JCPenney had major investments. I was Telaction's first computer graphics artist and designer, eventually managing a group of twenty artists. A lot of freelancers contributed to that project. One freelancer was Bob Patterson, who eventually worked on scientific visualization at the National Center for Supercomputing Applications (NCSA).

Working at Telaction was a real turning point for me—I realized that my strengths went beyond the computer graphics paint box. My ability to manage and collaborate enabled me to facilitate, motivate, organize, and shield the artists from administrative burden. I still play that type of role today where I facilitate, inspire, and communicate among different groups of people within a project. Telaction was a $106 million field-test that was too far ahead of its time and basically failed. With the advent of the Internet, shopping over the web provided the services that the Telaction Chicago field-test had attempted several years earlier.

The focus was on technology transfer [around 1990, when Plepys began producing videos for the Software Technology Research Center at UIC to document research projects] from the university to industry, primarily educating industry professionals about computer graphics and visualization. I helped to promote research and visualization to companies like Monsanto, Amoco, General Motors, and to a broader audience outside the educational arena. I was also responsible for business and financial administration over early grants and contracts that included awards from AT&T and the Illinois Department of Commerce and Communications. In 1991, I had the opportunity to join EVL and began working within the university to facilitate and bridge the gap between the researchers, technologists, artists, and the administration of the university.

I worked with Marc Andreessen at NCSA and supervised a group of research assistants to build and test greater functionality and layout capabilities for Mosaic [see p. 37]. To interactively document the VROOM exhibition at SIGGRAPH 1994, we developed a standalone application that incorporated a virtual reality simulator, called CAVEViewer. Mosaic provided the underpinnings and a scripting language for authoring

this nonlinear interactive desktop application to access images, textual information, credits, and to peruse VR environments in real time on a desktop system. EVL's early enhancements to the original Mosaic application characterized how embedded web pages, movies, and plug-ins work with browsers today. Our group was very involved with the first World Wide Web Consortium conference at the Hyatt Regency, downtown Chicago. EVL also used Mosaic and produced a prototype website for the City of Chicago to promote website development, distribution, and the use of the Internet.

As a student, I edited videotapes for the SIG-GRAPH conference. I returned to those responsibilities as the administrator of the SIGGRAPH Video Review (SVR) in 1993, producing nearly one hundred programs and managing the SVR archive. Initially, the SVR was a kind of a grassroots effort where people sent their computer graphics material to Tom DeFanti, who selected, edited, and published the work as a document for the SIGGRAPH conference. Over the years as the SVR grew, so did the audience expectation for a high-quality, professionally produced product. A good portion of the early material was also sent to EVL on film. These assets needed to be transferred to video and required the use of postproduction facilities outside the scope of in-house editing at EVL. Transitioning the production of the SVR from EVL to postproduction facilities in the Chicagoland area afforded me the opportunity to reconnect with associates from Telaction, the Center for New Television, the Illinois State Gallery, and other Chicago organizations. For many years, I was able to procure donations of production and editing time for the SVR. Working with burgeoning postproduction environments and with some of the best and brightest professionals producing commercial work was incredibly rewarding.

Over the years, I've tuned my eyeballs, refined my evaluations, and extended my knowledge base about the people, technologies, and techniques in order to better educate others. I've taught at Columbia College, Northeastern Illinois University, and the University of Illinois art departments, evaluating students' abilities, providing resources and guidance for their careers. Having served on a good number of graduate thesis committees has honed my ability to inspire and motivate. Keeping abreast of the current trends in the field of computer graphics is a foremost personal objective.

CineGrid is an interdisciplinary community focused on the research, development, and demonstration of networked collaborative tools to enable the production, use, preservation, and exchange of very high-quality digital media over photonic networks. I direct the CineGrid Exchange (CX), a distributed digital media repository. A goal is to preserve original high-resolution media, addressing issues like capturing metadata for cataloging assets or migrating to new formats, etc. My work with the CX is an extension of the kind of work I've been involved with for nearly two decades for the SVR. It is also a continuation of my interests as an artist and videographer. I am still working in the moving picture industry—only it's in the context of collaborating on a long-term, large-scale process to document digital images and technologies for the future.

Maxine Brown

Maxine Brown is a pioneering leader in technology at the University of Illinois at Chicago (UIC). As director of the Electronic Visualization Laboratory, she's recognized for her professional and academic excellence. She is a cofounder of the Global Lambda Integrated Facility (GLIF) [see p. 141]. In recognition of her services to UIC and the community at large, she received the 1990 UIC Chancellor's Academic Professional Excellence (CAPE) Award, the 2001 UIC Merit Award, and the 1998 ACM SIGGRAPH Outstanding Service Award. In 2009, Chicago's award-winning multimedia public affairs series *Chicago Matters: Beyond Burnham* designated her as one of fifteen Global Visionaries for her role in codeveloping StarLight, an international/national hub for advanced research and education networks. Her long and successful career from graduate school to industry to academia has been devoted to fostering computer graphics and the arts.

As a writer, I have helped define the technology revolution through documentation, grant writing, and promotion. As an organizer, I bring together institutions, people, their talents and abilities. As a mentor and self-described "EVL [Electronic Visualization Laboratory] Mom," I have tried to serve as a role model and an inspiration to the many young men and women who attended the University of Illinois at Chicago (UIC). I am proud that members of the EVL "family," who are also my friends and former students, are profiled in this book: Copper Giloth, who launched the SIGGRAPH art shows; Sally Rosenthal, who provided volunteer effort for *The Interactive Image* when I first arrived; Dana Plepys, whose attention to detail equals my own but who has my total admiration for her artistic and epicurean abilities; Mary Rasmussen, who as a student worked on a program to age faces and then adapted it to morph my face into a mandrill (a computer graphics icon) that was used on a SIGGRAPH '92 T-shirt [see p. 38]; Carolina Cruz-Neira, affectionately called "CAVE Woman" for her pioneering work on the Cave Automatic Virtual Environment (CAVE); and Margaret Dolinsky, whose artistic renderings of faces I loved and who got her first (and still only) job by helping do CAVE demos for individuals from Indiana University [see pp. 195–96].

Through all of these years, I have fostered the development of computer graphics technologies and helped proliferate artistic uses of these technologies. I wanted to be an artist when I was in high school, but I was very analytical too. As a child, I took art classes at the Philadelphia Museum of Art, and in high school, I had a four-year scholarship to take classes at the Philadelphia College of Art on Saturdays. At one point during my junior year, I broke out in psoriasis because I had to make a big decision between taking a double art major as a senior in order to build a creative portfolio for art school or to take math and science classes that would provide more options for college.

I always liked commercial art but I was very good in math. I had a wonderful math teacher

who said, "You're good at math. You ought to consider going into it." I was good in chemistry and lots of other subjects, but I decided to go into math and make art a hobby, not a vocation. In college and grad school, I ended up volunteering for numerous student organizations and would design logos and brochures to satisfy my artistic urges. When I was looking for a master's thesis topic in graduate school, one of my professors came to me and said, "You like to draw. I need someone to draw pictures. Are you interested?" My professor, Steve Smoliar, loved classical music and ballet. He was aware of labanotation and that IBM had just introduced a type ball so notators could laboriously "type" symbols on typewriters, and said, "If labanotation can be mechanized, it can be computerized." Because he knew I liked to draw pictures, Steve introduced me to the fledgling world of computer graphics and set me on my life's course.

Although I don't create art, I write about it so that others can appreciate the need for both art and technology. I help our EVL students promote their work and write their résumés to get jobs. Many students stay in contact over the years. I have an extensive historical SIGGRAPH poster collection, as well as prints from computer graphics luminaries, but many of the pieces are now fading, so I have put many pictures in storage. I enjoy living in Chicago where there is a lot of art and architecture. EVL has been an extraordinary place to be. I only intended to stay for a short time, but I've been here for over twenty-six years and it's still a wonderful adventure.

My story begins back in 1976. I received a master's degree from the University of Pennsylvania in the days when computer graphics was essentially line drawings on vector displays. My thesis was in computer graphics and dance, a novel exploration in art and technology for that time. I focused on labanotation, a language for notating body movement. The notation is analogous to music notation on paper versus listening to a recording of a musical concert. A musical recording conveys how instruments sound together, but the notation denotes specific notes for specific instruments. Similarly, a video recording of a dance performance visually captures how dancers all move together; labanotation denotes specific movements of specific body parts at specific times for individual dancers. The works of major choreographers, such as George Balanchine, were documented using this system. Labanotation was also used by Margaret Mead

EVL at the Supercomputing 1993 conference in November 1993. Some members of the UIC's EVL attended the Supercomputing 1993 conference to showcase the CAVE but took time out to celebrate Dan Sandin's birthday. Top row: Jim Barr, Sumit Das, Terry Franguiadakis, Trina Roy, Randy Hudson, Carolina Cruz-Neira, Chris Cederwall, Marcus Thiébaux. Front row: Tom DeFanti, Maxine Brown, Dana Plepys, Maggie Rawlings, Gary Lindahl, Dan Sandin. Foreground: Michael Papka. Courtesy of Maxine Brown.

A screenshot with Sandor and Cox listening to Brown's presentation at the School of the Art Institute of Chicago's (SAIC) symposium held during its 150th anniversary, *Celebrating Women in New Media Arts*, on March 18, 2016. Sandor, Cox, Brown, and Holmes contributed presentations to the panel "Topics in Art and Science: Data Visualization," with an introduction by Sabrina Raaf.

Whitney/Demos Productions' Connection Machine, 1987. Maxine Brown stands with Gary Demos, cofounder of Whitney/Demos with partner John Whitney Jr., in front of the company's Connection Machine supercomputer. Brown previously worked for Demos and Whitney at Digital Productions. Courtesy of Maxine Brown.

to document tribal dance movements. I can still read and understand it. For my graduate work, I created a computer editor to enable notators to efficiently type and edit symbols rather than draw with ink and pen. This was a very novel approach in the 1970s, before word processing and PCs.

After graduation, I lived in California and developed my career and interests in computer graphics, technical writing, and public relations. I realized that I'd rather talk to people than program machines. Working at ISSCO, a business graphics software company, was a great experience, and later I moved to Los Angeles and worked with the startup Digital Productions [DP], a famous Hollywood production business. Computer graphics pioneers Gary Demos and John Whitney Jr. started DP and purchased a supercomputer to render special effects. One of DP's first major films was *The Last Starfighter*, a classic in computer graphics history.

During this time, ACM SIGGRAPH was rapidly growing with the emerging industry and academic research. My first technical presentation at SIGGRAPH '76 changed my life. For the next twenty-five years, I became very active in SIGGRAPH and met a lot of wonderful people and graphics pioneers. Tom DeFanti, professor at UIC and codirector of EVL, was an officer of the

SIGGRAPH organization and cochair of the 1979 SIGGRAPH conference in Chicago, Illinois. When I started going to SIGGRAPH, only twelve companies exhibited at the conference. In 1979, I was in charge of the tradeshow exhibition along with two other colleagues, Jim George and Steve Levine. We began to grow the SIGGRAPH tradeshow to a record number of exhibitors. We did a lot of homework and twisted arms. In preparation for the conference, I frequently traveled to Chicago for meetings and that's when I befriended many of Tom DeFanti's students at EVL, including Copper Giloth, Frank Dietrich, and Zsuzsanna Molnar. I'm still good friends with them. We were all about the same age. They called themselves the "Chicago Mafia," and I loved it! I loved the fact that EVL (pronounced "evil" as a joke) was an interdisciplinary environment with artists as well as engineers. EVL computer science and art students collaborated on projects, enabling computer students to learn aesthetics and art students to learn programming. EVL produced interactive Electronic Visualization Events (EVE) to provide a public venue for students to showcase their work. People who were interested in technology and art came from all over the world to study at EVL. It was a place of excitement and growth and ultimately attracted me to move to Chicago.

ACM SIGGRAPH '84 Electronic Theater, 1984. Maxine Brown, chair of the SIGGRAPH '84 Electronic Theater, sits with Phil Morton in the audiovisual control center during the show, held in Minneapolis. Morton was head of the conference's Audio/Visual Group while he was an SAIC faculty member. Courtesy of Maxine Brown.

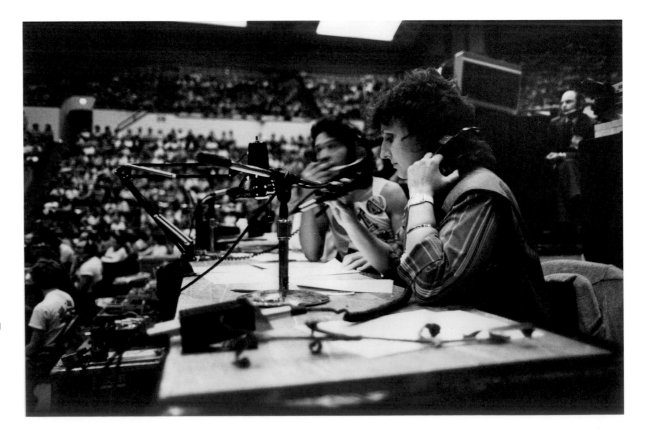

The first time I met Donna Cox, an art professor at the University of Illinois at Urbana-Champaign [UIUC], was during the Pacific Northwest Computer Graphics conference in Eugene, Oregon. For several years, the conference organizers invited me to their events to showcase the best of the SIGGRAPH Electronic Theater. Donna introduced me to Larry Smarr at his first SIGGRAPH conference in 1986—a pivotal year because of two major events that catapulted the computer graphics industry. Silicon Graphics Inc. introduced graphics workstations and Wavefront Technologies sold computer animation software. Before that transformation in the industry, production companies with proprietary software dominated high-end computer graphics. Suddenly, graphics workstations and animation software became available. Most of these new companies didn't realize they needed the artist's aesthetic sense to create amazing work. However, this industry transformation paved the way for low-cost computer graphics hardware and software that small companies and individuals could afford. Established high-end productions houses like Digital Productions and Robert Abel and Associates began to lose clientele. This resulted in a decline in opportunities that affected my own career.

At the same time, EVL was gushing with creativity and technology while my high-performance Hollywood world was constricting. Tom DeFanti asked if I wanted to move to Chicago and help him write grants to raise money for a computer exhibit called *The Interactive Image* that EVL was developing for Chicago's Museum of Science and Industry [see p. 74]. With great enthusiasm, I moved to the Midwest. NCSA also provided support for this show, enabling me to work more closely with NCSA as well as EVL.

When I joined EVL, I became a writer, historian, and commentator of this unique intellectual research environment. DeFanti acknowledges that I taught him how to turn pictures into words in order to get grant money to make pictures. *The Interactive Image* proved a great success. After that, our first big grant came from AT&T to work with the UIC Biomedical Visualization Laboratory to create an interactive computer system to age faces of missing children. That was a turning point at EVL and led to many funded projects.

At the SIGGRAPH '89 conference, NCSA wanted to push boundaries and demonstrate how future networks would enable scientists to collaborate over distance. NCSA organized the

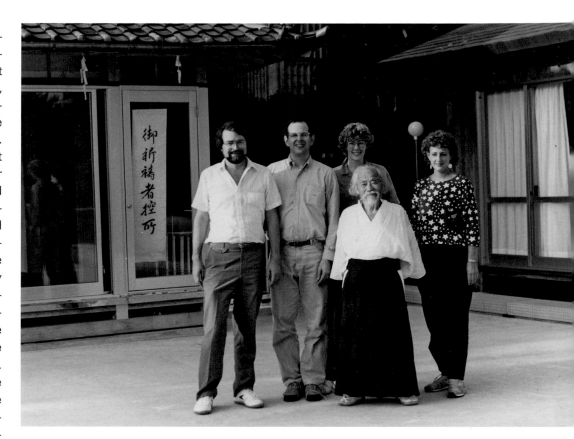

After participating in a Scientific Visualization Workshop in Tokyo, Maxine Brown and colleagues visited Sensei Shoei Isogai at the "Shrine of the Sacred Seal" in Gamagori, Aichi Prefecture, Japan, 1988. Shown here with the sensei are (left to right): Larry Smarr, Laurin Herr, Trisha Gorman, and Maxine Brown. Courtesy of Maxine Brown.

Maxine Brown at EVL, 1988, working at her desk. EVL art student Fred Dech (left) is working on his projects in the lab. Courtesy of Maxine Brown.

Maxine Brown having dinner at the Pump Room restaurant with Sally Rosenthal (left) and Ellen Sandor (right), 1989. Courtesy of Maxine Brown.

Maxine Brown, 1991, at EVL with PHSColograms developed by Ellen Sandor and (art)n produced in collaboration with NCSA scientists (*Benzene Passing through a Faujasite Ring*, 1990) and EVL alum John Hart (*Extensions to the Twin Dragon*, 1990). Courtesy of Maxine Brown.

presentation *Televisualization: Science by Satellite* in a small theater as an unofficial conference event and gave out tickets for three shows, with three hundred people each. I attended one of the shows. A video of then-senator Al Gore talking about the importance and future of networking and visualization—which EVL helped produce— was used to introduce the demonstration [see pp. 33–34].

During 1989, I was asked to cochair the SIG-GRAPH '92 conference, which was to be held in Chicago. I've volunteered organizing almost every venue at SIGGRAPH, but I'd never aspired to chair the entire conference, so I was hesitant. Both UIC and NCSA encouraged this cochair position, and provided my salary for three years so that I could focus and plan. I decided to use my new position to showcase innovation from EVL, NCSA, the University of Illinois, and other research institutions. In 1991, my cochair resigned, leaving me with full responsibility for the Chicago conference. By 1991, we had to decrease our budget because, at one point, international travel was curtailed due to the Persian Gulf war. We were still determined to have a quality conference with whatever budget we had and ended up breaking attendance records with more than thirty thousand attendees.

One of my friends and mentors, Jim George, agreed to be the SIGGRAPH '92 exhibits chair and to help me with other organizational aspects of the conference. At the '89 and '90 conferences, virtual reality development was becoming more prominent but was primarily devoted to head-mounted display technology. On the exhibition floor, people would stand in long lines to experience these one-person, virtual-reality head-mounted devices. I recall Jim saying, "We need virtual reality that more than one person can experience at a time." During SIGGRAPH '92 brainstorming sessions, Jim was persistent in talking about this issue. I really believe that Jim's persistence was one of the forces behind Tom DeFanti and Dan Sandin's inspiration to invent the CAVE technology, a room-sized virtual reality environment. EVL began developing the CAVE to premiere at SIGGRAPH '92. We asked companies to donate or loan us equipment, and it all came together at the conference.

SIGGRAPH '92 had many "firsts" in addition to the new CAVE technology. We had [40] PHSColograms of scientific visualizations around the outside of the CAVE, so the space looked stunning. In addition, 1992 was the first time SIG-GRAPH was networked to the outside world, and Tom DeFanti made use of these networks by creating the "Showcase" venue, enabling scientists to demonstrate their research in Chicago using workstations connected to their remote laboratories. And I introduced electronic "blinky" pins to SIGGRAPH, which were worn by conference organizers. (One of my inspirations was midwestern artist Jody Gillerman, who subsequently moved to California and who created her own electronic jewelry and wore it to SIGGRAPH conferences.)

The prototype CAVE was essentially an unfunded idea—remember that the CAVE at SIGGRAPH was built with borrowed parts! So in 1992 we submitted a five-year grant proposal to the National Science Foundation (NSF), and we received funding in 1993. Shortly thereafter, NCSA built a CAVE, followed by Argonne National Laboratory. I wrote extensive documentation about the CAVE and its applications. The NSF grant enabled us to buy equipment, to work with manufacturers to make enhancements to their equipment, and to improve the design. For SIGGRAPH '94, I cochaired the VROOM event (virtual reality room), where we had three CAVEs and several virtual-reality BOOMS (binocular omni-orientation monitors) running with a variety of applications, showing attendees that this technology was being adopted and used.

In 1992 General Motors Research saw the CAVE and we helped them build one. Ars Electronica also saw the CAVE and built one. NCSA industrial partners like Caterpillar used the NCSA CAVE. As a university, we could not build and sell CAVEs as a commercial business; our goal was to provide proof of concept. We eventually licensed the CAVE to Data Displays, then Fakespace, which was bought by Mechdyne. Some of our students started a company, VRCO, to sell CAVE software and do applications development; they too were eventually acquired by Mechdyne. The CAVE continues to be sold today.

In the early 1990s, Tom DeFanti and I would travel to NCSA in Urbana-Champaign once a week, and we witnessed what Marc Andreessen was doing with the World Wide Web and Mosaic [see p. 37]. We immediately understood the value of it. In fact, when we did VROOM in 1994, Dana Plepys put all the VROOM application documentation on the web. Because we weren't able to get networking to the conference venue, we used a local server on site. This is the first time most SIGGRAPH attendees saw the potential of the web. In fact, EVL and Dana Plepys subsequently worked with the City of Chicago to develop a web presence for them. Jason Leigh, then an EVL student—and now EVL director emeritus—figured out a way to open windows and show animations in web pages as early as 1994.

I believe that my interest and passion for EVL—its people and events—have contributed to EVL's success. People have tried to tempt me away from here, but I am really passionate about this place. I love that it is multidisciplinary: it's art, it's computer science, and it's application science

Co-organizers of the iGrid (International Grid) 2005 Workshop, hosted by Calit2 at University of California–San Diego. Shown here (left to right): Tom DeFanti, Maxine Brown, Larry Smarr. The 2005 GLIF map is on the wall. Photo by Harry Ammons. Courtesy of Maxine Brown.

too. Whether our applications enable people to fly to Mars, look inside molecules, or model automobiles, I find it all fascinating. Computer graphics is a fantastic tool that is relevant to a variety of applications where aesthetics count and are part of a bigger picture.

Maxine Brown having dinner at Miko's Japanese restaurant in Champaign-Urbana on Bastille Day, 1998. Shown here (left to right): Donna J. Cox, Tom DeFanti, Maxine Brown, Bob Patterson. Courtesy of Maxine Brown.

The Azalea Garden at the University of Tokyo, 1999. In the early years of an EVL collaborative project with Nippon Telephone & Telegraph, University of Tokyo, and Pacific Interface, Inc., then called N*VECTOR (Networked Virtual Environments for Collaborative Trans-Oceanic Research)—which still continues today with additional collaborators—EVL faculty and staff attended a meeting at University of Tokyo. During a break, everyone took a short walk to the campus's beautiful azalea garden. Shown here (front row, left to right): Xi Xiaonan (visiting Chinese professor), Yoshihiro Kawahara, (University of Tokyo), Goro Kunito (University of Tokyo), Tadamichi Suzuki (Fujitsu), Tomonori Aoyama (University of Tokyo), Maxine Brown (EVL), Tom DeFanti (EVL), Tadashi Enomoto (Telecommunications Advancement Organization of Japan); (second row): Jason Leigh (EVL), Greg Dawe (EVL), Hiroyuki Morikawa (University of Tokyo), Natalie Van Osdol (PII), Alan Verlo (EVL). Courtesy of Maxine Brown.

Faculty, staff, and students of EVL at UIC, 2010, standing in front of the soon-to-be decommissioned LambdaVision tiled display wall. Shown here (front row, left to right): Brad McGinnis, Naomi Yarin, Yiwen Sun, Arthur Nishimoto; (second row): Michael Lewis, Alessandro Febretti, Cristian Luciano, Victor Mateevitsi, Edward Kahler, Dennis Chau, Sungwon Nam; (back row): Derek Solt, Luc Renambot, Steven Conner, Andrew Johnson, Pat Hallihan, Tom DeFanti, Karan Chakrapani, Jason Leigh, Sangyoon (James) Lee, Maxine Brown, Jonas Talandis, Alan Verlo, Dana Plepys, J. D. Pirtle, Lance Long, Ratko Jagodic. Courtesy of Maxine Brown.

Martyl

Martyl (1917–2013) was both a celebrated landscape artist and the renowned designer of the iconic Doomsday Clock (1947), commissioned by the *Bulletin of the Atomic Scientists* at the University of Chicago. Being an artist member of a scientific culture, Martyl is without predecessors for bridging a gap between the two creative spheres. In the 1960s, she created early experimental "synaptic" artworks she produced with Mylar that merged artistic processes with scientific themes. Martyl's works are in the permanent collection of the Art Institute of Chicago, Whitney Museum of American Art, Brooklyn Museum, Illinois State Museum, Los Angeles County Museum of Art, Smithsonian National Museum of American Art, Oriental Institute of the University of Chicago, and St. Louis Art Museum, with more than 100 solo exhibitions at Printworks Gallery in Chicago and others throughout the United States. Martyl was married to nuclear physicist Alexander Langsdorf Jr. and had two daughters, Suzanne and Alexandra, four grandchildren, and two great-grandchildren. A native of Missouri and longtime resident of Illinois, Martyl preserved the landmark home and studio of modernist architect Paul Schweikher in Schaumburg, Illinois, where she continued to reside and work until her death on March 26, 2013.

|||

"The Doomsday Clock was my idea," emphasized Martyl. Many had not recognized her creative efforts and sense of responsibility to invent and update the appropriate cover image for the *Bulletin of the Atomic Scientists*. The scientists gave her few parameters: no money and a monthly deadline. However, she acknowledged the need for accuracy for this public communication icon. "Knowing all the facts was critical and time was of the essence. The Doomsday Clock was the proper visual metaphor to portend the potential fury that the atom bomb could unleash.

"I started drawing like all children, apparently had a slight talent for it, recognized by my parents. My father, Martin Schweig, was a well-known photographer and my mother, Aimee Schweig, who turned out to be a really good painter, later founded the St. Genevieve Summer School of Art, a thriving midwestern artists' colony. I went to drawing classes in the St. Louis Art Museum that were held every Saturday morning, which consisted of mostly copying part of the collection that was selected every week to be familiar with the collection. It sounds old fashioned to say 'copy the masterpieces,' but it's not such a bad idea. I never stopped painting."

Martyl continued to paint and exhibited at a very young age. She studied art history at Washington University in St. Louis before a life-changing event happened. "The leap was marrying Alex Langsdorf in 1941 because that opened a whole world.[1] In the 1940s, artists did not know how to talk to scientists, and scientists were all so preoccupied with their own fantastic leaps of imagination that they didn't care too much about the visual arts, but with some exceptions. I thought it was my duty to get the two together because I was in a position to do that. I got to know many

On January 22, 2015, the *Bulletin of the Atomic Scientists* moved the clock from five minutes to midnight to three minutes to midnight for "unchecked climate change, global nuclear weapons modernizations, and outsized nuclear weapons arsenals." Courtesy of the *Bulletin of the Atomic Scientists*.

well-known scientists through my husband, Alex, being from the Manhattan Project and cutting-edge science. He was building a cyclotron when I was courting him, so to speak, and that was cutting-edge science. Ernest Lawrence won the Nobel Prize for inventing the cyclotron, which is a particle accelerator to smash open atomic nuclei. Hitler was running all over Europe and all of a sudden the cyclotron, which was for cancer research, was closed down in secrecy and the curtain was drawn—pulled down, and there was a lot of activity back and forth from Chicago to St. Louis. Alex would work with that cyclotron, which was bombarding particles, trying to make uranium. That's when we met so many scientists and it made a big impression on me. The cyclotron alone with its radio oscillators and electric circuits opened my consciousness, and I could see there was a whole world there that artists didn't have a clue about.

"Enrico Fermi invited my husband to Chicago. We stayed an extra year in St. Louis because of the Manhattan Project. The atomic bomb subsequently was unleashed. We would have been there at the chain reaction, but he stayed in St. Louis an extra year. I moved to Chicago. I knew a lot of artists in Chicago and so I came first and he joined me. This is the era where the University of Chicago was the Grande Dame of Chicago because there were so many people who were famous that came in and out. Not just scientists, but artists, musicians, and so on. We were friends with everybody from Los Alamos to Santa Fe. It was all that historic activity—Oppenheimer and that whole project. This is how I became familiar with computers. The interesting part of this is that one of our friends who was director of developing computers at Los Alamos for this huge Manhattan Project, it took about three rooms, I think. The acronym for that was called MANIAC. Does that ring a bell? A very apt acronym. Nick Metropolis was from Chicago and he was one of the developers.

"I do get good ideas. Carrying them out is another story. For one of my good ideas, I was influenced by computers and the electric circuit. Because of my familiarity with machinery, circuitry, and so forth, it dawned on me that an electric circuit is more of an adjunct of our contemporary life. It's really part of human life itself. Everything in our technological society involves circuitry, our brain and our nervous system. So I thought about the interconnections and that word *synapse* comes from a whole series of paintings I called the *Synapse Series*. Those are circuits that are fraught with symbolism. The early circuits had shapes that were really morphic. I mean amazing, the forms that sort of lend themselves to lots of interpretations. I used paint and canvas with these ideas, and there was something that was nagging at me that didn't seem just right. It was too conservative to be painting on canvas somehow, Belgian linens to boot. I spotted it someplace in my husband's office—Mylar—and that was brand new. That was a result of World War II development, I think, that started the whole plastic industry.

"Between the electric circuitry and how they used Mylar in the fashion industry because of the patterning in it. I mean, it's a completely indestructible material. Well, it seemed to me to be a more appropriate medium for my idea about electric circuitry. So I started to use Mylar, and as far as I'm concerned, I was the queen of Mylar. The only other person who did use it was Robert Motherwell. I found all kinds of Mylar, but

I used the thickest. Saran Wrap is kind of a Mylar that comes in absolutely thick and translucent material. It was a new medium that had fantastic tensile strength and doesn't become brittle. You can dye it, coat it, and laminate it. I used several types of this material in thickness of about 3 to 14/1000 of an inch, and that opened up a whole era, you might say, of scientific imaginative.

"I figured if the Renaissance could produce cherubim, which is a fantasy, I can make fantasy out of electrical circuits. And that's what I did for some time, but I have to tell you it was premature because nobody knew the word *synapse* and it was baffling to a lot of people. And one of my first exhibitions, my second or third exhibition in New York, I did paintings not on Mylar, this was before there were radio oscillators, cyclotrons, and wind burst machines and all kinds. I remember one of the reviewers of the *New York Times* said I had a fantastic imagination. I think I said in an interview, 'I wish I did.' I could have gotten the Nobel Prize then because this was all literal stuff. That will give you an example of how it was bewildering to most people.

"There were a few scientists with a big social conscience, which my husband was one of; I too. But they started this when the bomb was dropped. It was literally a bombshell, if you'll pardon the pun, on the American public, who didn't know anything about it all. There were two things happening at once. The scientists themselves who tried to prevent the dropping of the bomb on innocent people to no avail and there's a lot that has been written about that. The social conscience of a half a dozen scientists decided to inform not just the public, because that would take some doing, but the sources of the media: newspapers, television, radio, and the whole print industry.

"I was at the University of Chicago. I was sitting in one of their dining rooms when the *Bulletin* editors were having a meeting. Jamie Calvin is a writer on the *Bulletin* staff. He saw me sitting at a table, came over to me, and said, 'Oh, we're having this meeting of the *Bulletin* and they don't know what direction the magazine should take because scaring people has its limitations. You can't always be the sort of thing other than the proliferation of nuclear power by rogue states and so forth. What direction should the *Bulletin* take?' He talked to me about it, and I was sitting at this table and they had napkins. It seems like artists and architects draw on napkins when they get ideas. I said, 'Well, obviously from what you tell me the clock should be on the world.' He said, 'That's terrific!' What all these high-powered thinkers were trying to figure out, in two seconds, I said, 'Put a clock on the world,' and that's how that happened. Artists like to be asked to do things, but not enough are.

"There was a board of directors, all the famous Nobel Laureates. You could look at the title page of the first edition, 1947. It became a metaphor for minutes to midnight and they called it the Doomsday Clock because of all the historical incidents that happened. The clock was moved forward and backward more than seventeen times. That's all been tabulated. You can get that on the Internet on your iPhone. It was always unique because the clock got moved back in intervals of whatever happened in the world. Lots of the press—I remember the *Dallas Morning News* called me, they thought I had changed the hands of the clock in my studio when this happened, and so I'd have to explain. It became big news when they moved the hands of the clock. I always said, 'How else am I going to get on the front page of the *Dallas Morning News*?' Certainly not as an artist; it was the hands on the Doomsday Clock. The evolution of the clock and the moving of the hands—let's put it this way—the clock has a life of its own."[2]

After the success of the clock, Martyl and Alex's landscape changed. "Fermilab is unique in all the laboratories across this nation. It was the leader and builder of what was half artist and half scientist, in the name of Robert R. Wilson. Bobby Wilson was one of my husband's closest friends from Berkeley under Ernest Lawrence. They were best friends for a very long time, and when Bob Wilson was awarded the contract to build Fermilab, he was at Cornell University then. He not only brought art with him but he brought graphic artists. He was a sculptor, and his sculpture is there. He was a formidable friend and a wonderful scientist. He insisted that art be a part of it, and when it was built, there were art galleries built there. His successor carried on, Leon Lederman, who is still running around the world. He's a world-class scientist with the same sensibilities of the arts. There's this huge street art mural that's in the gallery lounge I drew in Greece of the Grand Canyon that Robert Wilson installed there. It's black and white with the Grand Canyon symbolizing whatever you wish to say about it. It's a permanent installation there. So I've had about three exhibitions there over the years.

"To get to Fermilab, Alex had to cross from the University of Chicago, seven level crossings of railroads, and it took forever to get back

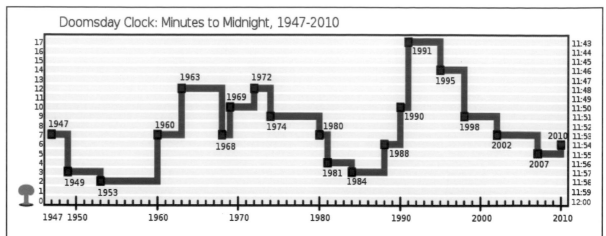

Doomsday Clock: Minutes to Midnight, 1947-2010

1947: It is 7 Minutes to Midnight
As the *Bulletin* evolves from a newsletter into a magazine, the clock appears on the cover for the first time, symbolizing the urgency of the nuclear dangers.

1949: It is 3 Minutes to Midnight
The Soviet Union denies it, but in the fall, President Harry Truman tells the American public that the Soviets tested their first nuclear device, officially starting the arms race.

1953: It is 2 Minutes to Midnight
The US decides to pursue the hydrogen bomb. In October 1952, the US tests its first thermonuclear device, obliterating a Pacific Ocean islet in the process; nine months later, the Soviets test an H-bomb of their own.

1963: It is 12 Minutes to Midnight
After a decade of almost nonstop nuclear tests, the US and Soviet Union sign the Partial Test Ban Treaty, which ends all atmospheric nuclear testing.

1968: It is 7 Minutes to Midnight
Regional wars rage. U.S. involvement in Vietnam intensifies, India and Pakistan battle in 1965, and Israel and its Arab neighbors renew hostilities in 1967. France and China develop nuclear weapons.

1969: It is 10 Minutes to Midnight
Nearly all of the world's nations come together to sign the Nuclear Non-Proliferation Treaty. Although Israel, India, and Pakistan refuse to sign, the *Bulletin* is cautiously optimistic.

1972: It is 12 Minutes to Midnight
The United States and Soviet Union attempt to curb the race for nuclear superiority by signing the Strategic Arms Limitation Treaty (SALT) and the Anti-Ballistic Missile (ABM) Treaty.

1974: It is 9 Minutes to Midnight
South Asia gets the bomb, as India tests its first nuclear device. Any gains in previous arms control agreements seem like a mirage. The US and Soviet Union appear to be modernizing their nuclear forces, not reducing them.

1980: It is 7 Minutes to Midnight
Thirty-five years after the start of the nuclear age and after some promising disarmament gains, the US and the Soviet Union still view nuclear weapons as an integral component of their national security.

1984: It is 3 Minutes to Midnight
U.S.-Soviet relations reach their iciest point in decades. Every channel of communications is constricted or shut down. The US seeks a space-based antiballistic missile capability, raising worries about a new arms race.

1988: It is 6 Minutes to Midnight
President Ronald Reagan and Soviet Premier Mikhail Gorbachev sign the historic Intermediate-Range Nuclear Forces Treaty, the first agreement to actually ban a whole category of nuclear weapons.

1990: It is 10 Minutes to Midnight
As one Eastern European country after another frees itself from Soviet control, Gorbachev refuses to intervene, diminishing the risk of all-out nuclear war. In late 1989, the Berlin Wall falls, symbolically ending the Cold War.

1991: It is 17 Minutes to Midnight
The US and Russia begin making deep cuts to their nuclear arsenals. The Strategic Arms Reduction Treaty reduces the number of strategic nuclear weapons deployed by the two former adversaries. A series of unilateral initiatives remove most of the intercontinental ballistic missiles and bombers in both countries from hair-trigger alert.

1995: It is 14 Minutes to Midnight
Hopes for a large post–Cold War peace dividend and a renouncing of nuclear weapons fade. There is growing concern that terrorists could exploit poorly secured nuclear facilities in the former Soviet Union.

1998: It is 9 Minutes to Midnight
India and Pakistan stage nuclear weapons tests only three weeks apart. Russia and the US still maintain seven thousand warheads ready to fire at each other within fifteen minutes.

2002: It is 7 Minutes to Midnight
Unsecured weapon-grade nuclear materials increase concerns about a nuclear terrorist attack. The US wants to design new nuclear weapons, including those able to destroy hardened buried targets. It rejects a series of arms control treaties and announces it will withdraw from the Anti-Ballistic Missile Treaty.

2007: It is 5 Minutes to Midnight
The world stands at the brink of a second nuclear age. The US and Russia remain ready to stage a nuclear attack within minutes, North Korea conducts a nuclear test, and many worry that Iran plans to acquire the bomb. Climate change also presents a dire challenge to humanity.

2010: It is 6 Minutes to Midnight
Talks between Washington and Moscow for a follow-on agreement to the Strategic Arms Reduction Treaty near completion. The dangers posed by climate change are growing, but at Copenhagen, the developing and industrialized countries agree to limit global temperature rise to 2 degrees Celsius.

2012: It is 5 Minutes to Midnight
The potential for nuclear weapons use in regional conflicts is alarming. Safer nuclear reactors need to be designed and built, and more stringent oversight is needed to prevent future disasters. Solutions to climate change may not be adequate to meet the hardships of large-scale disruptions.

2015: It is 3 Minutes to Midnight
Unchecked climate change, global nuclear weapons modernizations, and outsized nuclear weapons arsenals pose extraordinary threats to humanity. World leaders have failed to act with the speed or on the scale required. These failures of political leadership endanger every person on Earth.

2017: It is 2-1/2 Minutes to Midnight
In 2017, we find the danger to be even greater, the need for action more urgent. It is two and a half minutes to midnight, the Clock is ticking, global danger looms. Wise public officials should act immediately, guiding humanity away from the brink. If they do not, wise citizens must step forward and lead the way.

Courtesy of the *Bulletin of the Atomic Scientists*. A more detailed year-by-year description of movements of the Doomsday Clock can be found at http://thebulletin.org/timeline.

and forth, so the logical thing was to move out toward it. We were met with lots of criticism for leaving the university, the lake, and the city of Chicago—into a place that was visually beautiful. It was owned by Paul Schweikher, the architect who had built by himself, for himself and his wife, this house on seven and a half acres in an area of rolling farms. The house was Japanese in feeling but all redwood inside and out. It turned out to be a very suitable and wonderful place for an experience unlike urban living.

"My children, who were then very small, five and seven years old, were like liberated birds. They got to know a whole other population of farmers—that was like a whole other breed, like cowboys, a whole other division of society so that was an experience that we all had knowing about farm life and having a large garden. We lived here for decades, since 1953. The house being a work of art, which is acknowledged worldwide by all architects that know it. He is not as known as Frank Lloyd Wright but ever so much that some people think better in lots of ways.

"In light of speaking about the Schweikher House, which it is called now and was preserved with the help of architectural historian Susan Benjamin—it was just my house when I inherited his drafting room as my studio.[3] He had his architectural firm here. When Schweikher went off to Yale and we moved here, one of the great things was the studio wing of this great house, and one more word about the house and why we were so ecstatic about it when it was built in 1937–38—it was very innovative. It's mostly made of glass and California redwood, and so where the philosophy has the indoor–outdoor of Frank Lloyd Wright, it's a big improvement on Wright—it has passive solar, mind you, in 1938. Because he became a teacher, every architect almost in the world knows this house because it was innovative. That's why it's important, besides being a work of art.

"The landscape was so beautiful that twice in my career I have done the four seasons starting from one month, doing twelve months out of the year, so I am really an expert on Mother Nature's performance in every season because I have painted every month. I can tell you the thrill that it gives me all seasons, and that's why this is a house of all seasons. It's wonderful in winter as well as summer. It has overhangs about the sun and is surrounded by trees to keep it cool. It's an amazing place so I would attribute most of my life to the beauty of landscape in every part of the world, but here sort of turned the tide.

Top: Breezeway entrance to the Schweikher House and former residence of Martyl and Alexander Langsdorf. Center: The living room where Martyl's interview took place that once entertained architects Mies van der Rohe and Frank Lloyd Wright. Bottom: A view of the master bedroom. Pictured in the far right, connected to the main house, was Martyl's studio, where she enjoyed an inpouring of light for her artistic work. Courtesy of James Caulfield.

Have a Nice Day, 2002 by Martyl, with Ellen Sandor, Keith Miller, Pete Latrofa, and Janine Fron, (art)ⁿ. 40" × 30" PHSCologram: Duratrans, Kodalith, and Plexiglas. Courtesy of Ellen Sandor, (art)ⁿ. A painterly mountain landscape inspired by Martyl's *Tent Rocks* juxtaposed with the Doomsday Clock Martyl designed in 1947 for the *Bulletin of the Atomic Scientists*, which was set to five minutes to midnight in 2002 for unchanging nuclear concerns and climate change.

"I come from a family of liberated females and my husband, too. So having said that, and my name being not quite male or female, I only use the name Martyl. Almost to this day, when in doubt, I get Mr. Martyl. I've paid no attention to it, and as far as I knew, I've had such good luck in my career, my marriage, and everything, more good luck, maybe it was dumb luck, God knows. Women's issues, I didn't notice it in the arts so much until my attention was drawn to it. One of our closest friends was 'Peter' Horst Janssen, who wrote *The History of Art*, which everybody studied in school. Peter was his nickname and when he produced that history of art book—the five-pound baby we called it—we had a big celebration here.

"His sons have since revised it. I went to the opening of Judy Chicago's *Dinner Party* [see p. 12]. Everybody refused it in Chicago—the Art Institute and everybody. A couple of friends rented a place and that's where it was. When I

went, somebody came up to me and said, "Do you know that Janssen book hasn't got one woman artist in it?" And I said, "No, I didn't." I went home that night and I looked it up, and by golly, I was horrified. Not even the few women artists that came through history, even from the seventeenth century, Artemisia Gentileschi and Judith Leyster, who's at the National Gallery of Art right now in Washington, D.C. Nobody ever wrote about them before.

"Ellen Sandor was right on the cusp of science iconography and art in the mid-1980s, which is something I was always interested in and tried to bring about in the beginning. Ellen was one of the first to grab the ideas to show you how to breach science and art. It takes someone who has aesthetic qualities. Scientists know their equations are beautiful, which is really hard to understand. The artist has another dimension and can see the beauty in microbes. Photography has advanced

so now that to combine the two is something young artists all take for granted. Ellen was one of the first to use scientific processes to create a combination of art and science. The natural place for an exhibition was the Fermilab, whose director was half scientist and half artist. (art)n was a natural for an exhibition there in 1987, for which they have distinguished exhibitions, lectures, and musical events, and still do.[4]

"At the Arts Club of Chicago, I had to introduce a scientist, a natural physicist actually, named Rocky Kolb. He's a world-class astrophysicist. He's now chair of the Astrophysics Department at the University of Chicago and a longtime dear friend. In my introduction, I said, 'This has been a lifetime activity in my part to get science and art together and finally I can introduce an astrophysicist to the Arts Club and art patrons of the city of Chicago.' That's a fact and shows you how far we've come."

IN MEMORIAM

Martyl died on March 26, 2013. The Arts Club of Chicago gave a memorial service in her honor on June 1, 2013. Rocky Kolb gave a moving tribute,

where he described Martyl having a "great sense of humor, and a wonderful laugh. . . . Our world has lost a bit of its magic. A bright light has gone out; but how brightly it burned. The light warmed us, and it still illuminates our world, shedding light on things we see, but would otherwise fail to notice."

Excerpt from Dr. Rocky Kolb's memorial tribute to Martyl Langsdorf at the Arts Club of Chicago on June 1, 2013:

> Every day we wander in a world we have never learned to see fully, or have learned to ignore. Artists and scientists inhabit the same world and struggle to make sense of it in different ways. Martyl noticed the world in a way I cannot. She communicated her noticings to others in a way I cannot. I have a deep appreciation of the way she saw the world. My life is richer because of her noticings. Martyl also appreciated the way scientists notice the world. The noticings of scientists also enriched her life. The mixing of art and science produces a powerful concoction, an explosive cocktail. It happens only too rarely. It requires a catalyst. Martyl was a catalyst. Her home was a place where scientists and artists mixed. It was a golden age.

Rocky Kolb is chief scientist at Fermilab, Illinois.

|||

Notes

1. Alexander Langsdorf Jr. died in Elmhurst, Illinois, in 1996. The *New York Times* noted, "Dr. Langsdorf's contribution to the Manhattan Project was just a speck—a speck of plutonium, some of the first usable sample of the radioactive element. Dr. Langsdorf produced the speck from a cyclotron, an atomic-particle splitter, which he and another scientist had built at Washington University in St. Louis for medical research just before World War II. The speck was used in tests in Los Alamos, N.M., before the first atomic bomb was exploded in the New Mexico desert on July 16, 1945. That bomb was plutonium-fueled, as was the one dropped on Nagasaki. (The bomb dropped on Hiroshima was a uranium-fueled device.)" He is remembered for being a notable scientist who tried to persuade the US government, along with 155 others, including 70 from the Manhattan Project who signed the Szilárd petition, drafted by scientist Léo Szilárd that was circulated in July 1945, and asked President Harry S. Truman to consider a public demonstration of the atomic bomb first before using it against civilians. The petition purportedly never reached President Truman, for the atomic bomb was dropped on two Japanese cities, Hiroshima and Nagasaki during World War II. In 1946, Szilárd and Albert Einstein jointly created the Emergency Committee of Atomic Scientists, in which Linus Pauling, who won a Nobel Peace Prize in 1961, was a founding board member.

2. The renowned graphic designer Michael Bierut called the Doomsday Clock "the most powerful piece of information design of the 20th century." The Doomsday Clock was moved in a special episode of the CBS television series, *Madame Secretary*, that aired on March 27, 2016. The episode, aptly named "On the Clock," was based on a premise that negotiations between India and Pakistan were not going well, prompting the *Bulletin*'s Science and Security Board to consider moving the clock closer to midnight.

3. Julia Bachrach, longtime former historian for the Chicago Park District, was also helpful with the application process for adding the Schweikher House to the National Register of Historic Places. Bachrach's grandmother had a landscape painting from Martyl's Grecian travels in her personal collection. Since 2004, Bachrach has been helping the city reclaim public landscapes in honor of women, including recent park and beachfront dedications she officiated for Jane Addams (2011) and Marion Mahony Griffin (2015). See p. 258.

4. In 2002, to commemorate the Doomsday Clock and its enduring resonance with the uncertainty of our changing climate, Martyl, Ellen Sandor, and (art)n created *Have a Nice Day*—a PHSCologram tribute featuring the iconic hands of the clock approaching midnight, juxtaposed with one of her landscape paintings, *Tent Rocks*, that was featured in multiple gallery exhibitions in Chicago.

Ellen Sandor The Art of Science, Architecture & Chicago Imagists: Selected Works, 1987–2017
Detailed credits: p. 144

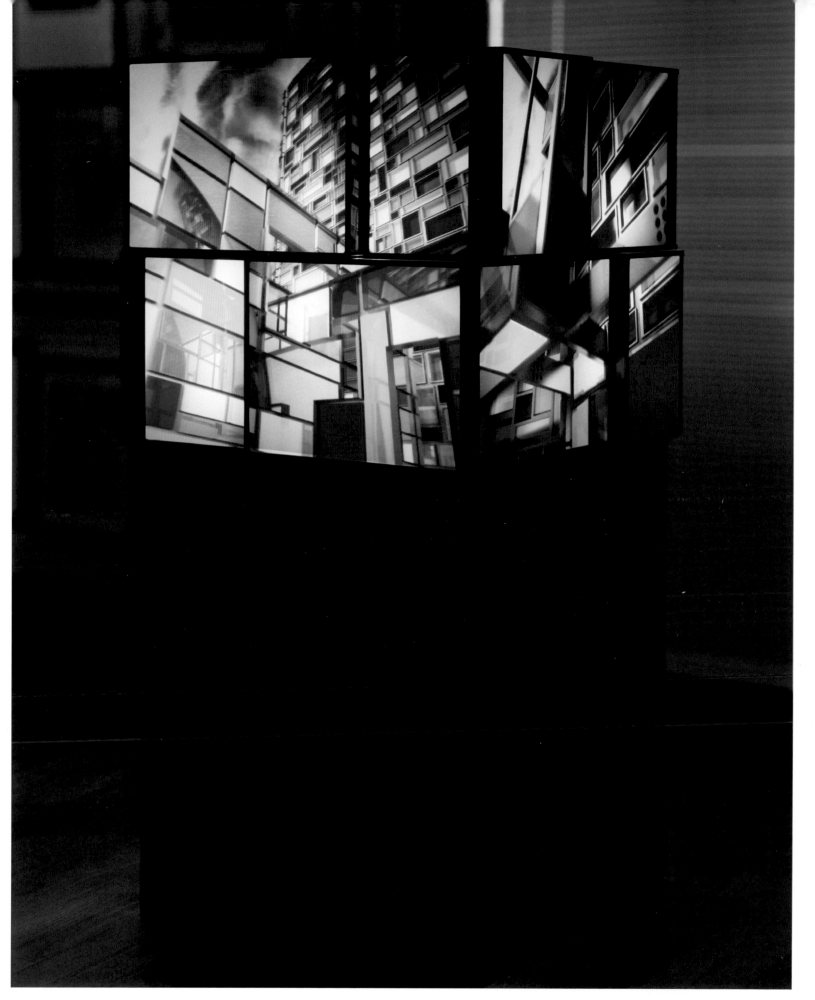

Nouveau Nouvel: Mondrian as Muse, 2014
Detailed credits: p. 144 **Ellen Sandor**

Ellen Sandor

(art)ⁿ studio in Chicago
Detailed credits: p. 144

Neutrinos in a New Light, Fermilab Artist in Residence 2016
Detailed credits: pp. 144–45 **Ellen Sandor**

Donna J. Cox Selected Domemasters and IMAX filmstrips from award-winning giant-screen documentaries, 1996–2015
Detailed credits: pp. 145–46

Tornado (Detail from *Universal Atmospheres*), 2006
Detailed credits: p. 146 **Donna J. Cox**

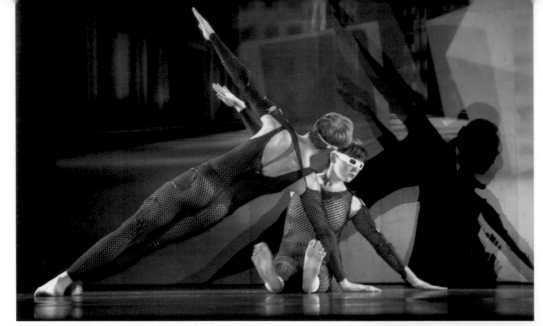

Carolina Cruz-Neira *Assisted Living*, 2004; *Assisted Living*, 2004; *Ashes to Ashes*, 2001
Detailed credits: p. 146

Ashes to Ashes, 2001
Detailed credits: p. 146

Carolina Cruz-Neira

|||||||||||||

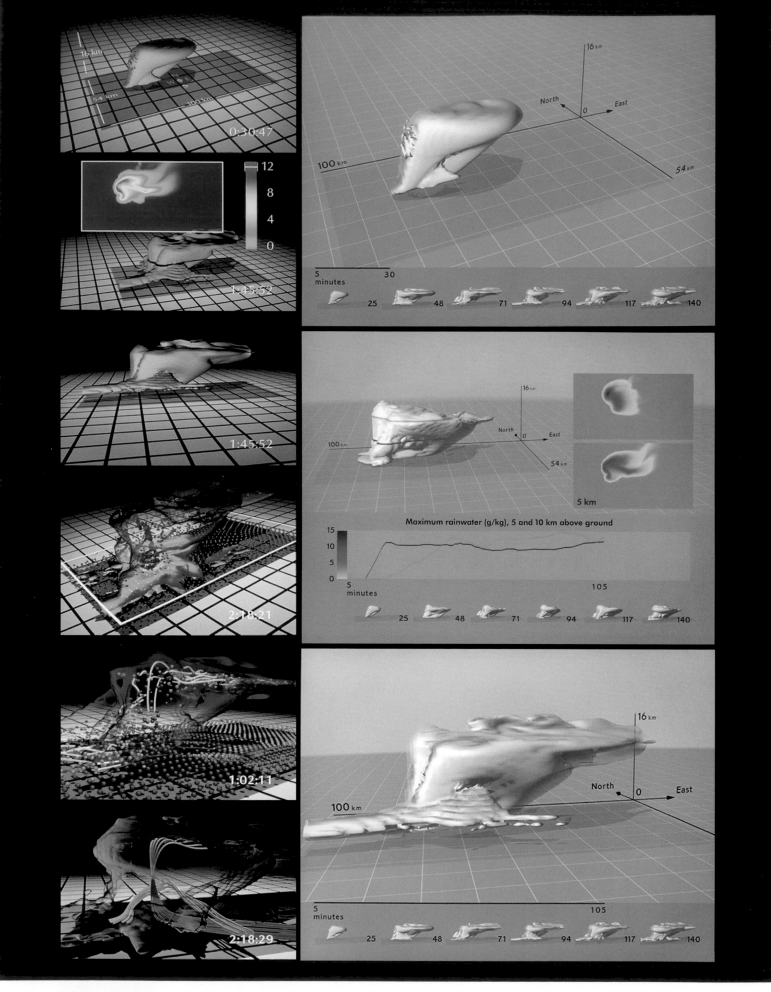

Colleen Bushell

Study of a Numerically Modeled Severe Storm, Summer 1990
Detailed credits: p. 146

Beyond this screen io waits for your arrival.
The **story** you are about to be told will be unique,
told for the first time, and only to **you**

io may **speak** about origins: its own, but quite possibly yours as well.
Or it may be a story of **dreams, desire, and destiny**
io **myth conversation.** Input/output.

io is a hybrid at the boundary between machine **intelligence** and **human** consciousness.

You are about to enter a place where **recollection** and **procedure**,
memory and **code**, interact in ways uncertain but fateful.

io is I, *io* is you.

360, 2005; *Io*, 2001
Detailed credits: p. 146 **Nan Goggin**

Mary Rasmussen

Maxed Out, 1992
Detailed credits: pp. 146–47

Beauty and the Beast, 1989
Detailed credits: p. 147 **Mary Rasmussen**

Martyl Langsdorf *Doomsday Clock, Have a Nice Day,* 2002; *Wyoming #13,* 2009; *Sangre de Christo Mountains I,* 1975
Detailed credits: p. 147

Bulletin of the
Atomic Scientists

JUNE 1947

HAROLD C. UREY
 An Alternative Course for the Control of Atomic Energy

AUSTIN M. BRUES
 With the Atomic Bomb Casualty Commission in Japan

YOSHIO NISHINA
 A Japanese Scientist Describes Destruction of Cyclotrons

SYLVIA EBERHART
 How the American People Feel About the Atomic Bomb

WAR DEPARTMENT THINKING on the Atomic Bomb

HARRISON BROWN
 The World Government Movement in the United States

THE SENATE DEBATES Mr.Lilienthal's Confirmation

BOOKS.....................UN Atomic Energy News

Vol. 3 PRICE: 25 CENTS No. 6

Minutes to Midnight: original cover design for the *Bulletin of the Atomic Scientists*, 1947
Detailed credits: p. 147 **Martyl Langsdorf**

Art Details for Part 1 Color Plates

Ellen Sandor

Page 126. (art)[n]: Selected Works.
Left to right and top to bottom: *Mies-en-scène: The Farnsworth House*, 2009
 Ellen Sandor, Chris Kemp, Chris Day, and Ben Carney, (art)[n]
 40" × 30" PHSCologram: Duratrans, Kodalith, Plexiglas
Perfect Prisms: Crystal Chapel, 2009
 Ellen Sandor, Chris Kemp, Chris Day, Ben Carney, and Miguel Delgado, (art)[n]
 30" × 40" PHSCologram: Duratrans, Kodalith, Plexiglas
No Fumare, por Favore, 1997
 Ed Paschke
 Ellen Sandor, Stephan Meyers, and Janine Fron, (art)[n]
 30" × 40" PHSCologram: Duratrans, Kodalith, Plexiglas
CRISPR-Cas9: A Ray of Light, 2017
 Jennifer Doudna, The Doudna Lab: RNA Biology, UC Berkeley
 Megan Hochstrasser, Innovative Genomics Institute, UC Berkeley
 Ellen Sandor, Chris Kemp, Diana Torres, and Azadeh Gholizadeh, (art)[n]
 Special thanks to Caleb Sandor Taub
 33" × 33" × 62" Digital PHSCologram Sculpture: Duratrans, Kodalith, Plexiglas
Nanoscape II: Viral Assembly, 1999
 Ellen Sandor, Fernando Orellana, Nichole Maury, and Janine Fron, (art)[n]
 Arthur Olson, The Scripps Research Institute
 30" × 30" PHSCologram: Duratrans, Kodalith, Plexiglas
AIDS Virus, Third Edition, 1989
 Ellen Sandor and Stephan Meyers, (art)[n]
 Dan Sandin and Tom DeFanti, Electronic Visualization Lab, School of Art and Design, University of Illinois at Chicago
 Special thanks to Kevin Maginnis
 20" × 24" PHSCologram: Cibachrome, Kodalith, Plexiglas
The Magnificent Micelle, Detail II, 2013
 Matthew Tirrell, Pritzker Director of the Institute for Molecular Engineering

Peter Allen, Scientific Visualization Director, UC Santa Barbara
 Ellen Sandor, Chris Kemp, and Diana Torres, (art)[n]
 30" × 30" × 63" Digital PHSCologram Sculpture and Base: Duratrans, Kodalith, Plexiglas
Virtual Bust/Franz K., 1993
 Chris Landreth
 Ellen Sandor, Stephan Meyers, and Janine Fron, (art)[n]
 30" × 30" PHSCologram: Cibachrome, Kodalith, Plexiglas
Chaos/Information as Ornament: A Tribute to Louis Sullivan, 1989
 Ellen Sandor, Randy Johnson, and Stephan Meyers, (art)[n]
 Tom DeFanti and Dan Sandin, EVL—Electronic Visualization Laboratory, University of Illinois at Chicago
 80" × 100" PHSCologram Sculpture: Cibachrome, Kodalith, Plexiglas
Egg Drop, 2002
 Karl Wirsum
 Ellen Sandor, Pete Latrofa, Keith Miller, Fernando Orellana, Janine Fron, and Jack Ludden, (art)[n]
 40" × 30" PHSCologram: Duratrans, Kodalith, Plexiglas
Have a Nice Day II: VR Tour Through the Decades, 2017
 In Memory of Martyl
 Ellen Sandor, Chris Kemp, Diana Torres, and Azadeh Gholizadeh, (art)[n]
 Special thanks to Janine Fron; Code by William Robertson, Co-Founder/CTO Digital Museum of Digital Art
 Virtual Reality Installation with Unity and Oculus Rift
 Narrated by Rachel Bronson, Bulletin of the Atomic Scientists
Page 127. *Nouveau Nouvel: Mondrian as Muse*, 2014
 Ellen Sandor, Chris Kemp, and Diana Torres, (art)[n]
 26" × 26" × 58" Digital PHSCologram sculpture and base
Page 128. A panorama view of PHSColograms and sculptures at the (art)[n] studio in Chicago, where art meets science.
 Digital photograph by James Prinz Photography.
Page 129. *Neutrinos in a New Light*
Top row: *Binary Bypass: Neutrinos for Data Communication*, 2016

Ellen Sandor, Chris Kemp and Diana Torres, (art)[n]
Jennifer Raaf, Sam Zeller, Thomas Junk, and the
Fermi National Accelerator Laboratory
Special thanks to Georgia Schwender, Kurt
Riesselmann, and Anne Teichert
12" × 42" × 72" Digital PHSCologram Sculpture

Solar Dynamo / Solar Interior, 2016
Visualization by AVL, NCSA, University of Illinois:
Donna J. Cox, Robert Patterson, Stuart Levy, Kalina
Borkiewicz, AJ Christensen, Jeff Carpenter; Scientific
Simulation by Juri Toomre, University of Colorado,
Boulder; Mark Miesch, NCAR; Nicholas Nelson,
LANL; Allan Sacha BRUN, UMR AIM Paris-Saclay;
Benjamin Brown, University of Wisconsin, Madison
Ellen Sandor, Chris Kemp, and Diana Torres, (art)[n]

Second row, left: *The Magnificent MicroBooNE:
Science through the Art of Jackson Pollock and
David Smith*, 2016
Ellen Sandor and (art)[n], Chris Kemp and Diana Torres
Jennifer Raaf, Sam Zeller, Thomas Junk, and the
Fermi National Accelerator Laboratory
Special thanks to Janine Fron, Georgia Schwender,
Kurt Riesselmann, and Anne Teichert
40" × 24" Digital PHSCologram sculpture

Second row, right: *Allies for Antineutrinos*, 2016
Ellen Sandor, Chris Kemp, and Diana Torres, (art)[n]
Jennifer Raaf, Sam Zeller, Thomas Junk, and the
Fermi National Accelerator Laboratory
Adam Bernstein and the Lawrence Livermore
National Laboratory
Special thanks to Janine Fron, Georgia Schwender,
Kurt Riesselmann, and Anne Teichert
30" × 30" Digital PHSCologram Sculpture

The Supernova Spectacle, 2016
Ellen Sandor and (art)[n], Chris Kemp and Diana Torres
Jennifer Raaf, Sam Zeller, Thomas Junk, and the
Fermi National Accelerator Laboratory
Special thanks to Janine Fron, Georgia Schwender,
Kurt Riesselmann, and Anne Teichert
30" × 30" Digital PHSCologram Sculpture

Third row, left: *Bubble Chamber Beginnings:
Revisiting the Vintage*, 2016
Ellen Sandor, Chris Kemp, and Diana Torres, (art)[n]
Jennifer Raaf, Sam Zeller, Thomas Junk, and the
Fermi National Accelerator Laboratory
Special thanks to Janine Fron, Georgia Schwender,
Kurt Riesselmann, and Anne Teichert
12" × 42" × 72" Digital PHSCologram Sculpture

Third row, right: *Neutrinos and NOvA: A Vasarely
Variation*, 2016
Ellen Sandor, Chris Kemp, and Diana Torres, (art)[n]
Jennifer Raaf, Sam Zeller, Thomas Junk, and the
Fermi National Accelerator Laboratory
Special thanks to Janine Fron, Georgia Schwender,
Kurt Riesselmann, and Anne Teichert
30" × 30" Digital PHSCologram Sculpture

Donna J. Cox

Page 130. Excerpts from giant-screen immersive
productions.
Left to right and top to bottom:
Dynamic Earth fulldome excerpt showing Hurricane
Katrina, 2012.

Scientific simulation by National Center for
Atmospheric Research (NCAR), Wei Wang, Ryan
Torn, Jimy Dudhia, Chris Davis, and visualization
by Donna J. Cox, Robert Patterson, Stuart Levy,
Alex Betts, Matt Hall, and Jeff Carpenter, Advanced
Visualization Lab, NCSA.
Courtesy of NCSA, Spitz, Thomas Lucas Productions.

Solar Superstorms fulldome excerpt showing
magneto-convection emerging flux, 2015.
Scientific simulation by Robert Stein, Michigan
State University; Åke Nordlund, Niels Bohr
Institute, Copenhagen University, Denmark;
Patrick Moran, NASA Ames Research Center; and
visualization by Donna J. Cox, Robert Patterson,
Stuart Levy, A. J. Christensen, Kalina Borkiewicz,
and Jeff Carpenter, AVL, NCSA.
Courtesy of NCSA, Spitz, Thomas Lucas Productions.

Solar Superstorms fulldome excerpt showing solar
plasma interacting with Earth's magnetic shield,
2015.
Scientific simulation by Homa Karimabadi,
University of California–San Diego; Mahidhar
Tatineni, San Diego Supercomputer Center (SDSC);
Vadim Roytershteyn, Space Science Institute;
Hoanh X. Vu, UCSD; Amit Majumdar (SDSC); and
visualization by the Donna J. Cox, Robert Patterson,
Stuart Levy, A. J. Christensen, Kalina Borkiewicz,
and Jeff Carpenter, AVL, NCSA.
Courtesy of NCSA, Spitz, Thomas Lucas Productions.

Storm Chaser Tornado fulldome excerpt from
SIGGRAPH 2006 fulldome theater.
Visualization Donna J. Cox, Robert Patterson, Stuart
Levy, Alex Betts, Matt Hall, NCSA; Simulation:
Bob Wilhelmson and Matthew Gilmore, NCSA;
Lou Wicker, National Severe Storms Lab, National
Oceanic and Atmospheric Administration.
Courtesy of NCSA.

Solar Superstorms fulldome excerpt showing solar
dynamo, 2015.
Scientific simulation by Juri Toomre, University of
Colorado–Boulder; Mark Miesch, NCAR, Nicholas
Nelson, Los Alamos National Lab; Allan Sacha
Brun, Saclay, France; Benjamin Brown, University
of Colorado–Boulder; and visualization by the
Donna J. Cox, Robert Patterson, Stuart Levy, A. J.
Christensen, Kalina Borkiewicz, and Jeff Carpenter,
AVL, NCSA.
Courtesy of NCSA, Spitz, Thomas Lucas
Productions.

Solar Superstorms fulldome excerpt showing
formation of first stars and galaxies, 2015.
Scientific simulation by John H. Wise, Georgia
Institute of Technology, and Brian O'Shea, Michigan
State University; and visualization by Donna J. Cox,
Robert Patterson, Stuart Levy, A. J. Christensen,
Kalina Borkiewicz, and Jeff Carpenter, AVL, NCSA.
Courtesy of NCSA, Spitz, Thomas Lucas Productions.

Cosmic Voyage, circa 1995 IMAX film strip test (three
panels) of two colliding galaxies.
Simulation by Chris Mihos, University of
California–Santa Cruz; and visualization by Donna
J. Cox, Robert Patterson, Erik Wesselak; 1993. Final
movie completed in 1996.
Courtesy of Donna J. Cox, NCSA, University of
Illinois and IMAX Corp.

PART 2

THE AESTHETICS OF NEW MEDIA EXPRESSION

In part 2, the artists converge on innovating aesthetic expressions in New Media Arts, while academic arts institutions provided an infrastructure for their communities of practice. Their artistic inquiries were supplemented by their departmental leadership roles held at the School of the Art Institute of Chicago (SAIC), Columbia College, and Indiana University, where they started and nurtured new programs that paralleled their own artistic evolutions. Joan Truckenbrod describes her experiments with mixed media that evolved with digital photomontage, printmaking, painting, and video art. Barbara Sykes and Annette Barbier both explored working with video art and image processing for their MFA projects at SAIC, and Barbier continued to incorporate video into her interactive and Internet-based artworks. With the advent of the Cave Automatic Virtual Environment development at Electronic Visualization Laboratory, Margaret Dolinsky made the medium her own and has produced seventy individual virtual reality artworks, some with variations on a theme and others that explore evolving forms of personal expression. Abina Manning provides a historical overview of SAIC's Video Data Bank, founded by Lyn Blumenthal and Kate Horsfield in 1976, which preserved seminal works by many women artists. Tiffany Holmes and Claudia Hart have worked with refined technologies to explore aesthetic possibilities for making provocative statements about the environment, surveillance, and representation of the body within their own artworks and in their teaching. These influential, internationally recognized accomplishments planted seeds for Chicago's arts community and continue to encourage future generations with experimentation and theoretical discourse.

Joan Truckenbrod

Joan Truckenbrod is a pioneering digital media artist with works internationally represented in museum collections, exhibitions, and publications. Truckenbrod's works probe the threshold between the material world and the virtual world, creating hybrid realities. The digital world takes on a costume of physicality, simultaneously injecting ephemeral digital media into the material world. Inspired by the simultaneity of realms in indigenous cultures, including the ancestral world, the spiritual world, and the everyday world, her artwork activates portals that negotiate the ritual of rites of passage. Truckenbrod is professor emeritus in the Department of Art and Technology Studies at the School of the Art Institute of Chicago (SAIC). As the first chair of the department in the early 1980s, she manifested a pedagogical vision to explore the potential of new technologies for creative expression, intervening in technological processes and subverting them for artistic purposes that continue to lead new forms of artistic expression into the present day. From the department's inception, Truckenbrod initiated the first course in telecommunication arts at SAIC, creating a tele-performance with the Electronic Café in Santa Monica, California, using video phones and fax machines. Envisioning the computer as a multidimensional studio, she created one of the first courses in the computer graphics field she called creative computer imaging, which combined elements of visual imaging and sound with motion that resulted in Prentice Hall's 1988 publication *Creative Computer Imaging*. Truckenbrod was awarded a Fulbright Fellowship, a Scandinavian-American Foundation Grant, an Illinois Arts Council Special Assistance Grant, and a fellowship at Kala Art Institute in Berkeley, California. She was represented by the Flatfile gallery in Chicago, while recent publications include *Joan Truckenbrod* by Telos. Her current work includes the exploration of environmental issues with fiber arts and video sculpture installations. This work is presented, along with installations that inspire her work, in a book by Truckenbrod, *The Paradoxical Object: Video Film Sculpture*, published by Black Dog Publishers in London in 2012. Truckenbrod had a one-person exhibition of her video sculpture at the Corvallis Art Center in Corvallis, Oregon, in November 2015.

With renewed interest in Truckenbrod's early innovative algorithmic artwork, this artwork is represented by the Black Box Gallery in Copenhagen, Denmark (blackboxgallery.dk). Beginning in 1975, Truckenbrod created line drawing by developing computer programs in the Fortran programming language, incorporating mathematical formulas from physics that described natural phenomena such as wind patterns as well as light patterns created by undulating reflective surfaces. She introduced color by translating black-and-white drawings into transparent color Xerox prints, overlaid to create multiple color drawings. Using the Apple IIe computer and a 3M Color-in-Color copier, she created fiber textiles using heat-transfer color prints

hand-ironed onto fabric in 1978 and 1979. The earliest of these textiles, Electronic Patchwork, is in the permanent collection of the Block Museum of Art at Northwestern University. Her work progressed onto Textronix and Silicon Graphics computers, using 3M's Scan-a-Mural plotters to create large, seven-foot by eleven-foot canvas digital tapestries. She also created large color photographic transparencies as digital tapestries. Truckenbrod's early algorithmic artwork is the focus of the website joantruckenbrodart.com, highlighting her innovative computer drawings and textiles.

The creative possibilities of the computer and the other pioneering artists inspired me. The work was expressive and insightful, with the presence of the hand in the image. The art could be controversial, provocative, or charged. I knew that the potential for computer artwork was so incredible. We were no longer constrained within the frame of one discipline. The computer was a studio environment where we could make image, motion, and sound. I knew we would eventually be able to make interactive work using various sensors.

It was this issue of looking at the invisible world [when she started making her first artworks with the computer]—things you couldn't capture with a camera. One could intuit and draw or paint representations; however, I liked the idea of working with a computer because I could visualize and explore the depth and breadth of these ideas. This process was invigorating, exciting, and inspirational for me. There is this question, "Do computers enhance our creativity?" I think they provide us many more options to create and evaluate what we are trying to express. This process is imbued with a complexity—the fact that we can build up layers of ideas, realities, realms that we have envisioned—we can build up a wealth of those and look at them in a very complex way. If I were painting, drawing, sculpting with clay or other materials, the simultaneity of ideas I can explore using the computer would not be available to me because they would be hidden in the materials in a way that they're not hidden using the computer.

I studied Fortran [for her MA degree, after which she became a professor at Northern Illinois University (NIU)], immediately writing computer programs to create drawings. NIU had a large frame IBM computer, which you could never see because it was locked in this room, so it was magic. It was this mystical kind of experience because it was jumbling numbers in this mysterious space. You punched cards with a card-punch and took it to the computer center, which was on the west side of campus in a tiny little building. The computer printout was delivered that afternoon or even the next day. If the run was successful, you could see what you had done in your program. The information for each drawing was transferred to a large tape. I think it was 1600 bpi, which was about twelve to fifteen inches in diameter and maybe an inch and a half thick.

I delivered this tape to the Geography Department, the only place on campus that had a plotter, and waited for time when the department was not using the plotter. They would mount the tape and do the drawings, as I was not allowed to use the machine. I was generally not there when the drawings were being drawn out, and I would pick them up later. Then there was a big discussion about color. They were only willing to use black ink on white paper and they weren't even willing to change the point size of the pen. Those were some of the early challenges. In creating these drawings I wanted to inject a sense of depth and motion. I created a multiple-color line drawing by overlaying four separate transparent color Xeroxes made from the same line drawing. I framed them in such a way that altered the alignment of the lines to create a sense of motion.

One black-and-white drawing and one of the color xerography drawings [part of her Fourier Transform series] are now in the collection of the Block Museum at Northwestern University [see p. 190]. These drawings were in their exhibition, *Imaging by Numbers: A Historical View of the Computer Print*, 2008. This idea of making an expressive mark has a palpability that reveals invisible phenomena that we experience intuitively and physically every day. My objective was exploring ways of making a mark that embodied the intrigue of the unseen but yet sensed through our body. This issue of virtuality and materiality is also critical and interesting to

me. At the College Art Association conference, I cochaired a panel where we used the word *tangiality*, which is a word created to express how we are experiencing materiality in the virtual world. For me there is simultaneity of both the virtual hidden experience with the physical material experience. Embodied in the construct of tangiality is the idea of digital raw materials, the multidimensionality of media in the digital studio practice. At the same time I was creating those drawings, I was integrating the use of the computer into my basic design and color theory courses at NIU.

Sonia [Landy Sheridan, of the School of the Art Institute of Chicago (SAIC)] had defected from the Printmaking Department at SAIC and formed her Generatives Systems program in which she used natural forms of energy to create images, as well as exploring the potential of copy machines. She was very interested in computing but didn't have any expertise, but she knew that if you were going to explore the idea of Generative Systems you had better incorporate computers. Consequently she embraced my work with computers. In addition to studying with her, I became her teaching assistant. Eventually I taught sections of her Process I and Process II courses. I received my MFA degree from SAIC in 1979.

To get matching funds to help buy an Apple computer, I wrote to Apple discussing my proposed art project using the Apple computer and outlining the matching fund grant I had received. Amazingly an Apple IIe computer arrived in the mail! We set it up in my office, creating a digital studio, and I started teaching a class in computer imaging out of my office. There was no data storage in this computer except for the use of audiotape, which they claimed was totally unreliable. Because I had a shared office, they moved the digital studio into a closet. Because I was impatient with this progress, I took a position at Virginia Commonwealth University for a semester. Within a month or so, Northern Illinois University called and said, "We're building you a lab! Will you come back?" They had moved my computers out of the closet and that became the big joke: "Joan's program is out of the closet." They moved the lab into two practice rooms in the music building. We increased the number of classes. I was already working with the Apple IIe when I met Sonia Sheridan at SAIC. She was interested in my computer-aided drawings, my programming ability, and my use of small systems because of her interest in accessible technology. With the Apple IIe I could basically take it apart and put it together. I couldn't do anything like that today, but I could then. I knew all the chips, how to put them in the computer, and how to wire everything.

I was still writing programs [when she began experimenting with heat-transfer computer images on polyester fiber to create tapestries for her MFA thesis show at SAIC]. A book that my husband gave me included a series of mathematical formulas that described invisible phenomena in the natural world. It was amazing—a physics book with formulas to describe experiences that I was interested in, like how light rays reflect off of an irregular reflective surface. I incorporated those formulas into my computer programs and, by changing variables, I generated sequential images that would describe these phenomena visually using the Apple IIe. There were no pixels. There were boxes in only sixteen or eight colors. It looked like a weaving. I knew I wanted to return these phenomena to the natural world, and textiles provided a fluid medium for doing so. Sonia Sheridan had done a lot of work with iron-on heat-transfer material and inspired this work. To create these tapestries, I took the monitor from the Apple IIe, turned it upside down on a 3M Color-in-Color copier that had backlight capability, and printed the sequential images displayed on the monitor, on heat-transfer material. As the variables changed, I made a print of each step in the sequence that described the invisible phenomena I was working with. These prints were heat-transferred to fiber [see p. 190].

The color would shift a bit [after several repetitions], creating a strange mystical color phenomena in some corners of the frames. I trimmed each print by hand and hand-ironed them onto polyester fabric. The 3M Color-in-Color copier used micro-encapsulated color beads that fused into the textile with heat. The first of this series is the largest of these textiles and is six feet wide by eight feet high, requiring two panels of fabric sewn together. It is titled *The Electronic Patchwork* and is in the collection of the Block Museum at Northwestern University. To create this tapestry, I hand-ironed each frame of the image sequence onto the polyester. Sometimes when registering each image, the print of the iron or the shape of the iron would show up as a shadow in the overall design, leaving a trace of the hand in the artwork. This juxtaposition of the hand process superimposed on the technology was part of the work.

I initiated their [NIU] curriculum in digital imaging. In 1977, I published my first paper on using computers to make drawings, titled "Computer-Assisted Instruction in Beginning Design." The conference proceedings were published by the University of Waterloo in Ontario, Canada, in a book called *Computing and the Humanities*, the conference proceedings for the third international conference on Computing in the Humanities at the University of Waterloo, edited by Lusignan Serge and John S. North. My young daughter came with me to the conference. We met Ruth Leavitt. She had a son about my daughter's age and we spent the entire conference hanging out together.

Ruth wrote one of the first books on artists and computers [*Artist and Computer*, 1976] that included Manfred Moore and some of the early computer artists. Ruth was a traditional artist who married a computer programmer who wrote all of her software. I feel blessed that I could actually write all of my own software. In high school I majored in math, so I have a pretty good ability to deal with equations and variables. It's always been intriguing to me that a formula is like infinity. A formula with variables is like looking into deep water and seeing things at the very level of that water and seeing everything from the visible scale to the nanoscale because a formula always entails the use of variables, which are infinitely malleable. It's only limited by what you imagine you can change. I found math and programming very interesting, intriguing, and always without boundaries. I have never found the boundaries that a lot of people talk about in digital media.

I have an idea ahead of time of how I want it to be formed, like with the color xerography. I engage the computer and find a way to create what I am envisioning. This uncovers the idea of why women are so good with making stuff. Women are insightful at intuiting, synthesizing, and giving form to ideas as they are makers. Women make stuff in everyday life—clothing, environments, structures, as well as artworks. They're craft oriented and we have that same ability with computers; we craft using computers. I wrote a paper "Women in the Social Construction of the Computing Culture: Evolving New Forms of Computing." This paper was published in the journal *AI and Society* in 1993. I have done extensive research on women and computing, women in technology, and that particular paper proposes that women in fact have insights into new forms of computing. I have

written other papers about women, computers, and creativity because I think we are central to this field. Who did the first software programming? Ada Lovelace [see p. 16]. And the original computer punch card was inspired by the punch cards used in the Jacquard loom, from the realm of craft. Women have played an incredible role. Women think about the processes and envision the output or the product rather than focusing on the machine and how the machine works. I think that's the advantage we have over men in terms of how we work with computers.

I grew up in Chicago, and feminism in Chicago totally influenced me in pursuing a professional career. Learning about Jane Addams and her development of Hull-House in Chicago was inspirational as she was the main person in Chicago addressing social problems facing women and children, and implementing a plan to develop help and support for women [see p. 13]. As a sociologist and feminist, she saw the potential of women for implementing change in the education, health, and well-being of women and children. She effectively advocated for women to vote in order to bring about change. Her original goal was to bring art and culture to the neighborhood. This expanded to include the pressing needs for childcare, education for women and children, and the encouragement for college education for women to become professionals in their fields. This was accomplished in an environment of skepticism on the part of her male colleagues at the University of Chicago. She was the only one to work in the community, establishing Hull-House in Chicago. I was definitely inspired by Jane Addams's work to pursue one's dreams. I visited the Art Institute regularly and was inspired by paintings by women. I also read the novel *Sister Carrie* by Theodore Dreiser, in which a young woman boldly left a small town in Wisconsin to live and find work in Chicago—something totally unacceptable in her time.

I initiated my Creative Computer Imaging class [at SAIC] teaching part time on Saturdays. The class was interdisciplinary, as imagining involved visual images, sound images, and animated images through time, all created using the integrated medium of the computer. I taught visual imaging using scanners, digitizers, and drawing tablets. We captured and manipulated sound with Sound Edit software and the microphone. Unlike Garage Band where you choose a sound like a drum pattern, you would capture your own speech or whatever sounds you wanted

Barbara Sykes

Barbara Sykes-Dietze is a pioneering Chicago video artist whose individual and collaborative works have been shown extensively worldwide and featured in major festivals and museums, including the Museum of the Art Institute of Chicago, Kunst Museum in Germany, Museum of Modern Art in Stockholm, Carlsberg Glyptotek Museum in Copenhagen, Museum of Modern Art in Paris, Metropolitan Museum of Art in New York, and Museum of Contemporary Art in San Diego, and are part of the Museum of Modern Art's permanent collection in New York. As one of the featured artists in the Museum of Contemporary Art Chicago's retrospective exhibition, *Art in Chicago: 1945 to 1995*, her bibliography and involvement in the Chicago's art scene were also published in the book produced from this show. Much of her work connects to indigenous cultures with strong lines to women's narratives and iconography that have enriched midwestern traditions of art making while providing new visions for future generations of women to work in experimental environments. Early in her career, she presented her work in Japan, Spain, and Australia, and was the first woman video artist to present in China. Sykes has a strong appreciation for community and created pivotal cross-institutional collaborations with the University of Illinois, School of the Art Institute of Chicago, Columbia College, Center for New Television, (art)n laboratory, and others, where she created an international precedent for video and computer art to be showcased. In 1981, she curated *Video: Chicago Style* and later curated and traveled with *Video and Computer Art: Chicago Style* (1988–89). Both exhibitions exemplified the revolutionary artworks that Chicago artists were creating and introduced emergent art practices that continue to influence artists and educators today. With these touring exhibits, she also created a trajectory of transitioning forms of expression that traversed from the analog into the digital, revealing a uniqueness that, as Sykes explained in her interview, "wasn't happening anywhere else in the world at the time," and launched an international community for digital art. Sykes studied with Dan Sandin at the University of Illinois at Chicago from 1974 to 1979 and performed with Tom DeFanti in EVE I and EVE II (Electronic Visualization Events) during the first real-time computer performance events of their kind. She received an MFA from the School of the Art Institute of Chicago in 1981 and subsequently held a tenured faculty position at Columbia College. Her present work continues with *Amma: A Documentary of a Living Saint*, which illuminates the humanitarian efforts of India's beloved "Hugging Saint."

didn't think about limits or what I couldn't do. I submerged myself in the process of creating art and focused on what I wanted to accomplish. The open nature of video art and computer graphics animation provides women with incredible opportunities for explorations, discoveries, and advancements, and has opened doors for future women to prosper in these areas. Each generation of women working in these fields has expanded our understanding of what is possible—revealing aspects of the world not previously imagined. They have inspired others through their own journeys, discoveries, voices, and visions.

I was exposed to artists, designers, and inventors [growing up in Chicago] and worked in a variety of art forms. Having completed high school at the age of sixteen, I went on to make a living as an offset lithographer. I didn't realize the women's movement started in Chicago in the 1960s, but I experienced its impact as the world changed around me. I grew up in a matriarchal family structure, and although my mother may not consider herself a feminist, she has always stood her ground against unfair societal norms and demanded to be heard. Early on, I witnessed inequities, injustices, and unfair treatment that my mother, other females, and I faced; I realized society provided little support, and more often than not, discriminated against women. So, like my mother, I've always been in alignment with much of the women's movement's agenda.

Mass culture [in 1974] had no idea that video, computers, or electronic art existed. At that time, I was bored with my career while creating art on the side. A dear friend of mine who was attending Antioch College had taken a field trip to New Space, Dan Sandin's experimental lab at the University of Illinois at Chicago (UIC). Intrigued by her description, I walked into Dan's class during the third week of the semester and asked if I could sit in. Dan graciously agreed. Here was this long-haired hippie in a Viking helmet, an extraordinarily articulate visionary, and gifted artist producing groundbreaking art [see p. 20]. I had never

Sykes performing during *A Movement Within*, 1976. Sykes's opening dance performance during her daylong live, interactive, multimonitor, and large-screen projection installation of the same name at the UIC. As she danced, Sykes interacted with the Sandin IP she preprogrammed to produce slowly moving computer-generated imagery in combination with the installation's live camera feeds. For the rest of the event, Sykes jammed/performed in real time on the IP to audience members' movements within the installation. Michael Sterling performed his original music on a Moog synthesizer during the entire event. Courtesy of Barbara Sykes.

Barbara Sykes **157**

Sykes and Jim Morrissette in production, 1976, documenting Sun Foundation's Environmental Science and Arts Program in rural Washburn, Illinois. Each summer, established artists and scientists from across the United States would teach two-week workshops to underserved rural and urban children and develop integrative and interdisciplinary studies to enable mankind to live in harmony with nature. In addition to documenting these activities, Sykes and Morrissette also cotaught workshops and gave lectures. Courtesy of Barbara Sykes.

seen anything like it. That day radically changed my life. Although the idea of a newly emerging art form was exciting, it was the power of the medium itself that was extremely provocative. It was the real-time interactive capabilities and the absolutely beautiful radiant colors, translucent at times, and luminescent at others, that fascinated and intrigued me.

During one of my sessions, Dan came in and watched for a while.[1] He asked me to explain my programming on the [Sandin] Image Processor (IP) and notation system. I had developed a unique and elaborate methodology for programming oscillators for the creation of sophisticated and luminescent imagery. Because I've always had difficulty remembering names, I developed a succinct notation system—pictorial representations of each of the IP's module functions, their specific order, and settings of my programming, which I would write down on a single page in a 3" × 5" notebook. When I finished my explanation, Dan said my work was beautiful and powerful, and that my notation system was like hieroglyphs. He invited me to give a lecture on my work to the class the following week. At the end of the semester, Dan spoke on my behalf to the dean of the Art Department for enrollment as a full-time student for the fall semester, where there was a two-year wait list. Dan then hired me as one of his teaching assistants and I began devoting my life to producing electronic art and

teaching. Dan played a key role in facilitating a major paradigm shift in my life and I am deeply grateful for all that he has done for me.

While still a student, I worked at UIC's Media Production Center—a production facility for documentaries and educational media run by gifted documentarians Jerry Temaner and Herb DeJoia, staffed by my primary mentor, Jim Morrissette, an incredible cameraman and editor. I was able to write, produce, shoot, and edit a selection of documentary and instructional tapes and use their equipment for the production of my own art.

In order to continue to explore the video medium, I quickly went from producing single-channel tapes to multimedia installations and interactive performance environments that incorporated my performances on the IP with audience participation, dancers, and musicians. These included *Reflections* (1976); *A Movement Within* (1976) with Michael Sterling on audio synthesizer; *Off the Air* (1977) with European conceptual artist Dragan Ilic; and *Environmental Symmetry* (1978) with dancer John Powers and music by Glenn Charvat, Doug Lofstrom, Rick Panzer, and Jim Teister.

My multifaceted relationship with Tom DeFanti was a catalyst for very powerful personal and professional transformations [see p. 21]. I had just started auditing Dan's class and was walking to it when all of a sudden, Tom slid down a ramp, landed at my feet, and grinning ear to ear, introduced himself. That was the beginning of our relationship. From that moment on, I was constantly being immersed in a vast array of new experiences, friendships, and opportunities. Our travels took us to cutting-edge facilities to see groundbreaking work and we hung out with some of the great minds and computer artists of the times. We also had a very prolific, creative partnership that produced a large body of texturally rich and historically important work. Two select pieces that Tom and I performed together were during the first live computer performances of their kind in the world: *The Poem* as part of the interactive Electronic Visualization Event, EVE I, in 1975, and *Circle 9 Sunrise* as part of the second Electronic Visualization Event, EVE II, in 1976, before audiences of over a thousand people during each performance. Our performances of *The Poem* and *Circle 9 Sunrise* were also included in the group tapes produced from these exhibitions, *EVE I* and *EVE II*. My skills continued to expand from pioneering work in electronic-image generation

to include emotionally connecting to the audience. *Electronic Masks*, a humorously engaging piece of animated tribal masks and totems from various cultures, is illustrative of the innovative work I did solely with the IP's oscillators and editing. In 1977, Gene Siskel, film critic and host of *Nightwatch*, interviewed me about my work and my performance of *Circle 9 Sunrise* during his live television program on WTTW, PBS in Chicago [see p. 192].

I wanted to teach for a living [in 1979] but I wasn't close to receiving an undergraduate degree. During the previous four and a half years at UIC, I had designed my own curriculum filled with independent studies producing electronic art rather than taking required courses. I was a recipient of the Edmond J. James Scholar in 1978 and 1979, an Alpha Lambda Delta Honor Society member in 1976, a Bates Scholarship,

and I had exhibited extensively internationally, but after four and a half years I wasn't close to getting an undergraduate degree. That didn't hold me back. Based upon my artwork, résumé, and letters of recommendation, I was admitted into the School of the Art Institute's [of Chicago, SAIC] MFA program in 1979 where I entered into an entirely different community of artists. Their Visiting Artists Program also provided incredible exposure to world-class interdisciplinary artists and their work. At SAIC I quickly became proficient with additional skills on the Rutt-Etra and Moog synthesizers and I integrated performance art and electronic music compositions into my artwork.

[At SAIC, her work evolved into] lyrical video poems and mystical stories on the cycles of life, death and rebirth, dreams, precognition and the timeless, reoccurring experiences of the

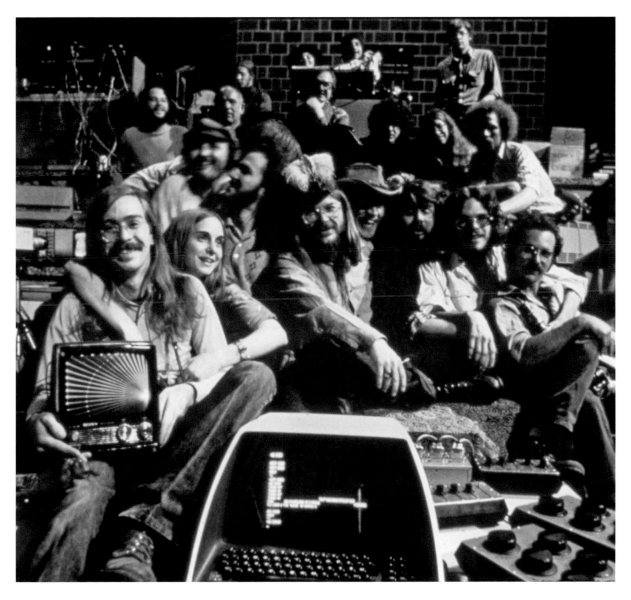

The primary performers of the first Electronic Visualization Event, EVE I, in Chicago in 1975. Bottom row (left to right): Tom DeFanti, Barbara Sykes, Dan Sandin, Phil Morton, Bob Snyder, and Drew Browning. Second row (left to right): Guenther Tetz and Larry Cuba. Top row (behind music stand on right): Michael Sterling. Courtesy of Barbara Sykes.

Sykes's interview by film critic Gene Siskel, WTTW, PBS, Chicago. Gene Siskel, film critic and host of *Nightwatch*, interviewed Sykes about her pioneering work in computer art, her performance of *Circle 9 Sunrise*, and the nature of real-time electronic art during a live broadcast on WTTW, a PBS station in Chicago. Courtesy of Barbara Sykes.

collective consciousness. These tapes, installations, and interactive performances were based upon poems I wrote and were inspired by indigenous cultures from around the world, including their female mythological and religious figures, rituals, religion, dance, music, and art. *I Dream of Dreaming* and *Witness* were multimedia performance art pieces that integrated large-screen video-projected imagery with monitors strategically placed in the theater and stereo music as part of the storytelling techniques. The single-channel pieces include *Video Haiku*, a collection of video poems and mystic stories: *Waking*, *Witness*, and *I Dream of Dreaming*. As a student at SAIC, I worked for Lyn Blumenthal and Kate Horsfield at the Video Data Bank, an international video art distribution organization, and co-coordinated *Recent Work*, their traveling video art exhibition, and documented SAIC's visiting artists, including New York performance artist Ellen Fisher's piece *Call Her Amedia*.

I was on a plane to New York [a few months after receiving her MFA degree from SAIC]. Ellen Fisher loved my documentation of *Call Her Amedia* and had recommended me to Meredith Monk [an avant-garde composer, singer, director, and choreographer] to document several of her pieces. Right before I left for New York, the

National Endowment for the Arts froze their grants, including Meredith's, which was to be used, in part, to pay me to document her work. I flew out anyway, had a great time, and fulfilled a prior obligation by presenting my first curated exhibition, *Video: Chicago Style*, a video/computer art and documentary exhibition at Global Village that also aired on Manhattan Cable. I flew home and presented *Video: Chicago Style* at Chicago Filmmakers, which was reviewed by critic Larry Lundy in the *New Art Examiner*, a national art publication. I was hired as a full-time teacher at Columbia College shortly afterwards.

I was born in Chicago and my life has been significantly shaped by its influences. It's a city rich in artists, innovators, and visionary mentors—individuals who not only conceive of possibilities, share their knowledge, and produce their own work but also create opportunities for others. You had Dan and Tom who had teaching research facilities that drew artists from different parts of the country so they could have access to and produce cutting-edge work on tool systems that weren't available anywhere else. Phil Morton was at SAIC, another educational setting that provided a variety of experimental tool systems designed for artists. Then there was Tom Weinberg and his pioneering institutions in the video revolution; the Center for New Television, Communication for Change, and Image Union on PBS that provided low-cost equipment access and training, funding, and exhibition opportunities.

These were artists' collectives and were the places where artists went to work, broke new ground, and flourished. Dan, Tom DeFanti, Phil, and Tom Weinberg created an atmosphere that was nonthreatening, open, and supportive where women could really flourish. In the seventies I grew up nurtured in these incredible stimulating and dynamically evolving collectives that had a built-in community-based sensibility. Janice Tanaka, Annette Barbier, Jane Veeder, Marilyn Wolf, Mindy Faber, Barbara Latham, Christine Tamblyn, Lyn Blumenthal, and Kate Horsfield are some of the women who were also doing important work and had come up at that time. Early on I understood that I was part of something much larger than myself, that it's great to be part of the community, to work with the community, to showcase it, and in that respect, to uphold the tradition of community and give back. Since the beginning my art, my career and my life have been interconnected and intrinsically intertwined.

In 2005 I left Columbia as a tenured professor of television after twenty-three years of service. My contributions to Columbia, Chicago, and the international art scene were as teacher, artist, independent producer, curator of national and internationally traveling exhibitions of Chicago video and computer art and documentary productions, and I was also the initiator and director of various program series consisting of experimental, documentary, and multimedia art, artists, and significant figures involved in these fields. In the process of accomplishing the variety of exhibition and funding opportunities for the TV Department students, Chicago artists, and independent producers, I developed collaborations with a broad range of cultural and educational institutions in Chicago, nationally and internationally, to cosponsor my events and host my curated exhibitions. At Columbia, I established and served as director of the Visiting Artists Series and the Visiting Lecturer Series that brought to the college internationally acclaimed artists and thinkers, including Barbara London, Gerry O'Grady, Copper Giloth, Raphael Franca, Marlin Rigs, Miroslaw Rogala, and Gene Youngblood. Gene's presentation in 1983 ignited the college into the computer age, inspiring the immediate purchase of computers, the hiring and training of faculty and staff, and the development of curriculum. To that end, I served on the search committees to hire, administrate, and develop curriculum for the program.

I invited multimedia installation artist Rita Myers [from New York] for a semester to teach the department's first interdisciplinary courses filled with students, faculty, and staff. One class produced *d/stabilize/d*, a multimonitor installation at ARC Gallery in Chicago in 1987. I initiated and served as director of the Media Artists Series, which showcased the TV Department faculty's experimental, documentary, mixed genre, and media art works during *Electronic Fields: Unheard Voices*, at the State of Illinois Art Gallery in Chicago, October 13, 2000–January 12, 2001, and *In Response: Video with a Social Agenda* at Columbia, May 26, 2000. I also brought in Tom Weinberg, his Fund for Innovative Television (FITV), and FITV's historic four-thousand-tape archive of innovative and provocative television programming to Columbia. Tom's profound contributions over the past forty years to Chicago and the nation's social and political activists, media artists, and documentarians in the creation, exhibition, funding, and distribution of their work

Detail from *Video: Chicago Style*, 1981–1982, used for an exhibition poster. This was the first video and computer art exhibition that Sykes curated. She screened it in New York at Global Village and Manhattan Cable, channel 10, in 1981, and at Chicago Filmmakers in 1982. Courtesy of Barbara Sykes.

Sykes's screening of *I Dream of Dreaming* at SCAN Video Gallery in Tokyo, Japan. This piece was inspired by Amaterasu, the Japanese mythological sun goddess, and conceived from dreams, poetry, and precognition. In 1988, she first produced it as a live, multimedia performance piece for the public; she danced in concert with a large-screen projector and monitors strategically placed, displaying her video/computer art at SAIC's performance space. Later, she produced it as a single-channel tape for distribution. In both productions, Sykes danced and used the IP and Rutt-Etra synthesizer, with sound by Stuart Pettigrew. As part of Sykes's fourteen-month Columbia College sabbatical and Chicago Artists Abroad Award, she presented *I Dream of Dreaming* as part of her *Retrospective*, a collection of her work, and *Video and Computer Art: Chicago Style*, an exhibition she curated that included her tapes in Japan, China, Australia, and Spain in 1988–1989. Courtesy of Barbara Sykes.

Amma: A Documentary of a Living Saint is an exquisitely beautiful, extraordinarily powerful film. Mata Amritanandamayi, affectionately known as Amma and as "the Hugging Saint" by the international press, is seen traveling the world leading a lifestyle revolution with unique links between unconditional love and spiritual devotion, with an emphasis on social service, gender equality, and global peace. This film offers a rarely seen example of a woman spiritual leader; it sheds new light on women's history; and it better represents women's roles in their community, their culture, and in society. Sykes is the producer, director, camera, digital video effects, and editor. Courtesy of Barbara Sykes.

During my first sabbatical, I went from two months of high visibility in the international art scene to twelve months in intensive research and production in remote areas of the world. I discovered an abundance of cultural, philosophical, and religious diversity, and intimately captured indigenous people and powerful events. My sabbatical provided a vast array of new experiences and a quantum shift in my understanding of the world. It was a phenomenal period of radical growth, honing my skills, and having life-altering epiphanies. I absolutely loved it and I am very grateful for these experiences. It was another pivotal time in my life when I was transformed and my work dramatically changed. Upon my return, I produced *In Celebration of Life . . . In Celebration of Death . . .* , my award-winning series of experimental, ethnographic documentaries, which includes *Shiva Darsan*, shot in Nepal, and *Song of the River*, shot in Borneo [see p. 193].

Art was very good to me, but I feel more and more driven to do work that plays an active role in change and contributes to the larger culture, stories I am intrinsically connected to, feel passionately about, and want to share. Now I am trying to push, grow, and contribute by using the technology in different ways. One of my strengths as a storyteller is being grounded in an aesthetic sophistication of great emotional depth that depicts the underlying sacred nature of the people and events portrayed. This has quite a different emphasis from what was initially very important to me and the community I grew up where there was an emphasis on the cutting edge, working on the most sophisticated tool systems, and creating groundbreaking work. In comparison today, children have more powerful systems than what I worked on back then.

Since the 1970s, computers have made exponential advancements and substantially changed the world. They are woven into the tapestry of global culture and life, revolutionizing and making substantial advancements in all fields. The technological revolution opened up countless doors for women and provided them with opportunities that have helped to accelerate women's progress and position in the world and also helped to expedite women's essential nature. Women naturally gather together, develop, nurture, and sustain.

It is the intrinsic nature of women to be creators and communicators. It is in our genetic makeup to birth humankind. We are also the primary caretakers in the development and sustaining of families, which in turn influences cultures, societies, and communities of all kinds. In a world that has oppressed, abused, and neglected women for millennia, technology has helped to empower women and helped them take on leading roles in the world, and with that comes progressive and substantive change.

An exquisitely beautiful, extraordinarily powerful portrayal of one woman's rise from poverty, abuse, and discrimination to become a world-renowned spiritual leader and global social activist [is how she describes her current project, *Amma: A Documentary of a Living Saint*]. It is an inspirational illustration of how one devastatingly poor, severely abused woman freed herself from social constraints, overcame tremendous obstacles, forgave her oppressors, and now shares the world's platforms with political and religious leaders.

Amma leads a lifestyle revolution across diverse ethnic, political, economic, religious, and nonreligious backgrounds.[2] It is a deeply moving portrait of one woman's extraordinary life and her inexhaustible ability to awaken the transformative power of love within us. This film shows how Amma practices and teaches a symbiotic relationship between spirituality and social change through direct action in the world and illustrates a unique, nonpolitical model of leadership that is spiritual with practical applications. Amma's story is universal, and offers a rarely seen example of a woman spiritual leader. There is a great need for a new vision and leadership. I hope that my work will present life-affirming role models, and in some positive way, help to bring balance, optimism, and inclusion to the world.

Notes

1. Sykes had quickly become proficient on the Sandin Image Processor (IP). While auditing Dan's course, she offered students one-on-one tutoring in exchange for a portion of their IP sign-up time to do her own work.

2. *Amma* was the recipient of the prestigious Gandhi-King Award for Non-Violence at the United Nations in Geneva in 2002; Nelson Mandala, Kofi Anan, and Jane Goodall are past recipients.

Kate Horsfield and Lyn Blumenthal

An interview with Abina Manning

Abina Manning is the executive director at Video Data Bank, a not-for-profit organization based at the School of the Art Institute of Chicago. Abina has worked to promote artists' film and video for many years, in both Europe and the United States. Prior to joining the Video Data Bank in 1999, she worked with a number of arts organizations in the United Kingdom, including the LUX Center, the London Film Maker's Co-op, London Electronic Arts, and Cinema of Women. She was director of the inaugural Pandæmonium Festival of Moving Images, a major European exhibition presented at the Institute for Contemporary Arts in London that showcased film, video, gallery installations, and multimedia works. Abina has participated in many international film and video festivals and conferences as a juror, panelist, curator, and advisor, and has worked on collaborative projects with arts venues internationally. She has a bachelor of arts in literature and philosophy from Middlesex University and a postgraduate diploma in film and television from the University of Westminster, London.

My understanding of the early days of the Video Data Bank (VDB) is that Kate Horsfield and Lyn Blumenthal were recent School of the Art Institute of Chicago (SAIC) graduates at a time when there was a lot of interesting activity in Chicago and on both coasts. Kate and Lyn had both come through art school, but they wanted to know, "What does it really mean to be an artist?" They took advantage of their proximity to SAIC's Video Department and borrowed the Portapak equipment and went out there and started interviewing artists, particularly women artists. That was the beginning of a huge collection of artist interviews that's grown to over four hundred tapes and is called *On Art and Artists*, which the Video Data Bank distributes.

[Some of their early interviews] were with really fantastic artists and critics like Lee Krasner, Lucy Lippard, and Elizabeth Murray [see pp. 8 and 23]. I haven't seen all of them, but I've seen

a number of them and what impresses me most is that there's often this moment in the interview where Kate, Lyn, or another interviewer asks questions about practice: "What do you do?" "How do you do it?" "What do you think about it?" "What's your career about?" The artist being interviewed looks up in amazement that anybody is interested and is asking these questions, because nobody was asking women artists anything at that time. The interviews recorded them talking about their practice and their domestic lives, whether it be relationships, children, or the difficulties of handling both. They're incredibly straightforward interviews. Many of us today are familiar with being interviewed or being on camera, and for sure that was not the case at the time.

The Video Data Bank was also publishing a magazine called *Profile*, from 1981 to '86. We recently rediscovered these in the office. What

happens often with organizations is that a piece of their history gets lost every time somebody leaves—it's a real struggle. We found some boxes of *Profile* magazines. Unfortunately we don't have copies of every issue, but we would like to republish them—they are so fantastic! There are transcripts of the interviews, but there are really great images and additional texts as well, sometimes drawings by the artists—and they could be available now for iPad. There are so many different ways to handle the material.

The archive has grown to number more than five thousand tapes. It's interesting to note that various titles go in and out of favor over the years. We see these changes related to activism, feminism, identity politics, or whatever is happening at a particular moment in time, and different titles come under the spotlight. That's why it's important for us to ensure that we keep all titles in the collection in good condition, or as good of a condition as we can afford to keep them in. The collection includes videos by Martha Rosler, whose work has achieved newfound attention over recent years. Linda Mary Montano's *Mitchell's Death* from 1977 and many of her other early works were recently featured at an exhibition at SITE in Santa Fe. Lynda Benglis, of course. Nancy Holt, who made some wonderful early works about perception. Joan Jonas with *Vertical Roll* from 1972 concerning the fragmentation of women's bodies. Then in Los Angeles, Susan Mogul was working with the Feminist Art Workshop at CalArts, and making tapes like *Take Off* in 1974. Dan Sandin's *Five-Minute Romp*, 1973, is also part of the collection.

Hermine Freed's work is about family. There's a piece I've always loved called *Two Faces*. It's from 1972 and she's looking at the mirror image of herself, kissing herself, playing with her hair. It's a joyful piece. We were offered a spot at the Moving Image Art Fair in New York that opened last week [March 2013]. Since VDB is a not-for-profit organization, they very kindly donated free participation. We were able to choose one piece to show, and that was the piece I chose. It was a revelation because she's not so well known. Many people,

Kate Horsfield. Courtesy of the artist and Video Data Bank, SAIC.

Lyn Blumenthal. Courtesy of the artist and Video Data Bank, SAIC.

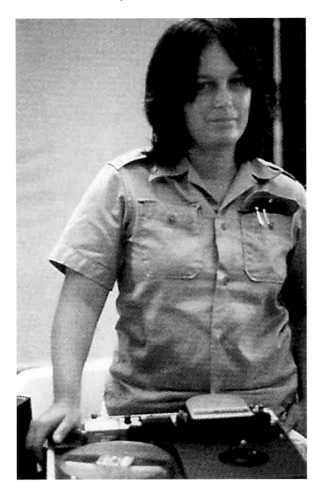

Five-minute Romp through the IP, 1973, B&W and color video, 00:06:34. In 1973, Dan Sandin designed and built a comprehensive video instrument for artists, the Image Processor (IP), a modular, patch programmable, analog computer optimized for the manipulation of gray-level information of multiple video inputs. As he explains in the video, Sandin decided that the best distribution strategy for his instrument "was to give away the plans for the IP and encourage artists to build their own copies. This gave rise to a community of artists with their own advanced video production capabilities and many shared goals and experiences." In this segment, Sandin demonstrates the routing of the camera signal through several basic modules of the IP, producing a "primitive" vocabulary of the effects specific to video. Courtesy of the artist and Video Data Bank, SAIC.

especially young people, were taking photos of the screen and videotaping the image. They were really taken with her images. Unexpectedly about twenty members of her family showed up at the art fair! Hermine died in 1998, and we have kept in contact with her daughter, but I had no idea that family members were coming from all over the country; they had a big reunion celebration with champagne. It was wonderful, and I felt like it was the start of something new for her work.

Kate and Lyn developed the first Video Drive-In that took place in Grant Park in 1984 and was later restaged in southern Europe. A massive screen publicly displayed video art for the first time ever in the park, and nearly two thousand people came each night for four nights. To develop an audience for video art was the key goal in the 1980s, along with packaging video programs; they curated themed VHS compilations, which is something we still do now at VDB, though no longer on VHS! *What Does She Want?* was released in 1987, a compilation Lyn produced featuring feminist film, video, and performance. There have been many others since, such as *Surveying the First Decade: Video Art and Alternative Media in the U.S.*, which looks at the state of video between the years 1968 and 1980 through the lens of a number of programs, including gender and video-processing tools. I don't think tape preservation was seen as a pressing issue until the early 1990s when they realized that video tape degrades and they were starting to lose the image quality of the work, especially tapes that hadn't been viewed for five or six years. Preservation became a really large part of Video Data Bank's work then, and still is. It's more important now than ever. The original tapes are degrading, and it takes a lot of money to preserve them; it is something we're trying to do.

We began transferring the analog collection that existed on a range of formats including ¾" Umatic and Betacam tape to digital formats [in the late 1990s]. For the last three or four years, we've been digitizing everything and making uncompressed files. It's a huge job that we do in the background of our day-to-day work. At this point in time we have digitized about 70 percent of the five thousand-plus analog tapes that are in the VDB collection, which are currently stored on hard drives so that we have the best possible analog and digital copies. Current best practice is still to keep the original analog tapes. Contemporary artists seldom give us their work on tapes anymore. More likely it's a file or a hard drive.

[Many exhibitors and festivals] want to download files for exhibition now. What is incredible to me as someone who has worked in the field for twenty years is ¾" Umatic, Betacam SP, and VHS were it for twenty years or more, and then suddenly we're in a digital era. Things shift. Nowadays they shift on a monthly basis! What we're looking at now as a distributor is that we're going to be streaming work to all of our customers in the very near future, and probably all of the analog tapes will go into offsite storage. We don't want to get rid of them because in some ways we don't know how robust the digital archive is, and for some works the tapes could still be the best copy, especially for early works. Some of them are just beautiful to look at, especially the open-reel tape.

Artists' submissions, recommendations from the community, or through seeing something at an art fair, a festival, or a screening [is how we acquire videos for distribution], and we talk to other curators. We also invite curators to propose compilations, and we have a viewing committee that watches everything. Sometimes submitted work is just not for us. Maybe it's a feature film,

documentary, or just very conventional work, and even though it might be very good, it's not for the Video Data Bank. The questions for us are: Does this work say something new, or is it using new tools or techniques? How does it relate to the collection? Is it talking about something that is relevant to now? Is it experimental or thrilling in some way? Is this something you want everyone to see? We are also thinking about our customers, because we are committed to earning royalties for the artists in the collection so that they can continue to make work. Fifty percent of our sales and rentals are to educational markets, to libraries and classrooms, and then we sell archival copies of work to museum collections. We also think about the festivals that show new work, how we're going to launch a title, and where it will be exhibited. And of course, the work has to make us feel excited.

A big revelation has been artists' uses of Blu-Ray and HD because the image looks so fantastic. For years and years when I've been traveling to festivals and events showing work, you could be nervous about there being a problem— there could be a glitch in the tape or something about the projection could make the image look terrible; but with HD, things just look stunning. If the artist is in the audience, they're usually very happy with the quality, so that's a big plus for us. There is so much creative work out there. Video art is still so young, and I can't think of another art form we have watched develop in our lifetimes.

Arcade, 1984, 4:3 color video, 00:09:35. "The syntactic structure and lateral movement of *Arcade* match its fairground equivalent. The work includes a series of images recycled from television and film, interspersed with location footage of Chicago El stations and punctuated with paintings created by Ed Paschke on a computerized paint box. Flashing insights and lights, the ready-made imagery presents a sideshow of current concerns playing on the slippage between the televised and the real" (Kirshner 1984). Courtesy of the artist and Video Data Bank, SAIC.

Beach Ball Boogie, 1978, created with collaborators Catherine DeJong Artman and Paula Garrett Ellis, and with technical assistance from Drew Browning. Top: An analog technology response to newly available digital tools and a critique of a gendered power structure. Right: Approximation of sophisticated digital tools using "crude" analog tools, including cardboard cutouts and a record turntable, to reflect on uneven access to more advanced tools. Courtesy of Annette Barbier.

full swing as a maker of video art, trying to fulfill the expectations of an academic environment for promotion and tenure. I had also been working with the Bally Arcade using BASIC, and began working with ZGrass on a UV1 computer.

I was able to persuade a colleague to use some of the repair budget to purchase a UV1 and taught the first computer graphics class in Radio/TV/Film, where twelve students shared one computer. I tried to persuade the rest of the faculty that computers were going to be essential to the curriculum. I eventually started working with the Mac under the tutelage of staff from the Advanced Technology Group. Not too long after, I was able to purchase some SGIs [Silicon Graphics Inc. workstations] and began teaching 3D computer graphics animation and modeling. In Radio/TV/Film, the department was mostly concerned with traditional, narrative media—so even video art, which was my fit—was new and suspect. While at Northwestern for more than two decades, I was, for the first ten years, primarily a video artist, using computers to enhance and manipulate mostly linear media.

The Home project started [in the 1990s] with the home page and grew into a web-based artwork that featured fifteen additional artists and supported an array of media, including video, sound, and animation. It is about the notion of home and identity, situated in a 3D world (created in VRML—web 3D) in which you traverse a suburban neighborhood to get into a house with many rooms, each with a score. The voice of one of six characters randomly plays in a visited room that showcases contributions from other artists linked to objects in the room. The next project was *River of Many Sides/Path of the Dragon*, a commissioned collaboration with both local colleagues and others in Viet Nam in which we shared our impressions of one another's countries. The project was realized as a media performance in three acts that traversed the history of Viet Nam, including a mythic time, the American war, and its reconstruction. A later iteration of the project was an interactive installation where participants on either side of a projection screen could collaboratively navigate down a river that represented a path through Viet Nam's history [see p. 194].

I steadily enlarged the role of computers and collaborated on the creation of two curricular programs [at Northwestern University] based on new technologies for the Center for Art and Technology and its associated certificates (undergraduate and graduate) and Animate Arts, an undergraduate major for students whose primary affiliation was in engineering, art, liberal arts, media art, or music. Students co-enrolled in this program in which programming, music, and visual and media arts were taught in interrelated ways in the same class. Presently, at Columbia College in Chicago, I am on the faculty of the Interdisciplinary Arts Department, primarily associated with the MFA in interdisciplinary arts and media.

I received a great deal of support from the university and other sources. The most recent grants I received were in 2012 from the Illinois Arts Council for the construction of Plexiglas boxes for the *Subtractions* series of feathers, laser engraved with the names of extinct bird species, and a Propeller Fund grant for an augmented reality work, *Expose, Intervene, Occupy: Re-interpreting Public Space*, for Chicago's Loop, created with members of the unreal-estates v1b3 collective, Ch. 2 collective, and Celine Browning.

I've been working on collecting data with a motion-capture system to create objects. I'm planning to create dual portraits with gaze-tracking data of two people looking at one another. Work in that vein includes a seventy-five-foot mural of plastic material cut using a water jet cutter driven by data collected from a motion-capture system. One piece called *Approach*, a collaboration with Drew Browning, is on view at the Prairie Center of the Arts in Peoria and was created in their residency program. I will also incorporate data collected from the movements of a friend doing yoga to sandblast lines/traces into rocks. I am at work on a new feather series called *Noms de Plume,* in which the names of the "discoverers" of a bird along with the English and scientific names are cut. Although technology still doesn't come easily for me, the results are so spectacular that it's well worth the effort.

IN MEMORIAM

While in the final editing stages of this book, Annette Barbier sadly passed on June 5, 2017, survived by her husband, Drew Browning, and their daughter, Celine Browning. Annette will be fondly missed by her colleagues, peers, and students whom she made a lasting impression on with experimental New Media artworks infused with feminist ideals and a reverence for nature.

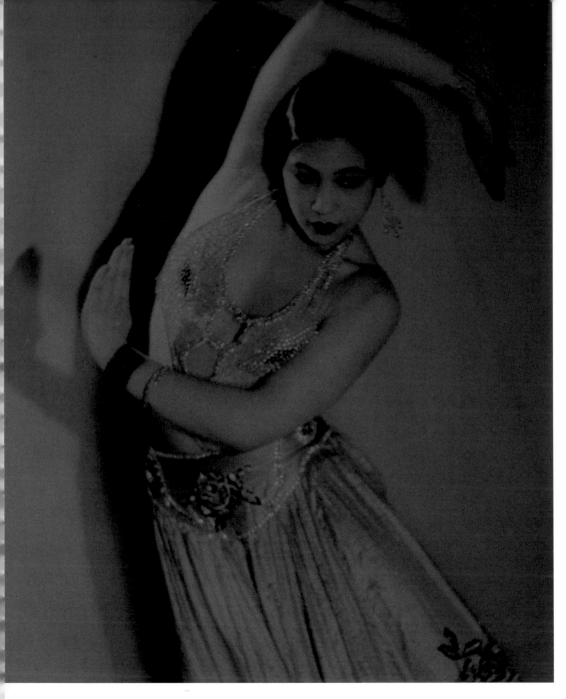

Image detail from *Blue Window Pane*: Simone Prieuer, Dancer, ca. 1930, Man Ray 11½" × 9" vintage gelatin silver print from the Richard and Ellen Sandor Family Collection. Digital photograph by James Prinz Photography.

It was difficult to show the work. The biggest thing that happened was having *Dream Grrrls* installed at Ars Electronica in Linz, Austria, in 1996. I had many other pieces installed there, but I did not actually get to go there until 1999 when *Blue Window Pane* was shown at the festival that year.[2] I felt very lucky that Indiana University was able to send me. I met a lot of people and saw a lot of good artwork. The most memorable experience in Austria was this train ride at midnight through the steel mill where music and arts technology was placed along the tracks. It was so surreal. It made me realize that the technology did not have to be bound up in a research lab but it could be taken to the streets. It also made an impression on me because I am from the Midwest and from a steel town. As a young kid, I saw the night sky as orange and thought

that was natural to occur at times. Seeing those types of bright colors intrigued my world and influenced my painting palette. I like the richness that pure color provides. It may also be an influence of modern art like Picasso or pop art and op art. I remember as a very young girl seeing Andy Warhol's soup can painting and making a special trip to the corner store to stare at the soup cans on the shelf. I didn't quite understand it all, but I knew that somehow a piece of the everyday world was making a big impact on the larger world. I looked at the cans because somehow I was hoping that they would connect me to that larger world.

Brenda Laurel and Carol Gigliotti's work also inspired me. I was interested in what they were writing. What I really enjoy is that they brought philosophy and ethics into the mix. I think it's important for artists to understand what's going on in the humanities and the sciences in order to do powerful art. I was grateful that women were talking computer science from a feminine perspective and looking at different roles that we can take on within VR. I enjoyed reading about the theatricality of VR as a medium. Now I apply that attitude to the operas I do. I feel like the performance space is a virtual space—the projections are the virtual worlds and I am situating people in another reality. I see the various disciplines and approaches contributing—all as a continuum.

I think what motivates me the most about using technology is seeing the possibilities for shifting perception and expanding thinking. I can be in the world of my imagination in so many more ways now. It's not just art in terms of paper and pen and brush, it's art in terms of experiential moments with art. Interactivity. Being able to influence a visitor's decision-making process and experience at the same time. I often think of the visitor as I create art because I know that they will come to realize the piece through their actions. There are many things that influence that interaction. One of the articles I read back in 1995 in *Leonardo* by Carol Gigliotti outlined the major criteria for aesthetics of virtual environments.[3] This became my mantra when designing new worlds. I considered the interface that I was using and sought to exploit it according to its unique properties. The CAVE was a first-person perspective of a 3D world that reacted according to the *xyz* positions of your head and hand that was not found elsewhere, so it was important that where the visitor stood and where their head or hand was

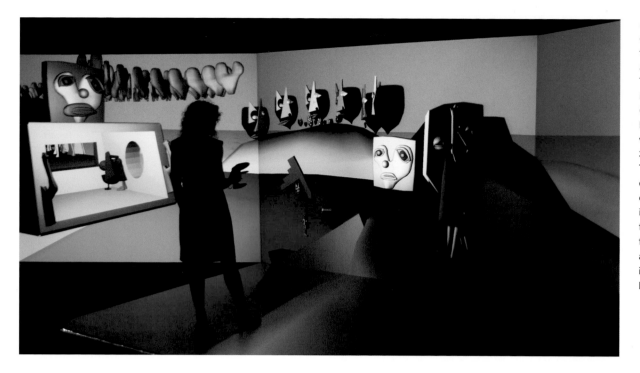

Figuratively Speaking, 2010, is a confrontation of faces as figures that have their own movements and sounds when approached. They exist on a wide-open landscape surrounded by the sea (see). The main characters are based on watercolor paintings, which have been recreated as 3D computer graphic models. The head movements, their expression, and the qualities of the face convey social information. Their asymmetrical faces and quirky movements facilitate communication with one another through captivating but incomparable voices. Courtesy of Margaret Dolinsky.

made a difference. For example, you could stick your head inside something that would make something change, while putting your hand in it caused nothing to occur. This allowed me to create events according to the intimacy of the interaction. My content was nonlinear so that it progressed with its own dream logic. The visitor could meander about and find their way to different places without much constraint. I want the visitor to find their own path through the artwork and create their unique experience. Many times, people followed paths or found fields of view that I had not considered. These were some of my most pleasant moments. I love to see how others are discovering their world, and the ways that they describe it. One day I had a reporter come to visit me and he said, "My cousin said to ask you to show me the one with the lizards." I could not think of any lizards in any of my work but I was thrilled someone else had their own dreams in my virtual environments. It's great.

VR work is not like painting that creates a frozen image, but initially it was struggle to go from painting, which I had complete control over.

Dolinsky's *Inter:Facing*, 2011, a solo exhibition of interactive artworks at the Grunwald Gallery, School of Fine Arts, at Indiana University. Photos by Kevin O. Mooney. Courtesy of Margaret Dolinsky.

One of Dolinsky's paintings, *Whirlhead*, 2015. Courtesy of Margaret Dolinsky.

music, the lighting, the dancing, and the movement. It made me think of how the real world became my virtual environment, spaces and places expanded to include real-world situations and virtual situations.

I like fusing technology into the world and its various platforms. I think technology will realize its full potential with artists and creative types influencing its path and creating new types of action.

Lately I have been trying to realize my characters as physical rapid prototype sculptures embedded with sensors and talking to one another. It brings them off the page, out of the computer box, and lets them sit next to me in the real world and say something. Pretty fun.

I also have been collaborating with a biologist studying chloroplast movement. He manipulates their movement to change the leaf's internal structure and my drawings appear on live leaves. I have found a new appreciation for plants as living organisms. They share our planet and keep everything alive. It's been somewhat of a departure for me from 3D modeling, but this process relies on my use of computers for drawing and painting. I paint and draw using programs like Maya, Corel Painter, Photoshop, and Illustrator. It is different than using paper and brushes physically but mentally the process of creating remains fluid in both analog and digital realms. For me it's really about process. I like to be there as it happens.

I'm a cochair of the Engineering Reality of Virtual Reality Conference in California for IS&T/SPIE Electronic Imaging. I have been involved since 2004. When I started going to the conference, few women attended this huge conference of mini-conferences. I organized a lot of networks and CAVE events. One of the tracks we host is "Women in VR." I've attracted a lot of women to attend and speak at the conference. We've expanded to include augmented reality too. Though it is an engineering conference, I feel artists are engineering virtual reality in their own way and we've brought artists into the discussion, which has added a new dimension to it. My cochair is Ian McDowall, an engineer who builds head-mounted displays and is CEO of Fakespace Labs in Mountain View, California. We have a great mix of engineers, scientists, and artists who speak, like Carolina Cruz-Neira, Ruth West, and Jacqueline Ford Morie. I've been working hard to give women a place to gather and have a voice.

With painting I was on my own, having gallery shows, and getting attention for my work. In computer graphics, however, it's important to be part of a team and have access to technology that you may not have a clear idea of how it works exactly.

I really found this out when working with the American Opera Theater. I created interactive sets for several productions and had to think about the stage, the audience, the actors, the

We've come a long way, though. It doesn't take months to create computer graphics for the CAVE. Now I carry a digital sketchbook on my phone and draw with my finger, create animations, and can share them across the world in no time. I can hardly wait to see what happens next with 3D, stereo, and pixel point data. There are so many new devices for scanning and photographing and displaying—just wait to see the many ways that they become interactive.

Notes

1. Jacqueline Ford Morie, PhD thesis, 2008, Smart-Lab at the University of East London.

2. Dolinsky collaborated on a series of iGrams with Ellen Sandor and (art)[n] of her work for her MFA show, in which PHSCologram snapshots from the CAVE were printed in real time for exhibitions and further research.

3. Carol Gigliotti, "Aesthetics of Virtual Environments: Interface, Content, Perception, Performance, and Plasticity," *Leonardo* 28, no. 4 (1995): 289–95.

published as hardcover books for a variety of different publishers, because they evolved as comic social commentaries. I wrote and illustrated *A Child's Machiavelli* and *Dr. Faust's Guide to Real Estate Development* (based on *Faust*) that I also created as paintings—meaning, paintings of book pages. The art world was more conservative then, and there was a lot of discussion about whether these things could actually be "art" or were perhaps instead "just illustration." They made fun of power structures and were always pink. I took a direct feminist position with my work, critiquing the power structure, because in those days, in the European art world, clearly women were marginalized. Making everything pink was intended to be offensive. When those books became popular and were published by Penguin—I thought I was actually going to be able to cross over into mass culture. This was really interesting to me as a possibility; after all, I was from the post–Laurie Anderson generation, and we thought we were heading into a utopian, democratic world of mass culture. It didn't turn out that way at all, corporations actually being the opposite of democracy. I decided to come back to the States because I had a fantasy that there was

a radical pop culture back there and that I could do these kind of funny, socially critical books if I came back. In the end, I was really just homesick! But I returned to New York, and when I arrived, I decided I should animate the books, with the intention of putting them on MTV. Of course, it never happened! But it was this decision, to go home and to learn animation, that brought me to simulations technology.

I started working with Maya [in 1998] because I decided that I wanted to animate *A Child's Machiavelli*, the more successful book. At the time, *A Bug's Life* had just been released. *A Bug's Life* was first screened in 1997 in the Berlin Film Festival, while I was living there, and I was fascinated because it had an Enlightenment quality. Pixar-style animation has a mathematical, geometric mind-model look, as my earlier work also did. As a medium, it was therefore immediately seductive to me. I thought of Paolo Uccello and Vermeer! So I investigated. I ended up attending the NYU Center for Advanced Digital Applications in Midtown Manhattan, a few blocks from the McGraw-Hill building, where my whole journey started at *ID* magazine. The guy who was the director of the center at that time was Peter Bardazzi. When I showed him *A Child's Machiavelli*, he said, "Oh, you have to come here!" So I did, having *no* idea of what I was getting into. I became totally obsessed. Something hit me hard: I had a headache every day! I didn't understand how hard it was to learn 3D animation when I first started, and how much of a commitment it was. I found myself in a situation where it was just me and the twenty-year-old guys. There were never *any* women around. Lynn Hershman was out in California at that time. That's part of the reason why I now show at bitforms gallery. Lynn really urged Steve Sacks, my gallerist, to put me in the gallery. At that time, I was in love with the work of Cindy Sherman—with the idea of a documentation that was fake, that was somehow also a performance, and was working from a fictional orientation and dealing with the female body, and artifice, and fantasy. I was already interested in these kinds of artificial constructs. So when virtual imaging came along, it fit all the bills. It was what I wanted, both a mind model *and* fantastical.

I was only doing Maya about two years, which was nothing in terms of the technical skills I had. But because of my contemporary art background, I was immediately hired at Pratt Institute [in 1991]. So I was teaching in a vocational context in a department then called "Computer Graphics

Roberta Construction Chart #2, 1975, Lynn Hershman, 20" × 24" vintage dye transfer print from the Richard and Ellen Sandor Family Collection. Digital photograph by James Prinz Photography.

and Interactive Technologies" now called "Digital Arts," something I really knew nothing about. I was pure contemporary. Pure art history. Then I had one year at RPI [Rensselaer Polytechnic Institute] standing in for an absent teacher (2002–2003). Then I taught at Sarah Lawrence, an over-the-top liberal arts school, which I loved (2003–2007). Both schools only offered half-time teaching and it wasn't enough to live on, so I adjunct taught everywhere in the New York area where you could teach 3D, always in vocational educational environments, because they were the only ones who offered it. It was considered a technical education for future industrial sweatshop workers. I would teach in places where, for the most part, I could not show or talk about the contemporary art world. It wasn't thinkable. The kids were sometimes hostile but mostly just disinterested. The schools didn't want me to mention it. In the beginning it wasn't gaming that was the sought-after employer, as it is now, it was children's animated films, as were being done by Pixar and Blue Sky.

[Many of her vocational students] were super macho. It was a boys' club, and there I was, a woman teacher. They took this as a kind of challenge. All they seemed to want to make were sexy babes in bikinis, and they were aggressively misogynistic eighteen- to twenty-year-olds. Although my work comes directly out of interests in history, classicism, and Romantic ideas about nature and the garden, then using growth algorithms versus the woman's body, and mathematics versus the woman's body as metaphors, I initially started working this way as of form of resistance to this kind of macho youth culture [see p. 199]. I would do demos of these very beautiful, sensual, naked women. I tried to make bodies that were not fashion-model-ish but plump and regularly human. The kids were very into debasing women, but if you actually made things that were sexy but sensitive, meaning sensual and with an emotional quality—they didn't know what to do. I would discuss these issues at the same time as I was producing these kinds of animations as technical demos. I developed my teaching strategy of doing a technical demo as a kind of socially engaged form of performance art at that time. I would confront these boys, and to my surprise they actually loved it. There would be waiting lists of kids trying to get into my classes.

I started getting girl students in New York, depending on the schools, beginning in the mid-'90s. If I was teaching in an engineering school,

like RPI, there'd be maybe one girl. At Pratt, where I also taught a class, over a period of six or seven years, I eventually began to have about 40 percent females. I think this was because my approach was so different and also because I was a woman. I made a safe haven for these girls, one that wasn't so sexist. My own work evolved in relation to this teaching process.

At Pratt I also met Claudia Herbst-Tait, who had recently published a book on women and digital code. We started writing theoretical papers. We would go into CAA [College Art Association]—a high art, art-history context—and analyze tech art in the terms of the contemporary art culture, describing it as a homosocial engineering world.

The Dolls, expanded cinema version created for *Conversations at the Edge*, November 15, 2015, at SAIC's Gene Siskel Film Center, curated by Amy Beste. Photo by Cassandra Davis. Courtesy of Claudia Hart.

Joan Truckenbrod *Fourier Transform*, 1976; *Spirit Site*, 2002; *Life of the River*, 2009; *Oblique Wave*, 1979
Detailed credits, p. 200

On Becoming, 1984
Detailed credits, p. 200

Joan Truckenbrod

Barbara Sykes

Electronic Masks, 1978; *Circle 9 Sunrise,* 1976
Detailed credits: pp. 200–201

In Celebration of Life . . . In Celebration of Death . . .
Detailed credits: p. 201 **Barbara Sykes**

Mother sings a lullaby
her voice drifting

Mother sings a lullaby,
for the clouds to enter the soul

Annette Barbier *River of Many Sides*, 2004; *Escape*, 2005
Detailed credits: p. 201

Morning Rituals, 1995; *Monsieur et Madame des Chloroplasts*, 2013; *Strait Dope*, 1998
Detailed credits, p. 201

Margaret Dolinsky

Margaret Dolinsky *Self-Portrait*
Detailed credits, p. 201

FRESH, 2008; *darkSky*, 2009; *Drinking the Lake*, 2010
Detailed credits, p. 201

Tiffany Holmes

Claudia Hart *The Alices Walking*, 2014; *The Dolls*, 2015
Detailed credits: pp. 201–2

The Seasons, 2009
Detailed credits: p. 202

Claudia Hart

Art Details for Part 2 Color Plates

Joan Truckenbrod

Page 190, top left: *Fourier Transform*, 1976
11" × 8.5" color Xerox transparencies of computer images overlaid
Algorithmic drawings created by developing FORTRAN computer programs inspired by Fourier transformations. These programs incorporated CalComp subroutines for creating drawings with the CalComp Pen Plotter. A series of drawings was created in black and white and translated into color using color Xerox transparencies that were overlaid to create this composition.

top right: *Spirit Site*, 2002
Video multimedia installation with Sound & video projection into handmade model house suspended from gallery ceiling
Video of salmon runs with the sound of rushing water in a stream is projected into an empty model house suspended from the gallery ceiling with clothesline. The video imagery of salmon fills the rooms of this house and proceeds out of the door and windows, washing over photographs of elderly people inside small window frames mounted on the back wall.

bottom right: *Oblique Wave*, 1979
36" × 48" computer tapestry, heat-transfer color computer image on fiber
A computer program was created in BASIC programming language for the Apple computer that incorporated mathematical formulas that described invisible phenomena in the natural world. Using this program a series of images was created and printed on heat-transfer material. The computer monitor was turned upside down on a 3M Color-in-Color copier with a backlight setting, to print each of these images. Another pattern was superimposed on each of these printed images as the guide for cutting each into new pieces, which were then rearranged. Next, this array of pattern elements were heat-transferred onto polyester fabric to create this computer tapestry.

bottom left: *Life of the River*, 2009
Dichroic ecoresin fish shapes in two colorways supported by steel seaweed-shaped poles. Public art installation in Green Bay, Wisconsin, along the Fox River. This installation was created to honor the American Indians who traveled along the river and were sustained by fishing. They fished only the number of fish they needed to survive, leaving fish to multiply for the future years. Fish shapes and steel supports were designed using the computer.

Page 191. *On Becoming*, 1984
30" × 24" Cibachrome Print
Computer digitized image of a face is superimposed over live video imagery of the same face, creating a synthesis of an analog and digital image. The image was photographed with a 35-mm camera off of the screen.
Courtesy of Joan Truckenbrod.

Barbara Sykes

Page 192, top: *Electronic Masks*, 1978
A humorously engaging piece of tribal masks and totems reminiscent of the work of North American indigenous cultures that portrays a mythic past, spirit guides, sacred objects, or symbols of a tribe, clan, family or individuals. *Electronic Masks* is illustrative of Barbara Sykes's earlier body of pioneering work that used the image processor exclusively to create detailed, luminescent figurative art such as masks, totems, animals, fishes, birds, people, and so forth, as well as abstract flowing forms, which set her work apart from others in the field. Audio by Glenn Charvat, Doug Lofstrom, and Jim Teister.

bottom: *Circle 9 Sunrise*, 1976
Barbara Sykes, Tom DeFanti, and Drew Browning
Image processor and a PDP1145 with ZGrass language
A real-time performance on digital and analog computers with Michael Sterling on Moog synthesizer during the second Electronic Visualization Event, EVE II, in 1976. They also performed *The Poem* together during the first interactive Electronic Visualization Event, EVE I, in 1975. EVE I and EVE II were the first events of their kind in the world as computer artists and electronic musicians performed their technological and artistic abilities together live before audiences of a thousand people during each evening's performance. These performances were held in an electronic sculptural and acoustic environment

within a four-story rotunda with multimonitor displays, an inflatable structure that housed a large-screen video projector and four channels of sound at the University of Illinois at Chicago Circle Campus.

Page 193. *In Celebration of Life . . . In Celebration of Death*

A series of video poems and mystic stories that are also experimental, ethnographic documentaries. *Shiva Darsan*, 1994, shot in Nepal, reveals the religious, cultural, and philosophical beliefs of indigenous people from various cultures by exploring their rituals, dance, music, and daily activities that revolve around life and death. From birth to death, special rites and celebrations mark the important events of one's existence, ensuring a symbiosis of body and soul with the divine. This deep relationship between the people and their god is reaffirmed through daily activity, strengthening their sense of sacredness and self-respect. Sykes shot all of the footage during her fourteen-month Columbia College sabbatical and Chicago Artists Abroad Artists Residency in Asia, the Mideast, and Africa in 1988–1989, and upon her return to the States, she edited and distributed them.

Courtesy of Barbara Sykes.

Annette Barbier

Page 194, top: *River of Many Sides*, 2004

A still from video documentation of Act II, media performance. Two performers (Nguyen Thi Minh Ngoc, Quoc Thao) and three media artists (Annette Barbier, Drew Browning, and Leif Krinkle) bring to life the experience of ordinary people in a time of turmoil, through the creation of a live stage performance in a virtual world.

bottom: *Escape*, 2005

Site Specific Video Installation

Exhibited at the 2005 UVFA/v1b3 public art event, this work uses the evocative potential of the fire escape to speak about flight, disappearance, and leave-taking.

Courtesy of Annette Barbier.

Margaret Dolinsky

Page 195, top: *Morning Rituals*, 1995

18" × 24" gouache

Morning Rituals depicts the moment of transition between sleeping and waking, referred to as the hypnopompic state when images from the unconscious occur. The artist in the ritual of waking up from a sea of dreams with the conjuring shaman of the morning summoning the belly strength to greet the day, meet familiar faces, and visit new possibilities.

bottom left: *Monsieur et Madame des Chloroplasts*, 2013

35" × 21" Live leaves on digital canvas

Monsieur et Madame des Chloroplasts is one image in the series *The Living Canvas*, created in collaboration with plant biologist Dr. Roger Hangarter where chloroplasts movements are manipulated to create Dolinsky's images in live leaves.

bottom right: *Strait Dope*, 1998

CAVE virtual environment

Strait Dope soberly relies on seemingly hallucinogenic imagery. It is filled with faces and animated vignettes that confront the visitor. In one scene, two emotables protect a third. When closely approached, the third emotable's face animates and changes in order to share its expressions.

Page 196. *Self-Portrait*, n.d.

Taken after a cross country journey to understand our changing landscapes and how that sense of transition might affect virtual environments.

Courtesy of Margaret Dolinsky.

Tiffany Holmes

Page 197, top left: *FRESH*, 2008

FRESH attempts to raise awareness about the high cost of bottled water in the United States, a country that has very good quality tap water.

FRESH 2.0 is a dynamic animation that randomly constructs fictitious natural landscapes from iconography appropriated from bottled water labels (see top left image). This generative animation has been displayed in a variety of venues, from Hong Kong to Chicago.

top right: *darkSky*, 2009

Lamps, plasma, custom software, datalogger

DarkSky is an interactive installation originally commissioned by Chicago's Museum of Contemporary Art. This participatory piece consists of twenty-seven salvaged table lamps that sit on a table with a bamboo top fronted by a large plasma monitor.

bottom: *Drinking the Lake*, 2010

Photograph mounted on acrylic, 151 × 47"

This photographic mural presents the rise and fall of Lake Michigan's water level for the previous 150 years, 1860–2010. The annual water level is represented by the height of the horizon line in the lake photographs collaged into the large-scale wall mural.

NOAA, the US government's main climate agency, says between 1972 and 2008, Lake Michigan ice cover declined by about 30 percent. Due to the disappearing ice, the lake can now evaporate year-round. With a growing population actually drinking that lake, scientists are concerned more than ever about dramatic drops in the actual water level of the Great Lakes.

Great Lakes water levels constitute one of the longest high-quality hydro-meteorological data sets in the US with records beginning about 1860. Thanks to Craig Stow and Keith Kompoltowicz for data compilation.

Courtesy of Tiffany Holmes.

Claudia Hart

Page 198, top: *The Alices Walking*, 2014

Live theater taking place on a 50' square pedestal

Experimental opera hybrid with a fashion show featuring "augmented-reality: wearables"
Photo: Sophie Kahn, featuring *Alice #4*, Julie Robinson
Mashing augmented reality, sculpture, cocktails, and opera, The Alices (Walking) is an experimental fashion show about spectacle, looking, and looking at others looking. It portrays a culture so addicted to the devices of high technology that it can only bear a world that is filtered through them.

bottom: *The Dolls*, 2015
Expanded cinema version created for *Conversations at the Edge*, November 15, 2015, at the SAIC Gene Siskel Theater in Chicago, curated by Amy Beste. Photo by Kurt Hentschaeger.

Page 199. *The Seasons*, 2009
3D animation projection, looped, 11 minutes 7 seconds

The Seasons portrays a room in which a slowly evolving sculptural figure gradually transforms. In this animated loop, a variety of visual, temporal, and conceptual cycles are offset and overlaid so that their movement is obscured. All is in flux but time seems to stand still, as in life.

A seated woman in a pose of erotic abandon cycles clockwise on a rotating pedestal. As she cycles, she decomposes, a vine of roses surrounding her blooms and then fades away. The room also revolves, though counterclockwise, while the animation camera pans back and forth. These movements function in counterpoint, to appear only on the edge of perception. Sound for the piece is of crumbling paper. The color scheme is white on white.
Courtesy of Claudia Hart.

MIGRATORY INFLUENCES AND INSPIRATIONS

In part 3, adventurous women describe how their midwestern roots influenced their migrations and creativity. In the former sections, most of the contributors to *New Media Futures: The Rise of Women in the Digital Arts* have innovated from a solid midwestern foundation while having global impact through international exhibits, film, and other endeavors. Rather, women gathered here chose to physically relocate to expand artistic inspiration and new perspectives in faraway places like France, Singapore, and Finland. Their migrations are often intertwined with communities of entrepreneurship, SIGGRAPH, filmmaking, and mentoring future students and practitioners. Brenda Laurel began her journey pioneering interactive theater and exploring electronic games in the Midwest in the mid-1970s that led her to cofound Purple Moon in California in 1996. Copper Giloth, a native Bostonian, became the first student to graduate from the Electronic Visualization Laboratory (EVL) in 1980, where she made early electronic artworks on the Bally Arcade and has since continued to teach and experiment with bookmaking and photography on her travels from Boston to France. Jane Veeder, a pioneer in video art at the School of the Art Institute of Chicago in the mid-1970s, later developed her freelance production company and worked in the game industry and academic community in California. Sally Rosenthal graduated from EVL in 1983 and continued to bring the EVL community spirit into her work with the SIGGRAPH Electronic Theater and many ventures, like Interval Research in California. Lucy Petrovic, an EVL alumna and active SIGGRAPH contributor, developed new academic programs in New Mexico, Arizona, and Singapore while continuing to create socially conscious virtual reality experiences for museum visitors. Janine Fron collaborated on commissioned PHSCologram installations and sculptures with Ellen Sandor and (art)ⁿ, lived abroad in Finland, and coformed the Ludica game art collective in Los Angeles in 2005, where she was inspired to independently develop cooperative green games drawn from nature. The collective tenure of interviews captures moments that shaped their communities of practice and outreach. In combination, their interwoven efforts share ties with all of the women interviewed in *New Media Futures: The Rise of Women in the Digital Arts* and reflect how interconnected we all are, revealing ways women form networks of support to courageously try out new ideas.

Brenda Laurel

Brenda Laurel has worked in interactive media since 1976. She served as professor and founding chair of the Graduate Program in Design at California College of the Arts from 2006 to 2012. She designed and chaired the graduate Media Design Program at the Art Center College of Design in Pasadena (2001–2006) and was a Distinguished Engineer at Sun Microsystems Labs (2005–2006). Based on her research in gender and technology at Interval Research (1992–1996), she cofounded Purple Moon in 1996 to create interactive media for girls. In 1990 she cofounded Telepresence Research, Inc., focusing on virtual reality and remote presence. Other employers include Atari, Activision, and Apple. Her books include *The Art of Human-Computer Interface Design* (1990), *Computers as Theatre* (1991), *Utopian Entrepreneur* (2001), and *Design Research: Methods and Perspectives* (2004). Her most recent writing, "Gaian IXD," was the cover article in the September–October 2011 issue of the journal *Interactions*. She earned her BA (1972) from DePauw University and her MFA (1975) and PhD in theater (1986) from Ohio State University. She currently resides in Northern California.

I was a nerd in high school on the debate team and my first love was psychology. I went to DePauw University as a psych major and got through three years. Then I hit statistics and I got a B in it. I hate statistics but I also decided that there was more than one way of knowing things about people and that theater would be as good a path, maybe a better one for me actually, than science. In those days as a girl showing up in chemistry, being the only girl in the class, I'd get the distinct impression that I had two choices: I could either take science and math or I could have a date. So I went with the date and didn't take any math beyond algebra and stopped my science studies with botany. I graduated as a theater major from DePauw University. I was valedictorian in high school and college. My mother was thrilled except that I gave a fairly radical commencement address at DePauw in 1972 that caused the faculty to riot, people were running around, and the dean tried to not give me my diploma. The person who actually handed me my diploma was the mayor of Indianapolis back then, Richard Lugar.

I couldn't afford to go [to Yale Drama School] so I auditioned at Ohio State and got into the theater MFA program where I did a double major in acting and directing. It took an extra year to get dual status and also complete the equivalent MA requirements. I took my general exams in 1975 and got into the PhD program in theater. At that point, I thought I was going to write my dissertation on Bernard Shaw, his political theater, and how beautifully he addressed a lot of the issues of his day, but an interruption occurred in 1975. Just as I had finished my generals, I met a guy named Joe Miller who was also a Buckeye [fellow Ohioan]. He was working at Battelle Memorial Institute in computer graphics and that was a very new field then. One night, he gave

me a tour of his computer graphics facility at Battelle. We went through security, got in this elevator, and went up to this room where there was a screen showing images coming in from JPL [Jet Propulsion Laboratory] painting themselves on the screen. I just fell to my knees and said, "Whatever this is, I need to have a piece of it." Really, really deeply as an enabling technology that I knew nothing about, but there was this amazing moment that happened.

PIONEERING NARRATIVES IN GAMES

Joe and a friend of his quit Battelle to start a little company to do home computers before we all had personal computers. The machine they were working with was an 1802 processor, which ironically was what was being used in the space program at the time because 1802s are really good with low temperature and they're pretty reliable systems. He said, "We wanna do this little machine." It was a little board that plugged into your television and the code was stored on cassette tapes. One of the cool things about it was you could synchronize audio on that tape that stored the commands that executed the next step in the program. We had 2K of RAM and 2K of ROM.

You could only load 2K of the program at a time, so you couldn't do any robust branching because at the end of any 2K segment you had to come back to the main storyline because you couldn't easily control what was going to show up next in the program. [At the time, Laurel had been hired by Miller's new company, CyberVision, to design interactive fairy tales. Her first production was *Goldilocks and the Three Bears*.] The choices had to be really little choices, i.e., what color are the flowers or is the servant a male or female, etc. That got me started on thinking about what is this thing we call interactivity? I knew about punched cards; I used a primitive punched-card system as a lighting designer when I was in college, and I was familiar with mainframe computing, but the notion of interactivity for a regular person with a computer was a really new idea.

When you stop to think about it, there were some video games in arcades that show up about 1971, I think, but interactivity in arcades was pinball games and that was certainly more than we could do with the computer. I got obsessed with what it would take to make these things more interactive—to make choices that would have more impact on the storyline. It's interesting because in those days it was also prime time for interactive theater, so I was directing too. I wrote and directed a play about Robin Hood where the audience could make noise, carry on, and direct the characters to do different things within a larger framework. It was partially modeled after Commedia dell'arte but had more freedom in it. At the same time, plays like *Hair* and *Dionysus in 69* were showing on Broadway. Off Broadway, there was a lot of interactive work and the "poor theater" was being developed by

Brenda as Philaminte in Molière's *The Learned Ladies* produced at Ohio State, 1975. Costume by Michelle Guillot. Courtesy of Brenda Laurel.

Jerzy Grotowski in Poland. There was a lot going on in the world of theater that was interactive, and I came to video-games with that model.

We eventually got 16K of RAM and we were all making jokes like: What are we going to do, *War and Peace*? It seemed like a huge amount of RAM. Eventually that company caved because there was a new kid on the block called Atari. We sold 10,000 units of the CyberVision computer and then the company went belly up and one by one we all found our way to the West Coast to work at Atari because that's where interactivity was happening, and in fact everyone who worked at CyberVision ended up at Atari sooner or later. I was the only woman in the Home Computer Division. I remember the first day I came to work, I had a cubicle, a telephone, no chair, and no desk. I went into the women's room and it was filled with young programmers smoking and I said, "You know guys, I actually have to pee. You need to get out of here. This is not your lounge anymore. This is the Women's Room."

I was the project manager for educational software for the brand new Atari 400 computer. I got into deep water with that. I ended up being director for software management for all of the computer products. My group made decisions about what kinds of products we were going to produce and what would later be called producing, and we had a relationship with the engineering side of the company. I was bringing up stuff like word processing, VisiCalc, and personal finance products that we were developing, and the president of Atari just went nuts. He wanted me to spend 80 percent of my budget porting stuff from the Atari games over to my computer, and I was giving long speeches to the president of the computer division that if you're going to have a computer it's gotta be different,

not a video game machine. We went around and around. I did get some of those things actually out in the world, like the Pilot programming language and some of the other fundamentals, now that we think of it, of what personal computing can do. I also produced *PacMan*, *Battle Zone*, and *Space Invaders*.

They [Warner Communications, which had bought the Atari personal computing division] had the attitude that personal computers and computer games were a fad and they were treating it that way, kind of a disposable deal. When it became clear to me I was going to get fired, I walked across the street to the Atari Lab, which was a new part of the company, and the guy who was managing it was Alan Kay. And I said to Alan, "I have all of these ideas about interactivity." By that time I had decided I wanted to do my theater dissertation on computer interaction, what I was calling interactive fantasy. I wanted to look at how we could apply principles of dramatic theory. For me that was about poetics. How could you build a system that incorporated some of that intelligence so that when the next event was generated by the game it could be dramatically interesting in the context of what the player was doing? That was something I knew I wanted to do, and I laid that out to Alan and he said, "Come on over, work for research." So I went to work for Atari Research in 1982.

Alan got a memo from Ray Kassar, the president of the company, saying, I hear that this dangerous woman Brenda Laurel is still working for the company. You need to fire this woman. She really blew it over there in the Home Computer Division. Alan wrote back and said, "She had bad management and she's really quite creative." He saved my job and I continued to work at Atari Labs until Atari started crashing in late 1983. A

Laurel's published books 1989–2015, from left to right: *The Art of Human-Computer Interface Design*, *Computers as Theatre*, *Utopian Entrepreneur*, *Design Research: Methods and Perspectives*, and *Computers as Theatre*. Courtesy of Brenda Laurel.

bunch of us got laid off and I was one of them. At that point I traveled around the United States for a while and thought about what to do next.

I took a little bit of a break for child-rearing where I was just consulting. I went to work for Activision, starting again in education and then taking over their personal improvement products. I was lucky enough to be the producer for Lucas-Film games. At that time they were going through Activision, they weren't producing their own games. So I produced a couple of their games and I was also able to see on the ground floor what was happening with *Habitat*. If you recall *Habitat*, it was probably the first avatar-based interactive social network and I think it was actually released in 1986 or 1987. I got to watch that happen and make some input. That was neat, and the other cool thing that happened at Activision was that Timothy Leary decided to defect from Electronic Arts and come over to Activision. They said, "Well this guy's nuts, why don't you take him?" So I became his producer. By the time the 1990s rolled around, I was doing speaking tours with him, William Gibson, and Bruce Sterling. I really had a tremendous opportunity to meet some amazingly smart and interesting people who were part of the cultural revolution, and Tim was incredibly interested in technology and euphoric about what computers could do for us.

IMMERSIVE ENVIRONMENTS AND INTERACTIVE GAMES FOR GIRLS

In 1985 I went over to NASA and saw some of the early virtual reality stuff they were doing for training astronauts and realized, of course, that there was tremendous potential there for the kind of interactive fantasy I was thinking about. We're not talking about personal computers anymore. We're really talking about experience design. By 1987, I had done enough research and work in that area to feel that I knew pretty much what was required, and I went back to NASA and recruited the guy who was running the NASA Ames Research Lab, Scott Fisher, and started a company called Telepresence Research together to do virtual reality, which turned out to be an exercise in crash dummies since it was way too early to do it well or economically.

Right after I finished my first book [in 1989], though it had not actually been published yet, I

got hired by Apple to edit a book of essays by people in their human interface group that was called *The Art of Human-Computer Interface Design*. I decided to bring some other writers in. Timothy Leary wrote an essay in that book, which caused a major upheaval at Apple as to whether or not they were going to let that go. In the end it did end up in the book, and I got Nicholas Negroponte to write and some other people who were the usual suspects, and I think that's why that book sold for so long. People actually buy it now more for a history text than anything else. That took two years and actually shipped in 1990 or 1991, and *Computers as Theatre* came out from Addison Wesley Publishing Company as well because I had put it on the back burner until I finished the Apple book.

I had two kids, the game industry wasn't going well, and I didn't know what I was going to do. I gave a talk at a conference in Los Angeles where I met David Liddell, who had worked with Alan Kay at Xerox Park on the first personal computer. David was founding a new company called Interval Research. John Perry Barlow actually introduced me to David, who hired me to work at Interval, and I was one of the first people there.

I was fed up with the male-centric game industry and decided that I wanted to investigate how we could produce something that girls would like with computers. My reason for doing that was because we knew that one of the reasons that boys had so much facility with computers today and computer lab in school was because they have their hands on video game machines. They knew if you punch return eighty times something will happen and they didn't feel like they were gonna break it or do something wrong while girls would just hang back. Girls had no way in, typically in their younger years, and I also knew from looking at the American Association of University Women's Reports that if we didn't get them by sixth or seventh grade, we weren't going to get them at all in terms of that little cluster of math, science, and technology. So if you're going to make an intervention that gets girls comfortable with technology that seemed to me to be the sweet spot in terms of age.

[Laurel then spent four years with a team from Interval] and a team from Cheskin Research doing nationwide research projects on play and gender. It's interesting because if I had asked why girls don't play computer games, the answer would have been really simple and that is: There aren't any that they like and they're not sold in places

Purple Moon television news interview at E3 1997. Photograph by Rob Tow. Courtesy of Brenda Laurel.

Brenda Laurel's daughter Hilary helping launch Purple Moon at E3 in 1997. Her three daughters were the "best booth babes ever." Says Laurel, "Hilary is twenty-seven now and I am a grandma." Courtesy of Brenda Laurel.

where girls go in and there's a lot of cultural signaling around it. It's a self-fulfilling prophecy, so that would have been the wrong question. The right question, I think, was the one we asked, "How do girls and boys play?" "What's really going on here?" "How can we take play patterns that girls really enjoy in other parts of their lives and incorporate them into some kind of computer-based study that they have that draw the thing that will pull them across the threshold of getting their hands on a computer?" That was the overriding goal that led to founding Purple Moon. Once we figured out that we could actually build something that could live in popular culture, we could start a company. We started thinking about content at that point. We knew some things by then about play patterns that related with both cultural and brain-based differences.

Women are wired, as far as I can tell, to navigate differently through space than men. That there's a preference of navigation by landmarks that's pretty well understood. We tend to be body-centric navigators. If you think about it, if you're looking at a side-scrolling video game, you don't have a first-person body-centric navigation opportunity, and that leads to the second major brain-based difference, which is around mental rotation. That's basically the ability to imagine something being in a different orientation than what you're looking at—a cube rotated or a geometric shape—what would it look like to see from the other side. For that kind of question under time pressure, girls perform less well at mental rotation tasks than boys, but when there is no time pressure performance equalizes; that was a gold mine of a finding because that told us why girls had trouble with side-scrollers—side-scrolling computer games. There was a rotation and a translation involved from the plane of the keyboards to the plane of the screen to the orientation of the character moving sideways. So if you had a game with a clock, and if you were fighting the clock, girls were predisposed not to do as well on those games as boys by their brain's biology. That for me was a major finding.

We developed an interface for navigating emotionally so that when you'd arrive at a choice— we were still working with nodes in those days because we had pretty limp little processors— the choice screen featured three different facial expressions of the character. If you moused over them, you would hear some inner thought like "I'm really mad and I feel that I should yell

Commander Laurel on the Bridge, 2007. *Star Trek Experience* at the Hilton Las Vegas. Courtesy of Brenda Laurel.

at someone," or "This is so unimportant in the grand scheme of things, I'm gonna let this go," or "I think I'll cry." You could pick one of those options and events would unfold from the basis of that choice. One of the important elements about the game is if you were nice and smiled the whole way through, it was really kind of boring— there wasn't a way to win. Yet interestingly, good things could happen if you whined. It wasn't attempting to be nonjudgmental but rather to give kids emotional rehearsal space for trying out different ways of responding to situations. Long after the company was gone, those games were still being used and may still be today as far as I know for autistic kids to help them understand emotions. I also got a lot of mail during the time from young adult males saying, "Thank you so much, I understand women so much better." [Laughs], a training tool for boys.

Copper Giloth

Copper Giloth is an award-winning digital media artist and educator whose work has been featured in international festivals, galleries, and museums, including the Museum of Modern Art, the Bronx Museum of the Arts, the National Academy of Sciences, and ACM SIGGRAPH. In 1980 Giloth became the first MFA candidate and woman to graduate from the Electronic Visualization Laboratory at the University of Illinois at Chicago. In 1982, Giloth chaired the first ACM SIGGRAPH juried public exhibition of experimental two-dimensional, three-dimensional, interactive, and time-based works by artists and scientists. In 1985, she cowrote "The Paint Problem" with Jane Veeder, published in *IEEE Computer Graphics and Applications* (vol. 5, no. 7). Throughout her career, Giloth has worked with a variety of art forms, including drawing, sculpture, animation, photography, New Media, and bookmaking. All of her work is constructed with a strong influence from blending fiber arts traditions with the craft of storytelling. She has created inroads for women in making artworks that are personal, collaborative, and at the forefront of contemporary thinking. She recently stepped down after twenty-one years as director of Academic Computing, Office of Information Technologies, at the University of Massachusetts–Amherst, where she continues as an associate professor in the Art Department; she has also previously taught at Princeton University, Kent State University, the University of Michigan, and the School of the Art Institute of Chicago. Giloth's current major project is a three-dimensional, historically accurate virtual/augmented reality reconstruction of the Labyrinthe de Versailles, a maze with thirty-nine elaborate fountains, each illustrating one of Aesop's fables; the Labyrinthe, covering six and a half acres, existed among the gardens of the Chateau de Versailles from 1665 to 1775.

Sometimes when you're tested you get thrown into other kinds of places. If you're in an environment with people where you feel secure, you can take all kinds of risks. I feel like that's what I had, the ability to take risks that weren't going to destroy me. I think that's an important place to be able to be in.

I come back to the theme of my mother often because part of her daily life was the production of our clothes, quilts, needlepoint, and, of course, mending everything.[1] Her use of the grid is what became the defining structure of my artwork. When I finally figured out I was going to make images with computers, that connection seemed obvious to the creative work done for centuries by American women. In high school, my strengths were in art and math. I ended up working on a degree in sculpture at Boston University. I chose sculpture because I was attracted to the building of a 3D object. That process of building was instrumental in my ultimately connecting to using computer programming for art making. During my studies at Boston University, I took a welding course and sat in on several experimental video courses at MIT.

Copper Giloth Selected Animations: 1978–85, concerning my landscape both internal and external. Courtesy of Copper Giloth.

Simulation of a water sculpture, *Rings*, designed by David C. Morris, 1978. ZGrass software, Vector General Display, PDP-11 computer. Courtesy of Copper Giloth.

Waveguide(1): Black-and-White Video Waveforms, 1980. A quasi-humorous/feminist/educational video explaining how to use a video waveform monitor. Produced with Zsuzsa Molnar. Courtesy of Copper Giloth.

I knew I wanted to create large-scale figurative sculptures with metal. While working as a welder in General Dynamic's shipyards in Massachusetts, I observed a computer-controlled flame-cutting system that used computerized drawings to cut large materials for ships. I had a real "Aha!" moment. This could be a way for me to build sculpture. All I needed to do was figure out how to program a computer. After working in the shipyards, I traveled to Africa to study African and Egyptian sculptures. It was actually when I was in markets in Nigeria, Togo, Burkina Faso, and Mali where I saw the perfection of the way they made their utilitarian objects and was finally able to make a bridge between my esoteric

education, building figurative sculpture, and the idea that objects could be beautiful and connected to one's culture. I concluded that maybe I needed a way of making art that was more connected to American contemporary culture.

I enrolled in several introductory computer-programming courses at the University of Illinois at Chicago Circle (UICC) in 1977, where I first learned how to program with cards on an IBM computer. Raul Zaritsky alerted me to the newly established graduate program at UICC's Electronic Visualization Laboratory (EVL), where I was invited by Tom DeFanti and Dan Sandin to apply in 1978 [see p. 21]. I became their first graduate in May 1980. In between finishing prerequisite

programming courses and enrolling in EVL's graduate program, I met Phil Morton, Jane Veeder, Barbara Sykes, and other future collaborators.

Being good at using tools (whether computers or sewing machines) was important, but not something I was ever willing to discuss. At the time, I felt connecting my work to quilt making and needlepoint was a bad strategy. Many painters and other artists thought admitting using technology to create work would delegitimize it. The art world has changed, though, and the use of technology and traditional women's fabric constructions has become much more commonplace. However, I never would have voiced those opinions back then.

For me, it was important that they [the hybrid video game computer systems at EVL] were personal systems! You didn't have to be in a room with a big computer or with all of these other people. You could work in a more intimate way, similar to how I had worked with traditional materials. They were low resolution, 160 by 100 dots per inch with two colors. I remember how exciting it was when we moved to 320 by 200 with four colors. Things have come a long way since then. But for me the question still is, what resolution do you really need to tell a particular story?

There were things going on in the Chicago art world that made the city somewhat different from other places around the country. One was the presence of very strong alternative video community. That community really had, through the Ford Foundation, supported video exhibition spaces with funding for artists. And there was the Chicago Editing Center whose director I knew, Cynthia Neal. She was very supportive of the experimental things that people were doing with digital computers. Analog video was making the transition to digital video.

When I first arrived at UIC they were still using vector graphics computer systems. These systems were used by Larry Cuba for the *Star Wars* vector trench scene. But then, raster display systems started to replace the vector graphics systems. The collaboration between these digital and video communities became a very rich and supportive place for me and many other artists to make-work. A lot of the women involved were interested in supporting other women. Cynthia Neal provided exhibition space and support for me and others who were working in these areas. I was head of the Circle Women's Liberation Union (CWLU) at UIC. The logo for the CWLU was the first computer graphics image on the Vector General Display configured with ZGrass software.

[Programming] a computer was very similar to the process of building a sculpture. That's why in the early days people who had degrees in sculpture were more likely to work with a computer than people who had studied painting. In order to build a sculpture, you have to build an armature to hold it and that's the same thing you had to do with a program. Programming was probably the most exciting thing I had learned to date. The idea that I could tell a computer to follow a process and make an idea happen was exciting!

[In addition] to telling stories, the other theme in my work is using technology to visualize the landscape within the context of our political environment. I was very interested in the objects that I chose to be part of my work and how those objects carry emotions. Today, I took one of my father's suitcases from my sister's house to carry some of my stuff home. I kept wondering how my father had used it for his travel and it made me want to use the tension present in personal objects like the suitcase in my work.

My life was changed by the EVL program. But my work started to change before I got there. I ended up making a connection through programming where I could use these new technologies to combine images, sound, and text within

Copper Giloth and her Datamax UV-1, Lear Sigler dumb terminal, graphics output monitor, video monitor, Epson tablet, and black-and-white video surveillance camera, circa 1981–1982. Courtesy of Jane Veeder.

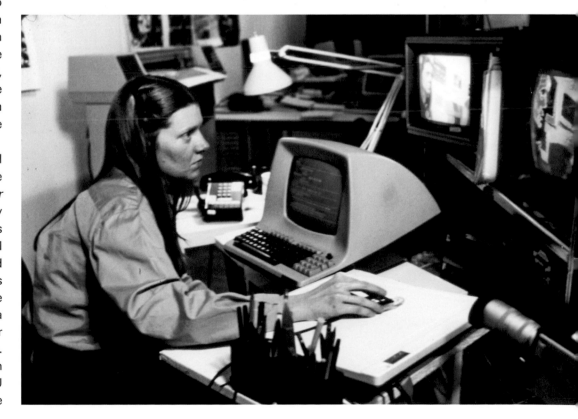

From Video Games to Video Art, 1980, installed at the Museum of Contemporary Art, Chicago, with a series of my plotter drawings output from the interactive installation. Datamax Computer, ZGrass software, custom software, and custom game controllers. Courtesy of Copper Giloth.

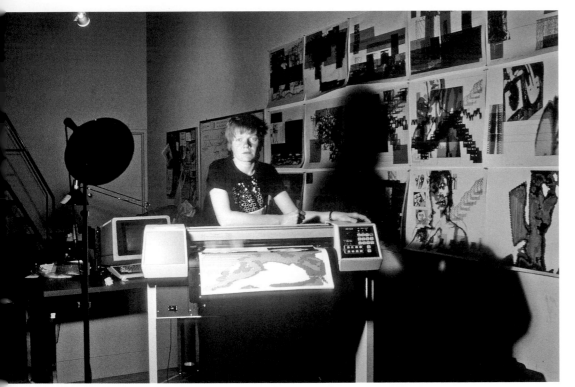

Copper Giloth with her plotter and a group of the Field's drawings on the wall, 1984. Courtesy of Copper Giloth.

Short stories continue to have an important role in the work that I do now.

I was very aware I was completely invisible from the art world. The art world didn't care. I didn't go to an art museum from 1977 through the early 1980s. It didn't seem like a place that was going to be supportive to me, so why bother? In 1984, Lynne Warren put together this show, *Alternative Spaces: A History of Chicago*. In it, she has a timeline that goes back to 1893 and shows how the 57th Street artist colony in Chicago came up through 1984 with these various alternative spaces, like the Center for New Television, N.A.M.E. Gallery, Chicago Film-makers, Artemisia, ARC—I think the connection of video to this community was very important [see Introduction].

I was the first art student to graduate in 1980. I was faster than other students only because I completed some extra courses ahead of time. I had my show in the UICC "Passion Pit" that used to exist in the Art and Design building. One of my works, *Skippy Peanut Butter Jars*, won numerous awards and was shown all over the world. *Skippy Peanut Butter Jars* is a coming-of-age story telling how and why I became an artist [see p. 264]. I tell my students, it doesn't matter what your resolution is, it matters what your story is. I wanted to be a visual short story writer. I came from Boston University, which had a very classical art school. For four years I made drawings and sculptures of nudes. During my graduate school years I was trying to deal with that life, my new life, and being able to put all of these things together to make meaningful work.

Tom DeFanti and I had an interactive drawing installation [at the Museum of Contemporary Art Chicago in the summer of 1980] that allowed visitors to explore my drawing process where I used reflections and rotations of a simple object to create landscapes. In the museum, there was a video game-like console where a visitor could draw a simple object. My program would make versions of the object using rotations and reflections of it and then allow the user to build a more complicated image. On the walls of the gallery were a series of my drawings printed on paper with a plotter that were created from the same program. This software was developed with two fellow graduate students, Dan Sadowski and Patty Harrison, and it was the kind of collaboration that was happening all the time at EVL.[2]

I taught at the School of the Art Institute of Chicago [in 1983–84] and worked as a software

stationary and moving grid structures. This process was a comfortable place for me to make-work and one that felt familiar given my earlier quilt and sewing experiences. More complicated were the issues of timing with video and audio given my lack of experience. My initial works were visual short stories. I was influenced by the short stories of W. Somerset Maugham and the simple form and morality of Aesop's fables.

designer for the start-up Real Time Design, Inc., which was established with funding by Bally and Midway Games. We were working to make ZGrass, a commercial product. I actually pioneered the work of making a paint program with modules that you could configure. ZGrass was an extension of the language BASIC. It had a lot of visual commands in it. It was much easier to program compared to the kinds of programming courses I had taken at the university—it was relatively simple. But you could combine sound and image together. You could also do things in parallel, which was really important in terms of having simultaneous things happen when you were making something. I wrote my first drawing program on a Bally Arcade that had some extra memory and a keyboard added to make it possible to write programs. My programs were stored on audiotape. My work had now become a series of small programs that I combined together to make a completed piece. This process was close to how I had built sculpture. It was a wonderful place to be in, this computer space, where I could make intimate little stories. I realized it had been far more difficult for me to be expressive in clay than with the computer.

I remained involved with SIGGRAPH [after graduating from EVL]. While at EVL I had worked as a student volunteer on the SIGGRAPH Video Review and I developed a reputation for being able to actually get something done in a fairly organized way. I had various roles at the SIGGRAPH conferences starting in 1979. The 1981 SIGGRAPH conference decided to exhibit a section of computer-based art at the 1981 Library of Congress Exhibition. The success of this joint venture convinced the SIGGRAPH organization to support the first competition for computer-based art at SIGGRAPH 1982 in Boston.

Although it wasn't the first exhibition at SIGGRAPH, it was the first competition, and they asked me to be chair of that.[3] I was the youngest person to do the SIGGRAPH Art Show. Joanne Culver and Cynthia Neal from Chicago and Darcy Gerberg from New York worked tirelessly on the exhibition. Louise Etra, from New York, was my mentor, instructing me how to go out and find the people needed to make the exhibition a success. I was asked to chair the show again in 1983 in Detroit. We built an extensive traveling exhibition so that after the central exhibition in Detroit in 1983 different forms of the exhibition travelled to thirty-two locations across Europe, USA, Canada, and Japan.

Real-time Design—Animation and Paint program examples (grid of four screens), 1982. Japanese and English character animations by Giloth and the first menu of the ZGrass paint system by Giloth. Courtesy of Copper Giloth.

SIGGRAPH '82 Art Show documentation website, 2006. This shows the first page of the website that includes all the work and twenty hours of artist interviews. Courtesy of Copper Giloth.

EXHIBITION OF COMPUTER ART

GALLERY LOCATIONS HISTORY

LOCATIONS SIGGRAPH '83 was the first SIGGRAPH Art Show to travel, with exhibitions held at museums and galleries across North America, Europe, and Japan.

UNITED STATES

EUROPE

コンピュータが熱くする、スーパー映像の世界。
コンピュータ・グラフィックス展
JAPAN

CANADA

CONTACT US

SIGGRAPH '83 Art Show documentation website, 2012–2015 in progress. This website will document the original three sites for the *SIGGRAPH '83* art exhibitions in Avignon, France; Tokyo, Japan; and Detroit, Michigan. Courtesy of Copper Giloth.

There were many women who became more prominent in the computer–human interface area [called SIG CHI] because it seemed to be a more open research area than computer graphics. I started working in this direction when I accepted a job at the University of Massachusetts–Amherst. SIGGRAPH funded me to make a documentary on Bob Mallary, an early pioneer artist in computer graphics. In the autumn of 1990, *Art Journal* published a timeline I worked on with Lynn Pocock that started with the 1945 ENIAC (Electronic Numerical Integrator and Computer) invention in which women who worked during World War II became the first computer software developers for the first computer [see figure 19 in the introduction]. Then I collaborated with Jane Veeder on the SIGGRAPH Video Review Index. We had a whole team of people across the country in computer graphics that helped us look at the vocabulary you would use for keywords to give us a better idea of how to get at the primary resource information.

I had another enlightening experience. In 1992, Maxine Brown was the SIGGRAPH chair of the conference in Chicago [see p. 38]. I was invited to be on the Electronic Film and Animation jury. I had an interesting role or actually several roles as the only woman, artist, and educator on the jury. I had never been on this jury before and it is the central event part the SIGGRAPH conference. We had some really knock-down, drag-out disagreements. There were some representations of women in some of the work that made me question whether SIGGRAPH was really an educational organization. Especially if they were willing to support putting out to our community large-breasted, beautifully rendered women on the screen who were being stabbed, marginalized, or just being objectified! I had a problem with some of the works. We had a big discussion about it and made compromises but I left disillusioned. I have always struggled with it. It is in many other disciplines and not just computer graphics: How do we sell computer graphics with women's bodies? And is it appropriate for SIGGRAPH to glorify these images?

I was definitely not popular, and it was very clear that I was never going to be on this jury again, no one was ever going to forget it, and they haven't. There were some pieces I kept out of this exhibition because I thought they were hostile. I got angry about it and in response sat down and watched the entire SIGGRAPH Video Review through 1993. I copied out onto videotapes every computer-generated image of a woman and every computer-generated image of a man. I made a piece of the footage about women called *Modeling the Female Body: A Survey of Computer Generated Women 1980–1994.* I submitted it to the SIGGRAPH '94 animation festival. It was accepted, but they told me I had to get permission and make it only three minutes long.

I had an administrative assistant because I had become an administrator and a professor, and we called all over the world trying to get permission for this piece, which was basically three minutes long with forty-five clips with how women have been imaged since 1978. When you look at this piece that got submitted and finally got shown at SIGGRAPH, nobody got very upset about it but there were some people who came up to me and said they hadn't really thought about imaging women that way. The only group who refused to give me permission was Pixar, which is not surprising. SIGGRAPH would not put it on the SIGGRAPH Video Review; the only way to get it is from Dana Plepys or me. I never distributed the one I did of men. It is interesting because when you look at the males and females, the females were exaggerated, having small waists and big breasts and placed in passive positions as opposed to the men, who

were generally pictured in active poses. I aimed this piece at the SIGGRAPH community to try to put forth the idea that one has a choice on how to build positive 3D models of women. There were men who came up to me and said, "Wow, I hadn't really thought about how negative some of these images appeared." I was simply trying to make the point that if we are an educational organization, we need to have to think about the power of putting out negative images of women!

I took an apartment [in 2002] in Aix-en-Provence, France, where Paul Cézanne painted and grew up. With my dog and my son for my companions, I brought my computer and I thought okay, it's time to relook at the world. That started me down the direction of how was I going to rethink my art practice and go back to my obsession with the reflections and rotations in the landscape [see p. 264].

I observed how technology was used in France to carefully prune trees to effectively shade the streets. I expanded my use of the digital camera to just watch people, and see how many people I could take pictures of who were on their cell phone, carrying baguettes, taking pictures of people, etc. I made a series of works constructed from nine hundred small photos all of the same set of doors that was shown at SIGGRAPH a few years ago. I was using a digital camera to look very carefully at the same object and trying to record small changes so that in the end one could see the light slowly changing. I started looking at the impressionists and thinking about the technology that had influenced them. I started watching people who watch stuff, watching people who were taking pictures of art—and began piecing them together. I realized this was an extension of what I was doing in graduate school and afterwards—the process of piecing things together to make a story. Because of my history with needlepoint and quilts, that type of thing is what interests

ACM SIGGRAPH SVRii Hypercard Index—Grid of four screens from the application. Courtesy of Copper Giloth.

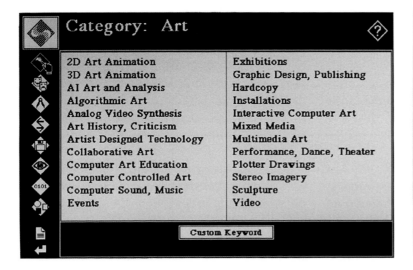

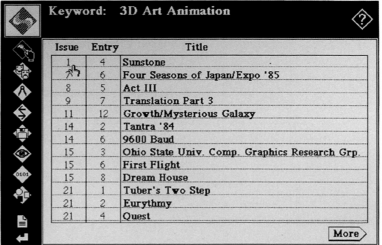

Modeling the Female Body: A Survey of Computer-Generated Women 1980–1993 (1994). This project is a survey to the *SIGGRAPH Video Review* Collection excerpting short selections showing how women were imaged using computer graphics from 1977 to 1993. Courtesy of Copper Giloth.

me. There are plenty of artists who have done this. It was important for me to make that connection with that strong history and with those pieces that I have lived with daily.

A new series of works traces their roots back to my sabbatical. When I went to France in 2002, my mother had just died. I spent a lot of time thinking about her sewing, her quilts, and her process and how it related to the structures in my artwork. Finally I was willing to delve into her stuff about a year ago. I got out her biology drawings she did when she attended Evanston Junior High School in 1933. She did drawings of the growth of a plant when she was in eighth grade. It was very interesting, how this young woman would've done this in 1933. I scanned her drawings into the computer and combined them with scraps of images of algorithmically derived plants and landscapes to form digital quilt drawings. These mother-daughter pieces use a grid to bring together my digital world with my mother's detailed ink drawings [see p. 265]. I now see this relationship of quilts and the landscape—as the quilt being the landscape of your life.

|||

Notes

1. Copper Giloth stressed the influence of her father in her life's work, as well as her mother. Her father worked at Bell Labs, where he designed telephone switching systems and guidance systems for missiles, which sparked Giloth's interest in technology.

2. In an exhibition review that appeared on September 28, 1980, in the *Chicago Tribune*, Alan Artner remarked, "The single installation by Copper Giloth and Tom DeFanti is a modified computer system upon which visitors may create their own graphics. This is quite a switch from the narcissistic installations of five years ago, and if it still takes a disproportionate amount of technology to have people do simple designs familiar from textiles, the idea is both positive and filled with possibilities."

In May 1982, the Museum of Modern Art Department of Film issued a press release for *Art & Technology: "Chicago Video" at MOMA* and acknowledged, "Since the late 1960s, Chicago has become a major center of independent video production, with particular trends and qualities which can almost be considered a school of its own. Unique about Chicago is the

pervasive interest in the use of analog computers in creating video imagery and sound. . . . The manipulation of strong symbols and clear graphic images is a common factor. Copper Giloth's *Popcorn* and *Skippy Peanut Butter Jars* are witty stories based upon simple graphic designs, while Jane Veeder's *Montana* is based upon one of America's symbolic animals, the buffalo."

On August 1, 1983, Don Akchin reported in *USA Today*, "For Copper Giloth, a Chicago artist and software designer, the computer software is a finished work of art. One of her programs, exhibited at the Museum of Contemporary Art in Chicago in 1980, lets viewers draw images on a screen and instruct the computer to rotate them, duplicate them, change their colors, and do other recombinations and rearrangements. The 'art,' says Giloth, is in her programming: 'People are playing within the environment I've created.' 'Right now,' she says, 'interactive art is extremely difficult for the art world to deal with.'"

3. The SIGGRAPH '82 Boston Art Show included eighty-eight drawings, animations, photos, videos, and installations chosen from over one thousand entries. The jury's vision stated, "The use of the computer in these works shows that style is established by the artist and not identifiably derivative of the computer hardware, as was the case five years ago." A printed catalog accompanied the exhibition with essays written by Gene Youngblood, A. Michael Noll, and Cynthia Goodman.

Jane Veeder's ZGrass machine, 1982. Courtesy of Jane Veeder.

move at the time. I asked Tom if I could join his project and learn to program in ZGrass. He agreed and said, "Copper can be your mentor!" Copper Giloth was an EVL graduate student at the time and she helped me get started, gave me a few sample programs, and showed me what she was doing [see pp. 22 and 215].

I convinced them [the Department of Education in Chicago that operated WBEZ, a public radio station] to let me devote my time to produce three or four animated ads they could put on television. That supported my tutelage in learning to program animations and development tools in ZGrass.[2]

I acquired a ZGrass machine with a loan of a couple thousand dollars from my mother. I said, "Mother, I have a chance to get on a train that is pulling out of the station. If I do this now, this is going to take me somewhere." She loaned me the money. I bought the machine and became one of the orbiting consultants for Real Time Design, Inc., working on development projects and my artwork, too. That move jumpstarted my career and gave me the confidence to take big bets after that as well. To this day, I encourage my students to work for start-up companies!

My personal creative work in digital computer graphics started, fairly predictably, with a translation of the video work I had done previously as the "subjects" of my exploration into programmed animation. *Montana*, done in 1982, was a reprocessing of my western video imagery—running bison, mountains, Chicago skyscrapers, and my trusty black-and-white video camera—into a digital, procedural realm. In those early years in computer animation, even watching a drawing draw itself was fascinating! In addition to the programs that ran the real-time animation, we would all write little tool programs like a drawing database tool or a tool to prototype lots of variations. In *Montana*, I combined traditional cel animation techniques—using Muybridge's [see Rosenthal p. 233] sequential photographs of a running buffalo—with simple procedural geometry like sine waves, basic motion graphics, text, etc. Each section of the program was run and recorded in real time using my video editor. Afterward, an interactive ZGrass program controlled by joystick contributed one channel of a soundtrack that also included a segment of a bird-call audiotape.

had evolved dramatically. As I moved through all the different rooms, sampled what everyone was presenting, and interfaced with the speakers, I thought to myself, "These are really smart, adventurous people who are all coming from different fields to something new." At that time, line-drawing algorithms were a research topic and raster graphics was the new thing eclipsing vector graphics. It was still pre-software as we know it today. Turner Whitted showed his twenty-second film demonstrating his new invention, ray tracing. By then, I had enough rudimentary Bally Arcade programming experience to know that you didn't have to be a total math genius to program, but you needed an organized brain to think procedurally, and I knew I had that. Following SIGGRAPH, I decided that I was going to redirect my energy to computer graphics, really learn to program, and make that my new direction. Video was filled with creative people by that time; I wanted a frontier. I also wanted a way to evolve my career independently.

EVL researchers were evolving the "GRASS" GRAphics Symbiosis System—Tom DeFanti's doctoral thesis—into ZGrass to run on a Z80A microprocessor. DeFanti was working on a project with Bally Midway to take the same chips that were in the Bally Arcade and Bally coin-op games and create a new, microprocessor-based computer graphics workstation—a revolutionary

In *Floater* (1983), my interest in visual perception surfaced and I created program-run animations that also produced the soundtrack simultaneously. I moved toward an explicit

investigation between representation and abstraction in *Floater*. In *4K Tape* (1986), I moved further toward abstraction to focus on perception and motion [see p. 266].

I also developed two interactive installations: *Warpitout* (1982), a menu-driven self-portrait game, and *VizGame*, a menu-driven looping animation game (1983). These were exhibited at SIGGRAPH conferences, in art museums, science museums, and other venues. A copy of *Warpitout* was purchased by the Ontario Science Center in 1984 as a permanent exhibit. Watching people play *Warpitout* was fascinating [see p. 266]. Some people would only get as far as digitizing their face, say "Far out," and walk away happy. For many, it was their first time navigating a simple hierarchical menu system. It even featured "Undo," which was an advanced user capability for 1982!

At Real Time Design, I worked on user interface design, promotional and demo motion graphics, tutorials, and documentation. One project was a simple paint program where I designed and coded the user interface. As computer graphics capabilities evolved, the first attempts at commercial production tools for industry emerged in the early '80s. The next step evolved as hardware with *lots* of buttons and requiring no programming, typically aimed at broadcast television stations. Then, early microcomputer systems, such as the Apple II and the Amiga, had paint programs. That was really the beginning of interactive graphics software where one could use a mouse and a menu. Then came Photoshop and Illustrator in the late '80s, which for many people was the beginning of computer graphics.

After Real Time Design closed its doors in 1984 or so, Tom DeFanti started a small consultancy. Our

Jane Veeder at work on *Floater*, 1983. The ZGrass machine output video and sound could be recorded in real time on a ¾" videotape editor. Photo by Clark Dodsworth. Courtesy of Jane Veeder.

Jane Veeder at work on *Floater*, 1983. Photo by Clark Dodsworth. Courtesy of Jane Veeder.

Jane Veeder and *Warpitout* interactive installation, 1982. Inside this repurposed coin-op game cabinet, Veeder installed her ZGrass machine that controlled the two lights and video camera that capture the player's face and allowed him/her to modify it using a simple hierarchical, menu-based environment. Veeder soldered the button and joystick controls herself. Courtesy of Jane Veeder.

first client wanted us to develop a paint program. They would say something like, "We need to have a brush—does your prototype have a brush?" I was already starting to have conceptual problems with people not examining their terminology, which led me directly to becoming an academic. If you look at the early paint programs, which were the first computer graphic products for nonprogramming artists and designers, they started out closely emulating traditional media, like "brush draw" and "pen draw." Often the marketing strategies at that time explicitly assumed that no creative person would be able to do anything with computer graphics but use such a product.

We [Veeder and Giloth, who coauthored an article, "The Paint Problem," for *IEEE Computer and Graphics* in 1985] took to task the marketing trend of offering graphics users prefab routines, simplistic menus, and retro terminology. We used Larry Cuba as an example of a creative artist who programmed. We talked about how computer graphics was not just a different way to arrive at the same results you would have with traditional media—but actually getting into new spaces and to get to those new spaces, you needed to proceed in a different process—a more iterative development process:

> One of the most obvious characteristics that distinguish our model of the computer artist is an emphasis on process rather than artifact. The commercial paint system is a tool optimized for minimal user involvement and maximum production output; by contrast, computer artists treat the computer as a generalized medium within which to develop facile tools over which they exercise intimate control. The production goal of these tools, like scientific tools, is the field itself, i.e., artists are developing tools to explore the creative digital process, investigate the medium, evolve their own perceptions and skills, and extend evidence of this to others.
>
> Filmmaker Larry Cuba exemplifies this computer artist model when he characterizes his work as "an ongoing research project with periodic 'progress reports' . . . each title could be the completion date . . . there's really only one project." Many computer artists, including ourselves, use much these same words. In speaking of his latest work, "Calculated Movements" . . . he describes a long process: first, establishing the visual vocabulary in the basic element and the basic parameters involved with its repetition and transformation. In the final work these elements are repeated and transformed in space and time, so a graphical object is also a graphical event. Second, he develops generalized tools to manipulate those parameters to explore the visual parameter-dimensioned space. (Giloth and Veeder 1985)

What was really prophetic is that we described how these paint programs should really function: rather than trying to mimic traditional media, they should harness the power of mathematics to draw things like perfect curves. This is exactly the kind of stuff that within four to five years Adobe Illustrator could do. Keep in mind that splines were a new topic when we wrote the paper. Doris Kochanek presented the first spline research paper at SIGGRAPH '84 in Minneapolis. We wanted developers to look at how people are using the medium itself and take their cues from that to develop tools for the future.

Copper and I worked by talking about something, drawing diagrams, and sort of beating it out. Then we went away and tried to make it work and test it. When there is a mutual respect and the collaboration is in the nature of a conversation, and there's something you can get back, then it's useful and enlightening. When it happens well, it's great, such as the SIGGRAPH Video Review Interactive Index (SVRII), which we developed in the early '90s using Apple's Hypercard to search the SVR, a wonderful video archive of the history and evolution of computer graphics, begun by Tom DeFanti. Copper made a huge contribution in the SIGGRAPH '82 and '83 Art Shows by really elevating the art exhibit to something that had dignity at the conference and she organized plans to travel it beyond the conference, which had a broad impact [see pp. 217–18].

Also, in having the opportunity to work at the EVL and for Real Time Design, I was able to collaborate with visionary technical people I could learn from, contribute, and recreate myself. The collaborative Chicago video/computer graphics scene gave me a strategic skills foundation that enabled me to work in software development and game design and to launch a teaching career where I could research technology, build labs, develop curriculum, and further evolve into 3D computer animation, interactive multimedia, interactive virtual worlds, and motion graphics, evolve with the times and technology. It enabled me to participate in the interdisciplinary SIGGRAPH community as a contributor. The Chicago electronic arts community gave us all a wonderful start and I will be eternally grateful for that.

Nothing goes from zero to full throttle in a linear progression. Things will stall because some constituent technology isn't there yet or is too expensive and then gets going again when other things come into play. People who have a pioneering mentality, whether they are inventors,

Warpitout installation at Ontario Science Center, 1984. Interactive computer graphics/sound installation, supporting real-time color graphic processing of a digitized (facial) image of the current player using a menu-driven selection of drawing and processing programs, and housed in a video-game cabinet. Produced with ZGrass system. Courtesy of Jane Veeder.

technologists, entrepreneurs, or creative artists, aren't going to stick with one thing while it goes through maturation and broad distribution because that is not what they do. They move onto the next thing that isn't there yet, trying to translate desire into capability. I really love the opportunity to work with something new that

Jane Veeder **229**

During the 1980s, postmodernism sprang up in Chicago at Feature and the Rhona Hoffman Gallery. A playful example of the John Hancock building in motion, reminiscent of Pixar's *Luxo Jr.* (1986). *Hancock Tower on Lake*, 1992, 9" × 6" vintage Chromogenic print from the Richard and Ellen Sandor Family Collection. Digital photograph by James Prinz Photography.

so moved by Randy's last lecture that I wrote him a long letter and shared the irony that "Andy was your principal inspiration, and he was my obstacle to make me work harder."

The other possible program at the time [when Rosenthal enrolled in EVL's two-year graduate program in 1981] seemed to be at MIT—they were doing computer graphics in their Architecture Machine Group. The University of Illinois appealed to me more because it was the only program in the country where you could get an MFA in computer graphics. They have, to date, one of the finest programs in the world, in which teams of artists and computer scientists—people who were in the art program and people who were in the computer science program—solve problems together. The computer scientists taught the artists how to program and the artists taught the computer scientists aesthetics. This is where I learned to program, which was just as difficult as when I tried to learn it at Brown. The difference was customized hardware and software for real-time animation and the supportive environment created by Dan Sandin and Tom DeFanti, who ran the program [see p. 21]. The principles they taught us, which I still use every day, were being an active part of one's community, the synergy between art and science, and that process is the essence of creativity. You could do pretty much anything you wanted to do in this environment. It was not a structured program in the sense of teaching anything at all. It was a learning environment in which we could swim in an ocean of customized tools and support.

I finally felt literate in this world I so wanted to be part of. The first piece I remember creating was made on the Bally Arcade. It was simply black boxes moving on the screen. They had a little bit of motion and they made people laugh. It was about two minutes long and I think it is the best thing I've ever done. It had a naïve charm. I think about that piece when I get stuck. I think, "You're all hung up because you know too much. Pretend you don't know anything and maybe you can get unstuck." It works.

I took a particular interest in the fourth dimension. In the graduate seminar, each of us was responsible for giving a talk to our peers. I did mine on the fourth dimension. In order to digest it myself and then to explain it to other people in a way they could grasp, I built a model of a "hypercube," or four-dimensional cube. It was a matrix of stiff paper cubes, each face of which had a magnet glued to it on the inside. I did the positive/negative magnetic thing so that you could remove slices to show the hypercube moving through time in our three dimensions. The sequence showed how cross sections aligned and resurfaced.

A gallery-style show on the observation floor of the John Hancock Building [was a collaboration with Mark McKernin that Rosenthal did for an MFA exhibition in 1983]. My work focused on Muybridge's studies on cow motion. My interest was in animation and Muybridge was, of course, an inspiration. My sister was a textile artist. I created a huge file that I printed and sent to her in New York, which she then programmed into a

knitting machine to create large-scale pixilated tapestry. The image was one of the frames of video that played next to it, of a computer animation of Muybridge's cows walking. She used the same image file to make sweaters. The name of the video piece was *Cows in the News*. I received calls and letters from people who had attachments to cows.[1]

The first SIGGRAPH conference I went to was in 1981 as a volunteer for the A/V [audiovisual] crew. Jane Veeder was A/V chair. Everyone remembers the first time they went to SIGGRAPH. It's a transformational thing that affects you for the rest of your life. It [the 1986 conference in Dallas, for which Rosenthal was the A/V chair] was one of the most spectacular memories of my life, not just in SIGGRAPH history. Hundreds of entries of the latest and greatest computer graphics were arriving at my home from all over the world. Johnie Hugh Horn, whom I had worked with since 1982, and I were doing everything together around SIGGRAPH productions. We were excited to open each package and pop it in the video player. When you see hundreds of things back to back, you can glaze over. One started playing and it was *Luxo Jr.* (1986). I remember welling up in tears and Johnie and I

looked at each other and said, "Everything just changed." We knew it from the first frame. We were thrilled to be able to choreograph a show that introduced *Luxo Jr.*, Pixar's first animation. I remember the gasps of admiration from the audience when *Luxo Jr.* was projected on the screen for the first time, like it was yesterday.[2] It still gives me chills.

Phil [Morton] was thinking about how to facilitate screening computer graphics images to large groups of people before it was possible [see pp. 20, 24]. We had the job of projecting computer graphics to audiences of more than five thousand people before there were video projectors, and he was a perfectionist. He was seminal in the evolution of this technology and is an unsung hero. All along, my heart and soul were in the Electronic Theater, which through the years had different names. When I first chaired the event in 1989 in Boston, I changed the name to the Electronic Theater. I always wanted to chair the Electronic Theater. I thought it was one of the finest shows on earth and believe it still has the potential to be so. Dan made it possible for me to understand that I could do these things at all. Tom gave me the opportunity to do them at SIGGRAPH. Being the A/V chair was the first time I was in charge of a

"Locomotion Study of a Man in a Surrey with Horse," 1878–81, Eadweard Muybridge, 6¼" × 8¾" vintage albumen print, from the Richard and Ellen Sandor Family Collection. Digital photograph by James Prinz Photography.

Sally Rosenthal **233**

WINNER AUDIENCE AWARD NEW HAMPSHIRE FILM FESTIVAL 2008
WINNER BEST DOCUMENTARY CINEMA SOCIETY OF SAN DIEGO 2009
WINNER AUDIENCE AWARD BROOKLYN INTERNATIONAL FILM FESTIVAL 2009
WINNER BEST FILM SCINEMA INTERNATIONAL FILM FESTIVAL 2009
WINNER BEST DOCUMENTARY INDIE SPIRIT FILM FESTIVAL 2009
WINNER AUDIENCE AWARD RHODE ISLAND INTERNATIONAL FILM FESTIVAL 2008

OFFICIAL SELECTION SAN FRANCISCO DOCFEST 2009
OFFICIAL SELECTION ASHLAND INDEPENDENT FILM FESTIVAL 2009
OFFICIAL SELECTION HAMPTONS INTERNATIONAL FILM FESTIVAL 2008
OFFICIAL SELECTION TRANSILVANIA INT'L FILM FESTIVAL 2009
OFFICIAL SELECTION MAUI FILM FESTIVAL 2009
OFFICIAL SELECTION NEWPORT BEACH FILM FESTIVAL 2009

"LUMINOUS" CLEVELAND FILM SOCIETY "BREATHTAKING...WONDROUS" ASHLAND DAILY TIDINGS

THE SCIENCE
OF ART.
THE ART
OF SCIENCE.

BETWEEN THE
FOLDS

A NEW DOCUMENTARY FROM GREEN FUSE FILMS

GREEN FUSE FILMS PRESENTS BETWEEN THE FOLDS EXECUTIVE PRODUCER SALLY ROSENTHAL ASSOCIATE PRODUCER ARIEL FRIEDMAN VISUAL EFFECTS & TITLES BY TODD SINES ·· SCALE
CINEMATOGRAPHY BY MELISSA R. DONOVAN AND PHILIPPE BELLAICHE FILM EDITING BY KRISTI BARLOW ORIGINAL SCORE BY GIL TALMI WRITTEN, PRODUCED & DIRECTED BY VANESSA GOULD

[i]NDEPENDENTLENS THOUGHTS in GREY CIRCLES 紀伊國屋書店

Poster for the award-winning documentary *Between the Folds* (2008), directed by Vanessa Gould, produced by Sally Rosenthal. The film was broadcast on PBS and was the recipient of a 2010 Peabody Award, among others. Courtesy of Green Fuse Films.

New Visions. We advertised a call for participation in *Wired* and *Details* magazines for creative work, in any format, on any computer. Hundreds of entries arrived, through which we learned what was happening creatively with computers during 1994–1996. The first year, most entries were on PCs. The next year, most were on Macs. It was nontrivial to advertise "any format"; in addition to CDs and hard drives, something came on a floppy, another ran on an Acorn computer, which I had never heard of. We had sessions at Interval and Voyager to review all the entries. Both companies voted on a first pass to reduce the quantity of material to a reasonable amount for the juries, which included Laurie Anderson, Jenny Holzer, Bruce Sterling, and Louis Psihoyas. Each year, the jury selected three pieces that won $5,000 each. One year we had the ceremony at Lincoln Center in New York.

I don't ever remember not collecting [pop-up books, of which she has more than five thousand works of paper-made sculptures]. Paper engineering has always been of special interest, which is no surprise because it is art and math. Pop-ups are transformations from two dimensions to three dimensions. I have always evangelized them. I love them and they make me happy. I spend a lot of time with these books, they are little virtual reality pop-up worlds. I was nerding out on the Internet and ran across a blog reference to a documentary about origami. I thought, "That's weird because I don't know many people who care about this—how could there be an entire documentary about origami?" So I Googled it and up came the website for *Between the Folds* (2008). I sent an email that I was excited about the project, I was passionate about folded paper, I have a pop-up collection—where can I see this movie?

She [director Vanessa Gould] wrote back that it would be at the Santa Fe Film Festival and that she would be there. From the moment the movie began, I was in tears. I expected to resonate with any film about origami but I wasn't expecting such a stunning documentary. Though it is about ten of the best paper folders in the world, this movie is not about origami. It is about the creative process, the intersections of art and science, the human spirit, inspiration, and the message anyone with a single piece of paper can do amazing things—mind-boggling, phenomenal things from fine art sculpture to medical research. I was completely moved by this movie and everyone in the room was spellbound. After a meeting with Vanessa in New York, I became the executive producer. I had never done this before and jumped in. *Between the Folds* was on two seasons of PBS Independent Lens, was broadcast in over forty countries, and won a Peabody Award. My goal is to help create an environment that supports the development of more wonderful independent work.

Notes

1. Rosenthal is also credited as a collaborator with Charlie Athanas and Copper Giloth on the video game *Wrap-Around* (1983), which supported two-button game play and featured Rosenthal's cows as part of the animated game objects for interaction. These artworks were featured together at the Louisville Art Gallery in Kentucky where Giloth gave an artist lecture. An image of Rosenthal's *Cow Sweater* was included in Diane Heilenman's local review of the exhibition. After her MFA exhibition, Rosenthal worked in Chicago for the next six years as a consultant.

2. In 1986, the short film received a standing ovation from the SIGGRAPH audience and *Luxo Jr.* became the first computer graphics animation to receive an Academy Award nomination for Best Animated Short Film. Industry veteran Edwin Catmull noted in *Computer Animation: A Whole New World* (1998), "*Luxo Jr.* sent shock waves through the entire industry—to all corners of computer and traditional animation. At that time, most traditional artists were afraid of the computer. They did not realize that the computer was merely a different tool in the artist's kit but instead perceived it as a type of automation that might endanger their jobs. Luckily, this attitude changed dramatically in the early '80s with the use of personal computers in the home. The release of our *Luxo Jr.* reinforced this opinion turnaround within the professional community."

3. In 1991, *Art Futura* also included artworks produced by Ellen Sandor and (art)[n]; Tom DeFanti and Dan Sandin, EVL, University of Illinois at Chicago; Donna J. Cox, National Center for Supercomputing Applications, University of Illinois at Urbana-Champaign; Rebecca Allen, Laurie Anderson, and other artists who were exploring digital media and were also from the Midwest.

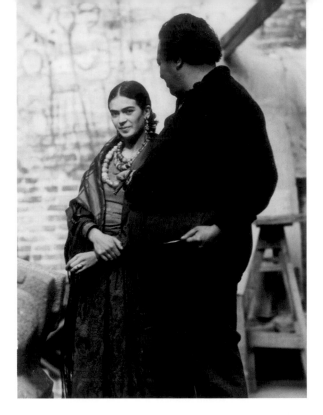

Diego Rivera and Frida Kahlo in San Francisco, c. 1930, Edward Weston, 4" × 3" vintage gelatin silver print from the Richard and Ellen Sandor Family Collection. Digital photograph by James Prinz Photography.

My graduate thesis project [1985] was a prototype of a remote design tool—an interactive animation tool. During my MFA show, two computers were hardwired together, allowing two people in different locations to create an animation together. I used references from traditional animation as part of the content. It was originally designed to work over the modem. At that time the baud rate was 300, much too slow for gallery display. I planned to exhibit the project connecting Chicago with a colleague in San Francisco via modem. This did not materialize. Instead, the computers were hardwired together. It would have been more significant exhibiting this project via modem. I did not realize the Internet was going to explode in a few years. I always thought interactivity was going to be on the edge—an on-the-fringe activity.

Sally Rosenthal was influential in encouraging me to chair the SIGGRAPH '88 Art Show while discussing the significance of computer art. Ellen Sandor and (art)[n] submitted an important piece called *Messiah* that was featured in the 1988 art show. It was a life-size sculptural PHSCologram in the shape of a cross, a tribute to a person who died of AIDS. Dealing with the subject of AIDS at this point in time was significant [see p. 56]. Creating a sculptural PHSCologram was also significant.

Kathy Tanaka and I cochaired the Electronic Theater, Computer Animation Festival [during SIGGRAPH 1994]. We agreed to do the Electronic Theater because we wanted to incorporate an interactive component to the show. We were able to procure Loren Carpenter, a Pixar programmer, to create a stereoscopic high-definition (HDTV)

Faux Vagin, 1963, Marcel Duchamp, original 18" × 23½" license plate from Duchamp's Volkswagen, mounted on Plexiglas and wood, from the Richard and Ellen Sandor Family Collection. Digital photograph by James Prinz Photography.

interactive audience participation piece, where three to four thousand people were able to interact together selecting images and controlling events on the same screen. It was significant and fun for us to stage. I worked for SIGGRAPH for many years. It was a great place to meet people who were involved in creating the cutting-edge graphics. It was a great place to connect with colleagues who are in the same field.

Today at the University of Texas–Dallas, I'm teaching interactive aesthetics and immersive environments. My focus within the last five years was to create immersive environments in a 3D space. Initially I started working with CAVE [Cave Automatic Virtual Environment] libraries, which allows people to work in a 3D virtual reality (VR) space. I created VR projects that were exhibited at the Tucson Museum of Art, Contemporary Museum of Art in Scottsdale, ISEA, and SIGGRAPH. The most recent interactive stereoscopic VR project I completed, *Desert Views, Desert Deaths*, was exhibited at SIGGRAPH. It addressed the US/Mexico border-enforcement policies as a memorial for those who have died of heat exhaustion and dehydration in the desert.

I feel I surrounded myself with mostly women who were in this field. They were my immediate friends that I kept in touch with all these years. They were the original group from Chicago who worked in technology and in a sense throughout my professional life. I kept in touch with these women and the work they create. I admire the work they create. I especially admire the work on the galactic visualizations that was created by a group led by Donna J. Cox at UIUC [see pp. 130–33]. It is amazing, beautiful work. I was fortunate to see a screening presented in ultra-high resolution at UCSD-Calit2 [University of California–San Diego/ California Institute for Telecommunications and Information Technology] when they were experimenting with transmitting film over the Internet. It's wonderful to see how women are actively involved in making some of the major influences within this field. Women added inclusivity and ethics to the digital revolution—inclusivity in the sense of demanding content makers be socially aware of cultural diversity, ethics in the sense of encouraging our society to think responsibly for what new technologies we create and how we are using them.

Left: *Creativity and Culture*, 1997. A black-and-white scanned photograph of Marc and Bella Chagall's shadows holding up their hand puppets is juxtaposed with Marc's drawings from Bella's *Burning Lights*. Sim Schwartz's Hakl-Bakl Marionette Theater poster provides a backdrop for a recreated papier-maché rendering of Marc Chagall's hand puppet of a goat. The couple would perform live puppet shows for children that told stories about Jewish holidays and family life. Right: *Work and Hope*, 1997. A sweatshop scene photographed by Jacob A. Riis is juxtaposed with an immigrant's sewing machine. Credits: Ellen Sandor, Stephan Meyers, and Janine Fron, (art)[n]; Carolina Cruz-Neira, Terry Welsh, Timothy Griepp, Brian Perles, Hamlin Krewson, Ben Meyer, and Ben Byrne, Iowa State University; Cynthia Beth Rubin, Stephanie Barish, and Miroslaw Rogala. Commissioned by the Museum of Jewish Heritage—A Living Memorial to the Holocaust. Courtesy of Ellen Sandor.

He was very supportive of my contributions to the team and everyone he worked with at (art)[n].

In her feminist lectures in Finland, Kirsti Lempiäinen encouraged us to identify masculine and feminine social constructs that made up our world and emphasized the importance of finding a harmonious balance between them to create a healthy future. For many of us, this was a new way of understanding the world and reviewing our lives, which gave me fresh insights for future projects. My coursework there was shared with international students from diverse backgrounds who were involved with grassroots projects to help women in developing countries. Their courageous stories of volunteerism and mission work made a lasting impression on me. I came to realize then how equanimity for women and girls around the world still had ways to go and how fortunate we all are to be living in an era of transformation.

At the same time, video games were enjoying another wave of popularity with sophisticated consoles like Sony's PlayStation and Nintendo 64 supporting role-playing creations that included the *Final Fantasy* series. Games such as these were more driven by story than action, which seemed to me like there may be something interesting for a female audience that was not all competitive sports or violence. I began exploring this more closely in Finland, while learning as much as I could from friends, through books, conferences, and playing when free time allowed. I also spent more time in nature than I had since I was a teenager. The Finnish forests and archipelago were invigorating, while some of the prairie-like countryside reminded me of home. The Baltic

Sea had its own calm, like Lake Michigan. For the first time, I saw many shooting stars and sunsets that looked like Monet's, and other times where the sun never quite set but moved around, encircling, unwinding, and unending. It was refreshing and I learned new ways to breathe.

In June 2001, after the *Battle of Midway Memorial* was successfully installed at Midway Airport in Chicago, Ellen and I coauthored a paper by invitation for the University of Chicago Cultural Policy Center, "Playing by the Rules: The Cultural Policy Challenges of Video Games." At the conference in October, Ellen presented our paper that explored the potential of art and games, and it was published online by the university. We included historical photography references from Ellen's private art collection she formed with her husband, Richard, that we all manage together. In 1993–94, we were early to start digitizing the collection, before most museums. It is important that younger generations are more hands-on with learning about history, especially the positive events, so they too can add their own contributions.

Shortly after, I had the opportunity to collaborate with Stephanie Barish, Celia Pearce, Tracy Fullerton, and Jacquelyn Ford Morie, who were all doing experimental work at the University of Southern California (USC). Stephanie had recently started directing USC's Multimedia Literacy Program and hired me in 2001–2005 to help her incredible team expand the program into the Institute for Multimedia Literacy (IML) where we assembled a vast library of resources and put together symposia, workshops, public lectures, and a unique teacher-training program in a landmark Richard Neutra building off campus.[1] We redesigned the building interior, drawing inspiration from Piet Mondrian and George Nelson. This was not a typical teaching with technology program. Community and camaraderie, process over product, creativity, critical thinking, collaboration, and outreach to the humanities were part of the IML's philosophy that cultivated an all-inclusive, interdisciplinary atmosphere.

Stephanie was the creative director for Survivors of the Shoah Visual History Foundation, which was located on the back lot of Universal Studios in its own trailers. Stephanie and her colleagues designed a beautiful vintage World War II–era visual interface for Shoah's awarding-winning educational CD-ROM, *Survivors: Testimonies of the Holocaust* (1998). When we first met in the mid-1990s, she gave the (art)ⁿ team an emotionally moving site tour while many professionals and volunteers were interviewing and transcribing the living testimonies of the survivors in our midst. More than forty-seven thousand eyewitness interviews were conducted in fifty-five countries and thirty-one languages and were digitally cataloged and archived for this seminal project that exemplified how technology could be used consciously to honor human lives with dignity. During this time, we first collaborated on (art)ⁿ's PHSCologram project for the Shoah Foundation—a haunting triptych of the Auschwitz barracks rendered from a Holocaust survivor's charcoal drawings that showed sunlight pouring through the empty space at different times of day that was impressionistic, poetic, and spiritual [see p. 41].

These works led to a commissioned PHSCologram series Stephanie and (art)ⁿ worked on for the Museum of Jewish Heritage—A Living Memorial to the Holocaust, located in New York City's Battery Park. The series was installed in the hexagonal museum's Rotunda Gallery and told the story of Jewish life before, during, and after the Holocaust with donated artifacts from the survivors re-presented as PHSCologram montages. As visitors left the gallery, they saw the Statue of Liberty on Ellis Island from the window as a reminder of our freedom. New Media artist and educator Cynthia Beth Rubin and Carolina Cruz-Neira, aka CAVE [Cave Automatic Virtual Environment] Woman, were also key collaborators, along with Carolina's talented students at Iowa State University. Carolina brought a lot of creative energy to our project and was always very dedicated to her students. We enjoyed collaborating with her several times, and she also helped curate a retrospective of (art)ⁿ's work in 2002, *(art)ⁿ Virtual Visions: Three Decades of Collaboration*, at Brunnier Art Museum, Iowa State University.

Tracy Fullerton and Celia Pearce were teaching at USC when I first met them, while they were building the Cinema School's game-design curriculum with their fellow colleagues, which is now considered a top school for game design in the US. *The Interactive Book* (1997), which Celia wrote, was very popular. She organized many New Media salons at USC and the Bridges I summit in 2001 with Sara Diamond and Mark Beam. Tracy, Celia, and I collaborated on game events and workshops together that we organized at the IML. I first met Jacki in 1994, when she produced *The Edge* at SIGGRAPH in

Left: Participants of Ludica's "Game Innovation Workshop" at DiGRA '05 collaborated and voted on each other's game-modding projects. Right: Brainstorming, design documentation, production [with provided game boards, game pieces, and art supplies from thrift and dollar stores], play-testing, and final presentations were all part of the creative process Ludica's game design challenge explored over the duration of the conference. Inspired by Bernie DeKoven's "Junkyard Sports" and Fluxus artists, who created games from found objects. Courtesy of Ludica.

both new game genres and new modes of game making. Our modus operandi is proactive, rather than reactive. Since we are, by definition, outsiders, we revel in our outsider status and leverage it to support our cause." [See pp. 270–71.]

The Ludica name was playfully made up as a feminine word play on Ludology and refers to Johan Huizinga's classic book *Homo Ludens* (1938), or "Man the Player." While Ludica is based in Los Angeles, the website domain, ludica.org.uk, resides in the United Kingdom where Celia and Jacki were working on their PhDs at SMART-lab, founded by its director, Lizbeth Goodman. Some of Ludica's activities as listed on the website include

> creating publications and a diverse range of innovative games, game concepts, interventions, and commentary that support a more balanced view of both game design and culture. Disseminating our projects and philosophies to the general public, game studies community, industry and New Media Arts community. Organizing events where we can share our individual work and the work of other women game artists/designers, as well as conducting workshops and brainstorming sessions to develop new work methods collectively. Mentoring and encouraging aspiring game designers and students K–12 through college, through workshops and participations in our projects, to develop their own unique vision for the future of game culture.

As a team, we submitted coauthored papers to conferences and organized game design challenges where we invited attendees to design and play-test their ad hoc games on the spot at conferences like DiGRA [Digital Games Research Association] in Vancouver and the SIGGRAPH Guerilla Studio in Los Angeles in 2005.[4] Our Ludica Atelier provided all of the supplies for making, testing, and presenting the games at both conferences, where the gathered audience at the end of the week could vote on their games that we provided fun awards for, like a deck of Charles and Ray Eames *House of Cards* and Lindt chocolates. We tried to do chalk art at SIGGRAPH near the convention center entrance and were told by guards it was too dangerous to play outside and were shooed away after cleaning up our games with buckets of water they gave us. We set up a mini-golf course made with recycled conference materials near the Guerrilla Studio entrance, which was a lot of fun. We also curated a virtual installation for ISEA [International Society of Experimental Artists] ZeroOne 2006 in San Jose. People really enjoyed these interventions and told us they were their favorite part of the conferences, which were mostly for looking and listening but not making or playing much.

"Play Belongs to Everyone" became Ludica's mantra. Our first paper together was called

"Sustainable Play: Toward a New Games Movement for the Digital Age," which I presented at DAC [Digital Arts Community] 2005 in Copenhagen and was later published in *Games and Culture* [vol. 2, no. 3, July 2007]. I was part of the morning session and bravely stood up for our work and said to an international audience of about a hundred people, "If you play war, you make war."[5] Tracy had custom t-shirts made for her students with a slogan from the movement, "Play Hard, Play Fair, Nobody Hurt." In our paper, we cited George Leonard, who eloquently said, "How we play the game may be more important than we imagine, for it signifies nothing less than our way of being in the world." We highlighted ways artists used games to be playful, like the Surrealists and Buckminster Fuller, and referenced Christo and Jeanne-Claude and Robert Smithson's Earthworks in our visual presentation. We wanted to bring a combination of these values and ideals into digital play culture while we continued to experiment with and research the origins of outdoor play, role-playing games, and traditional card and board games that were cooperative. We were essentially a collaborative group who wanted to bring a collaborative spirit into all forms of play. I have found that cooperative activities, such as the games we played, can help level the playing field by putting the players on equal ground. We are all on the same team. Removing a one-against-all competitive strategy from some playtime activities may be helpful for educators to minimize bullying issues in the classroom and on the playground. Unique leadership skills can grow out of a cooperative setting, where each individual's creative talents can playfully shine in a harmonious way.

One professor at the conference was curious about our motives, being from Los Angeles, which was considered the entertainment capital of the world. A few teary people came up to me afterwards and said these were important ideals for the community. New Games was more about being playful than scoring points that supported cooperative play and friendly competition as opposed to violence. An anonymous reviewer for our submission remarked, "I applaud the sentiments here, especially the overt and unapologetic gender analysis, which I am coming to believe may be the only thing that can save our rapidly collapsing civilization."

We began Ludica as an intergenerational group of women with our own experiences, expertise, and inspirations that were grounded in mutual values of wanting to do work that makes

Top: The Ludica team removed their "chalk art" games from the pavement of the LA Convention Center main drop-off area to discourage local vandalism and violence. Bottom: Game-modding experiments included Fibonacci forms mixed with traditional sidewalk games and mazes to encourage conference attendees to literally think "outside" the box. Courtesy of Ludica.

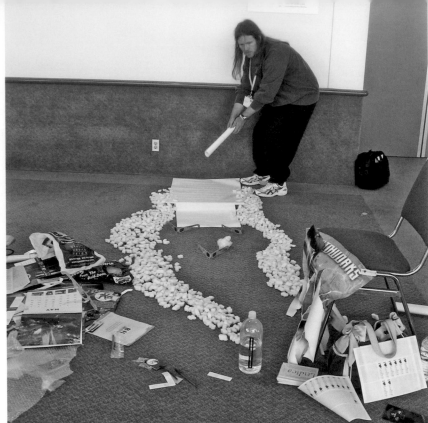

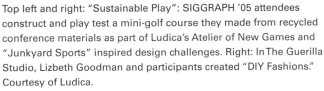

Top left and right: "Sustainable Play": SIGGRAPH '05 attendees construct and play test a mini-golf course they made from recycled conference materials as part of Ludica's Atelier of New Games and "Junkyard Sports" inspired design challenges. Right: In The Guerilla Studio, Lizbeth Goodman and participants created "DIY Fashions." Courtesy of Ludica.

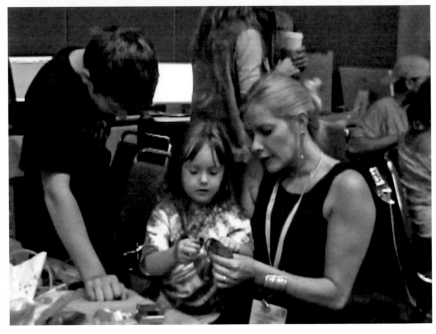

a difference in our communities. The times we spent together at each other's homes play-testing games, sharing discoveries, or on outings to exhibitions and other events, like road trips to GDC [Game Developers Conference] were always inspiring and fun. On one occasion, we went to the Fashion District in downtown Los Angeles. Looking at all of the fabrics in the crowded marketplace made me think about women and children who worked in sweatshops, which inspired me to learn more about textiles and fiber arts traditions, while costume play inspired us as a group to write our next paper.

Celia mentioned Ludica's friends and our activities in her keynote at Gaming Realities: medi@terra 2006 in Athens, Greece. She presented "Playing Dress-Up: Costumes, Role Play and Imagination" at the Philosophy of Computer Games: An Interdisciplinary Conference (2007) held at the University of Modena and Reggio Emilio, Italy. Jacki also presented it at Women in Games 2007 at the University of Wales. Celia and Tracy presented together at perthDac 2007: The Future of Digital Media in Australia and DiGRA 2007: Situated Play in Tokyo, Japan, which included the "Values@Play Board Game

Modding Workshop" with Mary Flanagan. Mary is an experimental game artist, cultural theorist, and educator who inspired us by her important work. She was from the Midwest, studied in Madison and the UK, but did most of her work on the East Coast, where she resides. New Media artist and educator Katherine Moriwaki shared in our LA dialogs too and worked with us on an unrealized quilting game mod concept that was a lot of fun to experiment with together.

We had gathered so much material that our enthusiasm for writing did not stop. The next paper we wrote together, "The Hegemony of Play," was met with a little controversy after Celia and Tracy presented it in Japan.[6] Some feminist rhetoric was brought into the larger discussion of the general exclusion of women from the game-making process and addressed issues of inclusiveness and diversity. Simone de Beauvoir was cited, as was an early history of board games that were developed by women designers for titles like The Mansion of Happiness (1843) and The Landlord Game (1904), which became Monopoly: "The first board game ever to be awarded a patent was also designed by a woman, Lizzie Magie, who originally patented The Landlord Game in 1904 and again in 1924. Magie owned the patent until 1935 when it was purchased by Parker Brothers to make way for their upcoming hit Monopoly, attributed to Charles Darrow, which would become the best-selling board game of all time" (Fron et al. 2007).

In parallel, we were also writing a book chapter for the MIT Press. Yasmin Kafai organized a workshop May 8–9, 2006, while she was a professor at UCLA, that was funded by the National Science Foundation as a follow-up discussion to the popular MIT textbook, From Barbie to Mortal Kombat: Gender and Computer Games (1998), edited by Justine Cassell and Henry Jenkins. Past and new contributors were invited to the workshop to brainstorm for its sequel book, Beyond Barbie and Mortal Kombat: New Perspectives on Gender and Gaming (2008). This was the first time I met Brenda Laurel, Justine Cassell, and Henry Jenkins, whose works I appreciated.[7] Everyone gathered in groups and presented their discussion highlights, which formed an evolving foundation for the book. There was also a Girls 'n' Games conference the next day with speakers presenting related research from Europe, Asia, and North America for inspiration. Ludica contributed a chapter on women in the workplace, "Getting Girls into the Game: Toward a 'Virtuous Cycle,'" that "challenges employers, educators, and game designers to recognize and change the ways in which current cultures of game making and game play discourage women and girls from interest and participation in the field."[8]

Since then, Jacki started her own company, All These Worlds, LLC. Celia is an associate professor at Northeastern University and Festival Chair of IndieCade. In 2005, IndieCade was cofounded by Stephanie Barish's Creative Media Collaborative, in which I was an early member through 2007. Being a native Chicagoan, I wanted us to create the "World's Fair of Play." As co-chair, I collaborated on the festival's initial concept, proposal research, and early development plans. I invited Celia to join our team and Ellen to be on our board. The festival continues to grow with a European venue and has celebrated the

Left and center: *Rock, Paper, Scissors Tag* and *Tournament Earthball* were played at USC with veteran New Games Referee, Bernie DeKoven, and Tracy Fullerton with her students. Images by Kurt MacDonald. Right: An example of a classic parachute game is still played today at Chicago's Garfield Park Conservatory events plus other venues in the United States and abroad. Courtesy of Janine Fron.

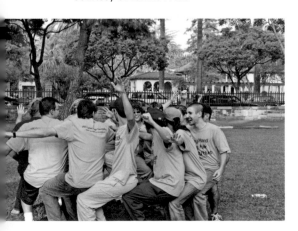

Celia Pearce and Katherine Moriwaki play-testing Ludica's Quilting Bee game concept, where players could collaborate on the creation of a quilt as a game-design challenge. The Ludica team journeyed to LA's fashion district in search of fabrics for the game elements. Courtesy of Ludica.

innovative works of many pioneers, including Tracy [for Walden, a game by the USC Game Innovation Lab], who is a professor and endowed chair of the Interactive Media and Games Division, USC School of Cinematic Arts. In 2005–6, I also collaborated with Sharon Sekhon as associate director to implement her awarded Community Partners proposal to create the Studio for Southern California History, a unique living history museum in Chinatown that creatively interwove new media exhibits with local narratives. I am grateful to have contributed to both of these women-led initiatives that utilized new media to inspire social change.[9]

Katherine Moriwaki, Mary Flanagan, Lizbeth Goodman, Katherine Milton, Judy Singer, Stephanie Barish, Marientina Gotsis, Pamela Dell, Jen Grey, Jeanne Hoel, Sharon Sekhon, Alice Gambrell, Elina Ollila, Inger Ekman, Hanna Hemilä, and Florence Shay were supportive friends to Ludica's beginnings alongside my continued inquiry into the nature of play.

Men who cheered us on and who were also encouraging friends I learned a lot from when I created my first games included New Games referee, author, theorist, and game designer, Bernie DeKoven; published writers Richard Kahlenberg, Alex Singer, and Larry Tuch; EVL alum Marcus Thiébaux; Jussi Holopainen, Staffan Björk, and Lars Konzack from the game studies community; and past USC colleagues, Richard Edwards and Christopher Gilman. My dad has always been my biggest fan, who encouraged

me to be hands-on, proactive, and persistent in everything I do. My mother, my sister, my aunt, and her daughters are always helpful, interested, and supportive too.

I am continuing to make progress with my cooperative green games and have been exploring organic fibers, including muslin, silk, cashmere, and wool. Some game pieces are sculpted or collaged with handmade Japanese papers, while other elements are embellished with watercolors, acrylic paints, and pastels that add something special to the overall feel of the game experience. These are unique games—they are not board games, because there is no fixed board to conquer. They are playfully imaginative, cooperative, tactile games for a new genre of green play I have been developing for families and educators that have a special connection to nature. I hope all of our combined efforts planted seeds that are helpful to others and may create a shared context where meaningful relationships between players can arise out of the spirit of play.

In 2007–2008, I had the opportunity to teach a foundational game-design course at Columbia College Chicago when Annette Barbier was chair of the Interactive Arts and Media Department. Tracy Marie Taylor, a New Media artist, painter, and photographer who is now teaching at Lake Forest College had curated a game art show of student and faculty work I saw there that was really wonderful and is how we met.[10] In the course, the students and I looked to art history, film, and traditional game play for inspiration

while learning about industry game pitches and how to develop original game proposals. We play-tested student work and collaborated with a sound-design class to exchange ideas and get a feel for working with peers. We talked a lot about role-playing games and fan culture too. I consistently offered examples of work produced by both men and women to provide a gender-balanced view to spark their creative imagination.

Children's author Pamela Dell, who is the former creative director of Brenda Laurel's Purple Moon, visited the class [see pp. 40 and 208]. Pam spoke about her experiences with character design, storytelling within games, and successful community-building activities that can be learned from the Purple Moon series, which students enjoyed. I brought examples of art-based games, like wooden Kandinsky dominoes and Karim Rashid's wooden Kozmos blocks to Claudia Hart's graduate class at SAIC [the School of the Art Institute of Chicago] for a seventieth anniversary lecture I gave about the Chicago Bauhaus at IIT [Illinois Institute of Technology], which was where (art)n was located when I first started working with Ellen. I also visited Justine Cassell's graduate class at Northwestern University and have given workshops for the Chicago and Highland Park school districts, Cranbrook Schools in Michigan, and the Chicago Park District. I additionally explored alternative forms of play-based education then, including Danish Folk Schools combined with Nordic concepts I learned in Finland that resonated with me.[11] Their approach supports more experiential "hands-on" and "learn-by-doing" experiences, which is how I try to authentically live my life.

In 2009, I was excited to write a short essay and interviewed the photographer Wendy Ewald for *Feminist Media Studies* that was published in the UK during the tenth anniversary year of the journal [vol. 11, no. 2, June 2011]. Editors Kaitlynn Mendes and Kumarini Silva introduced the topic, explaining, "Discussions of feminist play are necessary because of the way feminism has been constructed as 'unplayful' and at odds with leisure and fun."[12] They cited scholar Shira Chess, who said, "There has been no playtime in feminism. And why should there be: why would a series of serious social movements have time to concern themselves with feminine play or playful activism?"[13]

The issue included a review by Elizabeth Birmingham, associate dean of Arts, Humanities, and Social Sciences at North Dakota State University, of the cooperative poetry game *Prairie Prose* (2007–2010) I developed in collaboration with Michel Ségard.[14] Wendy Ewald and Betsy Birmingham were both from the Midwest whose accomplishments made an impression on me for my projects. Wendy won a MacArthur Fellowship in 1992 for her work with children living in other countries, including India, where they built a darkroom together that was published in her beautiful books *I Dreamed I Had a Girl in My Pocket* (1996) and *Secret Games: Collaborative Works with Children 1969–1999* (2000). Play is part of Wendy's creative process of collaborating with children to capture their imagination in the many wonderful photographs they made together. Her work is hands-on and playfully creative.

Betsy completed her dissertation at Iowa State University in 2000 on Marion Mahony Griffin, who was the first licensed woman architect in Illinois [see p. 4]. I read an article Betsy was interviewed for that was published by the *New York Times* on January 1, 2008, "Rediscovering a Heroine of Chicago Architecture." I learned Griffin initially worked for Frank Lloyd Wright in 1895 and was the second woman architect to graduate from MIT in 1894 after Sophia Hayden, who designed the Woman's Building for the World's Columbian Exposition hosted by Chicago in 1893. Julia Morgan also became the first woman architect from California to graduate from L'École des Beaux-Arts in Paris in 1902, with more than seven hundred projects built. I recently watched the documentary film *100 Women in the Studio of Frank Lloyd Wright* (2009), which included a symposium about hidden women from architectural history held at the Solomon R. Guggenheim Museum that Wright designed in Manhattan. These early examples of women who have broken the "glass ceiling" in their field encouraged me to continue working on my game projects.

Jane Walsh Brown, Dina Petrakis, Kimberly Ruffin, Doug Wood, and Julia S. Bachrach were all very helpful in getting *Prairie Prose* played during Earth Day and other local events. The game features bonus messages by men and women from the Prairie School era, including Jens Jensen, whose writings about nature inspired the making of the game that empowers players to use their own voices to be creative.[15] In 2009, I co-organized "Urbs in Horto-City in a Garden: Jens Jensen Reconsidered" with Julia Bachrach, former historian and preservationist, Chicago Park District, that was cohosted by

From left to right: Detail from *Fairies Feeding the Herons*, 1931, a commissioned mural by Marion Mahony Griffin for the George B. Armstrong School of International Studies, Chicago. Photo by Janine Fron. The Prairie Fairies flora fashion game is a variant of the *Fashionistas* in which players help the flower fairies find their costumes before their performance to save the native landscape. For 2–4 players, ages 7+. Jens Jensen would orchestrate Fairy Festivals attended by thousands in Chicago's endangered parks and nearby landscapes he worked so hard to conserve, including the Indiana Dunes. Carl Sandburg, who rallied for the environment with Jensen, also wrote a children's story in 1922 called "How to Tell Corn Fairies If You See 'Em." Courtesy of Janine Fron. District 102 students played *Prairie Prose* and the *Prairie Fairies* to celebrate Earth Day at the Allen P. Zak Science Discovery Center. Photo by Dorren Gertsen-Briand. Used with permission.

Lisa Lee, past director, Jane Addams Hull-House Museum, along with Mary Eysenbach, director of conservatories, Garfield Park Conservatory; Carol Schulz, board of directors, Kenilworth Historical Society; Elliott Miller, president, Highland Park Historical Society; and Jane Walsh Brown, past director, Westchester Township History Museum. The grassroots, three-day symposium brought together scholars and Jensen's living relatives in the US and abroad who gave presentations, book signings, and pilgrimage tours of historical Jensen-designed landscapes in Chicago and the North Shore suburbs that concluded at the Indiana Dunes National Park with a favorite Prairie Club song we all sung on a historic dune blowout at the end—"America the Beautiful."

Though I began to learn more about the Prairie School era while living in Los Angeles, it was in coming back home that I realized how universal the prairie spirit is. There are patches of prairie in Northern California's valley, in states like Texas and the Dakotas, parts of South America, and

From left to right: Rauner College Prep students create unique poems drawn from nature with *Prairie Prose* in celebration of Earth Day in Chicago's Wicker Park, organized by Doug Wood. Courtesy of Elaine A. Coorens, *Our Urban Times*. A roadside marquee featuring a *Prairie Prose* event for Poetry Month in Porter County, Indiana. Courtesy of Janine Fron. "Few words, endless meanings," a player ponders his poem at the Westchester Township History Museum. Photo by Heather Eidson, courtesy of the *Times of Northwest Indiana*. *Prairie Prose* and the *Quills!* series were featured at the Jane Austin Society of North America–Greater Chicago Region (JASNA-GCR) Spring 2016 Gala "Highbury and Beyond" to celebrate the bicentennial of Jane Austen's *Emma*. Courtesy of Janine Fron.

Prairie Prose Tea House Edition

A unique cooperative poetry game inspired by local Japanese Tea Gardens that allows up to 6 players to create their own seasonal haiku poems to read aloud together.

- Inspires Creativity and Zen.
- Enlivens Rhythmical Abilities, Storytelling and Imaginative Thinking
- Builds Players' Listening Skills and Vocabulary.
- 648 word choices drawn from nature, Japanese poetry and tea culture.
- Includes 324 handcut petals, gameplay instructions, original tea garden postcards, blank poetry book, references and one play mat with a drawstring storage bag, hand-painted on organic, muslin fabric - every game is unique. No special assembly.

Prairie Prose has been played at local events to celebrate Earth Day, National Poetry Month and Jens Jensen's birthday, and has been used in the classroom by elementary, middle, high school, and college educators.

Locally made. For more information, please contact: prose@pret-a-voir.com

Prairie Prose is a cooperative green game, locally made by hand in Chicago with natural materials, playable by people of all ages who can read and count. Special research was conducted at the Sterling Morton Library, The Morton Arboretum, Westchester Township History Museum, and the Chicago Park District.

Prairie Prose Special Edition

A unique cooperative poetry game inspired by the nature writings of Jens Jensen and his friends that allows up to six players to create their own seasonal haiku poems to read aloud together.

- A Dynamic, Social Experience that Gives Players Voice through Poetry.
- Enlivens Rhythmical Abilities, Storytelling and Imaginative Thinking.
- Builds Players' Listening Skills and Vocabulary.
- Putting concepts together from 'parts to whole' process with inspiration drawn from nature, Japanese poetry, ecology, and the Midwestern prairie landscape.
- *Prairie Prose* - Special Edition includes 324 handcut petals, gameplay instructions, blank poetry booklet, references and one play mat with a drawstring storage bag, hand-painted on organic, muslin fabric - every game is unique.

Prairie Prose has been played at local events to celebrate Earth Day, National Poetry Month and Jens Jensen's birthday, and has been used in the classroom by elementary, middle, high school, and college educators.

Prairie Prose is a cooperative green game, locally made by hand in Chicago with natural materials, playable by people of all ages who can read and count. Special research was conducted at the Sterling Morton Library, The Morton Arboretum, Westchester Township History Museum, and the Chicago Park District.

Left: *Prairie Prose* Tea House Edition and Special Edition. Also created as a School Edition teaching kit that has been used by K–12 and college educators while Extra Edition provided "Plein Air" petals to add to the game. For 2–6 players, ages 8+. The *Prose* game uniquely explored Prairie School ideals of organic living on gingko leaf messages. Center and right: A Jensen Council Ring in the restored Alfred Caldwell Lily Pool in Chicago's Lincoln Park, which also features a pavilion homage to Frank Lloyd Wright. In 1938, Mies van der Rohe first met Caldwell in the Lily Pool and was impressed with his work there, which started an important collaboration between the two comrades at IIT. Jensen spoke of a ring as a symbol for humanity, and is a visual motif in the Prose game that relates to the evolving discussion of a "magic circle" within the game studies community. Courtesy of Janine Fron.

Left: "Urbs in Horto-City in a Garden: Jens Jensen Reconsidered" concluded at the Indiana Dunes National Park with Professor Bob Grese, University of Michigan, reading Jensen's moving testimony to conserve the dunes. Courtesy of Janine Fron. Right: A dramatic story ring performance at the Indiana Dunes. Jensen intended his council ring designs to be used for playful community building endeavors through storytelling, poetry, and dance that was emulated by participants in the photo. In many ways, Jensen and his contemporaries used the arts to help save the native landscape from industrialization. Courtesy of the Sterling Morton Library, the Morton Arboretum.

Canada too. There is a kind of wildness about the prairie flowers and tall blowing grasses where beauty and inspiration just grow, making it seem like anything is possible. The winds on the Illinois prairie sometimes roar across the horizon just like the resounding waves of the Pacific Ocean—it is incredible to experience. I've walked through some of our meadows during a butterfly migration, and the imagination soars. It is no wonder that so many new ideas sprouted here that resonated with others. It is the prairie spirit in action, working its special magic on the world. Even in the city, when you stand in the Lurie Garden and you're amidst the prairie meadow that faces the Art Institute's Modern Wing, it's amazing to see that connection of how art grows out of the landscape.[16]

It was memorable to see Julia Bachrach rededicate the Chicago Women's Park and Gardens to Jane Addams on September 24, 2011, which is located on Indiana Street in the city's historic Prairie Avenue District.[17] The ceremony included the relocation of Louise Bourgeois's bronze sculpture *Helping Hands* (1993) to the memorial site for Jane Addams [see p. 13] that was commissioned by the AIC Ferguson Fund. This reminded me of the inaugural installation of (art)ⁿ's commissioned series for the dedication ceremony of the MJH [Museum of Jewish Heritage], where Louise's *Welcoming Hands* (1996) was installed near the museum in Manhattan's Battery Park. I saw Louise's work in Montréal, Chicago, and in LA with Ellen. I was inspired by Louise's drawings and her use of fabric for some of my own game projects that were play-tested at the Louisa May Alcott School in Chicago [see pp. 270–71].[18]

I more recently discovered Jane Addams's early contributions to the playground movement from one of Julia's special lectures, and that Addams wrote an essay called "The Play Instinct and the Arts, 1909–1929.[19] On May 9, 2015, Julia additionally dedicated the Marion Mahony Griffin Beach Park (formerly Jarvis Beach) in Rogers Park, which is near Wright's Emil Bach house on Sheridan Road and close to Griffin's former residence on Estes Street. In her manuscript *The Magic of America: Electronic Edition*, Griffin said, "Play is what we do for the sheer joy of doing it, the fascination of using our abilities" (IV:222). She also believed "all children should be brought up to express themselves in all the universal languages—the arts. It is no harder to learn them all than to learn one. The arts are play, and they play into each other" (IV:252).

Prairie wildflowers and grasses in Chicago's Millennium Park, designed by Piet Oudolf. Courtesy of Janine Fron.

MARION MAHONY GRIFFIN BEACH PARK

MARION MAHONY GRIFFIN (1871 - 1961) WAS AN EXTRAORDINARY
ARCHITECT, ARTIST, AUTHOR, AND VISIONARY. MARION AND HER
HUSBAND WALTER BURLEY GRIFFIN WORKED FOR FRANK LLOYD
WRIGHT EARLY IN THEIR CAREERS. HER EXQUISITE DRAWINGS HELPED
WRIGHT ACHIEVE FAME. MARION AND WALTER CREATED SOME OF
THE MOST SIGNIFICANT ARCHITECTURAL DESIGNS AND URBAN PLANS
OF THE EARLY 20TH CENTURY IN AMERICA, AUSTRALIA AND INDIA.
THEIR PLAN FOR AUSTRALIA'S CAPITAL CITY, CANBERRA, REMAINS
ONE OF THEIR MOST OUTSTANDING LEGACIES.

MARION WAS BORN IN CHICAGO AND LIVED IN HER FAMILY'S HOME IN
ROGERS PARK FOR MORE THAN TWO DECADES.

CHICAGO PARK DISTRICT
AUSTRALIAN CONSULATE-GENERAL CHICAGO
ROGERS PARK / WEST RIDGE HISTORICAL SOCIETY
ALDERMAN JOE MOORE
~2015~

Julia Bachrach, longtime historian for the Chicago Park District, renamed Rogers Park's Jarvis Beach in honor of Marion Mahony Griffin; and rededicated Chicago's Women's Park and Gardens to Jane Addams as part of an initiative to reclaim public spaces in celebration of women who made a difference to inspire future generations. Courtesy of Janine Fron.

Although the cooperative green games I designed are not inherently digital, they were influenced by my experiences of collaboration with (art)[n] and Ludica. They also could not easily be made without computers, scanners, printers, digital cameras, and the Internet for research, production, and connecting with others for workshops, meetings, and play dates. Games on paper are commonly made to play-test and rapidly prototype game-play ideas before committing to digital production, as noted in textbooks pioneered by Tracy Fullerton and Chris Swain (*Game Design Workshop: Designing, Prototyping & Playtesting Games*, 2004), and Eric Zimmerman and Katie Salen (*Rules of Play: Game Design Fundamentals*, 2003).[20] An expanded version of Tracy's book was published in 2008, *Game Design Workshop: A Play-centric Approach to Creating Innovative Games*, while Mary Flanagan's *Critical Play: Radical Game Design* (2013) "is the first book to examine alternative games" (Flanagan 2013), which was a topical theme in our shared Ludica adventures.

The immediacy iterative game-design processes bring to meetings or working in groups can create dynamic design possibilities that facilitate collaboration in the moment while imagination leads the way. Changes can happen on the fly with input from more than one person rather quickly as tangible, ad hoc elements, sometimes sketched, sometimes made with origami, crafty paper cuts, or other objects on hand. I have developed more than twenty original, playable green games plus additional variants and play sets, using techniques I learned from fiber, book, and paper arts traditions combined with various painting gestures and digital photographs I have taken in nature of water lilies, the ocean, and the prairie. These green qualities enrich the feeling life of the game-play experience that sparks the imagination of the players and connects them in the circle of life through play. Some of my games and their historical research were presented and played in an eco-pedagogy context at ASLE [Association for the Study of Literature and Environment] 2011 at Indiana University–Bloomington and at ASLE 2015 at the University of Idaho–Moscow.[21]

I greatly learned from collaborating with Ludica that good design is more flexible when repeatedly tried with different people, taking in what works outside of a design team and going back to initial prototypes to refine without scaling on budget. Earlier paper attempts can also be brought into new projects and make great ephemera for project documentation of process.

We did this a lot together for our interventions and just for fun. It's its own art form that does not hold back the creativity of making games, which can even emerge out of the oral tradition of story-telling. Children make up their own games all the time, as do many parents and teachers. It's part of our human nature to be imaginative, playful, and creative. Blending both styles of working are important, real world and digital. Today, many women are also using the Internet via social net-working tools to launch their own businesses, share knowledge, learn new skills, and even homeschool their children. There are more pos-sibilities than ever before, while finding balance and peacefulness can now become important aspirations for us all to share together.

When (art)ⁿ first started working on the MJH commissioned series during the mid-1990s with Stephanie Barish, Carolina Cruz-Neira, and others, we were all social networking before it became mainstream, which made our project much easier so we could focus on what was important—honoring the lives of the Holocaust survivors. It amazed us that we were doing heartfelt work that was very sophisticated here in the heartland. We internally constructed a private website to manage our workflow that included project references and visual resources the team could readily view and exchange comments on updated work files in different time zones.

Everyone involved in the Midwest and on both coasts—including the historians, building architects, artists, and postproduction crew—had access to the website and we met our deadline ahead of schedule. Some people were online at work or at home on WebTV to check in. A similar private website was created for the *Battle of Midway Memorial* project, where BOM veterans could share their memoirs, photographs, input, and contacts that could help us. We had to become experts in both cases about different facets of war—its challenges, horrors, and social outcomes. Being able to connect quickly and easily as a team helped us all to be in the heart space of these stories to create moving work. As the insightful poet Kahlil Gibran once said, "Work is love made visible." I truly believe when we work out of love, we can transform ourselves and our humanity.

||

Notes

1. The initial team included Kirsten Paul, Richard Edwards, Karen Voss, Steve Anderson, Christopher Gilman, and Aaron Zarrow—who all believed in col-laboration as a creative process and the importance of community. Richard later invited Tracy Fullerton and me to lead an experimental game-design workshop for his students at St. Mary's College.

2. National Museum of Women in the Arts and the Westchester Township History Museum near the Indiana Dunes were the first to offer the *Prairie Prose* cooperative poetry game along with the Morton Arbo-retum, University of Wisconsin–Madison Arboretum, The Clearing, Garfield Park Conservatory, and Ander-son Japanese Gardens. The *Prairie Fairies* flora fashion game and *Princess on the Prairie* fairy tale game are also part of my prairie themed games collection. I recently created *Quills!* in celebration of classic women authors from the US and the UK, whose metamor-phosing heroines reveal a transformation of ideals that evolved into modern feminism—from the Elizabethan Era through the American Renaissance. The *Quills!* game series was first shown at the JASNA-GCR Spring Gala 2016, which was held at the historic Women's Ath-letic Club in Chicago in honor of the bicentenary of Jane Austen's *Emma*.

3. The Millennium Wall is located at the edge of Ocean Avenue and San Vicente Boulevard in Santa Monica, California, and is inscribed with a powerful quote by Rachel Carson: "Meanwhile the sea ebbs and flows in the grander tides of Earth whose stages are measurable not in hours but in millennia-tides so vast they are irresistible and uncomprehended by the senses. Their ultimate cause may be joined to be deep within the fury center of earth or it may lie somewhere in the dark spaces of the universe." This inscription led to my discovery of Carson's seminal article, "Help Your Child to Wonder" (*Woman's Home Companion,* 1956). The article was posthumously published into a renowned book called *The Sense of Wonder* (1965) and can be interpreted as a founda-tional philosophy for green games, which coincided with the New Games movement that originated with Stewart Brand in Northern California (1966). In 2005, Ludica wrote about the history of New Games and the Earthball that was published in *Games & Culture* [vol. 2, no. 3, July 2007].

4. Ludica created the first ever "Game Design Atelier" for the Guerilla Studio, SIGGRAPH '05. Throughout the conference week, we hosted demon-stration projects and game-creation workshops that explored creativity with a cooperative New Games spirit. Whether game making, game modding, or play-testing—every activity was hands-on. Highlights included "Junkyard Sports" with Bernie DeKoven, chalk art, and "DIY Fashions" with Katherine Moriwaki.

5. On the popular *Grand Text Auto* blog, Nick Monfort noted in his December 2, 2005, entry: "Janine presented Ludica's work towards a contemporary ana-logue of the 'new games movement,' founded in the Vietnam War era by Stewart Brand. His activity was game modding—taking military parachutes and using them for play. At USC, various games were played, and

a tournament with Carnegie Mellon University (CMU) was organized. A relationship between [the] Earthball (and environmental gaming) and the environmental works of Robert Smithson and Christo & Jean-Claude [was explored]. Analog games were played outside on New Games Day last year; mods of hopscotch and other street games. They also set up mini-golf and a bowling game, fashioned out of conference schwag, providing play with recycled and reused materials. Janine encouraged us to seek better ways to be in the world as well as better ways to play."

6. More recently, Emily Rose Gitelman took up the hegemony debate in her SAIC BA thesis, spring 2014, "Beyond Princess Peach: Gender Issues and the Boy's Club Hegemony of Video Game Development," where she cites Ludica's "Hegemony" paper on the "exclusionary power structures of the computer game industry" supported by International Game Developers Association (IGDA) statistics.

7. Henry Jenkins published a notable research paper I first read while living in Finland that traced the erosion of green spaces from the twentieth century to the present, in which city-dwelling families increasingly have less access to the great outdoors of past generations to play in (Cassell and Jenkins 1998). An award-winning documentary filmed in Michigan, *Where Do the Children Play?* (2008), provides further insights into the different freedoms children experience when they play outside, online, in playgrounds, or in imaginary places in nature. Richard Louv's *Last Child in the Woods: Saving Our Children from Nature Deficit Disorder* (2005) and David Sobel's *Childhood and Nature: Design Principles for Educators* (2008) also made an impression on me.

8. Ludica was interviewed by Tina Tyndal in the inaugural IGDA Women in Games Spring 2009 newsletter. Cindy Poremba previously interviewed Ludica in March 2007, www.shinyspinning.com/ludica_transcript _2007.pdf.

9. We both saw Geena Davis speak about "Where the Girls Aren't" during a research forum held at the USC Norman Lear Center on February 9, 2006, concerning the gender disparity of women and girls in family films. Women and girls make up half of the world, Davis said, which should be accurately portrayed in films and other media. Ludica was formed in 2005 to address the misrepresentation of how women are often portrayed in games combined with support for their inclusion in the scholarship and creative process of developing games. The forum also inspired me to think about the many contributions women have made to our world that are invisible from our recorded history and how richer the world would be if we could fill them in. I am very conscious of this now in everything I do to find the balance. There was a book I came across by Elizabeth W. Barber, *Women's Work: The First 20,000 Years*, that really shows how important women's contributions have been to our society, from the beginning.

10. I gratefully worked with Dave Gerding and Tom Dowd, who were exploring collaboration in their work with games and New Media, while emphasizing the relevance of community to their students and peers.

11. Tim Walker is an American teacher who lives and works in Finland with his family. As a contributing writer for *The Atlantic*, he has written many helpful articles about Finnish education and play culture, which he also posts on his website, taughtbyfinland. com.

12. Ludica's research paper "The Hegemony of Play" was included in *Gender and the Media: Critical Concepts in Media and Cultural Studies* (2016), a four-volume compilation edited by Kaitlynn Mendes for Routledge. The paper was also highlighted as one of the "Canonical Feminist Texts for Games" at DiGRA/ FDG '16 during the panel "The Inclusive Schoolmaster: Embedding Gender Studies, Critical Race Theory and Issues of Inclusivity and Diversity in Games Curriculum," featuring Jennifer Jenson, Emily Flynn-Jones, Stephanie Fisher, Helen Kennedy, and Suzanne de Castell.

13. Shira Chess cited Ludica's "Hegemony" paper in her PhD thesis, "License to Play: Women, Productivity, and Video Games," Rensselaer Polytechnic Institute, December 2009, where she calls for continued research and evaluation.

14. I also created a Japanese-inspired Tea House Edition of the game. Some of my research included visits to the Anderson Japanese Gardens where Kimiko Gunji, professor emeritus and past director of Japan House, University of Illinois, seasonally performed traditional Japanese tea ceremonies. Gunji shared that women in Japan were not allowed to participate in Japanese tea ceremonies until the Meiji period (1868–1912). Since the eighteenth century, women in the Western world have gathered around cups of tea to advance social change, including women's rights at Hull-House.

15. Jensen's work was very spiritual. In *Siftings* he said, "There will never be any peace on this earth until we all learn to live, work and think together." This message resonated with me and connects with the merits of collaboration.

16. Designed by Dutch landscape artist Piet Oudolf for Millennium Park.

17. Renaming parks and reclaiming public spaces in honor of women was a vision shared by former district board commissioner Cindy Mitchell and Maria N. Saldaña, who was the first woman president of the Chicago Park District (2002–2007). The ongoing initiative was inaugurated in March 2004 for Women's Month, in light of the city's 555 public parks, only twenty-seven of which were named after women. As of 2015, there were forty-eight statues of prominent men in Chicago's parks, but none yet of women, with the exception of Dorothy in Oz Park, who is a fictional character from L. Frank Baum's *The Wonderful Wizard of Oz*.

18. I remember seeing Louise Bourgeois's many installations of sculpted hands often folded in imagined social situations and this made me think about how important it is to consider the people we are creating an experience for and what can happen between them: who is gathering and what meaningful exchange is taking place? These considerations are part of my creative process for making games, which is especially helpful in developing the game play and play-testing with players. I want to create moving work that touches the human spirit and connects us all in the circle of life.

19. Jane Addams's published essay "The Play Instinct and the Arts, 1909–1929," which is derived from her contributions to the playground movement

and kindergarten movement in the US, combined with her activities at Hull-House presages the World War II writings of Johannes Huizinga (*Homo Ludens*, 1938). In 1904, President Roosevelt declared Chicago was a leading city in developing green spaces for play and was the host city for the first "Play Congress" in 1907, which was attended by an estimated five thousand delegates, spectators, and festival participants.

20. Like Brenda Laurel, Mary Flanagan, and Bernie DeKoven, Eric Zimmerman also shares midwestern roots. The Midwest has a rich early history of play culture from the inception of the playground movement to John Lloyd Wright's Lincoln Logs, Charles H. Pajeau's Tinkertoy Construction Set, and Lucille King's Playskool Blocks. These three examples fostered free play, collaboration, storytelling, and imaginative thinking, and are highlighted for their innovation on a timeline at the Chicago History Museum. In 1986, Pleasant Rowland created the popular American Girl dolls in neighboring Wisconsin, which are reminiscent of a children's book series of foreign twins immigrating to the US from other countries, written by Chicagoan Lucy Fitch Perkins, Griffin's cousin from the Prairie School era.

21. *A Sense of Play: Greening Games from Nature* included a demonstration of *Prairie Prose* in which ASLE participants created poems from the game they read aloud to each other. *Underground Women: Designing New Landscapes* highlighted research, photos, and artistic examples of my games.

Brenda Laurel *Placeholder*, 1993
Detailed credits: p. 272

Corn Stubble and Clouds—the Greatest Show in Indiana, 2008; *New Moon on the Road from Middletown, Indiana*, 2008

Detailed credits: p. 272

Brenda Laurel

Copper Giloth

Field's #10, 1984; *Skippy Peanut Butter Jars* (a grid of 4 stills), 1980; *Labyrinth of Fables / Le Labyrinthe des Fables*, 2015
Detailed credits: p. 272

Mother-Daughter-BIOGrids, 2011
Detailed credits: p. 272 **Copper Giloth** ||||||||||||||||

Jane Veeder *4KTape*, 1986; *Warpitout*—Symbol menu and title screen, 1982
Detailed credits: p. 272

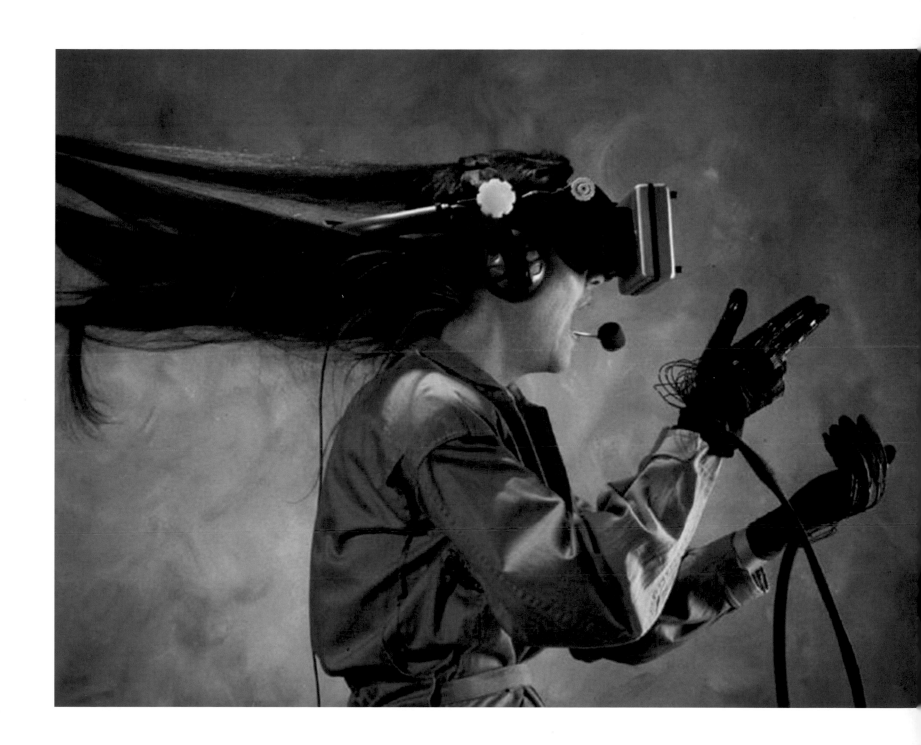

NASA Ames Research Center, Moffett Federal Airfield, California, 1989
Detailed credits: p. 272 **Sally Rosenthal**

Lucy Petrovic

Under control / In control still #1 & #2, 2005
Detailed credits: p. 272

on the subject of sex . . . still # 1 & 2, c. 2001
Detailed credits: pp. 272–73 **Lucy Petrovic**

 Janine Fron Ludica Interventions, 2005-2007
Detailed credits: p. 273

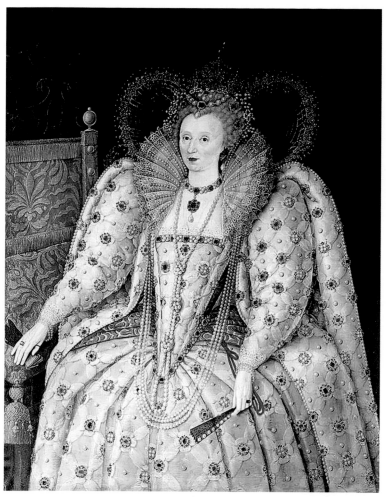

Quills! Elizabethan Edition I & The Magical Dream Weaver: exploring women's narratives in cooperative games
Detailed credits: p. 273 **Janine Fron**

|||||||||||||||||

Art Details for Part 3 Color Plates

Brenda Laurel

Page 262. *Placeholder*, 1993
Virtual reality project
I came to VR wanting to walk around in my dreams.
Rachel Strickland and Rob Tow and I scouted many
places around Banff, Alberta and learned their
stories. We worked with the Precipice Theatre
Company, an environmentalist improv group, to
make characters and affordances for stories in the
work. The work referenced the local landscape but
with an overlay of fantasy and imagination.
Page 263, top: "Corn Stubble and Clouds—the
Greatest Show in Indiana," 2008
Digital photograph
bottom: "New Moon on the Road from Middletown,
Indiana," 2008
Digital photograph
Courtesy of Brenda Laurel.

Copper Giloth

Page 264, top: *Field's #10*, 1984
19" x 25" archival inks on rag paper via a plotter
A series of forty drawings made from objects,
people, and the landscape combined to form digital
landscapes.
bottom left: *Skippy Peanut Butter Jars (a grid of 4
stills)*, 1980
3 minutes, stereo sound; ZGrass 32 computer with
narration
An autobiography about how I became an artist.
bottom right: *Labyrinth of Fables / Le Labyrinthe des
Fables*, 2015
Mobile app for the IOS/Android and Oculus Devices
written in Unity Software
Augmented/virtual reality app of the now destroyed
Labyrinth with thirty-nine fountains that existed at
Versailles from about 1665 to 1775.
Page 265. *Mother-Daughter-BIOGrids #3*, 2011
40" x 40" archival inkjet prints
Series of quilt-inspired prints created from scraps
of my mother's eighth-grade biology drawings

(1930) with digital scraps of computer-generated
plant forms.
Courtesy of Copper Giloth.

Jane Veeder

Page 266, top: *4KTape*, 1986
Visuals: Jane Veeder. Sound: Clark Salisbury.
Four-minute computer animation created as a
response to an impulse paper by Fritjof Capra
titled *The New Age*. Commissioned by the Austrian
Broadcasting Corporation (ORF) for Ars Electronica
'86 and funded by Siemens, Inc., 1986.
bottom: *Warpitout*—Symbol menu and title screen,
1982
Interactive computer graphics/sound installation,
ZGrass system.
Interactive computer graphics/sound installation,
supporting real-time color graphic processing of a
digitized (facial) image of the current player using a
menu-driven selection of drawing and processing
programs; housed in a videogame cabinet.
Courtesy of Jane Veeder.

Sally Rosenthal

Page 267. Rosenthal as the woman wearing headset
display, the Virtual Interface Environment
Workstation Project (VIEWlab) at NASA Ames
Research Center, 1989.
Courtesy of NASA.

Lucy Petrovic

Page 268. *Under control / In control still #1 & #2*, 2005
An interactive, immersive stereoscopic CAVE
environment
This immersive environment addresses issues of
control in human culture.
Page 269. "*on the subject of sex . . .*" still # 1 & 2, ca.
2001
Video, running time 4:13

An experimental video documentary—a candid and intimate portrayal of women's sexuality.
Courtesy of Lucy Petrovic.

Janine Fron

Page 270. Ludica Interventions, 2005–2007
Selected highlights from Ludica's collaborations, including game-design challenges, publications, and discussions. Ludica was cofounded in Los Angeles in 2005 with Celia Pearce, Jacquelyn Ford Morie, and Tracy Fullerton.
With special thanks to our collaborators and friends for their enthusiasm, inspiration, and friendship: Bernie DeKoven, Mary Flanagan, Richard Kahlenberg, Elina Ollila, Katherine Milton, Katherine Moriwaki, Alex and Judy Singer, and Larry Tuch. We hope our work continues to playfully challenge and inspire.
Courtesy of Ludica, www.ludica.org.uk.

Page 271. *Quills! Elizabethan Edition I & The Magical Dream Weaver:* exploring women's narratives in cooperative games

Clockwise from upper left:
Queen Elizabeth I of England and Ireland, circa 1592, by Anonymous, from Wikimedia Commons.

The Magical Dream Weaver, 2006–09 created by Janine Fron
Initially inspired by Louise Bourgeois, this unique cooperative game set explores the magic of fairy tales and women illustrators, like Jessie M. King, which later evolved into the *Quills!* series. © 2006 Janine Fron.

Quills! Elizabethan Edition I: The Heroines of Shakespeare, 2016–17 created by Janine Fron
The Quills! cooperative game series provides fans and educators with a panoramic view of women moving through the literary arts both as characters and as writers, offering players opportunities to directly engage with their writings in a playful and insightful manner. The women represented exemplify leadership skills—as pioneering writers, leading characters, and even ruling monarchs. Presented at the JASNA 2017 AGM in celebration of the 200th anniversary of the death of Jane Austen, who wrote about the queen in her juvenilia. © 2016 Janine Fron.

Jessie M. King's cover art for *How Cinderella Was Able to Go to the Ball*, 1924, published by G. T. Foulis, UK. From the collection of Janine Fron.
Courtesy of Janine Fron.

Closing Reflections

III

Throughout the editorial and contributors' adventures of working on *New Media Futures: The Rise of Women in the Digital Arts*, the Doomsday Clock was moved more than once and in 2017 is presently set at two and a half minutes to midnight. In this new century, it is imperative that we all work together, by which women play an equal role in the decisions that are made in our society alongside men to creatively use technology in responsible, beneficial ways that are in balance with nature. Martyl Langsdorf, the designer of the Doomsday Clock, passed away before this book was published. The Doomsday Clock marks an important contemporary precedent that brought artists and scientists together, with women and men collaborating at the helm, just as Martyl did with the *Bulletin of the Atomic Scientists*. A few weeks after the Doomsday Clock was moved, *Hidden Figures* received three Academy Award nominations that included Best Picture, Best Adapted Screenplay, and Best Supporting Actress. The dramatic film uncovered the true story about gifted African American female mathematicians who brilliantly worked in secret at NASA's Langley Research Center during the 1960s space race, which paralleled the African American Civil Rights Movement.[1] Many contributors to this book who collaborated with NASA scientists over the years salute the contributions these inspiring heroines made. The twenty-two women featured in *New Media Futures: The Rise of Women in the Digital Arts* all share in a range of artistic experiences, often drawing on traditional artistic forms of expression that enriched and inspired them to cultivate the future of New Media Arts. These multifaceted, talented women wanted to change the world by making it a better place for future generations with collaboration, creativity, and playfulness—all of which helped birth a socially conscious, cultural revolution at the dawn of the new millennium.

The seminal symposium *Simulations/Dissimulations*, held at the School of the Art Institute of Chicago (SAIC) in 1987, inspired many artists to consider new possibilities of artistic intersections with emerging technologies, which helped form Chicago's New Media Arts community during the infancy of video art, computer graphics, interactive games, scientific visualization, and virtual reality (VR). The culmination of *New Media Futures* coincided with the 150th anniversaries of SAIC (2016) and the University of Illinois (2017). *Celebrating Women in New Media Arts*, a special one-day symposium, was held at SAIC on March 18, 2016, during Women's Month "to examine the achievements of women in the field of New Media Arts and emerging technologies from the 1980s onward."

Symposium participants included Tiffany Holmes, dean of undergraduate studies and book contributor; Lisa Wainwright, dean of faculty; Ellen Sandor (MFA 1975, HON 2014), book editor and contributor; Donna J. Cox, book editor and contributor; Janine Fron, book editor and contributor; Elissa Tenny, SAIC provost; Barbara Sykes (MFA 1981), book contributor; Dana Plepys (BFA 1981), book contributor; Abina Manning, book contributor and director of the Video Data Bank; Carolina Cruz-Neira, book contributor; Margaret Dolinsky, book contributor; Lucy Petrovic, book contributor; Jon Cates, SAIC faculty; Brenda Laurel, book contributor; Jane Veeder (MFA 1977), book contributor; Copper Giloth, book contributor and former SAIC faculty; Stephanie Rothenberg (MFA 2003); David Getsy, SAIC faculty; Snow Fu (MFA 2014), SAIC faculty; Claudia Hart, book contributor and SAIC faculty; Lee Black (MFA 2011), SAIC faculty; Marlena Novak, SAIC faculty; Sabrina Raaf (MFA 1999); Maxine Brown, book contributor; Christina Gomez, SAIC faculty; Faith Wilding, former SAIC faculty; Terri Kapsalis,

Celebrating Women in New Media Arts

**Friday, March 18
9:30 a.m.–4:30 p.m.**
SAIC Ballroom, 112 S. Michigan Ave.

This exciting one-day symposium examines the achievements of women in media art and emerging technologies from the 1980s onward and celebrates the new book, *Women in New Media Arts: Perspectives on Innovative Collaboration.*

150 YEARS OF
SAIC School of the Art Institute of Chicago

Symposium participants include **Tiffany Holmes**, Dean of Undergraduate Studies and book contributor; **Lisa Wainwright**, Dean of Faculty; **Ellen Sandor** (MFA 1975, HON 2014), book editor and contributor; **Donna Cox**, book editor and contributor; **Janine Fron**, book editor and contributor; **Elissa Tenny**, SAIC Provost; **Barbara Sykes** (MFA 1981), book contributor; **Dana Plepys** (BFA 1981), book contributor; **Abina Manning**, book contributor, Director of the Video Data Bank; **Joan Truckenbrod** (MFA 1975), book contributor and former SAIC faculty; **Carolina Cruz-Neira**, book contributor; **Margaret Dolinsky**, book contributor; **Lucy Petrovich**, book contributor; **Jon Cates**, SAIC faculty; **Brenda Laurel**, book contributor; **Jane Veeder** (MFA 1977), book contributor; **Copper Giloth**, book contributor and former SAIC faculty; **Stephanie Rothenberg** (MFA 2003); **David Getsy**, SAIC faculty; **Snow Fu** (MFA 2014), SAIC faculty; **Claudia Hart**, book contributor and SAIC faculty; **Lee Blalock** (MFA 2011), SAIC faculty; **Marlena Novak**, SAIC faculty; **Sabrina Raaf** (MFA 1999); **Maxine Brown**, book contributor; **Christina Gomez**, SAIC faculty; **Faith Wilding**, former SAIC faculty; **Terri Kapsalis**, SAIC faculty; **Jessica Westbrook**, SAIC faculty; **Kirsten Leenaars**, SAIC faculty; and **Marie Hicks**, Illinois Institute of Technology faculty.

Ellen Sandor (MFA 1975, HON 2014) and (art)n, Chris Kemp, Chris Day, and Ben Carney, *Mies-en-scène: The Farnsworth House,* 2009, digital PHSCologram

New Media Futures Contributors: Ellen Sandor, Donna J. Cox, Carolina Cruz-Neira, Colleen Bushell, Nan Goggin, Mary Rasmussen, Dana Plepys, Maxine Brown, Martyl, Joan Truckenbrod, Barbara Sykes, Annette Barbier, Abina Manning, Margaret Dolinsky, Tiffany Holmes, Claudia Hart, Brenda Laurel, Copper Giloth, Jane Veeder, Sally Rosenthal, Lucy Petrovic, Janine Fron, Lisa Wainwright, Anne Balsamo, and Judy Malloy. Used with permission.

SAIC faculty; Jessica Westbrook, SAIC faculty; Kirsten Leenaars, SAIC faculty; and Lynn Tomaszewski, SAIC associate dean of graduate studies.

The SAIC 2016 event featured opening introductions made by Lisa Wainwright, Tiffany Holmes, Ellen Sandor, and Donna J. Cox. Topical panel discussions and presentations explored the early history of video art and New Media, VR, science and art, narrative in games, and cyberfeminism, which resonated with artists, faculty, and students who are striving to contribute to contemporary society in meaningful ways. The symposium concluded with a screening of Donna Cox's exquisitely rendered films of the earth and the cosmos at the Gene Siskel Film Center. In an insightful, concluding roundtable discussion, students were encouraged by all participants that they could make a difference in the world through hard work, tenacity, and compassion, as the women interviewed in the book candidly spoke of their experiences. The significance of community building underscored the entire event, with acknowledgment of all of the unknown women who made a difference before us.

Liz Phair ✔
@PhizLair

Hitch your wagon to a shooting star

right where you left me

400 FOLLOWING **22.8K** FOLLOWERS

Tweets Photos Likes

Liz Phair retweeted

SAIC News + Events @saic_news Mar 18
"We tend to privilege the individual as maker but we make things within a network of other people" -David Getsy moderating Flickering Bodies

↩ ⟲ 3 ♥ 6 •••

Chicago music legend, Liz Phair shares a post on SAIC's Twitter feed during *Celebrating Women in New Media Arts*. Courtesy of SAIC.

The importance of collaboration and the evolution of Renaissance Teams was another thread that wove the intergenerations of SAIC symposium participants together. These seeds were planted by Cox and Sandor's creative partnership to visualize the invisible with the *Etruscan Venus* PHSCologram series in 1986. Their visionary leadership combined with the work of their contemporaries in the book collectively innovated a new role in which women artists can be producers and directors of creative teams to do complex artistic work while breaking down more invisible sociocultural and political barriers that have prohibited people from working together in the past.

With supporting documentation and expert grant-writing skills, the proliferation of the Internet browser and the World Wide Web enabled many of the women interviewed to migrate their talents, expertise, and values to both coasts and abroad, all the while staying connected to their midwestern roots and being true to their ideals. The international influences of their collective work continue through scholarship, social media, and live events that are creating new opportunities for future generations of young women and men to flourish. Social media has additionally enabled women the world over to connect and collaborate with others like never before. No one is ever truly isolated and can more easily reach out to supportive kindred spirits who can help them build their dreams. Many of the active women in the book continue to forge ahead with new research initiatives, teaching, exhibiting, and cultivating their expression of consciously living in today's world. Women have become authors of their own stories. Together, we are all cocreators of our cultural heritage and stewards of our world.

Note

1. *Hidden Figures* was directed by Theodore Melfi, who cowrote the screenplay with Allison Schroeder, and was based on the nonfiction book of the same title by Margot Lee Shetterly. The cast featured Taraji P. Henson as Katherine Johnson, a mathematician who calculated flight trajectories for Project Mercury and other missions; Octavia Spencer as Dorothy Vaughan, and Janelle Monáe as Mary Jackson, with Kevin Costner, Kirsten Dunst, Jim Parsons, Glen Powell, and Mahershala Ali all appearing in supporting roles.

Appendix

ORIGINAL LIST OF GUIDING INTERVIEW QUESTIONS

1. What do you recall that you were working on in 1985 and were there any connections to or was there any awareness of the opportunities that were starting to open up in computer science and electronic art?

2. Were there any women in the 1980s and 1990s who were from the Midwest/working in the Midwest and who had an influence on your work or teaching?

3. What were your impressions of the world then, and how did you think technology and the arts could change it? What kind of a future were you imagining and how does it connect to the world we are living in today?

4. What are some of the early works from the 1980s and 1990s that you recall seeing or reading about that you thought were important and how have they shaped the field?

5. Who are some important pioneers of the time and what do you admire about them?

6. How would you describe the technical revolution that took place on the prairie and then the valley and beyond?

7. How has technology helped women and changed their opportunities, including the way they manage their time and shape their values?

8. In what ways have women contributed to the technical revolution and what breakthroughs may come of it for future generations?

9. What are you working on now and how does it mirror your vision of the world during the 1980s and 1990s?

10. Who are other women with whom you think we should be in touch?

11. Would you be interested in contributing written or visual materials to this project?

memory External data storage devices like flash drives or hard drives, and also in computer programs that store electronic information for temporary use or permanent storage.

monitor Also called a computer screen or terminal. A monitor is a display device and circuitry, plus an enclosed frame or box.

Mosaic The first web browser developed at the National Center for Supercomputing Applications in late 1992, publicly released 1993–1997, that popularized the WWW (World Wide Web).

network A cluster of computers and devices that are interconnected via communications channels that help people exchange information and share resources with each other.

Oculus Rift A virtual-reality head-mounted display developed by a division of Facebook and released in 2016.

operating system (OS) A set of software that manages computer hardware resources and provides fluid communication between software programs and content created between programs.

personal computer (PC) An affordable, general, all-purpose computer that can independently be used by individuals in schools, homes, and offices.

PHSColograms An acronym for Photography, Holography, Sculpture, and Computer Graphics, coined by Ellen Sandor in 1983 for creating "barrier-strip auto-sterographic images" with analog "garage-art" darkroom techniques and patented computer-interleaving processes. Images are horizontally photographed in series at slightly different angles across a scene, which are then sequentially computer combined as a weave that is output to transparent film and requires a matching linescreen, both carefully laminated to Plexiglas in alignment, and displayed in a light box for viewing the image in three-dimensions. PHSColograms can have limited animation and can be output in real time from virtual environments.

plotter An early computer printer, used to print vector graphics for computer-aided design applications. A pen or another instrument would move across the surface of a page to draw complex line art and some text at a fairly slow pace.

Portapak An early example of an analog, battery-operated video camera that one person could easily carry on the go, making it easy to record video outside of a studio setting.

RAM An acronym for random-access memory, which is a form of computer data storage.

ROM An acronym for read-only memory, used for data storage in computers and other electronic devices.

RT1 Real-time programming language for interactive graphics.

scientific visualization A combination of computer graphics, numerical information, and mathematical models of the physical world that helps researchers create a framework for describing and solving scientific problems.

software A flexible term for computer programs and electronic information that is created with computers.

video game Games that are created on a computer and are played by one or more players with a microcomputer and keyboard or joysticks to manipulate changes and respond to activities that appear on the screen. Video games can be played on consoles, hand-held devices, and arcade machines.

Virtual Director A virtual-reality software tool created in 1994 (patented in 1997) by Donna J. Cox, Robert Patterson, NCSA UIUC, and Marcus Thiébaux, UIC. Matthew Hall codeveloped the *Virtual Director* Application Programming Interface, which was extended by Stuart Levy. *Virtual Director* enables gestural camera paths and editable camera system to design flight paths through scientific data. It also provides remote virtual-reality collaboration with networked avatars.

virtual reality An immersive experience that simulates real and imagined worlds in three-dimensions where the viewer can see and/or navigate the immersive experience. Often the viewer shares the immersive space simultaneously with one or more people. With the aid of a stereoscopic (3D) display that is updated by the computer, the position of a viewer's head is often tracked within the environment. Often a VR sensory environment re-creates characteristics, visuals, motions, and sounds of reality. Computer modeling and simulation provide input for the environments. Viewers experience the environment through various interface technologies, such as hand-held devices, head-mounted displays, and/or projected walls.

VIVE A virtual-reality headset and tracking mechanism for room-scale virtual-reality applications.

VRML An acronym for Virtual Reality Modeling Language; like HTML, VRML is a programming language for creating 3D graphics within web documents.

web browser A software program that reads and displays web documents.

ZBox Customized hardware developed by Tom DeFanti for running ZGrass.

ZGrass GRAphics Symbiosis System developed by Tom DeFanti as part of his PhD thesis.

References

Ackchin, Don. 1983. "Cover Story: Art Students Learn to Program." *USA Today*, August 1.

Addams, Jane. 1935. "Play Instinct and the Arts, 1909–1929." *Jane Addams: Forty Years at Hull-House. Being "Twenty Years at Hull-House" and "The Second Twenty Years at Hull-House" in One Volume*, 344–47. New York: Macmillian.

Adler, Kathleen. 2006. *Mary Cassatt: Prints*. New Haven: Yale University Press.

Alfano, Elysabeth. 2012. "Ellen Sandor and the Future of Photography." *Huffpost Arts and Culture*, August 27. http://www.huffingtonpost.com/elysabeth-alfano/ellen-sandor-photography_b_1825990.html.

Allen, Harold. 1993. "Helen Gardner: Quiet Rebel." In *Sacred Spaces and Other Places: A Guide to Grottos and Sculptural Environments in the Upper Midwest*. Edited by Lisa Stone and Jim Zanzi, 158–61. Chicago: School of the Art Institute of Chicago.

Amirkhanian, Charles. 1996. "New Music for Electronic and Recorded Media: Women in Electronic Music—1977." *DRAM*. http://www.dramonline.org/albums/new-music-for-electronic-and-recorded-media-women-in-electronic-music-1977/notes (accessed September 29, 2016).

Anderson, Bethany. 2013. "The Birth of the Computer Age at Illinois." *University of Illinois Archives*, September 23, 2013. http://archives.library.illinois.edu/blog/birth-of-the-computer-age/ (accessed June 23, 2014).

Anderson, Laurie. 1986. *Home of the Brave* (words and music by Laurie Anderson). http://www.jimdavies.org/laurie-anderson/lyrics/hotb.html (accessed September 30, 2015).

"Argonne's Nuclear Science and Technology Legacy." 1996. Historical news releases, Argonne, Illinois, December 13, 1996. US Department of Energy. http://www.ne.anl.gov/About/hn/news961213.shtml (accessed October 11, 2015).

Artner, Alan G. 1980. "MCA Video Show Wins Top Ratings." *Chicago Tribune*, September 28.

Bagley, E. C., ed. 1917–1918. "Inventions of an American Artist." *School and Home Education* 37 (September 1917– June 1918): 144.

Balsamo, Anne. 2001. *Designing Culture: The Technological Imagination at Work*. Durham: Duke University Press.

Battisti, Emanuele. N.d. "The Experimental Music Studio at the University of Illinois, 1958–68: Environment, People, Activities." *Experimental Music Studios, School of Music, College of Fine and Applied Arts, University of Illinois at Urbana-Champaign*. http://ems.music.illinois.edu/ems/articles/battisti (accessed June 23, 2014).

Beirut, Michael. 2010. "Designing the Unthinkable." *New Design Observer*, January 12. http://designobserver.com/feature/designing-the-unthinkable/12447.

Benson, Julia E. 2003. "Weaving at the Bauhaus: Origins and Influences." *Art of the Firebird*. http://artofthefirebird.com/wp-content/uploads/2013/11/Bauhaus%20Slides.pdf.

Birmingham, Elizabeth. 2011. "Making and Playing Cooperative Games: Feminist Aesthetics and Values in *Prairie Prose*." *Feminist Media Studies* 11, no. 2 (June): 246–50.

Born, Kathryn. 2010. "Guerrilla Girl to Speak at SAIC Commencement." *Chicagoartmagazine.com*. May 19. http://chicagoartmagazine.com/2010/05/guerrilla-girl-to-speak-at-saic-commencement/.

Buck, Robert T. 1986. *Site Drawings by Martyl: The Precinct of Mut at Luxor*. Brooklyn: Brooklyn Museum.

Butler, Cornelia. 2007. *WACK! Art and the Feminist Revolution*. Cambridge, Mass.: MIT Press.

Carlson, Wayne. 2003–2004. "CGI Historical Timeline." *Ohio State University*. http://design.osu.edu/carlson/history/timeline.html.

Cassell, Justine, and Henry Jenkins. 1998. *From Barbie to Mortal Kombat: Gender and Computer Games*. Cambridge: MIT Press. http://web.mit.edu/21fms/People/henry3/complete.html.

Cates, Jon. N.d. http://joncates.blogspot.com/.

Catmull, Edwin. 1972. "A System for Computer Generated Movies." *Proceedings of the ACM National Conference* (August): 422–31.

———. 1974. "A Subdivision Algorithm for Computer Display of Curved Surfaces." PhD diss., Report UTEC-CSc-74-133, Computer Science Department, University of Utah, Salt Lake City.

Catmull, Edwin, and Frederic I. Parke. 1972. "Computer Generated Animation of Faces." *Proceedings of the ACM National Conference* (August): 451–57.

Kirshner, Judith Russi. 1984. "The Science of Fiction/The Fiction of Science, Video Data Bank." *Art Forum International* (December).

Korporaal, Glenda. 2015. *Making Magic: The Marion Mahony Griffin Story*. Sydney: Oranje Media. Kindle edition.

Laurel, Brenda. 2001. *Utopian Entrepreneur*. Cambridge, Mass.: MIT Press.

Leavitt, Ruth. 1976. *Artist and Computer*. New York: Harmony Books.

Lee, Eric McCauley. 2004. *Selected Works: The Fred Jones Jr. Museum of Art at the University of Oklahoma*. Norman: University of Oklahoma Press.

"Lillian F. Schwartz." *CompArt: Center of Excellence Digital Art*. http://dada.compart-bremen.de/item/agent/18 (accessed June 28, 2014).

Long, Timothy A. 2009. *Bertha Honoré Palmer*. Chicago: Chicago Historical Society.

Lujan, Susan M. 1987. "Agnes Meyers Driscoll." *Cryptolog* (Fall): 2.

Lutkehaus, Nancy C. 2008. *Margaret Mead: The Making of an American Icon*. Princeton, N.J.: Princeton University Press.

Mackintosh, Allan R. 1987. "The First Electronic Computer." *Physics Today* 40, no. 3:25–32.

Mahony, Marion. 1894. "The House and Studios of a Painter." Institute Archives-Noncirculating Collection 3, BS thesis, Massachusetts Institute of Technology, Cambridge, Massachusetts.

Mainer, Jeremy. 2007. "Doomsday Clock to Start New Era." *New York Times*, January 17, sect. 1, 3.

Malloy, Judy. 2003. *Women, Art, and Technology*. Cambridge, Mass.: MIT Press.

———. "Travels with Contemporary New Media Art." *GIA Reader* 21, no. 2 (Summer 2010). www.giarts.org/article/travels-contemporary-new-media-art.

Manning, Ric. 1983. "Computer Art Comes to Louisville." *Louisville Times*, December 10.

Martineau, Chantal. 2004. "The Art of Science Imaging the Future: The Intersection of Science, Technology and Photography." *Seed* (Spring).

Martyl. 1999. *Martyl: Mountains and Islands*. Introduction by Daniel Schulman. Chicago.

———. 2007. *Martyl: Inspired by Location*. Foreword by Robert T. Buck, introduction by Suzanne Folds McCullagh. Chicago: Printworks Gallery.

———. 2010a. *Martyl: Portable Landscapes*. Introduction by Judith A. Barter. Chicago: Printworks Gallery.

———. 2010b. *Martyl's West*. Clearmont, Wy.: UCross Foundation Art Gallery.

Mathews, Nancy Mowll. 1996. *Cassatt: A Retrospective*. Paris: Beaux Arts Editions.

Matt, Gerald. 2006. *Louise Bourgeois: Aller-Retour*. Nürnberg: Moderne Kunst Nürnberg.

McGrayne, Sharon Bertsch. 2006. *Nobel Prize Women in Science: Their Lives, Struggles and Momentous Discoveries*. Washington, D.C.: Joseph Henry Press.

McGregor, Alasdair. 2009. *Grand Obsessions: The Life and Work of Walter Burley Griffin and Marion Mahony Griffin*. London: Penguin Group. Kindle edition.

Mendes, Kaitlynn, and Kumarini Silva. 2011. "Feminist Games, Play and Expression." *Feminist Media Studies* 11, no. 2 (June): 245–46.

Meyers, Stephan, Ellen Sandor, and Janine Fron. 1995. "PHSColograms and Rotated PHSColograms." *Computers and Graphics* 19, no. 4 (July/August): 513–22.

Miller, Wilhelm. 2002. *The Prairie Spirit in Landscape Gardening*. Amherst: University of Massachusetts Press.

Mills, Kathy Ann. 2010. "A Review of the 'Digital Turn.'" *New Literacy Studies Review of Educational Research* 80, no. 2 (June): 246–71.

Muenning, Mickey. 2014. *Mickey Muenning: Dreams and Realizations for a Living Architecture*. Layton, Utah: Gibbs Smith. Kindle edition.

Müller, Ulrike. 2009. *Bauhaus Women: Art, Handicraft, Design*. Paris: Flammarion.

Mulvey, Laura. 1989. *Visual and Other Pleasures*. Bloomington: Indiana University Press.

Mumford, Lewis. 1926. "Art through the Ages: An Introduction to Its History and Significance, by Helen Gardner." *New Republic*, 236.

Neal, Margaret. 1988. "More than Art." *IEEE Computer Graphics & Applications* (November): 3–5.

Netwon, Judith Vale, and Carol Ann Weiss. 2004. *Skirting the Issue: Stories of Indiana's Historical Woman Painters*. Indianapolis: Indiana Historical Society.

Neuendorf, Henri. 2016. "Guerrilla Girls Unfurl Giant Banner on Façade of Museum Ludwig in Cologne. *artnet.com*, August 26. https://news.artnet.com/exhibitions/guerrilla-girls-museum-ludwig-protest-622715.

Nochlin, Linda. 1971. "Why Have There Been No Great Women Artists?" *ARTnews*, 23–39, 67–71.

———. 1988. *Women, Art, and Power and Other Essays*. New York: Harper & Row.

Noll, Michael. 1994. "The Beginnings of Computer Art." *Leonardo* 27, no. 1: 39–44.

Olson, Eva M. 1996. "Chronicle: Thirty Years of Change." *Collective Vision: Creating a Contemporary Art Museum*. Chicago: Museum of Contemporary Art.

Parker, Rozsika and Griselda Pollock. 2013. *Old Mistresses: Women Art and Ideology*. London: I. B. Taurus.

Pask, Gordon, and Heinz von Foerster. 1961. "A Predictive Model for Self-Organizing Systems, Part I." *Cybernetica* 3:258–300; "Part II." *Cybernetica* 4:20–55.

Pattison, Yuri. N.d. *Cybernetic Serendipity Archive*. http://cyberneticserendipity.net (accessed July 9, 2014).

Pearce, C., T. Fullerton, J. Fron, and J. Morie. 2007. "Sustainable Play: Toward a New Games Movement for the Digital Age." *Games and Culture* (Summer): 261–78.

Peck, Amelia, and Carol Irish. 2001. *Candace Wheeler: The Art and Enterprise of American Design 1875–1900*. New Haven, Conn.: Yale University Press.

"Physics in the 1960s: Plato." N.d. History of Excellence, Physics Illinois, University of Illinois at Urbana-Champaign. http://physics.illinois.edu/history/PLATO.asp (accessed July 9, 2014).

Ramsey, Doug. 2010. "Calit2 Profile: Visualization Research Pioneer Tom DeFanti." California Institutes for Science and Innovation. June 17. http://www.calit2.net/newsroom/release.php?id=1695 (accessed September 24, 2015).

Reichardt, Jasia, ed. 1968. *Cybernetic Serendipity, the Computer and the Arts.* 2nd ed. (rev.) September. Originally published Special Issue, London, July. htxp://cyberneticserendipity.com/cybernetic_serendipity.pdf (accessed July 9, 2014).

Richards, Marlee. 2010. *The Decades of Twentieth-Century America: America in the 1970s.* Minneapolis, Minn.: Twenty-First Century Books.

Rondeau, James. 2015. *Edlis|Neeson Collection: The Art Institute of Chicago.* New Haven, Conn.: Yale University Press.

Sachs, Robert G. 1979. "Maria Goeppert Mayer, 1906–1972: A Biographical Memoir by Robert G. Sachs." *National Academy of Sciences.* Washington, D.C. http://www.nasonline.org/publications/biographical-memoirs/memoir -pdfs/mayer-maria.pdf (accessed October 11, 2015).

Sandor, E., et al. 1994. "Company Makes Hard Copy Record of Virtual Environments." *Advance* (November 28): 12–13.

Schmerler, Sarah. 2014. "Feature Inc.'s Hudson, 1950–2014." *Art in America,* February 16. http://www.artinamerica magazine.com/news-features/news/hudson-/.

Schollmeyer, Josh. 2007. "The Big Picture: The People's Clock." *Bulletin of the Atomic Scientists* (January/February).

Schultz, Rima Lunin, and Adele Hast. 2001. *Women Building Chicago 1790–1990: A Biographical Dictionary.* Bloomington: Indiana University Press.

Ségard, Michel. 1984. "Artists Team Up for the Future." *New Art Examiner* (January).

Shanken, Edward A. 2007. "From Cybernetics to Telematics: The Art, Pedagogy, and Theory of Roy Ascott." In *Telematic Embrace: Visionary Theories of Art, Technology, and Consciousness.* Edited by Roy Ascott. Berkeley: University of California Press.

———. 2009. *Art and Electronic Media.* New York: Phaidon Press.

Shurkin, Joel. 1996. *Engines of the Mind: The Evolution of the Computer from Mainframes to Microprocessors.* New York: W. W. Norton.

SIGGRAPH Gallery. 1990. "ACM SIGGRAPH Touchware Pioneers." https://www.siggraph.org/artdesign/gallery/ S98/pione/pione.html (accessed October 11, 2015).

Sobchack, Vivian. 1990. "A Theory of Everything: Meditations on Total Chaos." *Artforum International* (October): 148–55.

Sonderegger, Elaine L. *SIGGRAPH '82, Art Show Boston, Massachusetts, July 26–30, 1982 Proceedings.* http:// www.vasulka.org/archive/4-23a/Siggraph(7052).pdf.

Sontag, Susan. 1977. *On Photography.* New York: Picador.

Springer, Alicia. 1982. "Art and Technology: 'Chicago Video' at MOMA." *Museum of Modern Art,* Department of Film Exhibition Press Release (May).

Squires, Carol. 2004. "The Art of Science." *The Art of Science Imaging the Future: The Intersection of Science, Technology and Photography.* New York: International Center of Photography, March 12–May 30. http://www .artn.com/files/pdfs/ICP_Essay.pdf.

"Status of Women in the U.S. Media 2014, The." 2014. *Women's Media Center.* http://wmc.3cdn.net/2e85f9517dc 2bf164e_htm62xgan.pdf.

Suehle, Ruth. 2011. "Michelle Obama Announces New NSF Undertakings to Improve Work-Life Balance and STEM Careers for Women." Opensource.com. September 26. https://opensource.com/life/11/9/michelle -obama-annouces-new-nsf-undertakings-improve-work-life-balance-and-stem-careers-wo.

Sutherland, Ivan E. 1968. "A Head-Mounted Three-Dimensional Display." *Proceedings of the AFIPS Fall Joint Computer Conference,* Washington, D.C., 757–64.

Taylor, Grant D. 2013. "V4N2: Humanizing the Machine: Women Artists and the Shifting Praxis and Criticism in Computer Art." *International Digital Media and Arts Association,* July 18. http://idmaa.org/?journalarticle=v4n2 humanizing-the-machine-women-artists-and-the-shifting-praxis-and-criticism-in-computer-art (accessed September 25, 2015).

"Timeline of Computer History." 2006. *Computer History Museum.* http://www.computerhistory.org/timeline/ ?category=cmptr.

Tucker, Daniel P. 2015. "Chicago Parks Have Zero Statues of Women, 48 Statues of Men." *WBEZ 91.5,* July 21. www .wbez.org/programs/morning-shift/2015-07-21/chicago-parks-have-zero-statues-women-48-statues-men-112436.

Tufts, Eleanor. 1981. "Beyond Gardner, Gombrich, and Janson: Towards a Total History of Art." *Arts Magazine* 55:150–54.

Turkle, Sherry. 1980. "Computer as Rorschach." *Transaction, Inc.* (January/February): 15–24.

Twombly, Robert. 1995. *The Prairie School: Design Vision for the Midwest.* Chicago: Art Institute of Chicago.

Van Zanten, David. 2011. *Marion Mahony Reconsidered.* Chicago: University of Chicago Press.

Von Foerster, Heinz, and W. Ross Ashby. 1964. "Biological Computers." In *Bioastronautics.* Edited by K. E. Schaefer, 333–60. New York: Macmillan.

Von Foerster, Heinz, and James Beauchamp. 1969. *Music by Computers.* New York: Wiley.

Waagen, Alice K. 1990. "American Handweaving: The Postwar Years." *Handwoven* (May/June): 4953.

Wald, Lillian D. 1935. *Jane Addams: Forty Years at Hull-House.* New York: Macmillian.

Warren, Lynne. 1984. *Alternative Spaces: A History in Chicago*. Chicago: Museum of Contemporary Art.

———. 1995. *Art in Chicago: 1945–1995*. New York: Thames and Hudson.

Webster, Sally. 2004. *Eve's Daughter/Modern Woman: A Mural by Mary Cassatt*. Urbana: University of Illinois Press.

Weidman, Jeffrey. 2007. "Many Are Culled but Few Are Chosen: Janson's History of Art, Its Reception, Emulators, Legacy and Current Demise." *Journal of Scholarly Publishing* (January): 85–107.

Weik, Martin H. 1961. "The ENIAC Story." *Ordnance Ballistic Research Laboratories, Aberdeen Proving Grounds*. http://ftp.arl.mil/~mike/comphist/eniac-story.html (accessed August 13, 2013).

Weimann, Madeline Jeanne. 1981. *The Fair Women*. Chicago: Academy Chicago.

Weiss, Ruth E. 1966. "BE VISION, a Package of IBM 7090 FORTRAN Programs to Drive Views of Combinations of Plane and Quadric Surfaces." *Journal of the ACM* 13, no. 4 (April): 194–204.

Whitney, John. N.d. Biograph page. https://www.siggraph.org/artdesign/profile/whitney/motion.html (accessed September 14, 2014).

Wiener, Norbert. 1961. *Cybernetics: Or Control and Communication in the Animal and the Machine*. 2nd rev. ed. Cambridge, Mass.: MIT Press.

Wilson, Mark Anthony. 2014. *Frank Lloyd Wright on the West Coast*. Layton, Utah: Gibbs Smith. Kindle edition.

Winter, David. 1996–2013. "Welcome to Pong-Story." *Pong-Story*. www.pong-story.com/intro.htm.

Wittkopp, Gregory, and Diana Balmori. 1995. *Saarinen House: A Total Work of Art*. New York: Harry N. Abrams.

Wood, Debora. 2005. *Marion Mahony Griffin: Drawing the Form of Nature*. Evanston: Northwestern University Press.

Wosk, Julie. 2001. *Women and the Machine: Representations from the Spinning Wheel to the Electronic Age*. Baltimore, Md.: Johns Hopkins University Press.

Wright, Frank Lloyd. 1901. "The Art and Craft of the Machine." *Brush and Pencil* 8, no. 2 (May): 77–81, 83–85, 87–90.

Yardley, William. 2013. "Martyl Langsdorf, Doomsday Clock Designer, Dies at 96." *New York Times*, April 10. http://www.nytimes.com/2013/04/11/us/martyl-langsdorf-artist-behind-doomsday-clock-dies-at-96.html.

Youngblood, Gene. 1970. *Expanded Cinema*. New York: E. P. Dutton.

DVD RECORDINGS

100 Women Architects in the Studio of Frank Lloyd Wright. 2009. Directed by Beverly Willis. New York: Beverly Wills Architecture Foundation.

Frank Lloyd Wright. 2004. Directed by Ken Burns and Lynn Novick. Arlington, Va.: PBS.

Frank Lloyd Wright's Taliesin West. 2007. Directed by Timothy Sakamoto. Los Angeles, Calif., in-D press.

Mary Cassatt: A Brush with Independence. 2002. Directed by Jackson Frost. Washington, D.C.: WETA.

Suffragette. 2016. Directed by Sarah Gavron. Universal City, Calif.: Universal Pictures.

Top Secret Rosies: The Female Computers of WWII. 2010. Directed by LeAnn Erickson. Arlington, Va.: PBS.

Index

||

Note: Page numbers in *italics* refer to figures.

ACM SIGGRAPH. *See* SIGGRAPH (Special Interest Group on Computer Graphics)
ad319, 101
Addams, Jane, 2, 13, *13*, 46n18, 153, 242, 253, 257, *258*, 260n19
Addison, Rita, 107
Advanced Visualization Laboratory (AVL), 71, 83
Ai, Zhuming, 108
AIC. *See* Art Institute of Chicago
Albers, Anni, 5
Albers, Josef, 5, 7, 154
Alexander, Joseph, 60
Alexandroff, Jane, 162
Algora, Montxo, 235
algorithmic art, 72, 150–51
Allen, Paul, 235
Allen, Peter, 144
Allen, Rebecca, 24
All These Worlds, LLC, 251
Altshuler, David, 58
Amacher, Maryanne, 47n28
Amma: A Documentary of a Living Saint, 156, *164*, 165, 165n2
Anatomical Eyes, 42, *91*
Anderson, Laurie, 9, 24–25, 47n37, 236
Anderson, Steve, 259n1
Andreessen, Marc, 49, 57, 78–79, 94, 96, 105, 110, 116
animation: 3D, 186, 188, 202; *Venus & Milo*, *33*, 84n8
Aoyama, Tomoniro, *118*
Apple, 36, 99, 204, 207, 227, 229
Applebaum, Edward, *107*
aquatint color printing, *2*
ARC (Artists, Residents of Chicago) Gallery and Educational Foundation, 9–11, 161, 216
Arcade (color video), *169*
architecture: in Chicago, 2, 4–5, 45nn4–5; by Frank Lloyd Wright, 6–7; John Hancock Building,

231, 232, *232*, 239; Schweikher House, 123, *123*, 125n3
Armour Institute of Technology, 2
Arns, Laura, 91
Arrott, Matthew, 94, *95*, *96*, 146
Ars Electronica, 40, 116, 170, 174, 176, 238
Art Chicago, 11
Art Institute of Chicago, 2, 5, 229, 242. *See also* SAIC (School of the Art Institute of Chicago)
Art Through the Ages (Gardner), 5
Artemisia Gallery, 10, 11, 216
Art Futura, 234–35, 237n3
@art gallery, *100*, 103n2
art games, 182, 249
Artman, Catherine De Jong, *172*
(art)ⁿ Laboratory: Chicago studio, *128*; Cox's involvement with, 182; Cruz-Neira's involvement with, 86–87, 90, 259; early creative processes, 68n1; Fron's association with, 38, 203, 242–43, 245; Kemp's association with, 62; Hart's involvement with, 184; recognition and exhibitions, 30, 36, 60, 64; Sandor's involvement with, 25, 41, *41*, 50, 53, 55, 56, 58, 60, 86–87, 90, 124, *128*, 182, 203, 240, 242; website, *58. See also* PHSColograms
arts and crafts movement, 45n4
Ascott, Roy, 83
Ashes to Ashes: A 9/11 Memorial, 88, 91–92, *134–35*
ASLE (Association for the Study of Literature and Environment), 258
Association for Computing Machinery, 23, 174. *See also* SIGGRAPH (Special Interest Group on Computer Graphics)
astrophysical jet animation, *77*
Atanasoff-Berry computer (ABC), 14
AT&T, 33, 77, 78, 110, 115
Atari, 38, 204, 206, 230

Athanas, Charlie, *Wrap-Around* (video game), 237n1
August, Jerry, 53
Augusto, Cesarr, *33*

Bachrach, Julia S., 125n3, 253, 257, *258*
Bajuk, Mark, *96*, 146
Baker, Polly, 94, *96*, 146
Bally Arcade, 217, 223, 224, 226, 232
Balsamo, Anne, xviii, 79, 277
Bangert, Charles, 23
Bangert, Colette, 23
Barbier, Annette, 22, 41, 149, 160, 170–73, 252, *277*
Barbier, Annette, works of: *Approach*, 173; art details, 201; *Beach Ball Boogie*, 171, *172*; *Escape*, *194*, 201; *Expose, Intervene, Occupy*, 173; *The Home*, 173; *Noms de Plume*, 173; *Patio Lights*, 171; *River of Many Faces/Path of the Dragon*, 173, *194*, 201; *Sram Rap*, 171; *Step on It*, 171; *Stereopticon I–IV*, 171; *Subtractions* series, 173
Bardazzi, Peter, 186
Bargar, Robin, *33*, 48, 79, *80*
Barish, Stephanie, *41*, 58, 67, 90, *244*, 245, 251, 259
Barr, Jim, *113*
Barrows, Scott, 108n1
Bartik, Betty "Jean" Jennings, 15, *15*
Basca, Mara, 170
BASIC, 46n19, 173, 217
Battle of Midway Memorial, 59, *59*, 243, 244–45
Bauhaus style, 5, 6, 46n8, 93, 104; course on, 188; early example of, *105*; IIT and, 28, 253. *See also* New Bauhaus style; Prairie School Style
Baum, Jeffrey, 58
Beam, Mark, 245
Beauchamp, James, 19, 20

ENIAC (Electronic Numerical Integrator and Computer), 14, 15–16, *15*
Enomoto, Mark, 97
Enomoto, Tadeshi, *118*
Equivalent (Stieglitz), *239*
Etra, Louise, 217
Etruscan Venus, 29, *29*, 54, 55, 278
EVE. *See* Electronic Visualization Events (EVE)
Evenhouse, Ray, 107–8, *107*
EVL. *See* Electronic Visualization Laboratory (EVL)
Ewald, Wendy, 253
Eysenbach, Mary, 253

Faber, Mindy, 160
Facebook, 103, 109
Fairies Feeding the Herons (Griffin), *254*
Fakespace Labs, 80, 116, 178
Fangmeier, Stefen, 94, *95*, 146
Faux Vagin (Duchamp), *240*
Feature, Inc. (gallery), 11, 29, 54, 56, 69n7, *232*
Febretti, Alessandro, *118*
Feminist Media Studies (journal), 242, 253
Fenton, Jay, 223
Fermilab (Fermi National Accelerator Laboratory), 121–22; gallery/ exhibitions at, *26*, 30, 56, *65*, 67, 125; Rocky Kolb at, 79, 125; Sandor as artist in residence at, 50, *65*, 67, *129*, 144, 145
fiber arts, 250; and games, 252, 258; heat-transfer images on textiles, 150–51, 152, 155, *200*; and storytelling, 212. *See also* Robinson, Aminah; weaving
film art, 30
films and filmmaking. *See* Chicago Filmmakers; IMAX films; Midwest Regional Film Center; *and names of specific films*
Fisher, Ellen, 160
Fisher, Scott, 207, 234
Flanagan, Mary, 181, 250, 251, 258, 273
Flanary, Barry, 62
Flemming, Bonnie, *65*
FORTRAN, 150, 151
Fox, Ed, *59*
Foxx, Jamie, *43*
Franca, Raphael, 161
Francis, George, 27, 28, 55, 75, 76, 146
Franguiadakis, Terry, *113*
Freed, Hermine, 167–68
Freeman, Jo, 11, 23
Freeman, Ken, 60
Frida Kahlo on White Bench, New York (Muray), 9
Friedan, Betty, 11, *11*
Frist, Bill, 106

Froesch, Phillippe Paul, 67
Fron, Janine: and (art)ⁿ, 38, 203, 242–43, 245; collaborations, 39, 58, 144, 146, 245–46; in Finland, 243–44; and game design, 246–52, 258; with Ludica, 246–50; personal statement, 242–59; photos, *41*, *277*; Prairie Prose and the Prairie School, 253–57
Fron, Janine, works of: art details, 273; *Bloom!*, *246*; *A Dozen Roses for Rainer*, 246–47, *246*; *Fashionistas*, 246, *246*; Ludica artwork, *247*; Ludica Interventions 2005–2007, *270–71*, 273; *The Magical Dream Weaver*, 271; *No Fumare por Favore*, 62, *63*, *243*; *Quills! Elizabethan Edition*, 271; *Quills! Regency Edition*, 255. *See also* PHSColograms
Fu, Ping, 34–36, *36*, 57, 77, 78, 94
Fu, Snow, 275
Fuller, R. Buckminster, 21, 249
Fullerton, Tracy, 39, 245, 247, 249, 250–51, *251*, 257, 259n1, 273
Fumar (Paschke), 62, *63*
Fund for Innovative Television (FITV), 161

Gallagher, Douglas, 60
Gambhir, Sam, 60
Gambrell, Alice, 252
game design, 246–52, 258; video-, 57, 242. *See also* art games; cooperative games; Ludica game art collective
games, women and, 38, 210
garage art: camera, 52–53; studio, 25
Gardner, Helen, 5
Garrett-Ellis, Paula, 171, *172*
Gatzke, Lisa, 97
Gaudí, Antonio, 67
Gaul, Nick, 146
Gavron, Sarah, 13
General Motors, 6, 110, 116
generative systems, 22
Generative(s) Systems, 109, 152
George, Jim, 114, 117
George Coates Performance Works (GCPW), 235
Gerbarg, Darcy, 217
Gerding, Dave, 260n10
Getsy, David, 275
Gholizadeh, Azadeh, 144
Gigliotti, Carol, 176
Gillerman, Jody, 117
Gilman, Christopher, 252, 259n1
Gilmore, Matthew, 145, 146
Gilmore, Roger, 20, 154
Giloth, Copper: collaboration with Veeder, 229; at EVL, 22, 24, 114, 203, 226, 239; "The Paint

Problem," 25, 222, 228; personal statement, 212–20; photos, *22*, *215*, *216*, *277*
Giloth, Copper, works of: *ACM SIGGRAPH SVRii Hypercard Index*, *219*; art details, 272; *Copper Giloth Selected Animations*, *213*; *Field's #10*, *264*, 272; *Labyrinth of Fables/Le Labyrinthe des Fables*, *264*, 272; *Modeling the Female Body*, 218, *220*; *Mother-Daughter-BIOGrids*, *265*, 272; *Real Time Design*, *217*; *Skippy Peanut Butter Jars*, 216, *264*, 272; *From Video Games to Video Art*, 216; *Waveguide(1)*, *214*; *Wrap-Around* (video game), 237n1
Gimbutas, Marija, 29
Ginzel, Lisa, *163*
Gitelman, Emily Rose, 259n6
Glass House Studio, 85
Gleeson, Brendan, 13
Godie, Lee, 9, *10*
Goeppert-Mayer, Maria, 46–47n20, 47n25
Goff, Bruce, 67
Goggin, Nan, 36, 49, 99–103, *277*; art details, 146; *Io*, *137*, 146; *360*, *137*, 146; workspace at UIUC, *102*
Goldstein, Herman, *15*
Gomez, Christina, 275
Gong, Christine, 56
Goodman, Lizbeth, 83, 248, 251
Goodsell, David, 56
Gore, Albert, 97, 116
Gorman, Trisha, *115*
Gotsis, Marientina, 251
Gottlieb, Lois Davidson, 7
Gould, Vanessa, 236
Graphics Circle Habitat, 21, *21*
GRASS (GRAphics Symbiosis System), 20, 226. *See also* ZGrass programming language
Greider, Carol, 62
Greiman, April, 100
Grese, Bob, *256*
Greunz, Markus, *42*
Grey, Jen, 251
Gries, Gero, 67
Griffin, Marion Mahoney, 4–5, *4*, 7, 45–46n6, 253, *254*, *258*
Griffin, Walter Burley, 4
Grooms, Red, 103
GRRL game movement, 210
Grudin, Eva, 181
Grzeszczuk, Robert, 60, 105, 146, 147
Guerrilla Girls, 42, *44*, 48n49, 181
Gundlach, Greg, 52

Haber, Bob, 78
Hairy Who, 9

Hakl-Bakl Marionette Theater poster, *244*
HAL 9000, 27, 39
Hall, Matt, 145, 146
Hallihan, Pat, *118*
Hancock Tower on Lake, *232*
hand-weaving, 5–6
Hangarter, Roger, 201
Hanrahan, Pat, 24, *25*, 72
hard copy, 69n11
Hardin, Joseph, 94
hardware, 16, 33, 88, 103, 115, 227, 232, 238
Harrison, Patty, 216
Hart, Claudia, 40, 41, 55, 149, 180–81, 253; personal statement, 184–89; photo, *277*
Hart, Claudia, works of: *The Alices Walking*, *198*, 202; art details, 202; *A Child's Machiavelli*, 186; *The Dolls*, *187*, *188*, *198*, 202; *Dr. Faust's Guide to Real Estate Development*, 186; New Media installations, 40; *The Seasons*, *199*, 202
Hayama, Komei, 162
Hayden, Sophia, 1, 3, 45n1, 253
Hayden Planetarium, 40, 82, 184
Healy, Terry, 60
Hemilä, Hanna, 252
Hentschaeger, Kurt, 202
Herbst-Tait, Claudia, 187–88
Herr, Laurin, *27*, *115*
Hesse, Eva, 9
Hesser, Terry Spencer, 67
Hidden Figures (film), 275
Hiller, Lejaren, 19, 20
Hirschman, Lynn, 186, *186*
The History of Art (Janssen), 124
Hochstrasser, Megan, 67, 144
Hoel, Jeanne, 251–52
Hoffman, Judy, 13
Hoffman, Rhona, gallery of, 11
Holberton, Betty Snyder, 15
Holmes, Tiffany, 40–41, 55, 149, 188; personal statement, 180–83; photos, *44*, *277*
Holmes, Tiffany, works of: art details, 201; *Breakout* game, 182; *darkSky*, *197*, 201; *Drinking the Lake*, 183, *197*, 201; *FRESH*, *197*, 201; *Mazed*, 182; *Nosce Te Ipsum*, 181–82; *solarCircus* project, 183; *Space Invaders* game, 182
Holopainen, Jussi, 252
Holt, Nancy, 167
Holt, Steven, 184
Holzer, Jenny, 236
Horn, Johnie Hugh, 233, 234
Horsfield, Kate, 22, 149, 160, 166, *167*, 168
HTML (HyperText Markup Language), 101
Hudson (art dealer), 56, 69n7
Hudson, Randy, *113*

Huff, Karen, 23
Hull-House, 2, 5, 9, 153, 242, 253
Hyde Park Art Center, 7, 46n14

ICARE (Interactive Computer-Assisted RGB Editor), 73, *74*, 77
Idaszak, Ray, 27, 28, *29*, 55, 75, 76, 146
iGrams, 40, 48n48, 175, 179n2
iGrid 2005 Workshop, *117*
Ilic, Dragan, 158
ILLIAC (Illinois Automatic Computer), 19
Illinois Institute of Technology (IIT), 5, 7, 28, 25, 28, 64, 219, 253
image processing, 149
Image Union, 160
Imagist art, 7, 9, 11, 62
IMAX films, 71, 79–83, 84nn14–15, *130*; *A Beautiful Planet*, *82*, 83; *Cosmic Voyage*, 79–80; *Hubble 3D*, 83
ImmersaDesk, 106
immersive environments, 53. *See also* CAVE (Cave Automatic Virtual Environment)
Immersive Google Earth in a CAVE, *90*
Indiana University–Bloomington, *42*, 112, 149, *174*, *176*, *177*, 258
IndieCade, 251
Infiscape Corporation, 85
Innovative Genomics Institute, 67
In[side]out, *101*
installation art, 8, 11. *See also names of specific installations and artists*
Institute for Multimedia Literacy (IML), 245
Interactive Computer-Assisted RGB Editor (ICARE), 73, *74*, 77
The Interactive Image (exhibit), 115
interactive media, 204
interactive performances, 160; environments for, 22, 158
interactivity, 205, 206, 239–41
interfaces. *See* computer-human interfaces
inter-media, 188
International Society of Experimental Artists (ISEA), 248
Internet Explorer web browser, 36, 97
Interval Research, 38, 203, 204, 207, 210, 231, 235
Intuitive artists, 25
Isaacson, Leonard, 19, 20
ISEA (International Society of Experimental Artists), 248
Isken, Ruth, 11

Jacquard, Jerry, 170
Jagodic, Ratko, *118*
Jane Austen Society of North America, 242, 255

Janssen, Horst "Peter," 124
Jeanne-Claude, 8, 103n1, 249
Jenkins, Henry, 251, 259–60n7
Jennings, Betty "Jean," 15, *15*
Jensen, Jens, 253, *254*, *256*, 260n15
Jeremijenko, Natalie, 181
Jewett, Brian, 146
John Hancock Building, 231, 232, *232*, 239
Johnson, Andrew, *118*
Johnson, Michael, *95*
Johnson, Randy, 53, *53*, 55, 144
Johnston, Ronnie, *95*
Jonas, Joan, 167
Jones, Jane Lloyd, 4
Jones, Nell Lloyd, 4
Junk, Thomas, *65*, 144, 145
Justis, Gary, 53

Kafai, Yasmin, 251
Kahlenberg, Richard, 252, 273
Kahler, Edward, *118*
Kahlo, Frida, 9, 46n16, *240*
Kahn, Sophie, 202
Kallick, Ingrid, *33*, *96*
Kaprow, Alan, 19
Kapsalis, Terri, 275
Karimabadi, Homa, 145
Kaufman, Rauh, 62
Kawahara, Yoshihiro, *118*
Kay, Alan, 206
Keller, Mary Kenneth (Sister), 46n19
Kemp, Chris, 62, *65*, 144, 145, 243
Kochanek, Doris, *229*
Koehler, Kathy, 37, 87
Kolb, Edward "Rocky," 125
Kolomyjec, Joanne, 23
Kompoltowicz, Keith, 201
Konzack, Lars, 252
Korst, Anda, 13
Kosmatka, Mike, 59
Kramaarae, Cheris, 100
Krasner, Lee, 166
Kraus, Gisela, *33*
Krinkle, Leif, 201
Krogh, Mike, *96*
Kroll, Maxine, 32
Kruger, Barbara, 185
Kubota, Shigeko, 163
Kunito, Goro, *118*

labanotation, 113–14
LambdaVision tiled display wall, *118*
Landreth, Chris, 33, *33*, 50, 62, 77, 79, *80*, 144
Lane, Jeff, 234
Langsdorf, Alexander, Jr., 119–20, 125n1
Langsdorf, Martyl. *See* Martyl
Lanyon, Ellen, 9
Laposky, Ben, 23
Lascara, Cathy, *39*

playground movement, 257, 260nn19–20
Plepys, Dana: collaborative involvement, 49; with EVL, 24, 41, 73; personal statement, 109–11; photos, *113, 118, 277*; with SIGGRAPH, 24, 55
Plepys, Dana, works of: art details, 147; *Drive or Be Driven, 140,* 147; *Eat Meat, 140,* 147; *Swim Year, 140,* 147
plotter, 22, 151, 216
Pocock, Lynn, 218
Pollock, Griselda, 8
Pong, 235
Portapak, 166
postmodernist style, 2, 231
Powers, John, 158
Prairie Fairies flora fashion game, *254,* 259n2
Prairie Prose (game), 253, *254, 255, 256,* 259n2
Prairie School style, 2, 4, 45n4, 93, 242, 253, 255, *256*
Prince, Patric, 24, 27
printmaking, 149
Pseudo Color Maker, 73, *74*
Psihoyas, Louis, 236
Purple Moon, 38, *40,* 203, *208,* 209, 210, 252

Raaf, Jennifer, *65,* 144, 145
Raaf, Sabrina, 181, 275
Ramberg, Christina, 9
Rasmussen, Mary, 32, 38, 49, 108nn1–3; collaboration with Sandor, 105; facial morphing program, 32, 112; personal statement, 104–8; photos, *107, 277*
Rasmussen, Mary, works of: art details, 146–47; *Beauty and the Beast, 139,* 147; *Maxed Out, 38, 138,* 146–47
raster computer graphics, 21, 72
Raven, Arlene, 11
Rawlings, Maggie, *113*
Ray, Man, 25, *26,* 53, 68n1, *176*
RealTime Design, 216, 222, 226, 227, 229
Real-Time (RT) scripting language, 93–94
Regensteiner, Else, 5–6
Reg/Wick Handwoven Originals, 6
Reichardt, Jasia, 20
Reitzer, Joe, *42*
Renaissance Experimental Lab (REL), 32–33
Renaissance Teams: and the collaborative process, 29–30, 32, 54–55, 58, 83; Cox's naming, 27, 71, 73, 75, 84n4; Cox's promotion of, 78, 79 104; interdisciplinary, 1; at NCSA, 77
Renambot, Luc, *118*

Renoit, Andres, 91
Resch, Mark, 53, *53*
resolution, 215, 216, 241; and CineGrid Exchange, 111; of movies, 79; and PHSColograms, 69n8
Rhona Hoffman Gallery, 11
Rich, Daniel Catton, 7
Richard and Ellen Sandor Family Collection, 50, 242
Riesselmann, Kurt, 144, 145
Rigs, Marlin, 161
Riis, Jacob A., *244*
Riley, Bridget, 20
RiverGlass Inc., 93, 97
Robert Abel Associates, 75, 115
Roberta Construction Chart #2 (Hershman), *186*
Roberts, Isabel, 7
Robertson, William, 144
Robinson, Aminah, 181
Robinson, Julie, 202
Rocca, Suellen, 9
Rockett games, 40
Rogala, Miroslaw, 58, 67, 161, 244
Rosen, Kay, 9
Rosenthal, Sally: and the EVL, 22, 24, 73, 109, 112 203, 232, 265; NASA Ames Research Center, *267;* personal statement, 231–36; photos, *22, 116, 277;* with SIGGRAPH, 27, 57, 233; Virtual Interface Environment Workstation Project (VIEWlab), 272
Rosenthal, Sally, works of: art details, 272; *Cows in the News,* 233; *Between the Folds* (film), 231, 236, *236; Squidball* (with New York University), 231, *234; Wrap-Around* (video game), 237n1
"Rosies," 15–16
"Rosie the Riveter," *17*
Rosler, Martha, 167
Ross, Muriel, 55
Rossi, Barbara, 9
Rothenberg, Stephanie, 181, 275
Roy, Trina, *113*
Roytershteyn, Vadim, 145
Rubenstein, Meridel, 238
Rubin, Cynthia Beth, 58, 245
Rueb, Teri, 181
Ruffin, Kimberly, 253
Rusell, Jeff, 91

Saarinen, Eliel, 6
Saarinen, Loja, 6
Sacha, Allan, 145
Sacks, Steve, 186
Sadler, Lewis, 105, 108n1
Sadowski, Dan, 216
SAIC. *See* School of the Art Institute of Chicago (SAIC)
SAIC Sound Area, 22, 223
Salen, Katie, 257

Salisbury, Clark, 272
Sandburg, Carl, *254*
Sandin, Dan: and the CAVE, 33, 87–88, 117; collaboration with DeFanti, 21, 26, 27, 28, 86, 214, 232; collaboration with Smarr, 75; at the EVL, 53, 154, 238; *Five-minute Romp,* 167, *168;* New Space, 157; photos, *20, 21, 29, 113, 159;* at UIC, 20, 55
Sandin Image Processor (IP), 20, *29,* 109–10, 147, 158, 165n1, 171, 223, 224
Sandor, Ellen, 275–76; with (art)[n], 25, 41, *41,* 50, 53, 55, 56, 58, 60, 86–87, 90, 124, *128,* 182, 203, 240, 242; background, 51–55; Chicago imagists and deconstructing architecture, 62–68; collaboration with Fron, 40, 203; collaboration with Rasmussen, 105; with garage art camera, *53;* at IIT, 28; medical imaging, 60–62; personal statement, 50–68; photos, *41, 59, 63, 65, 66, 67, 113, 116, 277;* PHSCologram collaboration, 29–30, 33, 38, 77, 90, 163, 184, 203, 240; at SAIC, 22, 25–26; social political work, 55–59; visit to UIUC, 28
Sandor, Ellen, works of, *126;* art details, 144–45; *AIDS Virus, Third Edition, 126,* 144; *Battle of Midway Memorial,* 59, *59,* 243, 244–45; *Binary Bypass, 129,* 144; *Bubble Chamber Beginnings, 129,* 145; *California,* 51; *Chaos/Information as Ornament,* 64, *126,* 144; *CRISPR-Cas9,* 67, *126,* 144; *Egg Drop, 126,* 144; The *Equation of Terror,* 57; *Have a Nice Day, 124,* 125n4; *Have a Nice Day II,* 67, *126,* 144; *The Magnificent Micelle, Detail II, 126,* 144; *The Magnificent MicrobooNE, 129,* 144–45; *Man Ray '83, 54;* medical imaging PHSColograms, *60; Mies-en-scène,* 64, *126,* 144; *Nanoscape II: Viral Assembly, 126,* 144; *Neutrinos and NOvA, 65, 129,* 145; *Neutrinos in a New Light,* 67, *129,* 144; *No Fumare por Favore, 126,* 144; *Nouveau Nouvel, 127,* 144; panorama view of PHSColograms and sculptures at the (art)[n] studio, *128,* 144; *Perfect Prisms, 126,* 144; *Pixels in Perspective,* 67; *Solar Dynamo/Solar Interior, 129,* 145; *The Supernova Spectacle, 129,* 145; *Tribute to Modigliani, 52; Virtual Bust/Franz K., 126,* 144; wearable art, *51. See also* PHSColograms

Sandor, Richard, *43*, 51, 67, 245. *See also* Richard and Ellen Sandor Family Collection
Sano, Darrel, 96–97
Schiff, Lewis, 56
School of Art and Design, UIUC, 100; building, 101, 216; Bushell at, 41, 93; Cox at, 27, 35, 71, 75, 93; Goggin at, 99, 100
School of the Art Institute of Chicago (SAIC): evolution of days, 2, 7; faculty, 6, 9, 20, 22, 23, 25–26, 40, 53, 55, 58, 150, 152–54, 160, 180–81, 188, 222, 253, 276–77; Gene Siskel Film Center, 41, 50; *Simulations/Dissimulations* symposium, 30–31, 275; students, *5*, 9, 10, 11, 22, 40, 51–52, 58, 62, 64, 67, 109, 159, 160, 171, 182; video facilities, 13, 21. See *also* Video Data Bank (VDB)
Schulz, Carol, 253
Schwartz, Lillian, 20
Schwartz, Sim, *244*
Schweikher, Paul, 123
Schweikher House, 123, *123*, 125n3
Schwender, Georgia, *65*, 144, 145
Science by Satellite televisualization ovont, *33*, *34*, 78, 116
scientific visualization. *See* visualization
Scott, Jill, 181
Scott, Victoria, 181
Ségard, Michel, 53, 68n2, 253
Sehmisch, Grit, 175
Sekhon, Sharon, 251, 252
Shalf, John, *39*
Shapiro, Joseph, 8
Shapiro, Miriam, 11
Shaw, Crystal, 146
Shay, Florence, 252
Sheridan, Sonia Landy, 22, 152
Shorman, Bill, *96*
Sherman, Cindy, 185, 186
Shoah visual history. *See* Survivors of the Shoah Visual History Foundation
Sibener, Steven, 62
Siegel, Lewis, 87
SIG CHI. *See* computer-human interfaces
SIGGRAPH (Special Interest Group on Computer Graphics): Art Gallery/Exhibition, 22–27, 29, 32, 76, 85, 87, 154, 212, 218, 221n3, 229, 240; Art Gallery/Exhibition photos, *29*, *30*, *38*, *77*, *217*; community, 23–26, 219, 224, 226, 241; computer graphics, 40; Electronic Theater, 75, 115, 231, 233, 234, 235, 240; Guerrilla Studio, 248, *250*, 259n4; *Science in Depth* at, 56; traveling art exhibition, 24, 217,

218; Video Review, 55, *74*, 111, 217, 218, 229
SIGGRAPH conferences, 24–27, 29, 32, 33, 36, 37, 39, 47n34, 47n35, 71, 72; **1976**, 114; **1977**, 24, 230n1; **1979**, 114, 230n1; **1981**, 154, 233; **1982**, 217, 218; **1983**, 217; **1984**, 75, 229; **1986**, 27, 75, 77, 115, 233; **1989**, 33, 77–78, 115–16, 117, 234; **1990**, 117; **1991**, 87, 117; **1992**, 36–37, 39, 56, 87–88, 105, 112, 116, 117; **1993**, 111; **1994**, 110, 116; **2000**, 181; **2001**, 62; **2004**, *234*; **2005**, *250*
Sigler, Holis, 9
Silicon Graphics Inc. (SGI), 32, 36, 48n47, 77, 89, 115, 151, 173, 235
Silleck, Bailey, 79, *80*
Silva, Kumarini, 253
Simpson, Diane, 9
Simulations/Dissimulations Symposium Poster, *31*
simulations technology, 3D, 186, 188
Singer, Alex, 252, 273
Singer, Brooke, 181
Singer, Judy, 251, 273
Sinsheimer, Karen, 60, 62, 69n12
Siskel, Gene, 68, 159, *160*
Skotkovich, Tom, 53
Smarr, Larry, 26, 36, 39, 55, 75, 78, 97; photos, *27*, *29*, *115*, *117*
Smith, Steve, 53
Smithson, Robert, 249
Smithsonian Institution, 38, 50, 60
Smoliar, Steve, 113
Snyder, Betty, 15
Snyder, Bob, 22, *159*, 223
Sobecka, Karolina, 181
social media, 38, 103, 278
Solt, Derek, *118*
Sommer, Christine, 34
Sontag, Susan, 13
Sound Area, 22, 223
space, virtual, 97
Spence, Frances "Fran" Bilas, 15
Spence, Homer, *15*
Spencer, Michael, 53
Spencer, Peggy, 53
Spero, Nancy, 9
Spivey, Deanna, *96*
Springfield, Rob, 101
Squidball (Rosenthal with NYU), 231, *234*
Squier, Joseph, 101–3, 146
Squires, Carol, 62
Stafford, Barbara Maria, 181
St. Aubin, Jean, *43*
Stein, Robert, 145
Steinway Hall, 4, 46n7
stereoscopic art, 241
Sterling, Bruce, 236
Sterling, Michael, *157*, 158, *159*
Stieglitz, Alfred, 238, *239*
St. John, Nancy, 28, 75–76, 94, *95*

Stone, Lisa, 55
Stow, Craig, 201
Streep, Meryl, 13–14
Strengell, Marianne, 6
Strickland, Rachel, 38, 210, *210*, 272
Studio Loja Saarinen, 6
Suffragette (film), 13, *14*
Sullivan, Louis, 64
Summers, Frank, 82, *82*, 145
Sun, Yiwen, *118*
supercomputing, 26–30, 33. *See also* Cray 1 supercomputer
Suresh, Subra, 42
Surrealists, 249
Survival Research Laboratory (SRL), 234–35
Survivors of the Shoah Visual History Foundation, 41, 57–58, 90, 245
Suzuki, Tadamichi, *118*
Swain, Chris, 257
Sykes-Dietze, Barbara, 22, 55, 149; personal statement, 156–65; photos, 22, 158, 159, 160, 162, 163, *277*; video productions, 25, 30, 161–64
Sykes-Dietze, Barbara, works of, 215; *Amma*, 156, *164*, 165, 165n2; art details, 200–201; *In Celebration of Life. In Celebration of Death.*, 162, 164, *193*, 201; *Circle 9 Sunrise*, 158, 159, *160*, *192*, 201; *Electronic Masks*, 159, *192*, 200–201; *Environmental Symmetry*, 158; *I Dream of Dreaming*, 160, *161*; *A Movement Within*, *157*, 158; *A Off the Air*, 158; *The Poem*, 158; *Reflections*, 158; *Retrospective*, *162*; *Shiva Darsan*, 164; *Song of the River*, 162, 164; *Video and Computer Art*, 156, 163; *Video Art*, 156, 160, *161*, *162*; *Video Haiku*, 160; *Waking*, 160; *Witness*, 160
synaptic art, 119
Szostak, Jack, 62

Taft, Lorado, 2, 45n3
Talandis, Jonas, *118*
Tamblyn, Christine, 160
Tanaka, Janice, 160, 170
Tanaka, Kathy, 235, 240
Tatineni, Mahidhar, 145
Taub, Caleb Sandor, 144
Tawney, Lenore, 5
Taylor, Jeanie, 100
Taylor, Tracy Marie, 183, 252
Teichert, Anne, 144, 145
Teister, Jim, 158
Teitelbaum, Ruth Lichterman, 15, *15*
Telaction, 110–11
telecommunications, 14, 33, 150
Televisualization: Science by Satellite, 33, *34*, 78, 116
Temaner, Jerry, 158

Tenny, Elissa, 42, *44*, 275
Testa, Angelo, 5
Tetz, Guenther, *159*
Thakkar, Umesh, *39*
Thao, Quoc, 201
Thiébaux, Marcus, 34, 82, *113*, 252
Thingvold, Jeff, *96*, 146
Thomas Lucas Productions, 145. *See also* Lucas, Tom
Thompson, Cynthia, 62
3D animation, 186, 188, 202
3D modeling, 62
3D simulations, 186, 188
Tirrell, Matthew, 62, 144
Tomaszewski, Lynn, 277
Toomre, Juri, 145
Top Secret Rosies: The Female Computers of World War II (documentary), 15
Torres, Diana, 58, 62, *65*
Tow, Rob, 272
Tracey, Robin, 34
Trockel, Rosemary, 185
Truax, Karen, 238
Truckenbrod, Joan, 22, 47–48n38, 149; personal statement, 150–55; photo, *277*; at SAIC 23, 25, 40, 150, 153–54, 181, 182
Truckenbrod, Joan, works of: art details, 200; *On Becoming, 191,* 200; *Electronic Patchwork,* 151, 152; *Fourier Transforms Series,* 151, *190,* 200; *Life of the River, 190,* 200; *Oblique Wave, 190,* 200; *Spirit Site, 190,* 200
Truism (Jenny Holzer), 69n9
Truong, Dien, 146
Tuch, Larry, 91, 252, 273
Tucker, Marcia, 22, *23*
Tufte, Edward, 94, 146
Turkle, Sherry, 25
Tyson, Neil deGrasse, 82, 83

Uhlmann, Gina, 53, *53,* 54
UIC Electronic Visualization Laboratory. *See* Electronic Visualization Laboratory (EVL)
Universal Atmospheres (sculpture), 84n19
University of Chicago (UC), 60, 62, 119, 120, 121, 153, 242, 245
University of Illinois at Chicago (UIC), 1, 13, 17, 19, 20, 28, 32, 34, 39, 86; Electronic Visualization Laboratory (EVL), 27, 30, 81, 109, 157, 175, 183, 201, 223. *See also* Electronic Visualization Laboratory (EVL)
University of Illinois at Urbana-Champaign (UIUC), 30, 39; supercomputing at, 26–28, 34; video production at, 80. *See also* School of Art and Design, UIUC

University of Illinois Chicago Circle (UICC), 214
University of Michigan (UM), 41, 181, 212, *256*
University of Southern California (USC), 242, 245, 251, *252,* 259n5, 260n9
University of Wisconsin, Madison, 24, 25, 27, 72, *73,* 242, 259n2
unreal-estates v1b3 collective, 173
Untitled Film Still (Sherman), *185*
Upson, Craig, 28, 75, 94
Utterback, Camille, 181

van Dam, Andreis "Andy," 231, 281
van der Marck, Jan, 8
van der Rohe, Ludwig Mies, 5, *6,* 67, *256*
Van Osdol, Natalie, *118*
Veeder, Jane, 41, 75, 160, 170, 203, 275; collaboration with Giloth, 212, 215, 218, 219; collaboration with Morton 22, 24, 222, 223–25; collaboration with Petrovic, 238, 239; "The Paint Problem," 25, 212; personal statement, 222–30; photos, *24, 223, 224, 227, 228, 277;* and SIGGRAPH, 233
Veeder, Jane, works of: *4KTape, 227, 266,* 272; art details, 272; *Floater,* 226–27, *227, 228; Montana, 225,* 226; *Program #7* (with Phil Morton), 224; *Program #9* (with Phil Morton), 224; *VizGame, 227; Warpitout, 227, 228, 229, 266,* 272; ZGrass machine, *225, 226*
Venice, California (Dennis Stock), *11*
Venus & Milo animation, *33,* 84n8
Venus series, 28–30, 54, 55, 75–77, 133, 278; photos, *27, 29, 30, 76*
Verlo, Alan, *118*
Vesna, Victoria, 181
video art, 20–21, 30, 109, 149, 156, 166–69, 223
Video Data Bank (VDB), 21–23, 41, 109, 149, 160, 166–69
video game design, 57, 242
video games: early programming, 205, 206; evolution of, 215, 216, 222, 237n1, 239, 244; industry, 24; male orientation of, 175, 207, 209; in popular culture, 57; software for, 21. *See also names of specific games*
videography, 110
Viola, Bill, 163
virtual art, 30, 39. *See also* virtual reality (VR) art
Virtual Director, 34, 37, *39, 80,* 82
Virtual Eye, 107, *108*
Virtual Hindu Temple, 2003, *87*

Virtual Interface Environment Workstation Project (VIEWlab), 234, 272
Virtual Pelvic Floor, 107, *107*
Virtual Reality Applications Center (VRAC), 85
virtual reality (VR) art, 149, 174, 176
virtual reality photography, 50, 55
virtual reality (VR) technology, 33–34, 38, 42, 85, 106, 175, 207, 241
virtual space, 97. *See also* CAVE (Cave Automatic Virtual Environment)
Virtual Temporal Bone, 106; team for, *107*
visualization: biomedical, 38, 104, 105; cinematic, 71, 79, 82; data, 28–29, 42, 78; digital, 93–98; solving problems in, 27–30, 71; scientific, 20, 28, 30, 32, 35, 42, 54–55, 56, 60, 62, 75, 79, 104, 110, 117, 182, 275; supercomputer, 77–78, 79. *See also* Electronic Visualization Laboratory (EVL)
von Foerster, Heinz, 18
von Neuman, Robert, 7
VR Juggler, 85
VRML (Virtual Reality Modeling Language), 173
VROOM, 89, 110, 116

Wainwright, Lisa, xviii, *44,* 182, 275–76, *277*
Walker, Tim, 260n11
Walker Art Center, 69n9, 101, 174
Wang, Wei, 145
Ward, Faye, 13
Warren, Lynne, 7, 13, 20, 216
water sculpture, *213*
weaving, 5–6
W.E.B. (*West Coast–East Coast Bag*), 9–10
web browsers. *See names of specific browsers*
Weber, Read, 7
Webster, Sally, *2,* 12
"We Can Do It!" poster, 17
Weinberg, Tom, 160, 161
Weiner, Norbert, 20
Wescoff, Marlyn, 15, *15,* 41, *41*
Wesselak, Erik, 145
West, Ruth, 178
Westbrook, Jessica, 181, 277
Weston, Edward, 238, *240*
Wharton, Margaret, 9
Wheeler, Candace, 1
Wheless, Glen, *39*
Whitehead, Margaret, 9
Whitney, John, Jr., 114
Whitted, Turner, 226
Wicker, Louis, 145, 146
Wilding, Faith, 181, 275

Wilhelmson, Robert "Bob," 78, 94, 97, 145, 146
Willisch, Marianne, 5
Wilson, Robert R., 121
Winkler, Karl-Heinz, *27*
Wirsum, Karl, 144
Wise, John H., 145
Witherspoon, Reese, *66*
Wolf, Marilyn, 160
Wolff, Robert Jay, 7
"women in games" movement, 38
Women in Information Technology and Scholarship (WITS), 100
Women in Technology International Hall of Fame, 16
Women's Building of the World Columbian Exposition (1893), 1–2, *3*, 45n1, 253; ground plan, *3*
women's movement. *See* feminism
Wood, Doug, 253, *255*
Work and Hope (Riis), *244*
World Wide Web (WWW), 28, 111, 116, 208n3, 278. *See also names of specific web browsers*
Wortzel, Adrianne, 181
Wosk, Julie, 16
Wright, Frank Lloyd, 2, 4, 6, 67, *256*; Ennis house, 7, 46n12; Marin County Civic Center, 6–7, 46n11; *Wasmuth Portfolio*, 4, 46n8
Wright, Olgivanna, 4
Wyatt, Scott, 32

xerography, 22, 72, 153
Xi Xiaonan, *118*

Yarin, Naomi, *118*
Yost, Jeff, *95*, 146
Youngblood, Gene, 161

Zanzi, James, *44*, 53, *53*, 55, *57*, 64
Zaritsky, Raul, 214
Zarrow, Aaron, 259n1
ZBox computer, 171
Zeisler, Claire, 5
Zeller, Sam, *65*, 144, 145
ZGrass programming language, 21, 110, 171, 173, 200, 215, 217, 224, 226
Zimmerman, Eric, 257